PATRONAGE & PRACTICE

SCULPTURE ON MERSEYSIDE

Edited by Penelope Curtis

TATE GALLERY LIVERPOOL

NATIONAL MUSEUMS & GALLERIES
ON MERSEYSIDE

The Walker Art Gallery was honoured to receive a National Art-Collections Award for its new Sculpture Gallery opened by the Minister for the Arts on 15 December 1988. This award has helped to make possible the publication of this volume of essays and the Gallery wishes to acknowledge with gratitude this assistance from the National Art-Collections Fund.

ISBN 1–85437–021–9

Published by order of the Trustees 1989

Copyright © 1989 Tate Gallery Liverpool
and National Museums & Galleries on Merseyside
and the authors

Prepared by Tate Gallery Liverpool;
published by Tate Gallery Publications
and National Museums & Galleries on Merseyside

Edited by Penelope Curtis
Designed by Jeremy Greenwood, Liverpool
Typeset by August Filmsetting, Haydock, St Helens
Printed in Great Britain by Printfine, Liverpool

ILLUSTRATION CREDITS

The British Architectural Library, RIBA, London,
p 33 (2)
The British Library, p 24
By courtesy of the Trustees of the British Museum
p 19 (13)
Norman Childs Photography, p 111 (2), p 112 (3),
p 114
Conway Library: Courtauld Institute of Art, cover,
pp 28, 32–40 (excepting (2) & (10)), p 72, pp 90–92
Country Life, p 15
Dr and Mrs Martin Evans, p 106 (3 & 5), p 107 (7)
Herbert Felton Photographer/BWS Publishing, p 11
Geoffrey Ireland, p 102, p 106 (4 & 6), p 107 (8 & 9),
p 108 (11)
Liverpool City Council, Libraries and Arts
Department (Binns Collection), p 23 (3)
The Metropolitan Museum of Art; bequest of Isaac
D Fletcher, 1917, Mr and Mrs Isaac D Fletcher
Collection, p 71 (9)
John Mills Photography, Liverpool, p 75 (2)
National Museums and Galleries on Merseyside
(Liverpool Museum), pp 13–19 (excepting p 13 (2),
p 15 and p 17 (7))
National Museums and Galleries on Merseyside
(Walker Art Gallery), p 13 (2), p 17 (7), p 26, p 27 (7),
p 39 (10), pp 50–55, p 59, pp 64–5, pp 67–9, p 75 (3),
p 76, p 77 (6), p 83, p 86, p 89 (5), p 103, p 112 (4),
p 113, p 117 (2)
National Museum of Wales, p 75 (4), p 78 (9)
Phaidon Press, p 108 (10)
Philadelphia Museum of Art, Rodin Museum, p 71
Julia Carter Preston, pp 94, 97
Museum of Art, Rhode Island School of Design; Gift
of Mrs Gustav Radeke, p 70
Meg Robbins Photography Liverpool, p 111 (1)
Royal Academy of Arts, London, p 57
Royal Commission for Historic Monuments, p 31
Tate Gallery London, pp 119–129, and David
Lambert (Tate Gallery Photographic Department),
pp 79–82, p 84 ((21) and (22))
University of Liverpool, pp 60–62
University of Leicester, p 27 (8)
By courtesy of the Board of Trustees of the Victoria
and Albert Museum, p 70 (7), p 71 (11)

CONTENTS

INTRODUCTION

This book is the second part of the collaborative project between Tate Gallery Liverpool and National Museums and Galleries on Merseyside initiated last year with the publication of *Sculpture on Merseyside*, a small colour guide illustrating over seventy local sculptures.

The present book is very different in nature, but it is to be hoped that the audiences for the two publications might not be entirely distinct from each other. The eighteen articles here look at different aspects of the pursuit of sculpture in the area over the last two centuries. The Tate collection is the obvious anomaly, as are the two essays devoted to it in this anthology. However, although the history of the national collection is not intertwined with the history of sculptors and patrons of this area, the Tate, with the opening of Tate Gallery Liverpool in 1988, has now entered that history. The nature of the national collection now has immediate relevance for Merseyside, and it is here that, for the first time, a significant proportion of its sculpture collection is on display.

The sculpture discussed is generally to be seen on Merseyside, either outdoors, or in the public buildings and galleries. Thus, though much of the work may have originally come to Merseyside to take its place in private collections, it is now accessible to the public.

Stamp's opening essay gives a vividly plastic 'bird's-eye-view' account of the architectural and sculptural profiles of Liverpool.

The essays' discussion of patronage begins with the collector Henry Blundell's first tour to Italy in 1777. While the bulk of Blundell's collection comprised classical antiquities, he also patronized his contemporary Canova. Blundell's collection was open to the public at Ince Blundell Hall outside Liverpool. Blundell's career as a collector was interrupted by the French revolutionary wars, and he died in the year that the Liverpool Academy, which he had helped to found, held its first exhibition. With the founding – four years later in 1814 – of the Liverpool Royal Institution, the climate might be said to be now conducive to sculpture – both its practice and patronage – and a school of sculpture begins to emerge in the city. Stevens looks at the varied support network necessary to those sculptors emerging after 1800, a network comprising architectural and decorative sculpture, the newly established institutions, teaching, copy drawing, editioning, portraiture, and church memorials – all strongly dependent on private patronage. Greenwood then looks at the establishment of a body of sculptors and patrons in Liverpool, Birkenhead and surrounding areas from 1830 onwards.

The next local private collector featured in the anthology is James Smith whose purchases of Rodin's sculptures around 1900 were later bequeathed to the Walker; he is discussed in the context of British enthusiasm for Rodin's work.

The nineteenth century is notable for civic support of public commemorative sculpture, and Yarrington and Read provide surveys of the phenomenon's appearance in Liverpool. Two case studies are also present; McPhee's study of a particular project – the sculptural decoration of St George's Hall – and Stevens' study of a particular sculptor, Sir George Frampton.

Civic patronage of sculpture in our own century is much rarer, and the anthology reflects this. Compton's survey of Merseyside war memorials records the last occasion when civic bodies invested on a large scale in public sculpture (certainly in commemorative sculpture), occasioned because there was felt to be no alternative. Kidson looks at an isolated period of civic interest in public sculpture (by now reso-lutely non-commemorative) in Liverpool in the early eighties.

The appearance of outdoor sculpture in cities has, since the First World War, tended to be due to institutional bodies other than the civic. University, commerce, arts support bodies, galleries and (notably in Liverpool) the church have occasioned commissions, and Carpenter, Silber, and the present author look at examples. Having lost its commemorative functions, public sculpture seems to have lost its civic backers. 'Civic' is, however, multi-layered, and of course includes the public. Most nineteenth-century commissions were supported by public subscription. The essays on civic patronage, with the exception of Compton's, also reveal the individual within the civic body, and in so doing, may draw attention to the changing nature of civic participation.

The book closes with two attempts, by Alley and Biggs, to account for the shape of the Tate's collection of twentieth-century British sculpture.

This book was not conceived with the intention of providing a total picture of sculpture on Merseyside over the last two centuries, but it nevertheless provides a fair picture, weighted, inevitably, in favour of the nineteenth century. It succeeds in raising many of the most significant points in any discussion about the support of sculpture, points which are as valid for the twentieth as they were for the nineteenth century. The overlaps between the various essays are illuminating; different perspectives throwing different lights on the same artists and patrons. The overlaps create a certain continuity and affirm that the focus is on one city. The essays on private patronage all involve bringing sculpture 'home' from abroad, yet a constant concern in the civic arena is a xenophobic one; should commissions be restricted to the home-grown sculptor, or can the net be cast wider? It is notable how the name of John Gibson, who left Liverpool for Rome at the age of 27 (one of a body of Liverpool-trained artists to make their home abroad), recurs through these essays whose common subject is Liverpool. Territorial ties were not necessarily broken, which makes for an interesting comparison with more recent times.

This project, like the last, was initiated by Edward Morris and Lewis Biggs of the Walker Art Gallery and Tate Gallery Liverpool respectively. I should like to thank Timothy Stevens for an early discussion with him which helped me as a newcomer to acquire a framework for the subject, Jeremy Greenwood for his enthusiasm, Alex Kidson for his help, and all the authors.

Penelope Curtis,
Assistant Curator,
Tate Gallery Liverpool

LOCATIONS OF SCULPTURE ON MERSEYSIDE DISCUSSED IN THE TEXTS

LIVERPOOL

Allerton, Greenhill Road, All Hallows, Allerton
William Spence: 'Monument to John Bibby'

Anglican Cathedral
Edward Carter Preston: interior and exterior porch figures, recumbent figure of Bishop Ryle and memorial tablets to Robert Jones, Helen Swift Neilson, Sir Max Horton
David Evans: 'Bishop Chavasse'
Giles Gilbert Scott, G W Wilson, Thomas Tyrell, Walter Gilbert: Memorial to 16th Earl of Derby
H G Ratcliffe: wood carvings
L Weingartner and Walter Gilbert: Reredos
G W Wilson: Reredos, Lady Chapel

Barclays Bank (formerly Martin's Bank), Water St
H Tyson Smith: Gates, interior and exterior details

Cotton Exchange
Francis Derwent Wood: 'Cotton Exchange Memorial'

Customs House, Canning Place
see Oratory

Derby Square
F M Simpson, Willink and Thicknesse (archs), C J Allen (sc): 'Monument to Queen Victoria'

Exchange Flags
Joseph Phillips: 'News Room Memorial'
Richard Westmacott and Matthew Cotes Wyatt: 'Vice-Admiral Horatio Viscount Nelson'

International Garden Festival Site
Graham Ashton: 'Dry Dock'
Kevin Atherton: 'Three Bronze Deckchairs'
John Clinch: 'Wish You Were Here'
Stephen Cox: 'Palanzana'
Raf Fulcher & George Carter: 'Sculptural Treatment for Arena Theatre'
Allen Jones: 'The Tango'
Dhruva Mistry: 'Sitting Bull'
Nicholas Pope: 'Unknown Landscape 3'

Lewis's Store, Ranelagh St
Jacob Epstein: 'Liverpool Resurgent' and three panels

Liverpool & London Insurance Office, Castle Street
W G Nicholl: Entrance hall decoration

Liverpool Museum, William Brown Street
Solomon Gibson: 'Mercury'
Collection of Ince Blundell marbles

Liverpool University Campus
C J Allen: 'Plaque to Francis Gotch', 'University War Memorial'
Albert Bruce-Joy: 'Christopher Bushell'
Mitzi Cunliffe: 'Three forms'
George Frampton: 'Plaque to George Holt'
Count Gleichen: 'Duke of Albany'
Barbara Hepworth: 'Square with two circles'
Eric Kennington: Figure on Harold Cohen Library
Phillip King: 'Red Between'
John McCarthy: Gateway to Mathematics and Oceanography

London Road
Richard Westmacott: 'King George III'

Metropolitan Cathedral
William Mitchell: Porch and Belfry designs

Oratory, St James Road
Francis Legatt Chantrey: 'Monument to William Nicholson'
John Gibson: 'Monument to William Hammerton', 'Monument to Mrs Robinson', 'Monument to William Earle', 'William Huskisson' – formerly at Canning Place, Customs House, later in Prince's Avenue
J A P MacBride: 'Monument to Dr William Stevenson'
Joseph Gott: 'William Ewart'

Pierhead
George T Capstick, Edmund C Thompson: Detailing on ventilation towers, Mersey Tunnel
George Frampton: 'Sir Alfred Jones'
William Goscombe John: 'Monument to the Engine Room Heroes', 'Edward VII'
Henry Pegram: 'Victory'
Stanley Smith and C F Blythin: 'Royal Navy Memorial'

Philharmonic Hotel, Hope Street
Frank Norbury, Pat Honan, H Blomfield Barr, C J Allen: exterior and interior decorative schemes

Prince's Avenue
F J Williamson: 'Hugh Stowell Brown'
See also Oratory

Royal Institution
See St George's Hall

Royal Insurance Offices, Dale Street
C J Allen: Frieze

St Clare's, Arundel Avenue
George Frampton and Robert Anning Bell: Altarpiece

St George's Hall
John Adams-Acton: 'W E Gladstone'
George Gamon Adams: 'Rev Hugh McNeile'
C J Allen: two panels, northern portico
Albert Bruce-Joy: 'Edward Whitley'
C J Cockerell: candelabra
Conrad Dressler: two panels, northern portico
Giovanni Fontana: 'Joseph Mayer', 'Samuel Robert Graves'
John Gibson: 'George Stephenson'
Ludwig Grüner (and Alfred Stevens): Minton tile floor, Great Hall
Francis Legatt Chantrey: 'William Roscoe' (tr. from Royal Institution)

Patrick McDowell: 'William Brown'
Matthew Noble: 'Robert Peel'
Benjamin Spence: 'Rev Jonathan Brooks'
Thomas Stirling Lee: Six panels, southern portico, two panels, northern portico
Willian Theed: '14th Earl of Derby', 'Henry Booth'

St George's Plateau
C B Birch: 'Benjamin Disraeli', 'Major-General Earle'
Lionel Budden & H Tyson Smith: 'Cenotaph'
Andrew Lawson (arch) and George Lawson (sc): 'Duke of Wellington column'
W G Nicholl: four recumbent lions
Thomas Thornycroft: 'Albert, Prince Consort', 'Queen Victoria'

St James's Mount Gardens
George Frampton: 'William Rathbone'

St John's Church
Benjamin Gibson: 'Matthew Gregson'

St John's Gardens
Thomas Brock: 'William Gladstone'
Albert Bruce-Joy: 'Alexander Balfour'
George Frampton: 'Sir Arthur Bower Forwood Bart', 'Canon T Major Lester'
William Goscombe John: 'King's (Liverpool) Regiment Memorial'
F W Pomeroy: 'Monsignor Nugent'

Sefton Park
J H Foley and Thomas Brock: 'William Rathbone V'
George Frampton: 'Peter Pan'
Alfred Gilbert: 'Eros'

Seymour Street
Charlotte Mayer: 'Sea Circle'

Sudley Art Gallery, Mossley Hill Road
George Frampton: 'Mysteriarch'
Henry Pegram: 'Eve'
C B Robinson: 'The Flight into Egypt', 'Psyche'
Auguste Rodin: 'L'Amour qui passe', 'Danaïde', 'Eve', 'Frère et Soeur', 'Mort d'Athènes'

Tate Gallery Liverpool, Albert Dock
'Modern British Sculpture from the collection'
The reader is referred to the handbook published in conjunction with this display which is on view 1988–1991

Technical College, Byrom Street
F W Pomeroy: lamp-standards

Town Hall, Dale Street
Francis Legatt Chantrey: 'George Canning'
J C F Rossi: 'Britannia'

University Art Gallery, Abercromby Square
Jacob Epstein: 'Einstein', 'Oriel'
Elisabeth Frink: 'Gogglehead'
John Gibson: 'Matthew Gregson'
G F Watts: 'Physical Energy'

Whitechapel, Post Office
C Reilly (arch) & H Tyson Smith (sc): War Memorial

Walker Art Gallery, William Brown Street
Carlo Albacini: 'Lucius Verus'
Jacob Epstein: 'Mrs Sonia Heath'
George Frampton: 'Head of Woman', 'My Thoughts are my Children', 'St Christina', 'So He Bringeth Them Unto Their Desired Haven'
Benjamin Gibson: 'Psyche and the Zephyrs'
John Gibson: 'Christ Blessing Little Children', 'Cupid in Disguise', 'Cupid pursuing Psyche', 'Flora', 'Helen', 'Love Tormenting the Soul', 'Psyche and the Zephyrs', 'William Roscoe', 'Mrs Sandbach', 'Sleeping Shepherd Boy', 'Tinted Venus'
Rinaldo Rinaldi: 'The Wise and Foolish Virgins'
August Rodin: 'Minerve au casque'
B E Spence: 'The death of the Duke of York at Agincourt', 'The Finding of Moses', 'Highland Mary'
William Spence: 'George Canning', 'John Foster Senior'
Bertel Thorvaldsen: 'Christian Charity', 'Day', 'Night'
Emile Wolff: 'The Goat Herd'
R J Wyatt: 'Nymph preparing for the bath'

Wavertree, Holy Trinity Church, Church Road
H Tyson Smith: 'War Memorial'

WIRRAL

Birkenhead, Hamilton Square
Albert Bruce-Joy: 'William Laird'
Lionel Budden (arch) & H Tyson Smith (sc): War Memorial

Port Sunlight
William Goscombe John: War Memorial

West Kirby, Grange Hill
Charles Sergeant Jagger: 'Hoylake and West Kirby War Memorial'

ENVIRONS

Chester, Cathedral
William Spence: 'Memorial to John Ford'

Farnworth, St Luke's
George Bullock: 'Monument to Anna Maria Bold'

Halsall, St Cuthbert's
George Bullock: 'Monument to Reverend Glover Moore'

Llanbedr, St Peter's
William Spence: 'Memorial to Ursula Lloyd'

Middleton, St Leonard's
William Spence: 'Monument to James Archer'

Sefton, St Helen's
George Bullock: 'Monument to Robert Blundell'
John Gibson: 'Memorial to Henry Blundell'

St Helens
George Frampton: 'Queen Victoria'

Sandbach, St Mary's Church
William Spence: 'Monument to John Ford'

Southport
George Frampton: 'Queen Victoria'
Grayson, Barnish and A L McMillan (archs), H Tyson-Smith (sc): War Memorial

ARCHITECTURAL SCULPTURE IN LIVERPOOL

Gavin Stamp

The pediment above the south portico of St George's Hall, the building described by Norman Shaw as, 'one of the great edifices of the world', is now a barren void covered by chicken wire. Once it was filled with sculpture: a group illustrating 'Commerce and the Arts bearing tribute to Britannia' carved by W G Nicholl from a design initially prepared by Professor C R Cockerell and improved by Alfred Stevens. Poor Harvey Lonsdale Elmes never saw that sculpture in place but he was sure that his 'pediment will be adorned with one of the richest compositions in sculpture ever executed in this country'[1]. In 1950 the sculpture was removed on the grounds that it was in a dangerous condition. And whereas the surviving fragments of the pediment sculpture of the Parthenon which inspired that on Liverpool's great temple has been reverently preserved in the British Museum, Nicholl's work is now 'lost', having probably been ground up as hard core for road construction.

The monstrous fate of this sculpture suggests, at the very least, a limited appreciation by the post-war Corporation of Liverpool of the intimate and vital connection between sculpture and architecture in the Classical tradition. It was not always so: back in 1841 Elmes had been able to resist the demand for economies in the decoration by pleading successfully to the committee of hard-headed Liverpudlians that this would result in 'the total destruction of the Design as a Work of Art and as an ornament of the town'[2]. St George's Hall was designed as a great civic building. Elmes therefore provided plinths and niches for future embellishment with statues of suitable heroes and dignitaries; he also allowed for a rich sculptural treatment in the parts of the building customarily alloted for the purpose in the Classical tradition: pediments and friezes, spandrils and lunettes. St George's Hall consciously departed from the planar aridity of so much contemporary Greek Revival architecture and returned to the sculptural decorativeness of the Renaissance and Ancient Greece.

Architectural sculpture is too often ignored today, partly because we no longer 'read' the symbolism and iconography of a building as past generations were accustomed to and also because of the very fact that it is usually subservient to an overall architectural scheme or conception. It is the sculpture that is consciously isolated and labelled, whether in a museum or open space or screwed to the otherwise blank wall of a modern building, that receives the attention. But such works do nothing for that synthesis of geometrical composition, formal discipline and sculptural and decorative enrichment that characterises the art of architecture at its greatest. 'It is in the nature of the conditions under which architectural sculpture and other decorations are produced that they should be to a large extent anonymous'[3], observed Professor William Conway in 1888 when investigating the contribution of Alfred Stevens to St George's Hall. This is probably as it should be, as the position and extent of the best architectural sculpture must be governed by the architect's total conception. However vigorous and expressive it may be, it is a means to an end and needs to be seen in its built context. This is certainly true of the Classical and Gothic traditions and even of the Arts & Crafts movement, which held Architecture to be the 'Mother' of all the Arts. Even so, it is possible to identify the distinctive work of a number of talented sculptors who greatly enhanced Liverpool buildings.

Architectural sculpture dominates the heart of the city, for at the summit of the proud new dome on top of the Town Hall rebuilt by

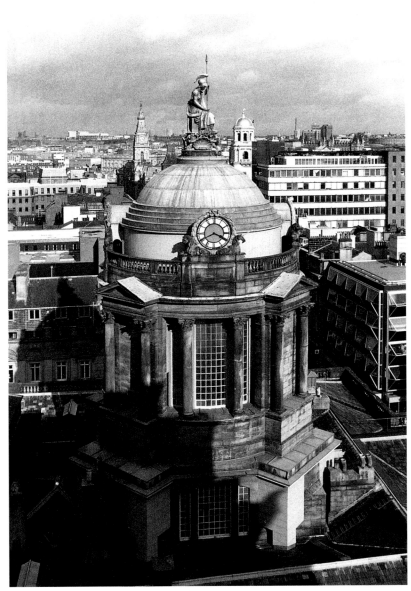

1. J C F Rossi, 'Britannia', Liverpool, Town Hall

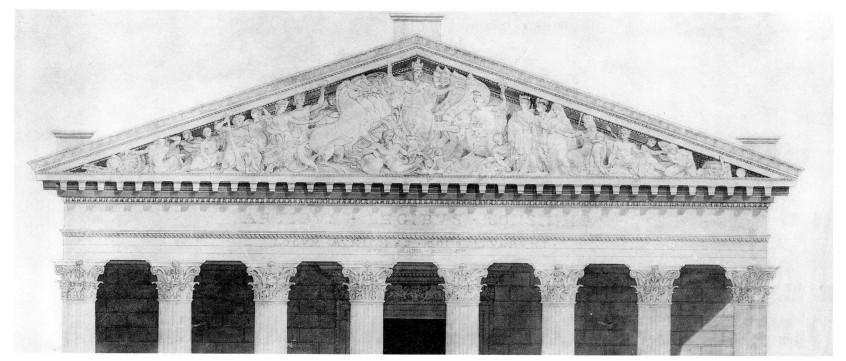

2. C R Cockerell, 'Design for the Sculpture on the pediment of St George's Hall, Liverpool', 1843

James Wyatt sits the Coade stone figure of Britannia. Modelled by Rossi, she was supplied in 1799 by Mrs Coade's firm and is one of several fine sculptural embellishments to Wyatt's building. The frieze between the Corinthian pilasters is carved with ropes, anchors and other elements appropriate in a seaport while four freestanding figures on the north portico look down on Exchange Flags and on the Nelson Monument, the work of the architect's son, Matthew Cotes Wyatt. Britannia herself looks the other way, down Castle Street to the Queen Victoria Monument. Designed by F M Simpson, Professor of Architecture in Liverpool, almost exactly a century later, this ebullient structure demonstrates how Classicism touched by the ideals of the Arts & Crafts movement almost allowed the sculpture to get out of control. The Queen-Empress herself sits under the central domed pavilion, but it is C J Allen's flanking groups, sitting on licentious Baroque pedestals, that hold the attention.

There can be no doubt that the finest architectural sculpture in Liverpool is – or was – to be found at St George's Hall where the scheme for decoration and embellishment was conceived on the most splendid scale. The lost pediment sculpture was originally based on an 'Idea for the Frontispiece of a Publick Building in England'. This drawing had been prepared for the Royal Exchange in London by Elmes's friend and successor, Cockerell, an architect whose ideal was sculptural and who could speak of 'the sculptor being a more important person than the architect who only furnished the framework for his brother artist', in ancient Greek temples, for, 'The lines of the sculpture contrasted with the right lines of the architecture to the improved effect of each'[4]. Cockerell brought in Nicholl to execute the work at Liverpool, although there is evidence that Alfred Stevens rearranged the composition in the sculptor's studio. (Stevens also improved Ludwig Grüner's design for the Minton tile floor in the Great Hall.) The pediment sculpture was in place by 1850.

Nicholl also modelled the four recumbent lions who guard the long east portico. He may well have executed much more within the building, for he was Cockerell's favourite sculptor and went on to do all the stone carving on the Liverpool & London Insurance office next to the Town Hall with its garlanded, mannered entrance of which Charles Reilly remarked that, 'There is no more original, and at the same time satisfying, public doorway in England'[5]. In the Great Hall of St George's Hall there are the winged figures in the spandrels of the lateral arches, the figurative and heraldic coffers of the vault, the decorative architraves and keystones, the great bronze doors bearing the acronymn 'SPQL' and the herms supporting the organ – all of which

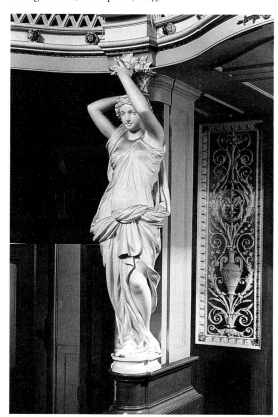

3. Caryatid, Concert Hall of St George's Hall

required the assistance of a sculptor or modeller. In the northern vestibule, embellished by Elmes with casts of the Parthenon frieze, there are Cockerell's magnificent candelabra cast with reliefs of cherubs within garlands while in the exquisite Concert Room above, the undulating balcony is supported on delightful caryatids with baskets on their heads who represent Flora, Goddess of Spring and Flowers, and Pomona, Goddess of Fruits and Gardens. Are these casts the work of Nicholl, whose 'progress was little better than a struggle for dear life,' recorded a friend after his death, 'until one day Cockerell, RA, found him out, happily for both, one requiring most important work well done, under his own eye, and the other sighing at once for fame and money, apparently so distant'[6]? They remain anonymous.

Elmes had also planned that the recessed panels within the subsidiary order and between the Corinthian pilasters on the long east elevation of his masterpiece should be filled with relief sculpture, but this was not attempted in his lifetime or in that of Cockerell. In 1882, at the instigation of Sir James Picton, the City held a competition for designs to fill the panels. This was won by Thomas Stirling Lee, who had been 'apprenticed to an architectural sculptor, so-called, in days I trust past, for I look for the time when the distinguishing epithet of "architectural" sculptor or "figure" sculptor will no longer exist and that we shall all be able to enrich architecture and be, in the most complete sense of the word, "sculptors" '7. Lee should, therefore, have been an ideal artist to embellish the building but his first two panels did not meet with the approval of the Corporation, partly because his style was novel and partly because of the presence of naked figures of girls, both pre- and post-pubescent. A man accused of selling indecent photographs told a Liverpool magistrate that obscene statuary on St George's Hall was setting a bad example to the public and the first series of six panels to the south of the portico was only completed because, in 1890, Philip Rathbone offered to pay for the remaining four. For the second, northern series, Lee was only allotted two, the remaining four being divided between Conrad Dressler and the local sculptor, Charles Allen.

Lee was a representative of the 'New Sculpture', that expressive and creative movement that revitalised Enlgish sculpture towards the end of the century; he also became a member of the Art-Workers' Guild which believed in the unity and equality of all the arts and crafts. At the time of the competition, Lee was most influenced by the Greek sculpture in the British Museum as well as by his friend Alfred Gilbert. However, although his panels have appropriately hieratic compositions, there is something gauche, or, perhaps, intrusively realistic about their character and they lack the smooth finishes and idealism of the Neo-Classical sculpture that Elmes must have had in mind for this building. The long, hieratic relief panels of the 1920s by Tyson Smith on Lionel Budden's Cenotaph in front of St George's Hall seem much more harmonious with the building.

Nevertheless, the whole controversy about the panels gave an important boost to architectural sculpture in Liverpool as elsewhere and there are some fine examples in the city of the 'New Sculpture' enhancing contemporary architecture. There is the frieze on Francis Doyle's Royal Insurance Offices in Dale Street, a building much inspired by the Arts & Crafts Baroque of Belcher's Chartered Accountants headquarters in London and, indeed, the sculptor, Charles Allen, had been Hamo Thorneycroft's chief assistant on the sculptural frieze on that influential prototype. Then there are the sculptured figures and the bronze lamp-standards by F W Pomeroy on E W Mountford's similarly Baroque Museum and Technical College. And, at a more popular level, there is, of course, the Philharmonic Hotel, that most exuberant realisation of Arts and Crafts ideals achieved by artists from the University School of Art: caryatids by Allen, *repoussé* copper panels and the wild, almost *art nouveau* gates by H Blomfield Barr, plasterwork by Pat Honan, stone carving by Frank Norbury, and splendidly decorative metalwork, woodwork and stained glass throughout.

The Philharmonic was completed in 1900. It was to be the last as well as the best of its kind, for the new century saw a reaction against both ebullient decoration and freely expressive architectural sculpture. Architects began to reimpose discipline as their ideal became more austere and controlled. This can be seen in the great Gothic cathedral that began to rise on St James's Mount after 1904. There is a vast amount of sculpture and carving in the building, but it is all of a consistent character and completely subservient to the sublime vision of its architect, Giles Gilbert Scott. Scott was a product of the Gothic Revival and there was much that was Ruskinian about his approach to variety, detail and materials. But as regards sculpture, he rejected the

4. C J Allen, 'The Murmur of the Sea', Philharmonic Hall Hotel

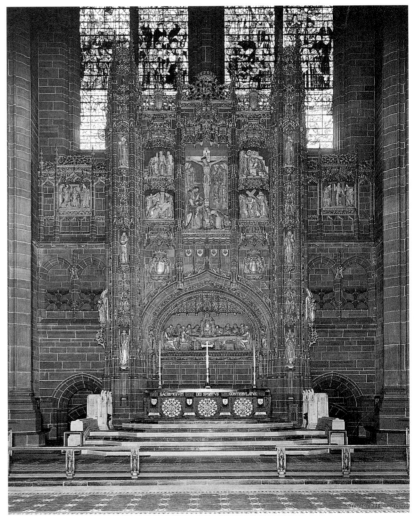

5. G G Scott, Walter Gilbert and L Weingartner, Principal Reredos, Anglican Cathedral

creed, preached by Ruskin and Morris and proclaimed by the Arts & Crafts movement, that it was the free expression of the workman's chisel that was most important in architecture. Just as Scott classicised Gothic, so he made sculpture an affair of ornament and detail within his total architectural conception. He only used accomplished but second-rate sculptors who did exactly what he wanted.

If not exactly lifeless, the architectural sculpture in Liverpool Cathedral cannot really be described as expressive or original. Most of the angels and Gothic detail on the woodwork was carried out by the carver, H G Ratcliff; the panels of the Lady Chapel reredos were carved

by G W Wilson while the sculpture on the principal reredos of red sandstone was the work of Walter Gilbert and L Weingartner, who carried out sculpture elsewhere in the building. A few memorials by David Evans show the refreshing influence of Gill but most of the sculpture in the Cathedral was the competent and smooth production of Scott's tireless executant, E Carter Preston, whose first work was the stylised recumbent effigy of Bishop Ryle.

The case of another similar memorial, that to the 16th Earl of Derby unveiled in 1929, is particularly instructive. With a recumbent figure of bronze lying on a carefully modelled plinth of grey marble, this free-standing monument conceived in the Renaissance rather than the Mediaeval tradition is arguably the finest work of sculpture in the Cathedral. Sculptors were involved in its creation – Wilson and Thomas Tyrell of Messers Farmer & Brindley as well as Walter Gilbert – but their task was to produce models from Scott's sketches which he then altered. Scott, like Cockerell before him at St George's Hall, knew exactly what he wanted and it is clear that if there was a single designer or 'sculptor' of the Derby Memorial, it was the architect himself[8].

Scott's attitude to sculpture did not escape criticism. In 1911, he began to receive rude and sarcastic letters from Pat Honan (at first anonymous and later signed), who called the work 'executive rubbish ... There being nothing in common between the sculpture and architecture argues *two* minds ...', 'Originality run riot – one-eyed angels at 1/0 per hour ... '. Honan was Irish and evidently embittered, hence his writing to Scott that, 'It ought to be refreshing to you not to have compliments paid you. All brilliant sculptors are dead *so* full size models – manly conceptions and no risks, and may the Sacred Heart grant you success beyond your wildest dreams ...'[9]. He was apparently also out of work, for within a year he was writing to Scott begging him to give him a trial as a 'modeller or carver'. But Scott did not need Honan, for the emotional power of his monumental Gothic creation relied on his original style of detailing rather than the expressive hand of the architectural sculptor.

A similarly authoritarian attitude towards sculpture was displayed by the architect of the second stupendous cathedral that began to rise, momentarily, at the other end of Hope Street after 1933. Unlike his erstwhile friend and collaborator, Herbert Baker, Sir Edwin Lutyens did not much patronize sculptors and he usually only needed carvers who would execute the classically inspired figures and decorative details his designs sometimes required. When Lutyens wrote to defend Epstein's sculptures in the Strand from mutilation by the South Rhodesians in 1937, the sculptor had every reason to complain that the letter was 'grotesque with its talk of the sculptor in the "full vigour of work and imagination", etc., etc., in view of the fact that this eminent and busy architect has never once even approached me with a request for sculpture during his long life'[10]. But, of course, the raw power of the work of Epstein could not really be reconciled with the precise, monumental geometry of Lutyens's buildings and only the architect Charles Holden ever succeeded in harnessing Epstein's creativity to fine architecture. But when Lutyens did need a sculptor, he went to one of the best: Charles Sargeant Jagger. He intended that the colossal central arched portal of the Metropolitan Cathedral should be surmounted by a towering figure of Christ the King and, as with Jagger's statue of George V in New Delhi, it would have been impossible to determine where architecture ended and sculpture began. Jagger's group – some 40 feet high in itself – would have grown out of the architectural mass, with worshipping figures at the feet of our Lord emerging from the stone in Expressionist fashion. But, both because of Jagger's premature death in 1934 and the later abandonment of Lutyens's design, this magnificent idea was never to be realised and we can now only appreciate the power of Jagger's conception from maquettes and photographs of the cathedral model[11].

There was, however, one 20th century Liverpool architect who was

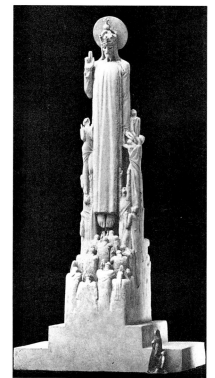

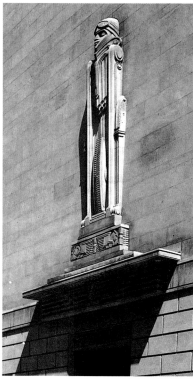

6. C S Jagger, maquette for 'Christ the King', reproduced from 1935 memorial exhibition catalogue

8. Herbert J Rowse (arch), E C Thompson and G T Capstick (scs), Mersey Tunnel ventilation tower

7. H Tyson Smith, Liverpool, Martin's Bank, Lift Lobby

always happy to collaborate with good architectural sculptors. This was Herbert J Rowse, whose Martin's Bank in Water Street – one of the finest realisations of American commercial Classicism in the country – displays the decorative versatility of H Tyson Smith. All the stone details, the decorative faience and plasterwork, the bronze gates and doors, screens and grilles, and even the lettering, all came from the hand of this fine artist. Rowse himself was remarkably versatile in his own field, for he rose magnificently to the occasion when asked to design the architectural elements connected with the Mersey Tunnel. To enhance this important civil engineering project, opened in 1934, Rowse chose an Expressionist, or modernistic style, akin to that adopted by Giles Scott for electric power stations. On Rowse's ventilation tower buildings, 'Art Deco' detail is stretched vertically and ornament becomes inseparable from sculpture. These highly stylised sculptural enrichments, which greatly contribute to the success of some of the most dramatic British buildings of the 1930s, were the work of a local sculptor, Edmund C Thompson, assisted by George T Capstick. There is here a complete fusion between architecture, decoration and sculpture in a highly original manner and it contrasts tellingly with the example of 'pure' avant-garde sculpture at Lewis's store in Ranelagh

Street. Here, although the free-standing figure by Epstein rises from a bronze ship's prow which emerges, however incongruously, from a stripped stone entablature, the general impression is not of fusion but of prestigious sculpture applied irrelevantly to the blank chamfered corner of a mediocre piece of commercial architecture.

The post-war decades have not been conducive to successful architectural sculpture. Sculptors have tended to resent being confined by an architectural brief while architects themselves have had very little use for any decoration and enrichment. But there is one curious exception that deserves mention: the combined porch and belfry on the Roman Catholic cathedral that was eventually raised above Lutyens's unfinished crypt. This wedge-shaped structure that emerges from Sir Frederick Gibberd's wigwam like a giant foot has, on its prominent vertical face, the work of the sculptor William Mitchell. Below, the bronze doors are thickly modelled in an abstract, Picasso-esque design while above the smooth stonework is penetrated and textured by diciplined geometrical facetting to make a relief pattern of Oriental or, perhaps, Aztec character. Whatever the merits of the design of the cathedral itself, this belfry does represent the latest example in Liverpool of that total formal and stylistic fusion between the work of the architect and that of the sculptor which must always be present in truly successful architectural sculpture.

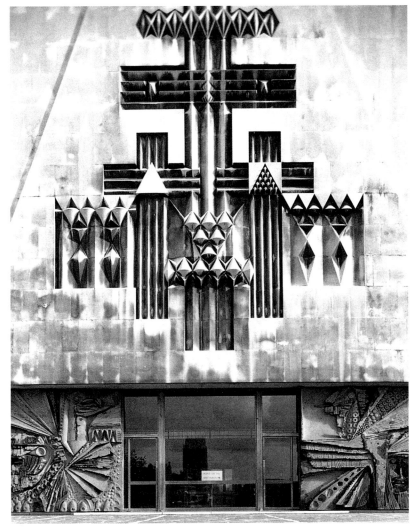

9. Frederick Gibberd (arch) and William Mitchell (sc), porch and belfry, Metropolitan Cathedral of Christ the King

NOTES

1 Sir Robert Rawlinson, *Correspondence relative to St George's Hall*, 1871, p 28; quoted in Quentin Hughes, *Seaport*, London, 1964, p 102.

2 Quoted in John Olley, 'St George's Hall Liverpool', part two, in the *Architects' Journal*, 25 June 1986, p 43.

3 Professor Conway, 'The World of Alfred Stevens in Liverpool', the *Builder* vol. liv, 31 March 1888, p 223.

4 Quoted in David Watkin, *The Life and Work of C.R. Cockerell, RA,* London, 1974, p 212,.

5 C.H. Reilly, *Some Liverpool Streets and Buildings in 1921*, 1921, p 42, quoted by Watkin, *op. cit.*, p 231.

6 Letter from Henry Baker, 1871, quoted in Rupert Gunnis, *Dictionary of British Sculptors 12660–1851*, London, 2nd ed. nd, p 271.

7 Address to the RIBA, 1892, quoted in Susan Beattie, *The New Sculpture*, New Haven and London, 1983, p 43.

8 An account of the evolution and authorship of the Derby Memorial design as well as a discussion of how Scott would get stonecarvers to work from sculptors' models (partly as an economy) is given by John Thomas in 'Classical Monument in a Gothic Church', *Transactions of the Historic Soceity of Lancashire & Cheshire*, vol. cxxxv, 1986, p 117.

9 Honan to Scott, 12th April, 2 May 1911, & 1 June 1912: Giles Gilbert Scott correspondence, British Architectural Library.

10 Jacob Epstein, *An Autobiography*, London, 1955, p 40.

11 Maquette illustrated in the *Charles Sargeant Jagger Memorial Exhibition, 1935*, catalogue, p 1 and Sargeant Jagger, *Modelling & Sculpture in the Making*, London and New York, 1933, plates iv & v.

HENRY BLUNDELL'S SCULPTURE COLLECTION AT INCE HALL

Gerard Vaughan

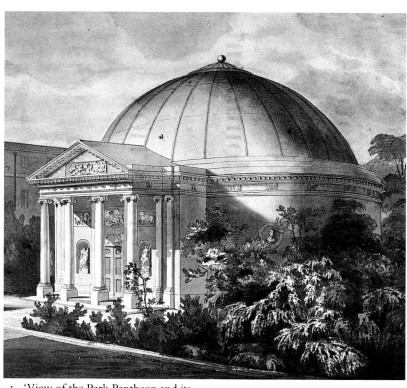

1. 'View of the Park Pantheon and its Portico', with Ince Blundell Hall. Frontispiece from Vol I of Henry Blundell's *Engravings*, 1809. Etching heightened with grey wash, 265 × 397 mm

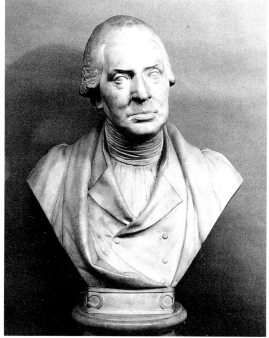

2. G Bullock, 'Bust of Henry Blundell', 1804. Marble; h 70 cm. Signed 'G Bullock Sculpt.'. Walker Art Gallery, NMGM, presented in 1959 by Col Sir Joseph Weld

The Ince Blundell Hall collection of classical antiquities assumes a place of special significance in the history of sculpture on Merseyside[1]. Henry Blundell's[2] vast and eclectic collection, now incorporated into the collection of the National Museums and Galleries on Merseyside[3], was since its inception in the late eighteenth century readily available for inspection by anyone of rank who cared to apply. Unlike other northern antiquities collections, such as William Weddell's at Newby Hall or James Hugh Smith Barry's at Marbury Hall, that of Blundell was rendered accessible by its proximity to Liverpool. Indeed, we have it from Blundell that, so great did pressure from visitors become, it was eventually found necessary to nominate one day per week for the admission of large parties[4], and to issue tickets in advance, as Walpole had done at Strawberry Hill. It can be presumed that the superb rotunda, or Pantheon, which was built around 1801–5 adjoining the main house, with an independent entrance, was conceived at least in part as a means of allowing public access to the collection without unduly disturbing the family.

It is clear that Henry Blundell was a public-spirited man who willingly assumed a role in the promotion of the fine arts in Liverpool. He was associated with a number of early art exhibitions, and was the first patron of the new Liverpool Academy, which held its inaugural exhibition in 1810[5]; it is known that in 1810, the year of his death, Blundell offered to provide a building in Liverpool for its occupation[6]. He was a close friend of William Roscoe, and in this context Blundell's enthusiastic picture collecting activities (though beyond the scope of this article) are worth noting. As a Roman Catholic, Blundell was debarred from holding any public office; it is true that involvement with learned and cultural societies was one of the few ways Catholics like Blundell could actively participate in public life.

The Blundells are said to have held the lordship of the low-lying fenland estate at Ince since the time of the Conquest[8]. In the late twelfth century Richard Blundell can be identified as lord of the manor, and the family's occupation is well-documented from the early thirteenth century. The name of Blundell is first found suffixed to Ince in 1367. Like so many of their Lancashire neighbours, the Blundells were a recusant family, as a result of which they learned to live as quietly and unobtrusively as possible. They supported the King in the Civil War, which led to the confiscation of the estate, but they eventually succeeded in repurchasing it. Burdened with fines and the double land tax imposed upon Catholics, the Blundells lived modestly in the late seventeenth and early eighteenth centuries, sending their sons and daughters to be educated in the English Catholic colleges and convents on the Continent.

Around 1720 Henry Blundell's father Robert decided to build the new house which remains today, and the fact that it appears to have taken some thirty years to complete suggests that the work was paid for from the annual income of the estate. Ince Blundell Hall, constructed of dark red brick and faced with local sandstone, is now known to be the work of Henry Sephton, the leading mason and architect in Liverpool in the second quarter of the 18th century[9]. With the principal facade's giant order of engaged Corinthian columns and pilasters, the house belongs firmly to the last phase of the English Baroque. Hussey has noted that the design has much in common with the work of Thomas Archer and James Gibbs[10]. Ince Blundell Hall bears an obvious stylistic relationship to near-contemporary buildings such as the first Buckingham House in London, attributed to William Winde, or the central

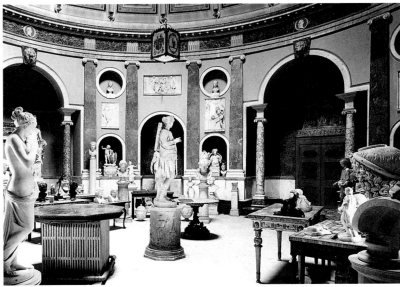

4. Interior of the Pantheon,
photographed in 1959

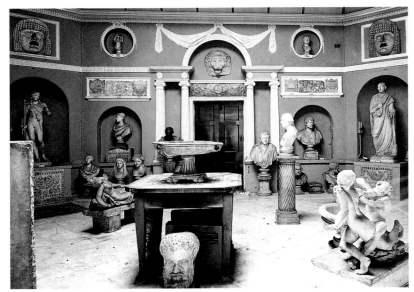

5. Interior of the Garden Temple,
photographed in 1959

block of Archer's Heythrop Park in Oxfordshire, built for the Talbot family to whom the Blundells were related.

As a child Henry Blundell was sent first to the college of the English Jesuits at St Omer in France, and then to the English college at Douai. In his old age Blundell recalled the rigorous instruction he received there in philosophy and the classics[11], oberving that: 'My constant diligent application to my studies so filled up my time that I was quite happy and left the colleges with regret.' In October 1745, the year of Prince Charles Edward Stuart's uprising in England, he left Douai for Paris[12], and he was briefly placed in the care of Dr Joseph Holden, the President of St Gregory's English seminary. Blundell found many friends and relatives in Paris, unusually crowded with English Catholics due to the worsening political crisis at home. Blundell would undoubtedly have known his Lancashire neighbour Charles Townley, then aged only nine, but his memoir is surely confused in suggesting that during these years in Paris he had much to do with Townley and his private tutor, the learned antiquarian and natural scientist the Revd John Turberville Needham. In 1745–6 Townley was in Paris only briefly *en route* to Douai to begin his education, and he did not live in Paris under Needham's tutelage until the years 1753–7. As Henry Blundell seems to have returned to England before 1750, it can be presumed that he knew Townley and Needham on subsequent trips to Paris. There is no reason to doubt the assertion made in his memoir that he was exposed to the brilliant circle of scholars and literary figures with whom Needham was then associated, including Buffon, Barthélemy, de Caylus, Dawkins, and the *salon* of Mme Doublet. What is important is the evidence that Blundell's personal association with Charles Townley, the most significant eighteenth-century English collector of classical antiquities, began in France in the 1740s and 1750s, and that through Townley and Needham Blundell was peripherally exposed to a learned circle of antiquarians. It will be argued later, however, that intellectually they had little in common. While Townley emerged as a connoisseur and scholar of considerable merit, who could hold his own with the most learned men in Europe, Blundell readily adopted the life of a country squire, showing little inclination (or, indeed, ability) to pursue any serious study of the culture of antiquity. The Towneleys and the Blundells were, of course, Catholic Lancashire neighbours, already bound together by a network of marriage relationships.

In his memoir Henry Blundell acknowledged that his life at this time was necessarily modest, due to his father's limited income. After his first wife's death Robert Blundell married Elizabeth Anderton in 1752, and in 1761 he handed over the Ince estate to Henry and retired to Liverpool. This coincided with Henry Blundell's own marriage to Elizabeth, daughter of Sir George Mostyn, Bart, of Talacre in Flint (whose wife Teresa Towneley was Charles Townley's great aunt), and the marriage settlement undoubtedly improved Henry Blundell's income. More significant, however, was the death in 1760 of Sir Francis Anderton without male heirs, for this brought to the Blundells the extensive Lostock and Lydiate estates, with the result that their income was more than doubled.

Henry Blundell's wife died in 1767 after the birth of a son and two daughters, and thereafter he devoted himself to estate improvements. He undertook walling the park, and he built the elegant Liverpool Gate, which survives today. Rather than adopt a fashionable neoclassical style, Blundell chose to imitate exactly a Baroque gateway with broken pediment which appeared in his huge Sebastiano Ricci 'Marriage of Bacchus and Ariadne'[13]. He noted in his memoir that he undertook extensive interior improvements and that he built 'a large body of offices without the assistance of a Wyatt or any architect', suggesting some ability in architectural matters. It is clear from the notes in his catalogues that Blundell occasionally visited Paris, where he purchased pictures, but he did not set out on his first Italian tour until late in 1776.

Blundell's plan was to join his friend and neighbour Charles Townley in Rome. By then, the Townley collection had assumed its definitive form, and was already recognized as the finest collection made in England in recent times. It seems clear that Townley's departure for Rome was hastened by his agreement to purchase from Gavin Hamilton[14], the painter who was then successfully operating as a dealer and excavator, the full-size figure of 'Venus'[15], recently excavated at Ostia in a state of remarkable preservation. To avoid sequestration for the papal museum, the transaction – including its restoration – had to be carried out in the strictest secrecy, and clandestinely exported. Townley was determined personally to supervise the process. He had arrived in Rome by mid-January 1777, and on 10 February Blundell addressed a letter to him from Turin, asking his friend to reserve accommodation in Rome. Blundell travelled by way of Milan, Venice and Ancona, arriving shortly before the end of February.

It was inevitable that Henry Blundell should be absorbed at once into the network of dealers, excavators, antiquarians and cognoscenti with whom Townley was by now on such familiar terms. Townley had been in Rome in 1767–8, and more recently had spent the years 1771–3

Opposite
3. Interior of the Pantheon,
photographed in 1958

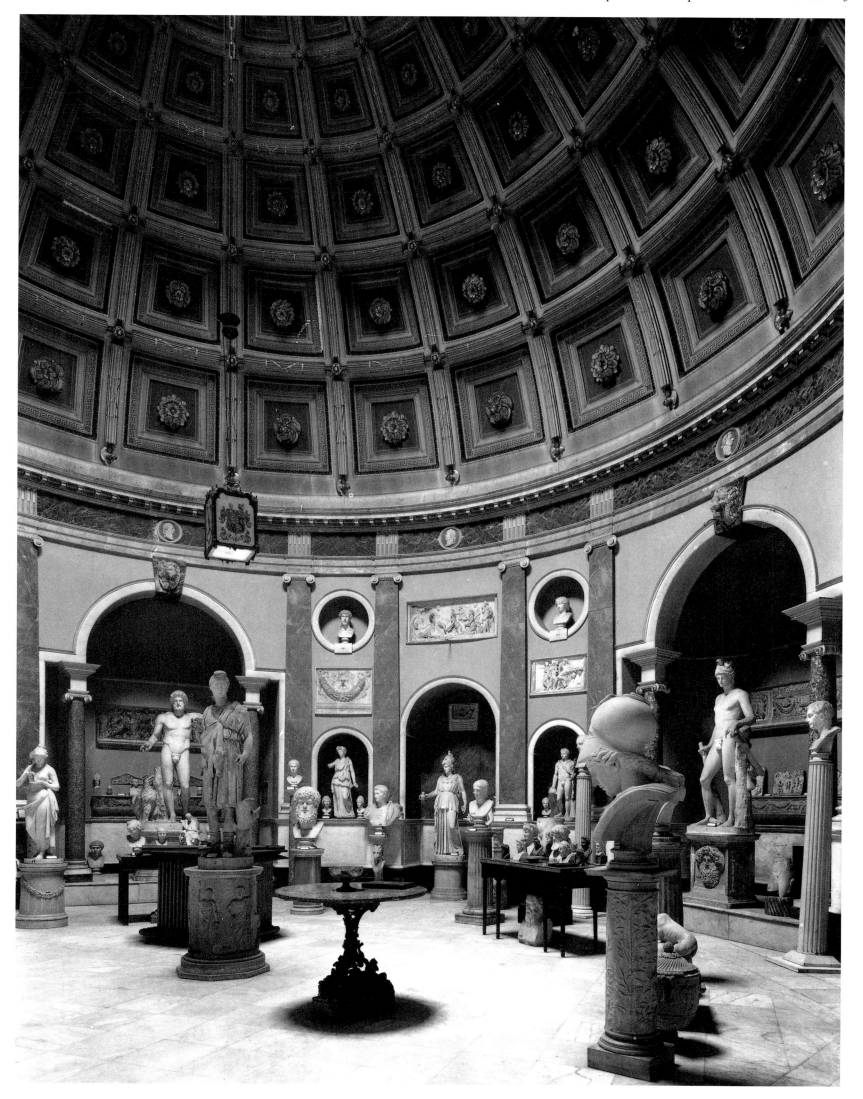

in the city. Blundell much later wrote in his memoir that: 'His great knowledge in antique marbles and arts not only instructed me but inspired me with a desire of being proficient in that line. I was much with him in Rome . . . Mr Townley was a great advantage to me as he knew well all those places where I was quite a stranger . . .'

In March the two friends travelled to Naples, where Blundell visited the excavations of Herculaneum and Pompeii. Townley also introduced him to dealer-associates such as Tomaso Valenziani, the assistant of Camillo Paderno, Keeper of the royal collection of antiquities then housed in the museum at the royal villa of Portici. For some time Valenziani had enjoyed a lucrative trade in supplying visitors to Naples with highly finished decorative table tops made of polished Vesuvian stone, and Blundell purchased a number of these from him. As well he purchased a few 'Etruscan' vases[16] and other fragments, but as the export of antiquities from Naples was prohibited he acquired little of substance. Both Townley and Blundell commissioned from Volaire, Vernet's highly successful pupil, representations of the spectacular 1767 eruption of Mt Vesuvius[17]. On his return to Rome Blundell acquired further modern pictures by Gavin Hamilton and Mengs, but more importantly he laid the foundations of the antiquities collection which in due course was to exceed Townley's in size, though not, of course, in quality.

Henry Blundell recorded in his catalogue[18] that the first antiquity purchased by him was the small seated philosopher, from Thomas Jenkins on Townley's advice. By 1777 Jenkins was well established as the foremost dealer in Rome[19], whose highly successful activities in the art market were underpinned by his equally successful activities as banker to the Grand Tourist trade. While Jenkins had been the particular favourite of Pope Clement XIV, he had had to work hard to re-establish his credibility with Clement's successor Pius VI, but the quasi-political nature of his position in Rome ensured that his influence did not diminish. Jenkins had supplied Townley with the majority of his finest marbles, and they were on extremely friendly terms.

It was natural, therefore, that Townley should introduce Blundell, and it can be presumed that it was through Jenkins that Blundell made his massive purchase *en bloc* of some eighty of the remaining antiquities from the Villa Mattei. Just under twenty were statues and busts, the remainder being cinerary urns and vases, bas-reliefs and inscriptions. This impressive purchase must, however, be seen in its proper context.

The disposal of the Villa Mattei collection had begun in 1770, when the Duca Giuseppe Mattei sold a group of thirty four of his finest antiquities to Pope Clement XIV for the bargain price of 4,300 *scudi* (c. £1,000). In exchange for this favour, it was agreed that the papal authorities would freely allow the export of any of the remaining pieces. The Duca Mattei subsequently sold groups of marbles to a range of dealers, including Gavin Hamilton, Thomas Jenkins and the sculptor-restorer Bartolomeo Cavaceppi[20], and by 1777 many had already found their way to England. Charles Townley had purchased two busts from Gavin Hamilton in 1773, and James Hugh Smith Barry of Marbury Hall had acquired five statues through Jenkins in 1775[21]. We know that in 1775 the Duca Mattei sold most of the remaining antiquities in the villa to Jenkins, so it can be taken for granted that it was Jenkins who supplied the Villa Mattei pieces to Blundell.

It must be accepted, however, that by 1777 the very best pieces had been extracted. Townley, for example, had no interest in any of the statues remaining after the papal purchase, and the majority which passed through Jenkins's hands were heavily, and often very imaginatively, restored.

The statue of 'Asklepios' was one of the better marbles acquired by Blundell from the Villa Mattei[22]. The arms were relatively intact and the head, though broken off, is generally accepted as original. The 'Isis', however, was perhaps more typical[23]. Its original appearance is recorded in one of the plates of the *Monumenta Mattheiana*[24], but it had been inelegantly restored with the head of a Sabina. Visconti, however,

6. 'Aesculapius' (Asklepios),
Engravings, vol I, plate V. Copperplate
engraving; 440 × 297 mm

recognised its true character, on the evidence of a bas-relief of an Isiacal procession in the Palazzo Mattei, as a result of which the figure was given a new male head and armed with appropriate Egyptian attributes. This sort of imaginative restoration would have been totally unacceptable to a collector like Townley. The cinerary urns and inscriptions were less restored and of greater specialist interest[25], but even so the very best had been extracted for collections such as the Vatican. Henry Blundell acquired antiquities from other sources as well. It is likely that the group of antiquities with a Villa Borrioni provenance were also purchased in 1777. It has to be said, however, that the Borrioni collection had been gradually dispersed over the preceding twenty years, largely through the agency of the sculptor-restorers Pietro Pacilli and his successor Vincenzo Pacetti, with the result that the very best items had long since been disposed of[26]. Several of Blundell's purchases from the Borrioni collection were notable for their unusual subjects, but none were of significant quality. A third source from which Blundell acquired antiquities was the collection of Palazzo Capponi, accounting for seven items including the group of the 'Faun and Goat'[27], and the archaic bas-relief of a seated man[28] which had been admired by Winckelmann as an example of primitive 'Etruscan' sculpture.

Furthermore, Blundell readily turned to the sculptor-restorers who played such an active role in Rome's antiquarian milieu. Blundell's catalogue records sixteen statues and busts purchased from Cavaceppi, but it cannot be known how many were acquired on this first trip. Many were heavily restored, and none are particularly remarkable. There can be little doubt that by the end of the 1770s the Cavaceppi studio had lost much of its pre-eminence, and that the noticeably different approach to the question of restoration pioneered by his gifted former pupil Carlo Albacini – who had by then been taken up by Thomas Jenkins – now dominated the Roman mainstream. Charles Townley no longer had any dealings with Cavaceppi, and the works Cavaceppi sold Blundell were all of a minor nature.

Blundell was by no means indifferent to modern sculpture, and in this he can be distinguished from Charles Townley. He commissioned modern copies after the antique from both Giuseppe Angelini and Carlo Albacini, including the latter's superb bust of 'Lucius Verus', a

copy of a well-known marble in the Villa Borghese[29]. Blundell was also in touch with Piranesi, whose entrepreneurial activities dealing in heavily restored antique *pastiches* were continuing, although he had never met with the success for which he had first hoped. Blundell purchased from him a restored and extensively recut antique *tazza*, thus joining the ranks of the twenty five British collectors recorded in the plates of Piranesi's *Vasi* as having purchased items from him. Blundell's vase was prominently reproduced on the frontispiece of the second volume of Piranesi's *Vasi*, which appeared the following year. The caption identifying the vase as being in Blundell's collection ensured, therefore, immediate international recognition[30]. Blundell's catalogue lists other minor items acquired from Piranesi, who supplied to Townley at the same time an extensive group of *aras* and columns for use as supports for the marbles he was about to unveil at his new house in Park Street Westminster.

Blundell's meeting in Rome with the former Jesuit Fr John Thorpe (1726–92) was of the highest significance for the future development of his collection. After Pope Clement XIV's suppression of the Jesuit order in 1773, Thorpe had remained in Rome, continuing to supplement his income by acting as agent for the purchase of art works for Lord Arundell of Wardour. As Blundell and Thorpe were about the same age, and as both had been educated at the English Jesuit college at St Omer in the early 1740s, it is likely they had been school friends, although Blundell nowhere says so in his notes. Whether or not this was the case, it is unsurprising that Blundell should form a close association with him, and engage him as his own agent for the purchase of marbles and pictures. A very substantial number of the art works which found their way to Ince Blundell Hall over the next fifteen years came through Fr Thorpe's hands. Thorpe maintained a regular correspondence with Blundell, informing him of all artistic and political developments in Rome, and several years after Thorpe's death Blundell told Charles Townley that he had in his possession several hundred letters from him[31]. Tragically, these letters appear to have been lost. It is worth noting that from this period on, Blundell reduced his contacts with Thomas Jenkins. This is not surprising, as the English Catholic community in Rome had always treated the Protestant Jenkins with deep suspicion; we know from Thorpe's correspondence with Lord Arundell how deeply he resented Jenkins, who recently had not only profited materially by dealing in confiscated Jesuit pictures, but also had established himself at Castel Gandolfo in the villa formerly occupied by the Father-General of the Jesuits, adjoining that of the Pope. It should be noted, however, that Townley had no such scruples.

Blundell lingered in Rome until at least September 1777, continuing to acquire large numbers of pictures and sculptures. While no accounts survive, it is quite clear that he did not lay out particularly large sums for single items, and we have seen from the evidence presented above that for the most part he acquired heavily-restored and unexceptional pieces which were of little interest to a specialist connoisseur-collector like Townley. Nevertheless, Blundell's emergence as a collector of antiquities was to be of particular significance for the Roman dealers, for he imitated Townley by continuing to expand his collection after his return home. Practically every other British collector of this period quickly abandoned the market once the enthusiasm and excitement occasioned by the Grand Tour had waned.

Unlike Townley, who was never to return to Rome, Blundell followed this first tour with three further visits. It is known that he was in Rome again late in 1782, remaining until the first week of February 1783[32], but there is no record of his purchase of particular antiquities. Nevertheless many more of the hundreds of minor pieces included in the collection must have been added at this time.

Blundell returned to Italy once more early in 1786, arriving in Rome in the middle of February[33]. Townley had written ahead requesting Jenkins to assist him, but Jenkins reported back that Blundell's behaviour towards him had been particularly reserved. It is likely that this

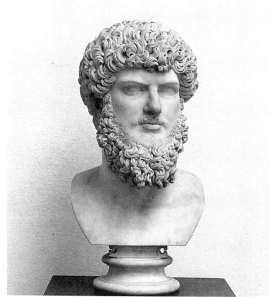

7. Carlo Albacini, 'Bust of Lucius Verus', c. 1777. Marble; h (with base) 89 cm, Walker Art Gallery, NMGM, presented in 1959 by Col Sir Joseph Weld

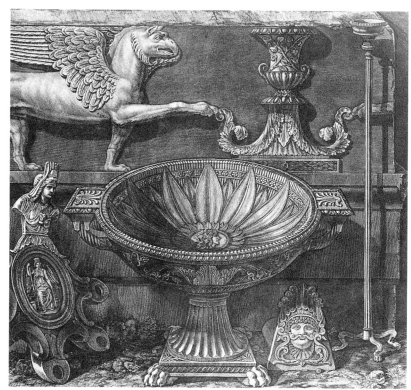

8. 'The Blundell vase', detail from frontispiece of vol II of G-B Piranesi's *Vasi*, Rome, 1778. Copperplate engraving

was also due, at least in part, to Jenkins's reputation as an expensive dealer who operated on a principle of maximum profit, and that Blundell, who constantly protested to Townley that he was a non-specialist, felt he could do better by employing his own agents and contacts. Early the following year Jenkins wrote to Townley in a derisive tone, ridiculing 'Blundell's ex-Jesuit [who] is rummaging the town over for bargains'[34], announcing that as usual Thorpe had been duped.

Despite this, Blundell could hardly avoid having some direct dealings with Jenkins, who had astounded the city with his purchase in September 1785, from the entrepreneur Giuseppe Staderini, of the antiquities collection *en bloc* of the Villa Montalto-Negroni[35]. The history of Jenkins's dispersal of this famous collection is beyond the scope of this article, but suffice it to say that it was a particularly exciting moment to be in Rome. Given this remarkable opportunity, it is worth reflecting upon why Blundell acquired so little from the Villa Negroni, and nothing of any importance, while Charles Townley and Lyde Browne were enthusiastically negotiating from London for a group of

9. 'Minerva', *Engravings*, vol I, plate I.
Copperplate engraving; 305 × 229 mm.
Engraved by William Skelton, 1799

10. 'Psyche', by Antonio Canova.
Engravings, vol I, plate XVII.
Copperplate engraving; 445 × 304 mm.
Engraved by William Skelton, 1799

11. 'Theseus', *Engravings*, vol I, plate
III. Copperplate engraving;
379 × 212 mm. Signed 'P. Vitali fec. aq.
fort' in the plate, lwr rt

the finest marbles, and Colonel John Campbell (later 1st Lord Cawdor) made personal selections on the spot. Townley purchased, for example, his much admired 'Caryatid'[36] for £400, and it should be noted that Jenkins reported to Townley that Blundell agreed to take this statue should Townley change his mind.

Blundell's reticence can be partly explained by the fact that he had just purchased two of the most expensive statues to enter his collection. It was at this time he bought from Jenkins the famous 'Minerva' of Palazzo Lante, for the substantial sum of £200[37]. For the first time, Blundell was purchasing in what might be called the international first stream, and the statue has been recognized ever since as the finest in the Ince Blundell collection. It has to be said that the market was considerably less buoyant in the 1780s than in the 1770s, and one suspects that if it had appeared a decade before it might have cost considerably more. Furthermore, at around this time Blundell also purchased for £200 his life-size statue of 'Diana'[38] from Carlo Albacini. As Albacini and Jenkins regularly worked in conjunction, it is tempting to suppose that Jenkins, too, had vicariously supplied this second statue; the fact that Thorpe had acted as intermediary is perhaps significant.

Both these statues had arrived at Ince before the end of 1786, when Townley recorded the disposition of the principal marbles around Blundell's house. He noted then that the thirty nine items he listed had a total value of £1,495. When Townley recorded a subsequent visit to Ince in 1792, he noted a total of three hundred and twenty five marbles, suggesting a massive increase in the intervening years.

It is true that Blundell's network, no doubt through Thorpe's agency, was rapidly widening. Around the mid-1780s he developed increasing contact with the circle which had formed around the late Piranesi's Venetian associate, the engraver turned dealer Giovanni Volpato. Volpato enjoyed a close relationship with the sculptor-restorer Antonio d'Este, and it was with this group, well-known for its openness to the Anglo-Roman milieu[39], that the young and prodigiously talented Antonio Canova, also a Venetian, became closely involved. Blunell's catalogue records that d'Este restored marbles for him, and that occasionally he sold him both antique and modern statues. We know that Blundell purchased from d'Este for £70 his reduced marble copy of the 'Capitoline Gladiator', presumably in 1786.

Henry Blundell's association with, and patronage of, Canova is of exceptional interest. One of Canova's earliest English patrons, Blundell probably gave the commission for the life-sized 'Psyche'[40] during his fourth and final visit to Rome in 1790. In a list of his works drawn up in 1795 Canova stated that he had executed the statue in 1792, and that Blundell had paid him 600 *zecchini* (c £300), considerably more, it should be noted, than Blundell is known to have paid for any antique statue. In addition to this, Blundell acquired a terracotta 'Madonna' which Canova had previously presented to 'his particular friend Mr Thorpe'[41], and he recorded in his catalogue with some sense of pride Canova's gift to him of the plaster model for the important early 'Theseus and the Minotaur'[42], the composition of which was almost certainly influenced by Gavin Hamilton's painting 'Achilles Dragging the Body of Hector'.

Around 1790 the Blundell collection acquired a group of twelve marbles from the Villa d'Este at Tivoli, the great Renaissance villa of Cardinal Ippolito II d'Este, which by the mid-18th century had fallen into disrepair, and from which the Duke of Modena had been steadily selling antiquities since the early 1750s[43]. The documents relating to the dispersal are complicated and will require further investigation, but it is likely that Ashby was wrong in presuming (on Dallaway's authority)[44] that Blundell's marbles were supplied by Jenkins. It would appear to be more likely that the Ince antiquities with a Villa d'Este provenance came from the substantial purchase of the remaining marbles made by Vincenzo Pacetti in 1788[45]. Much earlier, Antonio d'Este's father had been associated with the sale of marbles from the collection, and d'Este too might have been involved. While some of the Ville d'Este marbles were over-restored and of indifferent quality, they included the 'Theseus', esteemed by Charles Townley as the best specimen in Blundell's collection[46]. Blundell makes it clear in a letter addressed to Townley from Rome in 1790[47] that he had personally purchased the 'Theseus' – 'wh. for fine symmetry of human body, is as fine as anything I ever saw' – and other Villa d'Este marbles, although there is some evidence that Thorpe had begun negotiations earlier. Furthermore, the death of the keeper of the Capitoline collections, Niccolo La Piccola, occurred in 1790, allowing either Blundell or Thorpe to negotiate with his widow to acquire some of his finest marbles. The greatest prize of all was the remarkably well-preserved group of a 'Satyr and Hermaphrodite' (excavated by La Piccola, possibly in 1775, at a place called Salone

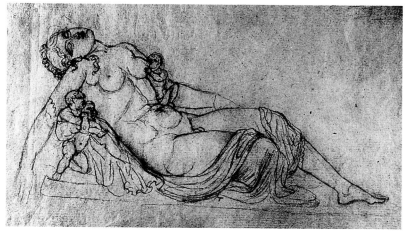

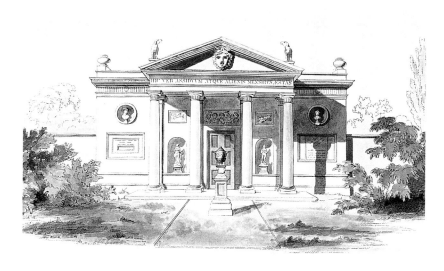

12. 'View of the Portico of the Garden Pantheon'. Frontispiece from vol II of *Engravings*. Etching heightened with grey wash; 253 × 364 mm

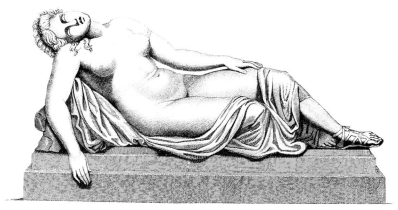

Top. 13. 'The Bessborough Sleeping Hermaphrodite', before reworking, pencil on paper. Townley Drawings, Dept of Greek & Roman Antiquities, British Museum

Above. 14. 'The Blundell Sleeping Venus', as reworked. Marble; h 50 cm, l 125 cm. Liverpool Museum, NMGM, presented in 1959 by Col Sir Joseph Weld

on the Via Collatina), and mounted on a plinth with the name of the artist – BUPALOS – inscribed in Greek. Firmly believed in the eighteenth century to be original, this 'unique' inscription is now dismissed as a modern forgery[48]. The Blundell group bears a certain resemblance to Townley's 'Nymph and Satyr', but Townley immeasurably preferred the former, and for years after its excavation he relentlessly tried to persuade La Piccola to sell it to him. Blundell was well aware of Townley's admiration for it. It was ironic, therefore, that the 'Satyr and Hermaphrodite' should find its way to Ince almost by chance.

Blundell clearly enjoyed this last trip to Italy, and he spent a good deal of time in Naples, where he reported on the progress of preparations for the new royal antiquities museum, informing Townley at the same time of the general Neapolitan displeasure at Albacini's restorations of the Farnese marbles. He regretted that he had been unable to attend Mrs Hart's 'taking off attitudes of antique Statues, characters &c'.

The acquisition of so many large statues in Rome in 1790 clearly presented a problem of space, and it was no doubt with this in mind that, on his return home, Blundell immediately embarked upon building the garden temple. His good fortune in acquiring these marbles had obviously caused him to reconsider the emphatic statement made to Townley three years earlier that 'I do not aim at a collection, or crowding my home with marbles, nor will I ever build a Gallerie[49].

The architect of the severely Tuscan neoclassical garden temple at Ince is unknown. Given his predilection for architecture the possibility that Blundell himself was involved with its design cannot be entirely dismissed. On the basis of circumstantial evidence the name of William Everard, a minor Liverpool surveyor and architect, has also been associated with it.[50] While there is no shortage of eighteenth-century English precedents for the placing of antiquities in garden temples, from those designed by Chambers for Lord Bessborough at Roehampton to Robert Adam's temple at Painshill (all c 1760), there is much about the Ince temple which suggests that the new Museo Pio-Clementino in Rome served as a particular point of departure.

The application of an original antique mask in the centre of the portico pediment exactly imitates Simonetti's treatment of the pediments of the Cortile Belvedere at the Museo Pio-Clementino in the Vatican, and the rather lavish application of original bas-reliefs is overtly Italianate. In the interior[51] the use of a Palladian tripartite, or Venetian, framework, and in particular the rather flamboyant swags, look more to the work of Dori and Simonetti in the Vatican, than to Adam at, say, Newby Hall. Furthermore, Blundell's deliberately informal method of display, with tables covered with marbles filling up the floor

space, reflected the new taste of the Pio-Clementino in Rome and left far behind the rigid symmetry of Adam's approach to the display of antiquities. If Blundell had commissioned the design in Rome, an obvious candidate would have been James Byres – who had recently provided designs for sculpture galleries for Charles Townley and James Hugh Smith Barry – but there is no documentary evidence to support this. In January 1791 Blundell informed Townley that the work on 'my great room' was well under way[52], and from 1792 Townley regularly referred to the marbles displayed in Blundell's 'Octagon Statue room'.

In the 1790s the revolutionary wars and the French invasion of Italy effectively prevented Blundell from aquiring further antiquities, and after the death of Thorpe in 1792 his interest noticeably diminished. When James Dallaway published his pioneering *Anecdotes of the Arts in England* in 1800 he noted that Henry Blundell's antiquities collection at Ince already comprised some four hundred items, and that Blundell was in the course of preparing a published catalogue.

The rather spectacular revival of Blundell's interest in his collection around 1800 might suggest a parallel improvement in his income, perhaps due to successful investment. The opportunity to purchase new marbles from existing English collections, at prices generally well below their previous Italian levels, suddenly presented itself, with the sales in quick succession of the collections of Lord Cawdor – Blundell's rival in Italy in the late 1780s – the Earl of Bessborough, the Duke of St Albans and Lord Mendip.

These sales, at which Charles Townley usually acted as his agent, provided a group of important new marbles. The Bessborough sale of 1801, for example, at which Blundell acquired twenty-two items, provided amongst others the 'Sleeping Hermaphrodite'[53], which James Adam had originally purchased from the Borrioni collection in Rome. Its metamorphosis into a 'Sleeping Venus', by the removal of the male genitals and genii, is documented in Blundell's *Engravings*, where he

described the Hermaphrodite as 'unnatural and very disgusting to the sight'[54]. This act, which would never have been countenanced by Townley, tells us something of Blundell's character, and in this context it is interesting to note his deliberate application of newly fashionable fig leaves to the male statues.

What is crucially important is the fact that Blundell's purchases at the Cawdor and Bessborough sales coincided with the decision to construct at Ince the elaborate and visually impressive Pantheon as the repository for his finest statues. Once again, the Pantheon form was not without precedent in England, beginning with Henry Flitcroft's pantheon in the grounds at Stourhead (1754–6), although this only housed modern works and casts. It is known that Charles Townley had seriously considered constructing a pantheon-like gallery for marbles at Towneley Hall, and in 1783 had commissioned drawings from Bonomi which were exhibited at the Royal Academy in 1787. It is likely, however, that Simonetti's great Sala Rotonda in the Museo Pio-Clementino at the Vatican – which had just opened to the public on Blundell's visit of 1782–3 – was a more obvious inspiration, although the Ince Pantheon differed substantially in its detail.

What is particularly puzzling about this superb neoclassical building is the absence of a known architect. Although Blundell regularly reported on the progress of the building in letters to his friends and relations, he nowhere identified an architect. While by no means faultless in its design and detail, the building is of such sophistication that it is hardly conceivable that Blundell alone could have designed it.

Who, then, might have provided the designs[55]? John Hope of Liverpool has been proposed as the executant architect[56]. Samuel Wyatt, who worked extensively in Cheshire and Lancashire and was known to be skilled in executing the Pantheon form (consider, for example, the saloon at Kedleston and the London Pantheon) would seem a likely candidate, but there is no documentary evidence linking him to Blundell. Another possible but still unlikely contender might be George Bullock, the sculptor and designer. Blundell is known to have been in regular contact with him during these years, but in 1800–1 Bullock – whose precise date of birth remains unknown – would have been aged under 20. Despite Blundell's general willingness to patronise young Liverpool artists, and Bullock's known interest in the question of appropriately displaying works of art, Bullock would surely have been too young to have been involved with the Pantheon's design; however, it is just conceivable that he might have provided the wooden model of the Pantheon to which Henry Blundell refers in his correspondence. The existence of a later drawing for alterations at Ince by John Gandy, who was in partnership with Bullock in Liverpool in 1809–11, supports the conclusion that in later years Blundell patronised Bullock's practice for purposes other than portrait sculpture. It is worth noting that in 1810 Henry Blundell became the first patron of the new Liverpool Academy, of which Bullock was the founder President. In the absence of documentation, an association with Bullock is hardly tenable; it is perhaps more likely that Blundell had at hand, drawings commissioned in Rome on an earlier trip.

In March 1801 Blundell informed Townley of the plans for his new room: 'It is about 37 feet inside diameter, circular, lighted from the top, as the Pantheon... the walls 6 feet thick, to get room for 4 large recesses, so as to be able to see round the principal statues; nothing is yet done about it, but on paper except a model in wood just put in hand'[57]. As Blundell is known to have dismissed his plasterers on grounds of slackness in December 1804[58], it can be presumed that by then the fabric was essentially completed[59].

The access which Blundell allowed to the public, and the detailed catalogues he published – he had intended the two volumes of *Engravings*, published in 1810, to appear in 1802, but the project had been shelved due to an unfortunate dispute with Townley, who had diligently supervised the engraving of the plates but objected to the unscholarly banality of Blundell's catalogue notes – prove beyond all doubt that Blundell was immensely proud of his collection. He was perfectly aware that it was eclectic and of uneven quality, and he can have had no objection to Charles Townley's description of it as being 'composed more of what the Italians call *Marmi eruditi*, than of choice specimens of fine Workmanship'[60]. Nevertheless, the Ince Hall Pantheon, with its overwhelming array of ancient and modern marbles, provided one of the most perfect expressions in England of the neoclassical ideal. It is to be sincerely hoped that one day Henry Blundell's great collection can be returned to the building created for its display[61].

NOTES

I am deeply indebted to the Hylas Charitable Foundation for permission to quote from the papers of Charles Townley, and to Mr H R Tempest for permission to quote from the Broughton Hall Archives.
I am also indebted to the following for help and advice: Camilla Boodle, John Davies, Rosemary Flanders, Sir Brinsley Ford, Francis Haskell, Edward Morris, Ed Southworth, Colonel Sir Joseph and Lady Weld, Wilfrid Weld, and Lucy Wood.

1 On the collection see Henry Blundell's two published catalogues, *An Account of the Statues, Busts, Bass-Relieves, Cinerary Urns, and other ancient Marbles and Paintings at Ince. Collected by H B*, Liverpool, 1803; *Engravings and Etchings of the Principal Statues, Busts, Bas-Reliefs, Sepulchral Monuments, Cinerary Urns etc., in the Collection of Henry Blundell, Esq., at Ince*, Liverpool, 1809, 2 vols.; published 1810. For accounts of the collection see especially J Dallaway, *Anecdotes of the arts in England*, London, 1800, pp 357–8; J Dallaway, *Of Statuary and Sculpture among the Antients. With some account of the Specimens preserved in England*, London, 1816; S H Spiker, *Travels through England, Wales and Scotland in the Year 1816*, London, 1820, pp 313–8; G Waagen, *Treasures of Art in Great Britain*, London, 1854, vol III, pp 242–60. For catalogues see A Michaelis, *Ancient Marbles in Great Britain*, Cambridge, 1882, pp 333–414; F Poulsen, *Greek and Roman Portraits in English Country Houses*, Oxford, 1923; B Ashmole, *A Catalogue of the Ancient Marbles at Ince Blundell Hall*, Oxford, 1929; B Ashmole, *A Short Guide to the Collection of Ancient Marbles at Ince Blundell Hall...*, Oxford, 1950. The Department of Classics and Archaeology at Liverpool University, and the National Museums and Galleries on Merseyside, are currently preparing for publication a new catalogue to be published in six volumes.

2 On Henry Blundell (1724–1810) see the above sources, and also J Nichols, *Illustrations of the Literary History of the Eighteenth Century*, London, 1818, vol. III, pp 739–40 (reprinting material from J Dallaway's *Biographical Memoirs of the late Charles Townley, Esq.*, 1814); J Gillow, *A Literary and Biographical History, or Bibliographical Dictionary of the English Catholics*, London, 1855, vol. I pp 244–5, *DNB*, vol. II, pp 727–8. For Blundell's portrait bust by George Bullock see illustration no 4.

3 The Ince Blundell antiquities, with a group of modern marbles, were presented to the Liverpool Museum in 1959 by Colonel Sir Joseph Weld, who had inherited the estate from the last of the Weld-Blundells.

4 *Engravings*, op. cit., vol. I, Introduction.

5 J Mayer, *Early Exhibitions of Art in Liverpool*, 1876, p 35.

6 Letter from William Roscoe and John Foster to Henry Blundell, dated 28 July 1810. Tempest Archives, Broughton Hall, Box XL, 9, kindly drawn to my attention by Edward Morris.

7 In his letter to Charles Townley of 3 April 1796 (Townley Papers), Blundell referred to Roscoe as 'an agreeable acquaintance of mine', and went on to praise Roscoe's great literary talents, particularly his recently published *Life of Lorenzo de' Medici* (1795), offering to forward a copy to Townley.

8 On the antiquity of the family, and the Ince Blundell estate, see especially *The Victoria County History: Lancashire*, vol. III, pp 78–82; E Baines, *History of the County Palatine and Duchy of Lancaster vol. V*, Manchester and London, 1893, pp 229–30 (J Croston ed.).

9 H Colvin, *A Biographical Dictionary of British Architects*, London, 1978, p 726.

10 C Hussey, 'Ince Blundell Hall, Lancashire', *Country Life*, vol. CXXII, 10, 17, 24 April 1958, pp 756–9, 816–9, 876–9; see esp. p 758.

11 See Blundell's autobiographical note dated 10 February 1808: 'A Letter Intended for a Friend', kindly drawn to my attention by Lucy Wood, and quoted here with the permission of Mr H R Tempest.

12 E H Burton and E Nolan (eds), *The Douai College Diaries: The Seventh Diary, 1715–1778. The Catholic Record Society, vol. 28*, London, 1928, p 244.

13 *Account* no. XXVII, p 219. Purchased by Blundell from 'Mr Bradshaw Pierson'.

14 On Hamilton see D Irwin, 'Gavin Hamilton: Archaeologist, Painter and Dealer', *Art Bulletin*, vol XLIV, June 1962, pp 87–102.

15 *British Museum Cat. Sculpture* no 1574, purchased for £600.

16 *Account* no CCCCXCIV.

17 *Account* no LIII.

18 Michaelis, no 44; *Account*, op. cit., no XLIX 'This was bought from Mr Jenkins, at Rome in 1777, much recommended by a friend; and was the first piece of ancient marble bought for this collection.' Blundell paid £20.

19 On Jenkins see especially T Ashby, 'Thomas Jenkins in Rome', *Papers of the British School at Rome*, VI, 1913, pp 487–511; and B Ford, 'Thomas Jenkins: Banker, Dealer and Unofficial Agent', *Apollo*, vol. XCIX, June 1974, pp 416–25.

20 On Cavaceppi see especially S Howard, 'Bartolomeo Cavaceppi, Eighteenth century restorer' (Garland 1980, Ph.D. thesis, Chicago, 1958); and C Picon, *Bartolomeo Cavaceppi: Eighteenth Century Restorations of Ancient Marble Sculpture from English Private Collections*, Exhibition catalogue, Clarendon Gallery, London, 1983.

21 On the Smith Barry antiquities and the Villa Mattei see G Vaughan, 'James Hugh Smith Barry as a Collector of Antiquities', *Apollo*, vol. CXXVI, July 1987, pp 4–11. On the sale to Clement XIV see also L Hautecoeur, 'La vente de la collection Mattei et les origines du Musée Pio-Clémentin', *Mélanges d'Archéologie et d'Histoire*, vol. XXX, 1910, pp 57–75.

22 Michaelis no 20; *Account* no XI. Illustration no 8.

23 Michaelis no 54; *Account* no XI, and Appendix IV; see also E Q Visconti, *Museo Pio-Clementino*, vol III, p 46.

24 R Venuti and C Amaduzzi, *Monumenta Mattheiana*, Rome, 1776, vol I, pl 87, as 'Sabina Augusta'.

25 38 of the cineraria published in the *Mon. Matt.* (ibid) were acquired by Blundell. The Ince Blundell cineraria are currently being prepared for publication by Glenys Davies.

26 The Villa Borrioni adjoined the Villa Ludovisi. Antonio Borrioni, who formed the collection, had died in 1756, but the auction arranged by Nicolo Conti, one of his heirs, was a failure. Thereafter, the Borrioni antiquities

were sold piecemeal by his heirs, usually through Pacilli and Pacetti, Townley buying a sarcophagus front as late as 1779 (*BM Cat. Sculpture* no 2323).

27 Michaelis no 35; *Account* no LVII. The large collections of the Marchese Gregorio Capponi, including bronzes, medals and gems, had been dispersed after his death in 1746, much of it going to the Capitoline Museum. A portion of the collection had been inherited by the Conte Cardelli, who in turn had sold items to Gavin Hamilton, Jenkins and Cavaceppi. Any of these could have supplied Blundell.

28 Michaelis no 259.

29 *Account* no C; E Morris, *Walker Art Gallery: Foreign Catalogue*, Liverpool, 1977, no 6538. Illustration no 5.

30 *Account* no DVII. See illustration no 6 for a detail from Piranesi's plate; the vase is also visible in the centre of illustration no 7. According to Piranesi's caption, it had been discovered at Hadrian's Villa in 1771 by his friend Domenico de Angelis.

31 Blundell to Townley, dated Ince 3 April 1796 (Townley Papers).

32 See Jenkin's letter to Townley, dated Rome 8 January 1783 (Townley Papers), and the reference in John Ramsey's Roman Diary for 3 February 1783 (National Library of Scotland, MSS 1833–1834), kindly drawn to my attention by Sir Brinsley Ford.

33 Jenkins to Townley, dated Rome 15 February 1786 (Townley Papers).

34 Jenkins to Townley, dated Rome 13 January 1787 (Townley Papers).

35 On the villa see V Massimo, *Notizie istoriche della Villa Massimo alle Terme Dioclezione*; Rome, 1836, esp. pp 219–21.

36 *BM Cat. Sculpture* no 1746.

37 Michaelis no 8; *Account* no 1. See illustration no 9. The price is recorded in a note on Blundell's collection made by Townley later in 1786 (Townley Papers). The 'Minerva' and the companion 'Lante Vase' had both been purchased in 1784 by the engraver and art dealer Volpato, who in turn had sold them on to Jenkins. Jenkins finally sold the Vase to Campbell in 1788 for 2,000 *scudi* (£500), and it was resold to the Duke of Bedford for £735 at Skinner & Dyke's Cawdor sale of 6 June 1800.

38 Michaelis no 22, *Account* no 2. Visible in the centre of illustrations nos 2 and 3.

39 See especially H Honour, 'Antonio Canova and the Anglo-Romans', *Connoisseur*, vol CXLIII, May 1959, pp 241–5, vol CXLIV, December 1959, pp 225–31.

40 *Account* no XVII; see illustration no 11. The statue was exhibited in London in the Arts Council *The Age of Neo-Classicism* exhibition in 1972; for full bibliography see cat no 314.

41 *Account* no LXXXIII. Private collection, 15″h. The figure is more likely to be a study for the figure of 'Meekness' on Canova's tomb of Clement XIV.

42 *Account* no DVI. It is possible that the present of an additional 100 zecchini, which Canova noted in the document quoted above, was a recognition of this gift. The finished statue (ex coll. Frey in Vienna, then Londonderry) is now in the V & A.

43 On the villa and its sculpture collection see especially T Ashby, 'The Villa d'Este at Tivoli and the Collection of Classical Sculptures which it contained', *Archaeologia*, vol LXI, 1900, pp 219–56.

44 Dallaway in Nichols, op. cit., p 739.

45 Ibid., p 239.

46 Michaelis no 43; *Account* no III. See illustration no 10, for Vitali's engraving.

47 Blundell to Townley, dated Rome 4 1790 (Townley Papers).

48 Michaelis no 30, *Account* no LXXV. On the modern status of the inscription see Ashmole no 30. The group is visible on the right side of illustration no 4.

49 Blundell to Townley, dated Ince 25 November 1787 (Townley Papers).

50 Colvin, op. cit., p 303, noting that a portrait of Everard holding an elevation of the Ince temple was exhibited at the Liverpool Academy of Art in 1869.

51 See illustration no 4.

52 Blundell to Townley, dated Ince 18 January 1791 (Townley Papers).

53 Michaelis no 25; *Account* no DXXXI; *Engravings* no XLI. Blundell paid £95, knowing it had cost Adam £200 some thirty years before.

54 For comparison see illustration nos 12a and 12b. On the statue see especially S Howard, 'Henry Blundell's Sleeping Venus', *Art Quarterly*, vol XXXI, no 4, 1968, pp 405–20.

55 Georgina Stonor kindly tells me that the plans for the Pantheon now at Stonor Park are unsigned.

56 Colvin, op. cit., p 431.

57 Blundell to Townley, dated Ince 23 March 1801 (Townley Papers).

58 Blundell to Stephen Tempest, dated 9 December 1804 (Broughton Papers).

59 Lucy Wood kindly tells me that she has attributed a damaged table-top, still in the Pantheon at Ince, to Bullock; Bullock's first securely documented furniture was produced in 1804.

60 Townley to Blundell (draft), dated 9 November 1799 (Townley Papers).

61 Ince Blundell Hall, the Pantheon, and the garden temple survive today, the property of a religious institution; the collections were removed from the house in 1959 and the Hall is not open to the public.

The antiquities collection of Charles Townley (1737–1805) was acquired after his death by the British Museum. A new Townley Gallery was constructed there but gradually his collection was scattered through the museum, much of it finding its way into storage. The major part of the Townley Collection has recently been brought together again in the new Wolfson Gallery at the British Museum.

Towneley Hall, near Burnley, Lancashire, passed out of the possession of the family in 1902, and is now the municipal museum and art gallery; it houses many mementoes of Charles Townley, including Zoffany's famous *Conversation Piece* of Townley and friends in his library.

PUBLIC SCULPTURE AND CIVIC PRIDE 1800–1830

Alison Yarrington

The princes of Tyre in their mercantile splendour have faded away; but the merchant princes of Liverpool are living facts of modern enterprise. Their navy covers the waters of the "vasty deep"; their palatial residences in the environs, and the many magnificent edifices of the town, and its numerous useful institutions, are all indicative of the greatness of the place. Now, to what origin or source can all this be traced but to the collective wisdom of an assembly popularly constituted? – an assembly, who represent the people; an elective and elected body, reciprocally responsible for the common weal[1].

This statement, made in a series of articles which appeared in the *Liverpool Mercury* in 1857, points both to the strength of Liverpool's civic identity which had become apparent by the mid-century and also the role of the 'elective assembly' in achieving this state of affairs. As with the many other emergent provincial centres in the early nineteenth century a sense of corporate identity was created and sustained through public statements of local strength and wealth which were aligned to national aspirations. Unlike today when local 'enterprise' culture is most often manifested in the form of large shopping malls and leisure centres, the aspirations of nineteenth-century civic leaders for their communities were predominantly expressed in terms of 'high art'. This was provided by major public institutions housed in suitable architectural splendour or, as will be discussed here, in the form of statues commemorating individuals. These individuals were chosen in order to provide a visible link between the provincial outpost and the political centre of power, a public expression of the indissoluble links which bound the two together. They were thus affirmatory symbols of civic identity where the subjects were chosen for their alignment with particular local circumstances.

During the first thirty years of the century Liverpool was to fund and raise three important monuments of this type which were originally intended to be executed in bronze and to stand outdoors in important public areas of the city. The first of these, and the city's first major public statue, commemorated a man whose actions in the wars against France seemed to guarantee the future free passage of the 'mercantile princes' navy and was thus closely identified with the present and future prosperity of the port. The death of Vice-Admiral Horatio Viscount Nelson (1758–1805) at the battle of Trafalgar was commemorated in many provincial centres and in Liverpool as elsewhere the work had a specific, local meaning with iconographic references to the current economic and political situation[2]. It was designed by Matthew Cotes Wyatt (1777–1862), a young sculptor with local connections, but the realisation of the design and its completion was entrusted to a well known metropolitan sculptor Richard Westmacott (1775–1856) whose reputation was based upon his public statues, in particular those celebrating national heroes, such as his 'Monument to General Ralph Abercromby' (1805, London, St Paul's Cathedral).

Shortly after the Nelson commission the decision was made to raise a second bronze statue when in 1809 the corporation promoted a scheme to erect an equestrian monument to King George III as a gesture of the city's continuing allegiance to the crown. Again, Westmacott was employed, and the monument was finally unveiled in 1822. It was works such as these and his statue of the 5th Duke of Bedford (1809, London, Russell Square) and Charles James Fox (1816, London, Bloomsbury Square) that established his reputation as the country's

1. M C Wyatt and R Westmacott, 'Monument to Nelson', 1807–15, Liverpool, Exchange Flags

leading sculptor in bronze.

Liverpool's third public monument was erected after a period of prolonged peace and economic prosperity following the wars against France. This portrait statue commemorated the prime minister George Canning (1770–1827) who had been MP for the city 1812–22, a work which encapsulated the political and social allegiances of leading members of the town council. Although finally executed in marble and placed in the Town Hall it was originally intended to be made in bronze and to be placed in a more accessible outdoor location. The sculptor who carried out the commission was Francis Legatt Chantrey (1781–1841), whose reputation as the foremost portraitist of the day was well established when the Canning memorial statue was commissioned in 1827. Moreover at this date he was directly challenging Westmacott's supremacy in the field of bronze statuary by establishing his own foundry in order to execute a series of major portrait statues: 'George IV' (1822–28, Brighton) and (1825–31, Edinburgh), 'William Pitt' (1825–31, London), 'James Watt' (1826–32, Glasgow). It is in the Canning commission that the two sculptors were in open rivalry and also set briefly against the growing reputation of the Liverpool raised John Gibson (1790–1866). The story of the commission provides a fascinating insight into the vagaries of such public commissions and the difficulties which arose from such democratic methods of funding.

In each instance the decision to create such works demonstrates a desire on the part of leading citizens to provide a public symbol of Liverpool's wealth and progress, which would communicate both to the local population as a whole and to other rival provincial centres. They were equally symbols of the cultural development of a city which was to establish an Academy of Arts in 1810 and the Liverpool Royal Institution in 1817[3]. The promoters of these two important institutions included William Roscoe (1753–1831) and Sir John Gladstone (1764–1851), at first political allies and then opponents. Both men were involved in the selection of designs for Liverpool's public monuments under discussion here, Roscoe co-ordinating the Nelson monument commission and Gladstone that to Canning. Both were involved in the discussions over the statue of George III. It is interesting to note that, unlike many other provincial centres, the choice of leading metropolitan sculptors to execute these three works of public sculpture was made against a background of a modest but thriving local sculpture industry, thus strengthening the presence of this art form in Merseyside. The foundation stone of local sculptural activity was the firm of S and F Franceys where John Gibson had received his early training, and which had employed the German sculptor F A Lege (1779–1837) who by 1817 had become one of Chantrey's leading studio assistants[4]. Also based in Liverpool was George Bullock (1777/8–1818) who was to be elected President of the Liverpool Academy in 1810. His design for the Nelson monument was the main local challenge to the outside contenders and contains many of the features found in the prizewinning design, which according to *The Monthly Magazine*, he proposed to execute in artificial stone[5].

Liverpool's decision to commemorate Nelson's death and the victory at Trafalgar was by no means unique; similar meetings took place up and down the British Isles and Nelson monuments resulted in Birmingham, Edinburgh, Dublin, Glasgow, and Great Yarmouth, with many others proposed but not completed. There was a particular sadness at Nelson's death amongst many people in Liverpool, which was made all the more poignant when it was made known by Alderman Aspinall that Nelson had been planning a visit to the city[6]. The enthusiasm amongst the local population for a Liverpool Nelson monument, and its importance for those holding office in the city, may be measured by the quick accumulation of the public subscription, which by 20 November 1805 had reached £4,500 and just under three months later had almost doubled[7]. By the time that the town meeting called by the

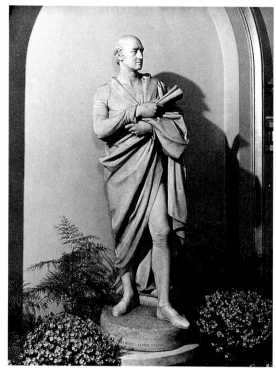

2. F L Chantrey, 'Statue of George Canning', 1829–32, Liverpool Town Hall, NMGM

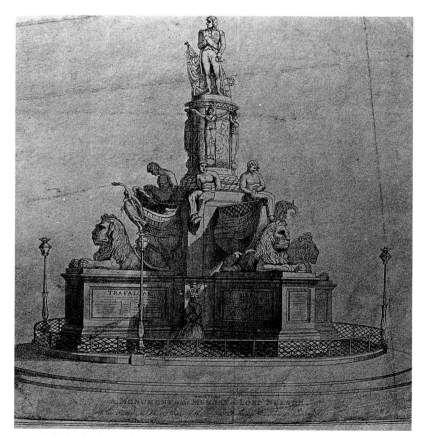

3. G Bullock, design for a 'Monument to the Memory of Lord Nelson', c.1807, Liverpool, William Brown Library, Binns Collection

Mayor Henry Clay for the 15 November 1805 took place, the Corporation had already decided to vote £1,000 towards the cost of a monument to Nelson in order to open a public subscription; a move initiated by Aspinall who made a private donation of £200. William Roscoe chaired this first public meeting and, although the exact pattern of his subsequent role in the commission is not known, his leadership at this stage suggests that he was one of the prime initiators of the scheme. For example, in March 1806 he was petitioned by his friend Henry Fuseli on behalf of J C F Rossi that the sculptor's name could be added to the list of those to be approached for designs. Fuseli states in his letter to Roscoe that Rossi considers Roscoe to be 'the Soul and Conductor of the plan'[8]. Roscoe's *The Life of Lorenzo de' Medici, called the Magnificent* (1795) and his *Life and Pontificate of Leo the Tenth* (1805) are written testimony to his admiration for the results of enlightened artistic patronage, a role he himself tried to emulate in Liverpool where he was the leading patron and promoter of the arts until his financial crash in 1820. His own contribution to the fund was £52, a sum that was not matched by a fellow member of the committee, John Gladstone, who only subscribed £21. Another important member of the committee of subscribers which controlled the commission was John Foster (1759–1827), Surveyor and Architect to the Liverpool Corporation. His role was that of intermediary between the committee and the sculptors, a role he was to maintain for the George III commission and which his son John Foster the younger (1786–1846), assumed for the Canning commission. Henry Blundell of Ince took no public part in the deliberations over the monument but he supported it generously with a gift of £100. The other members of the committee were Thomas Earle, John Bolton, George Case, L Heywood, John Wiston, Thomas Booth, Joshua Birch, William P Litt and William Ewart[9]. These 'mercantile princes' were not alone in their enthusiasm for the scheme. There were other groups whose prosperity was largely dependent upon the maintenance of British naval dominance of the high seas, such as the West Indies Association (chaired by Gladstone) and the Committee of Underwriters. Both gave generously (£500 and £750 respectively) to a monument commemorating the naval commander who had forced withdrawal of Napoleon's army from Boulogne and ensured British naval supremacy.

Although no minute book of the committee's deliberations survives it is known that several sculptors were preparing designs for the monument during March 1806 which were submitted as models to the committee of subscribers for adjudication. Amongst these was John Flaxman, whose wife, writing a note at the foot of her husband's letter to Willam Hayley in June 1806, reveals that he had chosen to enter designs for only three of several competitions in which he had been invited to participate: Nelson for Liverpool, Cornwallis for India and the 'Committee of Taste' Nelson monument for St Paul's Cathedral[10]. This provides yet another indication of the prestige attached to such commissions, although Flaxman's enthusiasm may have resulted from the fact that he was paid ten guineas for his design. The sculptors selected to present designs – Bacon, Nollekens and Westmacott – show the keenness of Roscoe and the committee to commission a sculptor with an established reputation in order to provide a work of high quality. J C F Rossi was also eager to gain the commission, particularly in view of his failure to get the City of London Nelson commission in May 1806. It is interesting to note here that in the Corporation of London's choice of the largely inexperienced John Smith for this prestigious work, the process by which the commissioning of public monuments was made was beginning to be questioned by sculptors who feared for their professional reputations if the competition should go against them, or if the strictures placed upon them prevented them from producing work which they considered represented their skills properly.

Roscoe had to relinquish the chair of the committee to Foster when he was elected MP for Liverpool in October 1806. Westmacott's tender

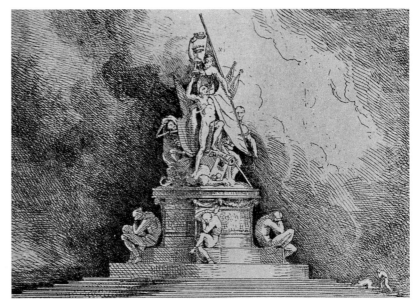

4. M C Wyatt, design for a monument to Lord Nelson, c.1807, London, British Museum

for the work was obviously strongly favoured by Foster and his work would have been well known to Roscoe, partly through his work for the Duke of Bedford at Woburn and his contact with the Whig circle of Holland House. The winner of the competition may be seen to have been almost a foregone conclusion with Foster in such a position of influence. Farington provides the information that the committee had consulted James Wyatt II (1746–1813), who was then acting as interim President of the Royal Academy. This expert advice came from the architect of the Liverpool Exchange (after destruction of the interior by fire it was rebuilt by Foster with designs approved by Wyatt) and the father of Matthew Cotes Wyatt. Asked to recommend sculptors to approach for designs, he only provided two: John Bacon the younger (1777–1859) and Richard Westmacott, both of whom had been employed by the Committee of Taste on monuments for St Paul's Cathedral[11]. Nicholas Penny has provided detailed information of the connections between the Foster and Wyatt families and Westmacott, which support the view that a form of nepotism was at work in the eventual choice of design[12]. However, the final choice of Westmacott to carry out the design may have resulted from the strong plea which Fuseli made on his behalf to Roscoe in January 1807 when he wrote to his friend and patron asking if he would view the model in Westmacott's studio before it was sent to Liverpool the following week. In this communication Fuseli made it clear that he considered Westmacott's design superior to that of Rossi whom he had recommended. He also adds: 'One great man always makes another: it is supposed that You can do everything with the Committee and I everything with You: In this last I told them, they were lamentably mistaken and that you would certainly Judge for yourself'[13].

It is not known when the final choice of design was made although the selection took place during that year. Matthew Cotes Wyatt's dramatic model (now lost) was exhibited at the British Institution in 1808 (no. 486). The surviving drawing, now in the British Museum, is of a colossal group in which Nelson is shown being claimed by a skeletal Death. He transcends this mortal, physical, event as his soul ascends to Heaven guided by a figure of Victory that crowns him with immortality as he steps up from the prone figure beneath his feet. This figure is ambiguous either representing a dead combatant or Nelson's physical body. Given that Wyatt was to use this idea again in his 'Monument to Princess Charlotte' (1820–24, Windsor, St George's Chapel) where the embodiment of her soul steps upwards from her shrouded corporeal form, the former interpretation seems more likely[14]. Nelson is guarded, not by angels, but by a figure of a modern

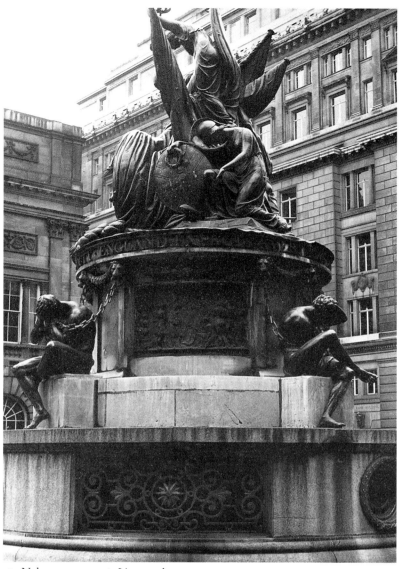

5. Nelson monument, Liverpool, back view

British sailor who strides forward, a reference to the means by which Nelson achieved victory. At the back of the monument a figure of Britannia mourning her loss is set against swathes of drapery produced by the fall of the standards. Together these elements give the appearance of a trophy when viewed from a distance. The base contains four bas-reliefs which depict the hero's greatest moments of victory which are interspersed with figures which represent great human suffering. These chained prisoners/slaves are bowed down by profound grief, displaying a form of restrained anguish. In the final work the most agitated of these is placed beneath the figure of Nelson triumphant in death, and this separation is marked by the words 'Every Man' which form part of the text which runs around the pedestal: 'England Expects Every Man To Do His Duty'. This juxtaposition of prisoner, text and the corpse from which Nelson's soul steps upwards towards Victory emphasises the didactic nature of the work. It also emphasises thereby the transforming quality of patriotic self-sacrifice upon ordinary men and the triumph of the human soul over death when it attains immortality through heroic action. Matthew Cotes Wyatt's drawing of the monument shows small figures prostrate on the steps of the monument overcome by the sublimity of the scene in front of them. Such a colossal scale was obviously out of the question for the monument itself. It was equally impossible to entrust the difficult technical task of completing the full scale model and casting it in bronze to a young artist whose reputation was based purely upon his skill as a painter. Who better to turn to for help than the highly reputable sculptor Westmacott, those professional reputation had been endorsed by his election as ARA in 1805 and who was a friend of the Wyatt family? It must be recognised

that it was this sculptor's conversion of Wyatt's confection into a solid and iconographically coherent form which prevented the failure of the whole undertaking, for Wyatt had no experience of working on such a scale in this particularly difficult medium. For Westmacott the task was not mere hack work, but an opportunity to carry out a design to the extent that he was able to introduce elements which were, in detail if not in conception , his own. It is known from his letter of July 1811 to the committee that he took particular pride in the figure of the sailor[15]. Thus, whilst the original idea was Wyatt's who received praise for it as such, the individual elements were created very much in Westmacott's own version of modern heroism which is visible in his other monuments to heroes made during this period[16].

The design of the monument was one which in the final analysis operates at several different levels. That stated above is the simplest interpretation. However, given the location of the monument in front of the Exchange, at the very heart of the commercial centre of the city, plus the controlling hand of Roscoe in determining the outcome of the commission, another interpretation is possible. This relates to Roscoe's political beliefs which were staunchly Whig and centres upon the meaning of the four prisoners around the base of the monument. In its final form, as completed by Westmacott, the strong Michelangelesque flavour of these figures coupled with the subject itself would appeal to Roscoe's aesthetic and political sensibilities. The subject of slavery was a life-long preoccupation which is given voice in his published writings. His detestation of the slave trade, which was such a strong factor in the accumulation of wealth in Liverpool had arguably caused him to lose his parliamentary seat when in 1807 he voted successfully in favour of the aboltion of the slave trade[17]. Such views placed him in direct opposition to Gladstone and Bolton. Gladstone was a merchant who relied heavily upon the success of his trade with the West Indies and was also a slaveowner with plantations in Demerara. Bolton's trade as a merchant was also connected with the slave trade and he, like Gladstone, was to become chairman of the West Indies Association. As a Canningite Tory his Liverpool house became a centre for this political grouping. Roscoe's views on the subject were therefore diametrically opposed to those of his two fellow committee members. He was a fervent admirer and supporter of Charles James Fox, evidence of which is found in Martin Arthur Shee's 'Portrait of William Roscoe' (1822, Liverpool, Walker Art Gallery) where he is depicted in his study with a bust of Fox at his right hand. Roscoe's views on the slave trade and slavery had already been eloquently expressed in his poem *The Wrongs of Africa*, published in two parts in 1787/8, and with other political pamphlets such as *An Enquiry into the Causes of the Insurrection of the Negroes in the Island of St Domingo* (1792) and was to continue in 1811 with the publication of *On the Right of Great Britain to prevent other Nations from carrying on the Slave-Trade*. The inclusion of the chained prisoners in the completed Nelson monument, and their presence in Bullock's design (although here it is obvious that they are captured sailors) has a dual role in the context of Roscoe's involvement in the commissioning of the work and can be read as both an allusion to the enchainment of prisoners of war – over 4,000 were held in the Liverpool gaol during the war period – and as an image of suffering produced by slavery. The hypocrisy of this commercial trade which caused such intense human suffering is the subject of scrutiny in Roscoe's earliest poems composed before *The Wrongs of Africa* were published:

> Shame to Mankind! But shame to BRITONS most,
> Who all the sweets of Liberty can boast;
> Yet deaf to every human claim, deny
> That bliss to others which themselves enjoy:
> Life's bitter draught with harsher bitter fill;
> Blast every joy, and add to every ill;
> The trembling limbs with galling iron bind,
> Nor loose the heavier bondage of the mind.

Yet whence these horrors? This inhuman rage,
That brands with infamy the age?
Is it, our varied interests disagree,
And BRITAIN sinks if AFRIC's sons be free?

Mount Pleasant: a descriptive poem 1777[18]

Roscoe's political hero Fox was to die in September 1806 and Westmacott was to execute his monument for Westminster Abbey, arguably his most accomplished work. He exhibited the figure of the African slave at the Royal Academy in 1815 (no 867). In the monument this figure is placed at the foot of Fox's deathbed in an attitude of prayer, a reference to Fox's role in continuing the attack against the slave trade which the politician was to support even in his last speech to the House of Commons in June of that year although he was to die before he saw it put into effect[19]. However, whilst such a figure is a direct reference to a specific political ideology, the meaning of the inclusion of the chained slaves/prisoners in the Liverpool monument is veiled. Whilst it corresponds to Whig principles it also forms part of the traditional language of sculpture, as seen in Pietro Tacca's 'The Leghorn Monument' (1623–24) where the figures represent the four corners of the earth. Also it has to be set against another major contemporary work of Westmacott's: the monument to William Pitt (1807–13, London, Westminster Abbey). Roscoe and Fox's main political adversary is depicted as an orator with a chained figure personifying 'Anarchy', writhing in chains beneath him, bowed down by the weight of Pitt's oratory. However the inclusion of chained prisoners in a monument to Nelson is only found in Liverpool, where it appears twice in competition designs of men with local knowledge. It is of course these figures which are nearest to the spectator where their obvious spiritual and physical suffering have a greater emotional impact than the spiritual elevation of the hero above.

It is obvious that had there been an unambiguous, open Whiggite reference to the slave trade, committee members such as Gladstone and John Bolton would have objected. However such references were veiled, concentrating upon the human anguish engendered by slavery, which were open to many shades of interpretation depending upon the political sympathies of the viewer. No objections to the inclusion of these figures were raised when the work was finally unveiled in October 1813. Indeed the most critical comments centred upon the naturalism of the figure of Nelson, which was described in the *Liverpool Mercury* as having departed too far from classical references and was thus lacking in sublimity[20]. The original appearance of the work is now considerably altered since its removal to its present site in 1866 when the rusticated base of Westmoreland stone was replaced with one of granite which raised the sculptural group a further six feet from ground level. Nevertheless, despite its somewhat battered appearance today, the monument represents an attempt to display civic pride with ambitious richness. When Roscoe wrote of 'Freedom' in *Mount Pleasant* he provides us with heightened imagery which is repeated in visual form in the Nelson monument:

To future ages gives the warrior's name,
Whose breast expansive own'd thy generous flame,
Who at thy sacred shrine resign'd his breath,
And sternly grasp'd thy lovely form in death.[21]

Following the success of the subscription to the Nelson monument and the satisfactory progress of the model in Westmacott's studio, the people of Liverpool were soon offered another opportunity to give expression to their sense of civic and national pride by subscribing to a public monument initiated by the city council. At a special meeting held at the Town Hall on 21 October 1809, a Loyal Address to King George III was proclaimed with the announcement that a statue was to

6. M A Shee, 'Portrait of William Roscoe', 1822, Liverpool, Walker Art Gallery

be erected by public subscription to mark his forthcoming Jubilee. Once again the corporation demonstrated its support for the scheme by a donation of £500 and an early decision was made to locate the statue in Great George Square where the foundation stone was laid[22]. Despite the alacrity with which the decision had been made to launch this project it was to be some time before any decision was finally reached over the exact nature of the commission, although Westmacott refers to the matter in correspondence with the committee over the progress of the Nelson monument in 1811[23]. The continuing, long drawn out conflict with France, and the illness of George III which had led to the declaration of the Regency in 1812 made such a work a less attractive proposition than that to Nelson. It was only in August 1815, after Napoleon's final defeat at Waterloo, that the committee took the decision to ask selected sculptors to submit designs for a statue of George III. Once again the sculptors asked to submit designs were Westmacott, Wyatt and Bacon and they were promised payment of ten guineas on submission of the completed drawings to Foster, who was again acting as agent to the committee[24]. It was only in May 1818 that a contract was finally drawn up and signed by Westmacott to execute a bronze equestrian statue[25]. In order to guarantee the quality and progress of the work Westmacott proposed that Sir Thomas Lawrence should report to the committee at each stage of the commission.[26]

There can be no doubt that the choice of Westmacott was sound; in 1811 he became an RA and in 1816 Sculptor to the new Board of Works, recognition of his high professional reputation which was by now largely based upon his public statuary and the high technical quality of his works in bronze. In 1814 he had been entrusted with a major commission for a colossal statue of 'Achilles' to celebrate military victory which in 1815 was specifically dedicated to the Duke of Wellington and funded by a subscription raised amongst the 'Ladies of England'. There is a connection between this statue and the Liverpool statue of George III in that both were almost exact copies of classical works. The 'Achilles', unveiled in the same year as the statue of George III, was taken from the Dioscuro on Monte Cavallo, Rome. For those members of the public that found the link between the classical model and the Duke of Wellington somewhat tenuous, Westmacott was to explain that the quality of the Phidian sculpture meant that: 'a cast from it has ever been a desideratum in Northern Academies of sculpture and

7. R Westmacott, 'Monument to George III', 1822, Liverpool, London Road

8. A Canova, 'Equestrian Statue of Charles III', 1806–19, Naples, Piazza Plebiscito

painting. The present patriotic subscription was deemed an incident favourable for obtaining a correct model of it'[27].

The same motives may have prompted Westmacott's adherence to the classical model when he came to execute the Liverpool statue. The committee's choice of an equestrian statue as a symbol of loyalty to the crown was a grandiose idea if rather conservative. The tradition of depicting the monarch as a superior horseman had a distinguished history in Western Europe stretching back to the 'Marcus Aurelius' (AD 161–180, Rome). This was the only sculptural work of its kind surviving from antiquity and it therefore became the standard reference for modern sculptors involved in designing equestrian statues, and the one that Westmacott was to follow so closely in his statue. The most consistent use of this image to convey the idea of absolute power and majesty is seen in the series of equestrian statues of Louis XV raised as focal points of the new *places royales* in major town throughout France, for example that by Emile Bouchardon for the Place Louis Quinze in Paris (1763). Because of the different political structure which had evolved during and after the Civil War, examples of this kind of statuary were comparatively rare in Britain until the eighteenth century when some towns employed them as dual symbols of allegiance to the crown coupled with civic pride. Before this period the most notable example was Hubert Le Sueur's 'Charles I' (1633, London, Charing Cross) which was somewhat different in intention. Closer precedents for Liverpool's statue were executed by Michael Rysbrack for Bristol (1734) and by Peter Scheemakers for Kingston-upon-Hull (1736). Rysbrack's work for Bristol was the result of a public subscription supported by leading civic dignitaries, similar in conception to the Liverpool project[28]. In more recent times, Westmacott's former master Antonio Canova had been commissioned by the Neapolitan Bourbons in 1806 to execute a colossal equestrian statue of Joseph Bonaparte to be placed in a large piazza in front of the royal palace in Naples (now the Piazza Plebiscito). After Napoleon's defeat the statue was rededicated to Charles III and completed in 1819, three years before Liverpool's statue was unveiled. Westmacott was to follow these precedents in taking the

'Marcus Aurelius' as his model, but he depicts the monarch in a more severely simple form of classical dress than the original. Initially he appears to have contemplated using a more spirited pose for the horse, however the technical difficulties of casting works with a more complex balance would have involved considerable expense and the subscription for the Liverpool statue was not accumulating as fast as had been anticipated[29]. The result was a work which provided an example of the high quality of Westmacott's work in bronze and an exemplary neo-classical adaptation of an antique model. When Westmacott's statue was finally unveiled it had become (by accident rather than design) a monument to the King who had died in 1820, rather than as had been originally intended, a celebration of his Golden Jubilee. Also the location had changed following the wishes of the subscribers from Great George Square, where the foundation stone had been laid, to the centre of the wide part of the London road to the north-east of the city centre. The area around the statue was then paved to provide access to the statue, although it was moved once more to its present position. The criticisms that had been raised against the Nelson monument concerning its lack of sublimity and classical reference could not apply here. Although there was unease about the high pedestal upon which the statue was raised there could be no question of it having the most immaculate pedigree[30].

The third public statue which exemplifies the sense of civic pride which was so rapidly growing during the period under review was dedicated to George Canning, a political figure whose connections with the city were of a different complexion to those of either Nelson or George III. He was neither a romantic hero nor did his career demand unquestioning loyalty. He was, however, tangible proof of local aspirations wedded to a sense of national identity. In his political career he had achieved high office having been Foreign Secretary (1807–9 and 1822–7) and Prime Minister for the four months prior to his death in 1827. Having been MP for Liverpool Canning still had many supporters and friends in the area and they were to be active in demanding that

some permanent monument to him should be raised locally. If the statue of George III had turned out to be a damp squib in the protracted discussions over its form and purpose, the Canning monument were to produce fireworks which nearly wrecked the whole project.

The statue was commissioned at a time of great commercial prosperity and growth for the city. During the period in which the three monuments were raised the population of the city had almost doubled and in 1831 stood at 202,000. Just as the population and the revenue from the port's trade expanded, so did a feeling of confidence, a confidence which eventually was to reach its highest form of expression in the architectural development of the city and the large quantities of public statuary raised during the reign of Queen Victoria. It is a testimony to the confidence of Liverpool's civic leaders in 1827 that they made the decision to commemorate Canning's 'splendid talents and private virtues' in the form of a bronze statue at a public meeting of 'gentlemen, clergy, merchants and other inhabitants' of Liverpool held in the Town Hall on 27 August 1827. It should also be remembered that the monument provided the opportunity to stress the strength of the Tory cause, which during that year had received several body-blows in the form of the debate over Catholic emancipation and the general weakening of the anti-Reform cause. What better way to confirm political allegiances than focusing public attention upon the merits of one of its most important leaders? A similar project was already under way in London to commemorate another 'bulwark of the Protestant cause'. The monument of Frederick Augustus, the Duke of York (1763–1827) which resulted in the 'Duke of York's Column', was funded through public subscription and Chantrey, Gibson, MC Wyatt and Westmacott were all to submit designs for the statue during 1829.

In Liverpool the statue of Canning was also the result of a public subscription. This was initiated and supported by the leading members of the Council, this time under the chairmanship of Mayor Thomas Littledale, who was to continue in this role for the duration of the commission. Initially the committee planned to erect a bronze statue and thus it was inevitable that Westmacott should be approached[31]. He now had a formidable rival in Francis Chantrey, who was beginning to threaten his supremacy in the field of bronze statuary but despite this it seemed probable that he would gain the commission. His association with the Foster family had continued to flourish, now through John (1786–1846) who had been appointed architect and surveyor to Liverpool Corporation on the death of his father in 1824. This gave him an ideal means of canvassing the committee directly for the Canning commission. By 1827 he had successfully undertaken two major sculptural works for the city of a similar kind and he had a series of important commissions in hand, furthermore his bronze foundry was well established whilst Chantrey's was still in the process of construction. There were other considerations which would have swayed the committee in its deliberations over the relative merits of the two sculptors, for although Westmacott still maintained his leading role as a sculptor of the heroic subject, Chantrey had no rivals in his own favourite area of sculptural practice, portraiture. Allan Cunningham, his spokesman, secretary and assistant, had recently published an article in the *Quarterly Review* which cleverly promoted the idea of his works being the embodiment of 'Englishness': 'England may be justly proud of Chantrey; his works reflect back her image as a mirror', sentiments which would undoubtedly raise his appeal in works which were meant to convey the idea of national and local pride[32].

A prime mover of the Canning project was John Gladstone, one of his most fervent supporters. It was at Gladstone's invitation and with his financial backing that Canning had agreed to stand for the Liverpool seat in 1812 which he held until his decision to change his seat to Harwich in 1822. Although both Chantrey and Westmacott had worked for patrons which a variety of political persuasions, Westmacott's early work for the Whig circles opposed to the slave trade upon

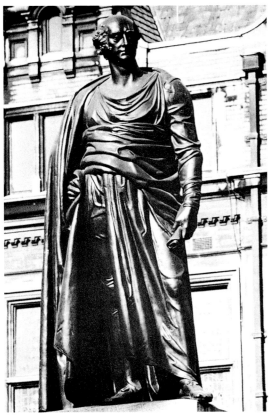

9. R Westmacott, 'Monument to George Canning', London, Parliament Square

which Gladstone's fortune had been based may have counted against his claims to the commission to execute this celebration of a Tory politician in Liverpool. Also, the sculptor could no longer rely upon the support of Roscoe who was stricken with paralysis in 1827 and played little part in public life. Outside Liverpool he executed a major public statue of Canning which was unveiled in Parliament Square, London in 1831, and it must be assumed that he would have adopted a similar format had he been employed on the Liverpool statue (Chantrey was to use the same basic composition for both the Liverpool and Westminster Abbey statues of Canning, signing the contract for the latter only nine days before the Liverpool contract on 18 June 1829[33]).

After the success of his bust of Horne Tooke at the Royal Academy in 1811 and his brief flirtation with the 'friends of Liberty', Chantrey had always been careful to maintain a deliberate political neutrality in all his public affairs. In the context of Liverpool he had one major advantage over Westmacott in that Canning had sat to him for a bust commissioned in 1818 by Colonel John Bolton, a work which was completed by the following year and placed in the Town Hall[34]. Like Gladstone, Bolton was one of Canning's foremost supporters in Liverpool and furthermore a leading member of the committee. Chantrey and Canning's mutual friendship with Sir Walter Scott was another point of contact. Scott's last meeting with Canning had taken place at Bolton's home 'Storr's Hall' on Lake Windermere, in the company of Wordsworth and Southey in September 1825[35]. Therefore in Liverpool Chantrey's claims over those of Westmacott were based upon his ability to make a posthumous portrait of Canning, an advantage which prompted Littledale to instruct Foster to approach Chantrey in order to assess his interest in such a commission. Cunningham replied to the letter which had arrived during one of his employer's prolonged business trips away from London[36]. This document demonstrates the importance of Cunningham to Chantrey's business practice, a skilful response written on 14 November to the enquiry concerning the sculptor's ability and skill to execute an over-life-size bronze statue as a

monument to Canning and one which provides a sharp contrast to Westmacott's brief note to Foster which merely indicated a willingness to undertake the work. In his letter Cunningham concentrated upon the sculptor's unique position to make such a work, describing him as a 'distinguished friend' of the politician whose 'elegant and graceful form is impressed upon the artist's fancy' – so much so that he has a 'distant and perfect recollection of the man'. In addition to this first-hand knowledge of the man himself, he pointed out that Chantrey owned a collection of portraits of Canning 'by first rate artists', an invaluable resource to aid him in producing a posthumous portrait. In relation to the sculptor's technical ability to execute an over life-size statue in bronze he gave a list of works in that medium currently under way. As commissions from large cities and towns similar to the Liverpool project this would have appealed to the committee's already well-developed sense of inter-city rivalry. Most significantly Cunningham states that the sculptor was busy erecting furnaces for the purpose of casting these statues. This indicated that, if contracted for the statue it would be under his direct control throughout its execution, thus minimising expense and delays, and that he was now able to challenge Westmacott directly for commissions in bronze[37].

A detailed letter was sent by Chantrey on his return to London, confirming Cunningham's eager response to the committe's enquiry, in which he gave further details of the possible scale and price of the work. He also stressed that an essential preliminary stage of making any design would be an inspection of the site for the statue: 'In order to give full effect to a Bronze statue it ought to look towards the South or South West so that the likeness may be aided by the light of the sun[38]. At this early stage Chantrey was adamant that the cost would be £4,000, a figure which it seems was cited when the first approach was made by the committee. It was this estimate which was to become the focus of controversy between the sculptor and the committee and to cause a bitter quarrel between Chantrey and Sir John Gladstone.

The committee only considered Chantrey's and Westmacott's claims in their preliminary deliberations, although John Gibson petitioned for the work through another committee member, William Earle, whose uncle had talked over the matter with the sculptor at his studio in Rome. Gibson's application was made on the basis of his Liverpool connections and his high reputation. He also pointed out that it would be far cheaper to execute a work in marble or bronze in his Rome studio because of the availability of materials and good craftsmen. An attractive idea to a committee already worried about the state of the subscription, but unfortunately a decision had already been reached when Gibson's letter was received[39].

Due to the difficulties of deciding between Westmacott and Chantrey and possibly to allow Gibson's participation, the committeee suggested to Chantrey (who already assumed he was to have the commission) that the best means of arriving at a decision would be to hold a competition. Chantrey's response to this suggestion was by now familiar: he loathed the process of public competition and the harm that it could do to the most established of reputations. His response to Foster's letter of 6 December 1827 gave particular reasons for his refusal in the case of the Canning statue: 'It is now many years since I engaged in competition and even if it were now my practice I should doubt the propriety in the first instance not only from existing circumstances with which I need not trouble you – but because no other sculptor has enjoyed the same advantage with myself in having studied from the living man'[40].

As a result of Chantrey's blunt refusal to compete and his continued insistence that he was the only sculptor with sufficient knowledge of the sitter's appearance and character to complete a successful portrait statue, the committee decided against a competition. Once again Chantrey was questioned by Foster about his current commitments and also about the cost of a design: 'made in the chastest taste, and the work

executed in the ablest manner'. At a meeting of subscribers held at the Town Hall on 16 January 1818 it was reported that Chantrey had agreed to execute the statue within three years for £4,000. The subscription then stood at £3,200 with £3,000 promised[41]. A report of the committee's deliberations over the choice of sculptor was read out by John Gladstone, who at this point obviously supported Chantrey's tender for the commission: 'it was for the subscribers to determine whether they would place themselves, in Mr Chantrey's hands, on the terms he proposed; or to relinquish the advantages that might fairly be expected to be reaped from his superior genius, his acknowledged taste, his high reputation and intimate knowledge of Mr Canning with the advantages of the works Mr Chantrey has already executed, or in this case rely on such designs or models as might be furnished by other Artists, with the uncertainty by whom the work might be executed'[42].

It was hardly surprising that the meeting unanimously agreed to employ Chantrey to execute a bronze statue of Canning. It was also decided that the site of the statue was to be either St George's Crescent at the head of Lord Street, or between the yet unbuilt Custom House and the River Mersey. A new committee was voted by the subscribers to decide upon a site and to supervise the commission which looked little different to the general committee that had initiated the project including Littledale, Birch, Bolton, Gladstone and Foster[43]. Towards the end of January, Foster visited Chantrey's studio where the sculptor was busy casting the statue of George IV for Brighton, a task which would prevent him from leaving London for at least three weeks. Foster also gave him information about the fund, to which Chantrey's somewhat pointed reply was that he hoped it would ultimately amount to the £4,000 that he had estimated when agreeing to execute the statue. On receiving this news from Foster, Littledale replied immediately that no more than £3,600 could be guaranteed although up to £400 might be allowed if after completion there was any surplus. It is obvious that the fund was faltering despite appeals to the Liverpool's major trading companies[44]. When Chantrey visited Liverpool discussions took place and a modification to the plan was proposed in order to reduce costs. The sculptor's charges for bronze statues ranged from £7,000 for the statue of Pitt for Edinburgh and £3,150 for the statue of George IV for Brighton (1822–8), depending on the scale and complexity of the work and whether it was the first work of its kind[45]. Chantrey and Foster (who was acting as agent for the commission) continued to correspond over the possibility of making the statue in marble rather than bronze which would reduce costs. In a letter of 21 April 1828 Chantrey tried to emphasise the positive advantages of the committe's forced decision stating that working in marble he felt 'more able to express the sentiment I wish to embody' from his memory of the man and adding that it had always been his ambition to make a statue of him in that material[46]. Gladstone, who was angry at the lack of wider consultation with the subscribers, believed that the sculptor was deliberately manipulating the situation in order to do less work for his money. In order to force Chantrey to complete the original bronze statue below the figure that the sculptor had originally estimated he issued a highly defamatory circular to the subscribers in which Chantrey's professional integrity was called into question. When a meeting of subscribers was held in August that year to receive a report proposing that the statue should be placed on the first landing of the principal stairs of the Town Hall, Gladstone forced amendments to the resolution. These were to the effect that the original proposal of a bronze statue sited in St George's Crescent should be reinstated. To Littledale and Foster's embarrassment these were carried. A letter from Littledale to Chantrey which tried to soften the blow of the change of plan indicating the committee's regret over the decision of the subscribers further enraged Gladstone[47]. Chantrey's reply written in October refuted Gladstone's allegations pointing out that it was 'infinitely less trouble' to make a figure in bronze rather than marble. In marble

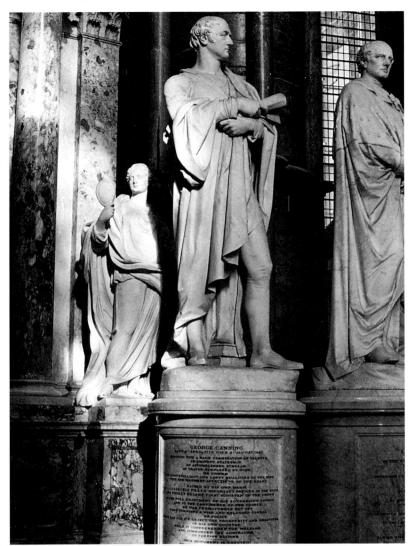

10. F L Chantrey, 'Statue of George
Canning', 1829–34, London,
Westminster Abbey

completed statue was just under eight feet high and raised on a marble plinth three feet six inches high, the delicate rendering of the surface demonstrating all that close attention to finish which Chantrey had indicated would occur when he had stated his preferences relating to materials. It is a measure of his tenacity of purpose that he survived Gladstone's attack and completed the monument as he always wanted. To some degree Gladstone's accusations were true: Chantrey's statue of Canning for Westminster Abbey cost only £150 less than that for Liverpool, and it is quite obvious that he used the same plaster model for both, with only small changes (in the drapery over the right arm and the position of the books at Canning's feet) between the two works.

These first attempts at public art were made in order to establish a firm sense of Liverpool's increasing civic strength and to convey this to the public at large. Although the number of such works must be seen as modest when gauged against the proliferation of such works during the Victorian period they are still significant. They demonstrate the desire on the part of the civic leaders and a significant proportion of the community to have works of the finest quality as focal points of the rapidly expanding city. In this way they act as symbols of the increasing sense of civic independence which is stated with reference to national concerns. The reading of such visual texts depends upon the relationship which existed between the commemorated individual and the community, and how that relates to local concerns. There is thus a difference between a work such as the Nelson monument that locates a sense of patriotic pride in a national hero with reference to specific local issues, and that to the monarch which is expressed in a language of sculpture that was universal. The statue of Canning is a monument to the political allegiances of the civic leaders as much as it commemorates a man with local connections, and as such differs in intention to its precursors. It is a sign of the increasingly democratic principles upon which, until recent legislation came into effect, local government has been based, that Liverpool's civic identity is now expressed in projects which do not express the will of 'merchant princes' through the medium of public sculpture. It is perhaps only now apparent how deftly the Liverpool work of Wyatt, Westmacott and Chantrey married local and national references, a rare historical moment when the private and the public spheres could not merely be satisfied but also simultaneously expressed.

statuary: 'If he [the sculptor] does justice to his work, his chisel must pass over all the improved parts, and the last day that it remains in his possession, he finds employment both for his head and his hands'[48]. He further sets out in detail the form of the agreement and gives his costing of bronze statues relating to the height of the figure which determined that if the Canning statue were to be cast in bronze it would have to be no more than eight feet high, raised on a pedestal of equal height. Although the letter is couched in very moderate terms and Gladstone not mentioned by name, Chantrey accuses him of 'ignorance of facts'. In order to respond to this letter Gladstone demanded that Foster produce all his correspondence with the sculptor for scrutiny by the committee, which he refused to do, at the same time refusing to continue acting as the committee's go-between.

Having read the detailed information in Chantrey's letter concerning his working methods and his understanding of the agreement that existed between himself and the committee, it became obvious that Gladstone's accusations were unfounded and that the sculptor had, indeed, been acting in good faith. By December good relations between the two parties had been restored, although Chantrey refused to communicate any further with Gladstone except through the committee. Yet again the decision over the material to be used was reversed and an application put forward to house a marble statue in the Royal Liverpool Institution. It is fortunate that this application was rejected and that Chantrey's statue was finally located where he had originally planned it to be seen, on the main staircase of the Town Hall. Here it was agreed it shoud stay, subject to the right of the subscribers to move it if a more suitable site with greater public access could be found. The

NOTES

1 *Pen-and-ink Sketches of Liverpool Town Councillors by a Local Artist. Reprinted from the "Liverpool Mercury"*, *1857*, Liverpool, 1866, p viii

2 For a detailed discussion of this aspect of early nineteenth century sculpture see: A Yarrington, *The Commemoration of the Hero, 1800–1864*, New York & London, 1988.

3 T Fawcett, *The Rise of English Provincial Art: Artists, Patrons, and Institutions outside London 1800–1830*, Oxford Studies in the History of Art and Architecture, Oxford, 1974, p 94.

4 *ibid.*, p 62.

5 Ibid., See also R Gunnis, *Dictionary of British Sculptors 1660–1851*, new and revised edn., London, 1951.

6 According to [J. Aspinall] *Liverpool a Few Years Since*, 3rd edn., Liverpool, 1885, pp 174–5.

7 Yarrington *op. cit.*, p 119. The *Liverpool Chronical* provided regular updates of the state of the scheme with lists of new subscribers.

8 *The Collected English Letters of Henry Fuseli*, ed. D H Weinglass, Millwood & London, 1982, p 342: Letter to William Roscoe, 14 March 1806.

9 Letter from John Foster the younger to Sir William Barton, 25 July 1820, local records: 73/Geo 1/8, Liverpool, William Brown Library.

10 Sixteen Autograph Letters signed to William Hayley the Poet and Friend of William Cowper, London and Rome, 1786–1814, Cambridge, Fitwilliam Museum, [Autograph] 1–1935 31, [June 1806].

11 Farington, Diary, 1 March 1806, p 3167 (typescript).

12 N Penny, 'The Sculpture of Sir Richard Westmacott', *Apollo*, vol. 102, pp 120–127.

13 Fuseli *op. cit.*, p 356: Letter to William Roscoe, 10 January 1807.

14 N Penny, *Church Monuments in Romantic England*, New Haven and London, 1977, p 97.

15 Liverpool public records, 73/Geo 2/5.

16 RIBA Drawings Collection; 3/1/22: Letter to M C Wyatt from D A W Robertson, n.d. [1813–14].

17 G. Chandler, *William Rosce of Liverpool*, London, 1953, pp 115–16.

Roscoe was in fact nominated to stand again in the election held the following year, but he refused.

18 *ibid.*, p 333.

19 N Penny, 'The Whig Cult of Fox in Early Nineteenth-Century Sculpture', *Past and Present*, vol. 70–73, December 1975, p 103, n. 1.

20 *Liverpool Mercury*, 29 October, 1813.

21 Chandler, *op. cit.*, p 339.

22 J Touzeau, *The Rise and Progress of Liverpool from 1551–1835*, 2 vols., Liverpool, 1910, vol. 2, p 755.

23 Liverpool Public Records 73 Geo 2/5.

24 Liverpool Public Records 73 Geo 1/4.

25 Liverpoool Public Records, 73 Geo 2/11. Westmacott sent a letter to the committee enclosing a contract which he had drawn up to take the same format as the contract for the Nelson monument.

26 *ibid.*, 73 Geo 2/10.

27 *The Gentleman's Magazine*, vol. 85 (i) [February 1815], p 127. T Fawcett, *op. cit.*, p 173 gives details of the ideas circulating in Liverpool in 1814 for an 'ambitious' Liverpool Institution housed in a special building with apartments for exhibitions of painting and sculpture. In this context the combination of art and utility in providing a 'copy' of one of the most admired antique models in the city adds strength to the idea of a similarity of purpose behind the 'Achilles' and the statue of George III.

28 For a full discussion of Rysbrack's statue as an emblem of civic pride, see K Eustace, 'William III, Queen Square, Bristol, 1731–1736', *Michael Rysbrack Sculptor 1694–1770*, City of Bristol Museum and Art Gallery catalogue, 1982, pp 23–34.

29 The casting of equestrian statues was recorded in G Boffrand, *Description de ce qui a été pratiqué pour fondre en bronze d'un seul jet la figure equestre de Louis XIV élévée par la Ville de Paris dans la Place Louis le Grand en mille six cent quatre vingt dix neuf*, Paris 1743. This was a standard reference work which Westmacott would have known. It was certainly consulted by Chantrey when he was working on the first equestrian statue of George IV for Marble Arch (see: Yarrington, *op. cit.*, p 238).

30 T Fawcett *op. cit.*, p 148, n 18.

31 Liverpool Public Records, Min 350 COU I 2/3, p 12: 8 November 1827.

32 *Quarterly Review*, vol 36, (1826), pp 131–3)

33 *Chantrey Ledger 1809–41*, Royal Academy, p 213.

34 A Potts, *Sir Francis Chantrey 1781–1841: Sculptor of the Great*, National Portrait Gallery Exhibition Catalogue, London 1981, p 16, no. 6. See also R Walker, *National Portrait Gallery: Regency Portraits*, 2 vols., London 1985, vol. 1, p 93 (316a). Chantrey made a delicate *camera lucida* drawing of Canning which Walker has shown was a preliminary drawing for the bust from life.

35 *Dictionary of National Biography*, p 304.

36 Min 352 COU I 2/3, p 13.

37 It is also proof that Chantrey was already constructing his foundry well before the date of 1830 estimated by Margaret Whinney [*Sculpture in Britain 1530–1830*, Harmondsworth, 1964, p 222].

38 Min 352 CGU I 2/3, p 14–15

39 *ibid.*, p 26.

40 *ibid.*, p 17.

41 *ibid.*, p 20.

42 *ibid.*, p 23.

43 *ibid.*, p 24.

44 *ibid.*, p 30. The chairmen of the Liverpool, Portugal, Brazil, South American and Mexican Association, the West India Association, Mediterranean and Levant Association, the Ship Owners Association and the East India Association were all summoned by the committee to try and raise further funds.

45 *Chantrey Ledger*, p 171, p 146.

46 Min 352 COU I 2/3, p 34

47 *ibid.*, p 39.

FROM BASILICA TO WALHALLA

Benedict Read

The Liverpool and Manchester Railway opened on the 15th of September 1830. Though not the first public railway in Britain, it did link two of the major commercial centres of the country at a time of economic expansion, and the railway was to contribute to this process, with receipts from passengers alone within the first ten years of operation amounting to nearly £344,000, and savings for the public on this one line were nearly a quarter of a million pounds annually – so this made the opening of the line an event of some expectation[1]. 'There was a gathering of the noble and celebrated, from all quarters. The Duke of Wellington, Prince Esterhazy, Sir Robert Peel, Lords spiritual and temporal, members of Parliament and celebrities of all kinds, gathered in great numbers... The day was fine, and the assembled multitudes probably exceeded in number any spectacle before and since... when after a period of expectation strained to the utmost the train appeared in sight, rolling along slowly in its majesty of power, the excitement seemed almost too great to exhibit itself in the usual British cheer. Foremost on the gorgeous car prepared for the occasion stood the hero of a hundred fights, the Conqueror at Waterloo, grave and impassive, with arms folded, enveloped in his military cloak, surrounded by the noble and distinguished from all quarters. The real hero of the day, the spirit at whose bidding all this mighty scene had been conjured up – George Stephenson – headed the train, driving with his own hands the locomotive, manufactured by himself, appropriately named *The Northumbrian*'[2].

Among the celebrities present was William Huskisson who had been MP for Liverpool since 1823. In that role, we are told, 'he had won golden opinions from the commercial community by his attention to their interests, and by the liberal and enlightened policy which he had adopted and was engaged in carrying out'[3]. He was also a senior politician of national distinction: he had been junior and senior Minister in Governments from 1804, but had more recently had to resign from office as Secretary for War and Colonies in Wellington's current administration. He dragged himself from a sickbed in his anxiety to assist in doing honour to the occasion[4], and while the trains were stopped at Parkside to take in water, he got out to go and greet his former colleague, as they had only met once since their rupture. Unfortunately the other train, drawn by *The Rocket* came steaming up. There were cries of 'Take care, an engine is coming', and 'Get in! Get in!'. Huskisson, with enfeebled body, and nerves unstrung by sickness, became flurried; he missed his footing in attempting to ascend, he was caught by the open door of one of the carriages and fell on to the railway line just as *The Rocket* came up and passed over his right leg which it crushed; from the effects of this accident he died in a few hours[5].

On September 24 his remains were interred in the new St James' Cemetery in Liverpool; there was a public procession in which all sects and parties vied with each other in paying the utmost respect to the memory of the departed statesman. On November 3rd a public meeting was held in the Sessions House, Chapel Street, Liverpool, to take suitable steps towards the erection of a monument to the late member (sc. of Parliament), and about £3000 was raised, apart from the expenses of the funeral.[6] In the end, three separate commemorative statues of Huskisson were to be produced. This was not due to the high emotional pitch surrounding the circumstances of his death as described, but rather to the differing requirements and settings of public statuary monuments during the nineteenth century, as will

1. J Gibson, 'Statue of William Huskisson', inaugurated in 1847, in its original position outside the Custom House, Liverpool

become evident in tracing the examples under consideration in Liverpool during the rest of the century and beyond.

At first sculptors were invited to compete for the commission by sending in models. Among those invited was John Gibson, former protégé of William Roscoe, Liverpool sculptor (by adoption), resident in Rome but still friends with leading Liverpool families. Gibson declined the invitation, 'being impressed with the bad results of competition on these occasions, and the difficulty which those totally unconnected with art have in selecting the best designs'.[7] Eventually the commission was given to Gibson, and on his own terms, which meant treating the subject in classical style. He wrote to a friend in Liverpool: 'My intentions in this work are to avoid altogether everything like English portrait statues. I shall represent him simple, grave and reflecting with grand drapery. This style will not please the vulgar, for the modern dress or morning gown brings the deceased naturally before them. I am very much pleased with the committee for allowing me that scope which every artist of good taste and ambition requires'[8]. The representation was of Huskisson standing – draped in the Pharos, with the right arm and shoulder uncovered, holding a scroll which he is unrolling at the same time looking at the spectator with firmness. It made an impression on those who saw it and Mrs Huskisson hearing of this came to Rome to inspect it[9]. 'She sat before it, looked and looked, and burst into tears, keeping her face covered for some time: after a long death-like silence she said – "You have been most successful"; and again becoming affected she retired with me, saying, that she would return next day.' Meantime the committee had heard of the bare arm and shoulder and sent instructions that they should be covered. Gibson showed their letter to Mrs Huskisson when she had returned for a further inspection of the statue. 'Oh, I hope that beautiful arm will not be covered' was her response, and having communicated her opinion via the Marquis of Anglesea and a friend of his to the committee, the statue was allowed to be finished without alteration[10].

The completed version in marble was installed in the cemetery at Liverpool in the mausoleum designed by John Foster. But to some extent it was not really accessible there, it was fine marking the spot where Huskisson was buried, but this was not a public site connected with the services that Huskisson had rendered to the commerce of Liverpool such as inside the Custom House would be, which is where a proposal was made for the statue to be removed to.

Mrs Huskisson rather took against this idea, and asked to be allowed to present herself a second statue to go inside the Custom House; this offer the Mayor and Council accepted. Gibson now began on a second statue, eight feet high, still in classical dress, but differently posed: 'this figure was represented in a moment of deep thought, with the left hand raised before the chest, a slight action in the fingers as if calculating, and the right hand hanging down holding a book (in classical scroll form). This again is bare-necked and draped with a mantle in large and magnificent folds – a mode of attiring the statues of our great men not entirely in accordance with the ideas of our committees'. Mrs Huskisson came to Rome again to inspect the work's progress and suggested many improvements in the face, which rendered this the more like of the two. She herself considered this statue the superior one[11]. All of which was as well, considering she was footing the bill.

In the summer of 1844 Gibson came to Liverpool to instal the statue, but he found on examination that the position destined for it in the long room of the Custom House was altogether unsuitable, and the only place in the building where there was a proper light was unobtainable. Mrs Huskisson wanted the statue to be seen to advantage and proposed a site outside the building where she was prepared to fund another version, this time in bronze. After some difficulty this generous offer was also accepted. The second marble statue was placed with Lloyd's at the Royal Exchange in London (they had been subscribers to the Liverpool Nelson monument[12] and no doubt had extensive business connec-

2. C R Cockerell, drawing of interior side wall, Great Hall, St George's Hall

tions with the town); they presented it in turn in 1915 to the London County Council who placed it in Pimlico Gardens[13] (where it still is). Meanwhile Gibson went with Mrs Huskisson to Munich in 1846 to inspect the bronze, cast by Mr Müller, 'a simple modest young fellow' according to Gibson[14]. The statue was finally installed in Canning Place, outside the Custom House, on October 15th 1847, in the presence of the sculptor and Sir Robert Peel and others[15]. It survived the war-time bombing that gutted the Custom House (illus.1), and was moved to Princes Avenue in 1954; more recently it has been moved for safe-keeping to the Oratory in St James's Mount Gardens. Peel's comment on one of the Huskissons is worth noting – 'It is very like Huskisson, but you have given a grandeur of look to the figure which did not belong to him'[16]. Peel himself was in fact the next in line for commemoration, together with George Stephenson, the direct instrument of Huskisson's demise.

By the time they had died, however, and called forth the requisite statuary commemoration, a new focal point for the public was arising in St George's Hall. Described as it went up by Rawlinson as 'that temple-like structure to pleasure the "Merchant Princes"' of Liverpool[17], the building was to serve as a form of civil Basilica, with Law Courts and other areas, particularly the central St George's Hall, to be rendered 'permanently available for the use and enjoyment of the inhabitants generally with instructions that, in any scheme to be proposed, the recreation and improvement of the working classes should form a prominent and essential part'[18]. A role for sculpture on and in the building was envisaged by both architects involved, H L Elmes and his ultimate successor C R Cockerell. Both men were sculpture-friendly – Elmes wrote to Rawlinson in 1844: 'Consider ... the effect produced by painting and sculpture as auxiliaries, – the latter (ie sculpture) devoid of colour, yet pre-eminent in form, the material harmonizing with the architecture in massive durability, while the gracefully flowing drapery, the marked expressive countenance, and the apparent capability of motion, all contrast with the greater severity of the architectural framework. Were this feeling general, – alas! for gilt frames and watch-boxes recesses for statues'[19]. Elmes provided square panel-blocks for carving on the exterior (though these were not even started until the 1880s), and a water-colour study by him of the great east

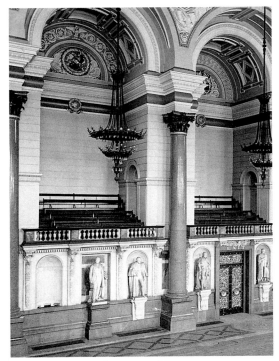

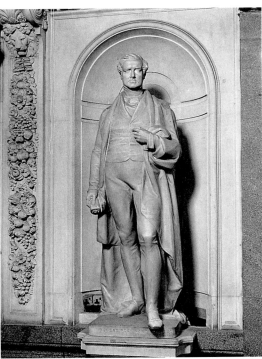

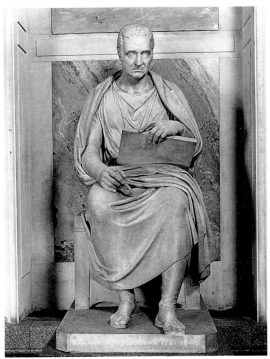

3. General view of interior of Great
Hall, St George's Hall

4. M Noble, 'Sir Robert Peel',
inaugurated 1854, NMGM

5. J Gibson, 'George Stephenson',
inaugurated 1854, NMGM

portico[20] indicates his ultimate aim of statuary enrichment described by Rawlinson.[21] Another study of the screen at the end of the Great Hall also includes statuary,[22] but in neither is it really possible to determine the type of sculpture foreseen, between general neo-classical decorative and specific contemporary commemorative.

Certainly an Elmes drawing giving the elevation of the interior side wall of the Great Hall makes no provision for niches to take statuary[23], whereas a drawing by Cockerell that details his alterations in the design of the same elevation quite clearly does[24]. And a more detailed drawing indicating the decoration of this wall not only has a niche flanking the door, but includes a statue standing in the niche (illus.2)[25]. This could well portray a gesturing politician holding forth, and since the figure is by no means clearly togatose, in fact the collar with lapel of a frock coat can easily be postulated, it is suggestive of the ranks of contemporary subjects who were to come to occupy many of these niches over the ensuing years (illus.3).

While there is no clear indication who took the decision to make the Great Hall the place for Liverpool's public statues (for the time being) they had certainly begun to arrive by the time of the hall's formal opening by the mayor on Monday 18th September 1854. This happened in the presence of the council, the magistrates and an immense array of visitors, and two statues, of Sir Robert Peel (d1850) (illus.4) and George Stephenson (d1848) (illus.5), were unveiled at the same time, before the Bishop of Chester offered a prayer and afterwards 'Messiah' was performed – to be followed on ensuing days by Mendelssohn's 'Elijah', Haydn's 'Creation' and miscellaneous concerts in the evenings[26]. There is little evidence, either, for a detailed structure of responsibility for the statuary: it would appear from the Minute Book recording the Proceedings of the Courts of Law and St George's Hall Committees between July 1849 and January 1856[27] that while application to them for permission to place a statue in St George's Hall might be required from Committees of Subscribers[28], when Peel's statue (by Matthew Noble) was ready for transmission to Liverpool, while the building's controlling Committee was prepared to receive this, it was up to the sculptor to come and actually select the niche in St George's Hall that was to take the statue[29].

As already indicated, the first public statues to be set up in St George's Hall were those to Peel and George Stephenson. Stephenson had

died first, in 1848, and his commemoration at Liverpool was very much for his local contribution. He had been the real hero behind the successful completion and opening of the Liverpool and Manchester Railway and the Council had presented him with the Freedom of the Borough in 1833 in recognition of this[30]. Some put it more forcibly: 'It would not be too much to say, that the genius of the Northumbrian miner has effected more for the progress of the human race in fifty years, than all the conquerors and statesmen had done in the five hundred years preceding'. Of course, his backers in Liverpool who had put up money for the railway should not be forgotten: 'It is only bare justice to keep in remembrance the fact that it is to the sagacity, enterprise, and perseverance of Liverpool merchants that the world is indebted for the development of railways in their present form'[31]. John Gibson was selected as sculptor, in spite of any possible problems there might be concerning the representation of a man with the skills very much of the day by a sculptor totally devoted to the language of antiquity. Gibson recorded: 'Mrs Lawrence says that Stephenson should have a look of energy – a man of action more than contemplation. I will endeavour to give him a look capable of action and energy, but he must be contemplative, grave and simple. He is a good subject. I wish to make him look like an Archimedes. Activity and energy are momentary, contemplation is more suited to marble. The statue must give an idea of his studious moments'[32]. This it possibly does, though it is impossible to find any clue as to the figure's real identity from the props he holds, so total is the classical identification. One wonders also whether Gibson was trying to match in pose the statue of his patron William Roscoe that was executed in 1841 by Chantrey and placed in the Gallery of Art attached to the Royal Institution in Liverpool; Gibson might reasonably have expected this commission and having failed to get it, wish to make a point. The Chantrey was eventually installed in St. George's Hall, having been made available for transfer in 1870[33].

Peel was less specifically a subject of local significance. There had been important points of contact with Liverpool over the years, though not always of advantage to the town. Liverpool had lobbied Peel in 1823 for the transfer of the Assizes from Preston to Liverpool (and Manchester) but without a reply being recorded. On the other hand Peel visited Liverpool in October 1828 for no special reason, 'it

being apparently solely attributable to a desire on Mr Peel's part, as a public man, to ascertain for himself the truth of the famed progression of this wonderful town of which he had heard so much'. The Council was certainly impressed and gave him the Freedom of the Borough in a Gold Box. In January 1829, they tried again for the transfer of the Assizes, and though the deputation was graciously received, nothing transpired until 1835[34]. Peel was of course a long-time associate of Huskisson and attended the unveiling of Gibson's statue in 1847. But the feeling for him in Liverpool was possibly more part of the general, national mood that manifested itself at his death: 'Sir Robert Peel … stands out in the history of our Country as one of the greatest Statesmen who ever held the reins of Government. His tragic death, in 1850, produced a deeper feeling of grief throughout the Country and more general expressions of lamentation and regret at the irreparable loss the nation had sustained than any other English statesman'[35]. It is possible to postulate special cases for gratitude and grief among certain particular sections of the Liverpool population towards particular political actions and campaigns that were connected with Peel: his part in Catholic Emancipation, the gradual liberating of trade restrictions and lowering the price of bread through the Repeal of the Corn Laws. Beyond these one can formulate a particular identification with Peel by the mercantile classes enfranchised by the Reform Act of 1832; they could see in him, the son of a calico printing works owner in Bury, the first member of these classes to rise to the supreme political position in the country of Prime Minister. At all events, after his death memorial statues went up to him throughout the country in numbers that totally eclipsed any previous record[36]. Liverpool interestingly did not go to Gibson for theirs, in any case he obtained the commission for the national memorial in Westminster Abbey, where Peel stands toga-clad in the process of making a speech. Instead Liverpool turned to a still relatively unknown Northern sculptor, Matthew Noble, who produced for them a characteristically vigorous modern dress representation (which one can only feel is more appropriate to Peel and all he stood for. One should however note certain other Peel commissions like Baily's for Bury and Behnes' for Leeds which specified that the artist must limit the statue's dress to the exact coat, waistcoat and pantaloons in which Sir Robert had made his last speech in the House of Commons[37]).

Noble did other Peels for Tamworth, Peel's home town, and Salford, with which Noble was to establish close links as sculptor – and many years later he was to be the principal sculptor of the monument in Parliament Square in London. But his Liverpool Peel is significant as one of the very first of the public statues that were to become the staple of his successful career.

The next figures to be commemorated by statues in St George's Hall were certainly local. The Reverend Jonathan Brooks, rector and archdeacon of Liverpool for many years came from an old Liverpool family. He was acknowledged as one who

for more than fifty years filled a large place in the general esteem of the inhabitants… Few men have enjoyed in their day and generation more general respect than fell to the lot of Archdeacon Brooks. Of a dignified and noble presence, his manners were genial, courteous, and with perfect truth it may be said, those of a gentleman. When presiding at vestry meetings in the stormy times of contested church-rates, when occasionally very strong language was indulged in, a quiet pleasant remark from the "old rector" would calm the troubled waters, and frequently cause all parties to laugh at their own violence'[38].

Even though he had already had a marble bust of himself presented to the Town Council in 1835[39], soon after his death application was made for a statue to be erected in St George's Hall. A sum of £1800 was collected by voluntary subscription to defray the cost of the statue, and Benjamin Spence, an English sculptor resident in Rome (and a one-time protégé of Gibson), was announced as the successful competitor

out of several sculptors who sent in designs[40]. The completed work arrived in Liverpool in 1858[41].

Criticism over the commemoration of the likes of Brooks by statues was eventually to be voiced:

With all respect to his memory, it is difficult to see the grounds for a public recognition of this character. Statues in our local "Walhalla" should be reserved for men who have distinguished themselves in some way above and beyond their contemporaries, either by enlarging the circle of human knowledge and power, or by some great public benefit conferred. If every clergyman who respectably performs the duties of his sacred office is to have a statue erected to his memory, all honour and distinction by such a tribute would be lost[42].

Granted the nature and extent of sectarian feeling in Liverpool in these years, it is not really surprising to see so many clergymen commemorated – Brooks and McNeile in St George's Hall, Monsignor Nugent and Canon Lester later in St John's Gardens (see below). And while it may have been a part of their professional calling to respond to the social and civil problems of nineteenth century Liverpool perhaps the actuality of their having done so deserved remembering.

In 1857 a *living* benefactor came to be commemorated. William Brown provided money for the Free Library and Museum in the street now named after him. 'Among the honours showered by a grateful population on the living head of the donor … is a statue of him, for which Mr MacDowell has received a commission from the town and corporation, and which is to convey his lineaments to future generations from a pedestal in St George's Hall'[43]. The sculptor concerned was the eminent Royal Academician Patrick MacDowell.

A living subject once allowed, others followed. In 1864 it was proposed that a statue should be erected by public subscription to the then Chancellor of the Exchequer, the Right Honourable W E Gladstone MP 'as a permanent memorial of the services he has rendered to the town, and the country at large'[44]. Gladstone had first been a Minister under Peel in 1843, and was still to be Prime Minister four times between 1866 and 1894. But as important (in a way) locally was the fact that he had been born in Liverpool and his family were prominent in the community. The commission for the statue went to John Adams (later known as Adams-Acton, to distinguish him from other Adams). The *Art-Journal* in London was not impressed: 'Under what cirumstances, or by whose influence, this commission was obtained, we are at a loss to guess; certainly the event is not to be attributed to any merit of the sculptor above that of his compeers'. The commission was heedless, given in utter ignorance – the work could have been done by Foley, MacDowell, Calder Marshall, Durham, Bell, Weekes and others (these were all prominent members of the British School of Sculpture that the *Art Journal* was championing). It was 'deplorable' that second or third-class artists should be commissioned[45].

Adams had in fact studied with Gibson, in Rome, and Gibson 'was not slow to discover the genius of his new pupil and soon pronounced Adams to be "mighty clever" and above all "matchless in portraiture" '. Gibson sent distinguished tourists round to the young sculptor's studio, and among these was Gladstone. 'The sculptor and the future Prime Minister were mutually attracted from their first meeting' and their friendship lasted till Gladstone's death. In Rome Adams executed the first and 'perhaps the finest' of the many portrait busts which over the course of years he did of the politician; to the last Gladstone himself preferred it above all others, and it stood always in his library at Hawarden[46]. So the choice of Adams for the St George's Hall statue was not that surprising. By the time it was set up in 1870, the *Art Journal's* attitude had modified: 'the figure, which is clothed in rich, yet simple, classic drapery, is dignified and sculpturesque'[47] (illus.6).

By this time other, later commissions had been executed and installed: William Theed's '14th Earl of Derby' (commissioned 1867, unveiled 1869) (illus.6) and Giovanni Fontana's 'Joseph Mayer' (also

6. St George's Hall, Great Hall, doorway showing statues (left, '14th Earl of Derby', 1867–69, by W Theed, right, 'W E Gladstone', 1864–70, by J Adams Acton)

7. Detail from W Theed's statue of Henry Booth, post 1869, NMGM

commissioned 1867, unveiled 1869)[48]. Derby was head of the Stanley family, major landowners and political figures in Liverpool; he himself had first been a government minister in 1831, he had been Secretary for War and Colonies under Peel (1841–5) and was eventually three times Prime Minister, a position he held when the statue was first proposed. Mayer on the other hand was a purely local benefactor who had given part of his great collection of works of art and antiquities to the town. They in turn resolved to commemorate this with a statue in St George's Hall. The sculptor was selected by the sitter who had already done a great deal of work for Mayer. He was so keen on the job, he got up every morning at five o'clock to knead the clay with which he was building up the statue, and his wife was reported to be 'in such extasies that she says she will never want again'[49]. When the Reverend Hugh McNeile was made Dean of Ripon in 1868 a large number of his admirers in Liverpool subscribed to erect a statue of him in the town. He had held various clerical appointments in Liverpool since 1834 and had been a champion of Protestant Conservatism. When the completed statue (by George Gamon Adams) was first offered to the Town Council for placement in St George's Hall, the offer did not meet with universal approval, and so was withdrawn for a time. At a subsequent meeting of the council it was accepted by a considerable majority of members[50]. In 1873 a statue was adumbrated to commemorate Samuel Robert Graves, merchant and ship owner, Conservative MP for Liverpool from 1865 to 1873 and previously mayor of the town. The commission went to Fontana, with a lesser commission for a bust to George Adams. The statue was unveiled in St George's Hall in 1875[51].

The last of the series of statues of this period inside St George's Hall that one should note is not in fact in the Main Hall, but in the North Entrance Hall of the building. This represents Henry Booth, the engineer, who died in 1869 (though it has not proved possible to discover when the statue was actually set up). Booth was the son of a Liverpool corn merchant but soon gave up a career in this business to become involved from the early 1820s in the proposals and schemes for the Liverpool and Manchester Railway. He worked with George Stephenson on the Rainhill trials of 1829 and Booth deserves some credit for his part in the success of Stephenson's *Rocket* locomotive, since it was Booth's suggestion of a multi-tubular boiler to give a very large and effective heating surface for the production of steam that Stephenson took up and incorporated to make his locomotive so obviously effective.

Booth was responsible for other pieces of engineering vital to the early success of the railways – he invented the coupling-screw, spring buffers and the lubrication for carriage axles that remained in use for many years[52]. It is perhaps appropriate considering his role that his statue remains quietly in the background, unlike that of his colleague Stephenson. But at least Booth, as portrayed by the sculptor William Theed is a man of his age, unlike Gibson's Archimedes/Stephenson; Theed includes representations of some of Booth's achievements, so that all may know and recognise his cultural contribution: an incised *Rocket* below an emphatic screw-coupling in marble (illus.7).

The figures commemorated by the St George's Hall statues of the 1860s and 1870s – possibly even since Brooks and Brown in the later 1850s – were there undoubtedly because they were of local significance. One reason for this limitation was almost certainly the creation of an alternative site for major commemorations, just outside St George's Hall on the plateau adjoining Lime Street. Elmes' first designs for the site had required separate buildings for the courts and the hall (they were then distinct commissions) and some entailed the implicit creation of a great public square[53]. To some extent this actually came about with the setting up of Elmes' building, because its eastern, principal entrance facade – for some 15 years – faced the neo-classical screen by John Foster put up in front of Lime Street Station in 1835–6 (illus.8 – this is either a realistic depiction or an imagined reconstruction). Here therefore was a 'grand open place', 'the only really fine quarter we have in Liverpool'[54] which even came to be identified as 'the Forum of Liverpool'[55]. And here in 1861 the foundation stone was laid for a column to commemorate the Duke of Wellington, the great national hero who had died in 1852 and had been commemorated throughout the country to an extent (so far) second only to Peel. The site chosen for the Liverpool column attracted some initial satirical comment – it was over a

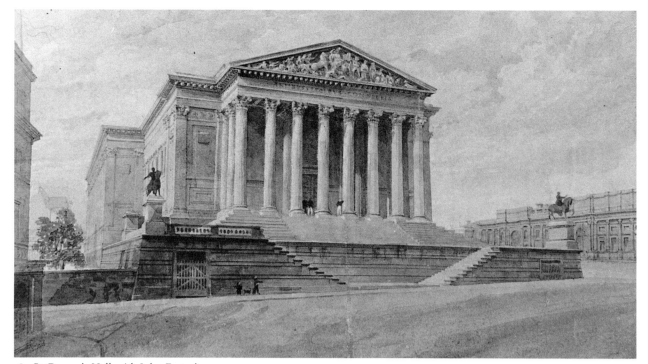

8. St George's Hall with John Foster's screen in front of Lime Street Station

9. A and G Lawson, 'Duke of Wellington Column', 1862–3, Liverpool, Lime Street Station

fathomless quicksand, so construction would start from the top downwards; the monument was reported emerging upside-down through the soil in New Zealand[56]. A Memorial Committee was formed with John Torr, Liverpool merchant and sometime Conservative MP for the town as chairman. The Liverpool sculptor John McBride lobbied for the job of doing the statue, claiming in letters that Torr had spoken out very warmly for him[57]. But the column going up to the designs of the Edinburgh architect Andrew Lawson, it is not surprising the commission for the statue went to his brother, the sculptor George Lawson. The column was completed in November 1862 and the memorial unveiled in May 1863. A bronze relief by Lawson at the base of the column was installed in 1865 – it represents the Duke's command at the Battle of Waterloo, 'Up Guards and at 'em'. It faces down Lime Street, as does the Duke above 'like St Simeon Stylites ... stern and forlorn in his isolated grandeur' (illus.9). Picton comments with a quotation from Dante, 'which freely rendered into the vernacular, may be held to mean "The least said the soonest mended" '[58].

In 1862 the Town Council had commissioned a memorial statue to Prince Albert; they chose Thomas Thornycroft as sculptor, though not, it would appear from a letter of Thornycroft's, without some competition from Foley and Marochetti[59]. Prince Albert at this time was beginning to be the subject of a commemorative campaign that nationwide exceeded the records held hitherto by Peel and Wellington, leading Dickens to write in 1864 to John Leech: 'If you should meet with an inaccessible cave anywhere in that neighbourhood, to which a hermit could retire from the memory of Prince Albert and testimonials to the same, pray let me know of it'[60]. Thomas Thornycroft was an established sculptor; his wife, also a sculptor, had come to Gibson's attention in Rome, and through him the couple were introduced to Queen Victoria and Prince Albert with whom they became friends. The choice of Thornycroft by Liverpool was therefore tactful as well as justifiable, granted Thornycroft's professional standing. The equestrian statue was unveiled by the mayor in October 1866; it received some criticism – 'Stable-Boy at Lucas's' wrote to the *Weekly Albion*: 'Sur – I arnt much ov a riter, but I no sumthin abowt an orse' and so on, actually raising sophisticated points about idealisation and realism in sculpture while criticising the false and unnatural position of the horse's feet[61]. He was supported the following week by 'Stirrup-Leather', who

ends by stating: 'If, instead of sanitary improvements, the Liverpool public are to have equestrian statues, let the articles supplied be at least correct, otherwise they caricature the illustrious personages to whom the honour is intended, and expose the town to additional obloquy and ridicule'[62].

A follow-up to 'Prince Albert' in the form of a statue of Queen Victoria was almost inevitable, and in 1868 an eight member committee of the Town Council chose Thornycroft as sculptor. The Queen gave several sittings to the artist and in April 1869 came to see the statue and expressed herself very much gratified. Cast in bronze, like Albert, by Elkington's of Birmingham, the statue came to Liverpool by road by mid September, 1870[63]. Efforts were made to have the unveiling performed by a celebrity, but Royalty, Mr Gladstone and the Earls of Derby and Sefton all declined, so in the end the Mayor officiated on November 3rd. In his speech to the estimated crowd of 35–40,000 the mayor stated: 'The ceremony of today ... proclaims to the world at large that the people of Liverpool, the second commercial port in the world, acknowledge that their country is governed by a sovereign beloved, respected, and esteemed by her subjects; besides, it shows that their loyalty is not confined to the mere expression of words, but unanimously they erect a statue in this place, one of the most frequented parts of the town, where citizens and strangers, in passing, may point up and say, "There stands the statue of Queen Victoria, the exemplary sovereign of Great Britain" (Loud applause)'[64]. One man, it is true, was reported passing by the gathering crowds declaring 'it was all humbug'[65].

Some of the massive crowd watched from 'the unfinished railway hotel in Lime-Street'[66], so by this time the pristine form of the notional Forum had been broken up, though the new neo-classical Public Library building of 1857–60 provided an extension in the opposite direction and other buildings followed suit in compatible styles down the same axis between 1874 and 1884. Besides, though Waterhouse's hotel was certainly not strictly classical, its Rundbogenstil still managed a certain symmetry and grandeur appropriate to the site. Here between 'Victoria' and 'Albert' came in 1883 the statue of Benjamin Disraeli, Earl of Beaconsfield who had died in 1881. Picton wrote that 'perhaps there is no town in the kingdom where the erratic but brilliant genius of Benjamin Disraeli has been more fervently admired after his success

was assured'[67]. The statue was moved back nearer to St George's Hall (and had its originally higher pedestal reduced) when its site was taken over by Budden and Tyson Smith's Cenotaph in 1930. One critic had recently commented on the bad taste of putting a subject however illustrious between the sovereign and her consort[68]. The sculptor of the 'Disraeli' was C B Birch, who the same year produced the statue of Major-General Earle, member of a prominent Liverpool family who was killed on the march to Khartoum. The statue is set on a pedestal much nearer St George's Hall than 'Disraeli' was originally; the figure's vigour is not dissimilar from that of Birch's 'Lieutenant Hamilton VC' in action against the Afghans, of 1880. There is a touch, too, of Birch's master Foley in the uplifted left arm, recalling the latter's 'Gratton' of 1873 in Dublin.

Foley had been generally recognised in the last fifteen years of his life (he had died in 1874) as the master of public statuary in Britain. Liverpool were to discover this when they approached him for a statue of William Rathbone who had died in 1868. Rathbone was in a way an exceptional local hero – at a public meeting held after his death to decide how he might best be honoured, 'the respect and affection felt by *all* classes of the community' was mentioned, and while a committee of 107 worthies was formed to receive subscriptions[69], working men wrote in to the press objecting to the swell committee, meeting in the Mayor's parlour 'with a stylish flunkey at the door enough to frighten a poor man away' and criticising the lack of provision for collecting money from the workshops of the working men[70]. Rathbone could clearly be identified with the fight against political, religious and class discrimination from the days when the slave trade was the staple branch of Liverpool commercial enterprise onwards – 'for half a century he was intimately identified with every public movement which aimed at . . . moral, political, or social improvement'[71]. But he was in addition clearly identifiable as 'emphatically the friend of the working men'[72]. When a memorial statue was first mentioned, it was to be for the inside of St George's Hall. But with no disrespect to the heroes commemorated there, they all came from one or more of the commercial or religious or political class hegemonies of the time. As if in recognition of this, the executive committee appointed by the 107 to carry out the erection of a statue to Rathbone unanimously chose an entirely public site in Sefton Park currently being laid out[73]. This was at a meeting held on June 10th 1868; on July 3rd, following on one of the earliest proposals that the statue should be executed by 'the best living artist', the commission was offered to John Henry Foley.

At this stage in his career, Foley was snowed under with public commissions. He accepted the Liverpool offer, but with reservations, stating that 'the works he had in hand would disable him from executing the statue within three years, and . . . he might probably require even a little longer time. In consideration of the great reputation of the artist this condition was acceded to'[74]. Foley's last years were to be plagued by illness as well as overwork and the Rathbone statue when finally unveiled in 1876 had required completion by Thomas Brock, one of Foley's official work executors; Brock was entirely responsible for the reliefs on the base. Granted Foley's reputation, though, it was not surprising certain of his pupils featured in Liverpool's public statues of the 1880s and 1890s. Birch's contributions we have already seen on St George's Plateau – F J Williamson, who trained with Foley and was then engaged as his studio assistant for nearly twenty years[75] executed the statue of Hugh Stowell Brown, originally in the grounds of his Baptist Church in Myrtle Street, where it was unveiled in October 1889; it was moved in 1954 to Prince's Avenue.

Albert Bruce-Joy, another pupil, executed the statue of Edward Whitley in St George's Hall of 1895[76]. Whitley had been a Liverpool Councillor from 1865 till his death in 1892; he was mayor 1868–9 and a Conservative MP for Liverpool constituencies from 1880–92. He was a solicitor, had family ties with the Greenall Whitley brewery and was a

Sunday School teacher for forty years[77] - he must have felt in good company in St George's Hall.

Bruce-Joy's other public statue in Liverpool, that of Alexander Balfour, unveiled in November 1889, opens up a further vista, particularly with regard to siting. Balfour was not a politician as such, whether secular or religious. But he was a religious man, a pillar of the Presbyterian Church, and very much involved in charitable work, especially with the YMCA and the Mersey Mission to Seamen[78]. Soon after his death in 1886, 'it was resolved that a statue of Mr Balfour be erected in a public position, if possible near the river, and the sailors for whom he toiled so earnestly'[79]. In fact it was set up in St John's Churchyard, beyond the church (which then still stood on the west side of St George's Hall) right down towards the Old Haymarket[80].

The point of course is that this was a new site for a public statue in Liverpool, away from those regularly used for the previous forty years, and when St John's church was finally closed in 1898 and then demolished a new scenario came into existence, with the space occupied by its churchyard released for other uses. In 1899 the *Liverpool Review* could state 'St John's Churchyard will become Liverpool's alfresco Valhalla[81]. On the other hand it was rumoured that potential subscribers for a second Gladstone memorial (the Grand Old Man had died in 1898) were holding back in case it should be 'relegated' to St John's Churchyard; really the only place for it was the junction of Lord Street, Castle Street and James Street[82].

The alfresco Valhalla supporters clearly won the day, as over the ensuing decade no less than six statues or sculpture groups by major sculptors of the time were sited in the former churchyard which became St John's Gardens. A Council committee was called for in November 1903 to carry out improvements of the site – this was carried out by the City Surveyor, Shelmerdine, assisted allegedly with advice from Mr Frampton, the well-known artist, sculptor and Royal Academician[83]; the main scheme, drawn up by Shelmerdine as a modification of a design by Frampton, had Frampton's statues of Rathbone and Forwood along a Broad Walk with, below, a centrepiece formed by Brock's impending 'Gladstone'[84]. There were even proposals to have the Gardens enriched with allegorical sculptures of Mining, Shipping, Spinning, and Machinery to be executed by Derwent Wood and Henry Poole[85]. Criticism soon arose about the layout of the Gardens – it was believed Mr Frampton was responsible in a private capacity – and over the youth and obscurity of Derwent Wood and Poole[86]. Within three days Frampton had written to deny the whole layout was his[87].

Whatever the criticisms or responsibilities, the Gardens were opened in the summer of 1904, when also the Gladstone memorial was unveiled. The great politician was represented in the act of delivering a speech, the pedestal supported by bronze figures of those virtues he backed – Justice, Truth and Brotherhood. The sculptor was Brock, by now by far the senior and most respected of Foley's pupils, having obtained the commission for the national memorial to Queen Victoria outside Buckingham Palace in London. Other memorials were on their way – one was to Monsignor James Nugent who had been a priest in Liverpool since 1848 and very much involved in charitable work and social organisation among the poor. The sculptor Frederick Pomeroy was responsible: 'an important feature of the design is the introduction of the figure of a ragged boy, whose appealing face is looking up at the Monsignor, whose left hand is gracefully and kindly resting on the boy's shoulder (illus.10). The effect is electrical, and the sculptor was highly complimented upon the new idea'[88].

Balancing this both physically in the gardens, and politically in terms of denomination was the third Frampton statue on the site, of Canon T Major Lester, Anglican vicar of St Lawrence Kirkdale from 1855, founder and organiser of Industrial Ragged Schools and Homes, involved with Liverpool School and Hospital Boards. He is engaged in

a typical work of benevolence, bearing in his arms a little girl, whom he is in the act of taking to one of his homes for the outcast and the destitute[89]. Finally, towards the bottom of the Gardens (presumably close to where 'Alexander Balfour' was originally sited – he had been moved meantime up towards the top of the Gardens) lay Goscombe John's Memorial to the King's Liverpool Regiment. A design of his had been chosen in 1902[90] and £3,000 collected by subscription; it was unveiled by Field Marshal Sir George White in 1905[91]. The monument commemorates the over 200 officers and men of the regiment killed in Afghanistan, Burma and South Africa between 1878 and 1902. Britannia mourns the dead at the top – at either side are two soldiers, one in the dress of 1685 when the Regiment was first raised (illus.11), the other in the dress of 1902, the last year of the Boer War. At the back is a Drummer Boy of the period of the Battle of Dettingen (1743) at which the Regiment distinguished itself. The monument is impressive, whatever one's feelings about military action; it clearly helped Goscombe John obtain the commission for the (much larger and more elaborate) Port Sunlight First World War Memorial across the Mersey, of 1919–21, let alone other monuments in Liverpool.

The concentration of monuments in St John's Gardens over these few years may have created 'Liverpool's Open-Air Sculpture Gallery'[92], but it did not leave much room for any others of any scale or significance. So when decisions were called for over a major memorial to Queen Victoria[93], after her death in 1901, a special site had to be found. This was settled in May 1901, before even designs had been invited, and was to be in St John's Crescent on the site formerly of St George's Church and before that of the Castle of Liverpool; it is now usually referred to as Derby Square. Sculptors were invited to send in designs on paper for a memorial and at the end of October 1901 three awards were made – first, to R Lindsay Clarke, second to C J Allen, third to Henry Fehr; all three were working with architects. They were asked at this point to submit models, and in March 1902 the design of C J Allen was ultimately selected. Of the three finalists Allen alone had any Liverpool connections, and they were very strong[94]. He had been teaching sculpture and modelling at the School of Architecture and Applied Art at University College, Liverpool since 1894 (he moved on to the School of Art from 1905 to 1927). He was associated with the prominent Rathbone family and his architectural partners on the scheme were Simpson, Willink and Thicknesse of Liverpool.

The monument as executed was substantial, with an overall height of 65 feet and total diameter at base of 90 feet. The statue of Victoria is 14 foot 6 inches high. There are supporting statues of Justice, Peace, Charity and Wisdom, representing the Queen's virtues, and flanking groups of Industry, Commerce, Agriculture and Education, symbolic activities of the Victorian era. In principle this is little different from the programme of the Albert Memorial in London of 40 years earlier. But Allen has brought to its treatment all the best he might have learned from Hamo Thornycroft (whose assistant he had been), especially in the blending of idealism and naturalism, in form as well as concept, let alone the wider lessons provided by his generation's sculptor heroes such as Alfred Stevens and Jules Dalou.

Within a few years, more public statues were required. Edward VII died in 1910; an idea circulated to place an equestrian monument to him on one of the pedestals at the South end of St George's Hall. In the end Goscombe John's memorial was sited at the Pierhead (illus.12). Here it presides over a Frampton statue of Sir Alfred Jones, shipping broker, president of the Liverpool Chamber of Commerce, Chairman of a bank and founder of the Liverpool School of Tropical Medicine. Also on this site is Goscombe John's 'Monument to the Engine Room Heroes', that is, the type of heroic worker without whom Liverpool's economic structure could not have functioned[95]. It may seem ironic to have these figures set against the Edwardian splendour of the Cunard Building, and the Mersey Docks and Harbour Board that now no

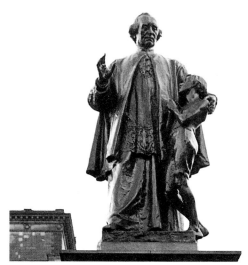

10. F W Pomeroy, 'Memorial to Monsignor James Nugent', c.1904, Liverpool, St John's Gardens

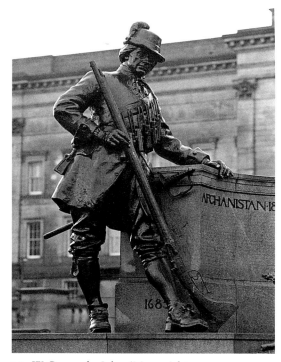

11. W Goscombe John, 'Memorial to the King's (Liverpool) Regiment', 1902–5, Liverpool, St John's Gardens

longer function as such. 'Sic transit gloria mundi' and all that, how are the mighty fallen, the clichés easily roll off the tongue. But Edward VII still looks good, and that must be a tribute to the art of sculpture that put him there.

Some forty years earlier, in his speech at the unveiling of the Thornycroft 'Queen Victoria' on St George's Plateau, the then Mayor of Liverpool had attempted to set in context the occasion of unveiling a piece of public commemorative statuary:

It must be well known to you all that the records of history, ancient and modern, show that it has ever been the custom of the people of all nations to acknowledge and perpetuate, in some marked manner, their respect and esteem for those among their rulers who faithfully fulfil the duties connected with their high station. (Hear, hear.) The inhabitants of Liverpool of the present day do but follow in the wake of those who have gone before them[96].

These words were not just rhetoric. Ever since the Age of Enlightenment, for various reasons statues had begun to be erected in Europe and North

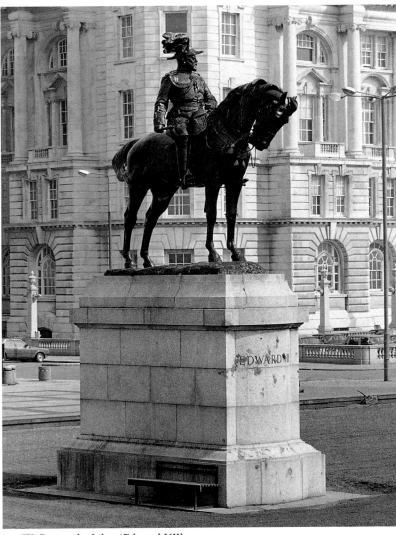

12. W Goscombe John, 'Edward VII',
1916–21, Liverpool, Pierhead

America to political, military and cultural heroes. The phenomenon was not new and indeed the impact of neo-classicism from the later eighteenth century could not but reinforce, justify and stimulate the notion – any reading of Pausanias' *Tour of Greece* reveals a culture and terrain jampacked with public statues. In Britain, after preliminary efforts to commemorate Benefactors of the Nation in St Paul's Cathedral, London, the Napoleonic Wars unleashed a plentiful supply of dead heroes for commemoration, and as the nineteenth century progressed a momentum built up that formulated in public statuary commemoration a major and original contribution to the history of art (though it is still to be widely recognised as such)[97]. Liverpool was as assiduous as any of the other municipalities in Britain who began to reflect their new found economic, political and cultural status in the commemoration by statues of their heroes. Between 1830 and 1916 at least 34 public statues were set up in Liverpool. In quantity alone Liverpool outpaced her peers[98], while for the famous names in Victorian Sculpture – Gibson, Noble, Foley, Brock, Frampton, Pomeroy, Goscombe John – there can be no better place to observe the achievements of these artists in that public field that meant so much to them and to the citizens who had them put up.

NOTES

I am very grateful for the help I have received from the Walker Art Gallery (especially Edward Morris and Alex Kidson) and the Local History Library at Liverpool City Library. Others I should like to thank include Penelope Curtis, Dr Elisabeth Darby, Sophie Hare, Professor Peter Kidson, Janis Lyon, Timothy Stevens and Dr Philip Ward-Jackson.

Certain basic sources are cited in abbreviated form, as follows:

AJ – *Architects Journal*.

Eastlake – Lady Eastlake (ed), *Life of John Gibson, R A Sculptor*, London, 1870.

JCS files, WAG – Files of the Survey of Sculpture in Liverpool undertaken under the Job Creation Scheme and deposited at the Walker Art Gallery there. This has been an invaluable source of information.

Matthews – T Matthews, *The Biography of John Gibson, R A, Sculptor, Rome*, London, 1911.

Picton – J A Picton *Memorials of Liverpool Historical and Topographical*, (2 vols), London and Liverpool, 1875.

Touzeau – J Touzeau *The Rise and Progress of Liverpool from 1551 to 1835*, (2 vols), Liverpool, 1910.

Waller – P J Waller *Democracy and Sectarianism. A political and social history of Liverpool 1868–1939*, Liverpool, 1981.

1 Figures from Touzeau, ii, p 860. Allegedly there or at least there for a very early public journey was the 21 year old Alfred Tennyson who was inspired to write of the event: 'Let the great world spin for ever down the ringing grooves of change'. See Hallam Lord Tennyson, *Tennyson A Memoir* 1897 i, p 195 and R B Martin, *Tennyson The Unquiet Heart*, 1980, p 121.

2 Picton i, pp 419–20.

3 Picton i, pp 396–7.

4 Picton i, p 419.

5 Picton i, pp 419, 20; Touzeau ii p 859.

6 Picton i, p 420.

7 Eastlake, p 113.

8 Quoted in *Liverpool Mercury*, October 12 1832, *Liverpool Courier*, 17 October 1832.

9 Eastlake, pp 113–14.

10 Matthews, p 80.

11 Eastlake, p 115.

12 Picton i, p 269.

13 Lord E Gleichen, *London's Open-air Statuary* (1928), p 93, repr.

14 Eastlake, pp 118–9.

15 Matthews, pp 108–9.

16 Eastlake, p 112.

17 In a letter to H L Elmes, 2 April 1844, quoted in R Rawlinson, *Correspondence relative to St George's Hall Liverpool*, 1871, p 26.

18 Law Courts Committee Minutes, 4 October 1854, cited in L Knowles *St George's Hall Liverpool*, 1988, p 30, and J Olley 'St George's Hall Liverpool Part Two', *AJ* 25 June 1986. p 61. For the basic idea of the civil basilica, see the Basilicas Aemila and Ulpia in Rome, cited in A. Boëthius and J B Ward-Perkins, *Etruscan and Roman Architecture*, Harmondsworth, 1970. See also A Desgodetz, *Les edifices antiques de Rome . . .*, Paris, 1682, of which an English edition appeared in 1795.

19 Rawlinson (*op. cit.* n. 17) etc p 34.

20 British Architectural Library/RIBA Drawings collection, U13/44 repr *AJ*, 18 June 1986, p 45 (illus 22).

21 Rawlinson (*op. cit.* n, 17) p 6.

22 British Architectural Library/RIBA Drawings collection, U13/77 repr *AJ*, 18 June 1988, p 41 (illus 12).

23 British Architectural Library/RIBA Drawings collection, RAN 55/K/4, repr *AJ*, 18 June 1986, p 40 (illus 10).

24 Victoria and Albert Museum, E.2000–1909 repr *AJ*, 18 June 1986, p 40 (illus 11).

25 British Architectural Library/ RIBADrawings collection, J10/38 5.

26 Picton i, pp 514–5

27 Liverpool City Library.

28 See Minute 5 December 1855 (p 452) concerning a proposed statue of Archdeacon Brooks.

29 See *ibid* Minute 22 April 1854, p 298.

30 Touzeau ii, p 860.

31 Picton i, pp 418–19.

32 Eastlake, p 121.

33 See Finance and Estate Committee Minutes for 11 November 1870: 352 MIN/FIN II 1/17 p 311.

34 Touzeau ii, pp 804–6, 843–4.

35 Touzeau ii, p 844.

36 The Iconography of Peel in R Ormond, *Early Victorian Portraits* (National Portrait Gallery Catalogue), 1973, pp 372–3, lists 15 public statues of Peel erected between 1851 and 1877 and there may well have been over 20. See B Read, *Victorian Sculpture*, New Haven and London, 1982, p 107 for a brief attempt to set this in context.

37 *Art Journal*, 1851, p 242.

38 Picton ii, pp 135–6, pp 349–50.

39 Touzeau ii, p 870. It might be noted that other nineteenth century notables of Liverpool *only* received a bust in the Town Hall, eg James Aikin MP, though this was at the request of his family. See M Bennett, *Artists of the Pre-Raphaelite Circle. The First Generation*, Catalogue of Works in the Walker Art Gallery etc., 1988, p 194.

40 *Art Journal*, 1856, p 252.

41 *Art Journal*, 1858, p 300.

42 Picton ii, p 350.

43 *Art Journal*, 1857, p 163.

44 *Art Journal*, 1864, p 362.

45 *Art Journal*, 1865, p 29.

46 This all from the Adams-Acton point of view, in A M W Stirling *Victorian Sidelights*, 1954, p 125.

47 *Art Journal*, 1870, p 190.

48 Dates from *Art Journal*, 1867, pp 126, 195; 1869, p 353.

49 This information comes from the excellent, full documentation cited in *Walker Art Gallery Liverpool Foreign Catalogue* 1977, Text Vol., pp 307–8.

50 *Art Journal*, 1871, p 8; for details on McNeile, see Waller. The opposition to McNeile's commemoration was based on claims he had 'devoted himself to the promotion of ill-blood between classes' and 'had advocated punishing with death those clergy who heard auricular confession'; he was 'a vituperative and socially injurious partisan'. *Liverpool Daily Post* 10 November 1870. The statue was smuggled into St George's Hall and unveiled in secrecy and almost trepidation; *Liverpool Mercury*, 7 December 1870.

51 See *Foreign Catalogue* (*op. cit.*, note 49), pp 306–7.

52 *Dictionary of National Biography*.

53 See eg designs illustrated in *AJ*, 18 June 1986, p 39, illus 5–8.

54 *The Albion* 15 October 1866.

55 Picton ii, p 186; cf. C Reilly: 'The old railway station had a row of columns facing it, which must have given the plateau almost the fine effect of a Roman forum', C Reilly *Some Liverpool Streets and Buildings in 1921*, (1921), p 70. That Elmes recognised this in his final unitary design can be seen in a minute free sketch at the bottom of one of his plans (BAL/RIBA Drawings Collection, U13/39).

56 *The Porcupine*, 27 July 1861; 17 August 1861.

57 See JCS file, Walker Art Gallery.

58 Picton ii, p 186.

59 The letter is quoted in E Manning, *Marble & Bronze – The Art and Life of Hamo Thornycroft*, 1982, p 40.

60 See B Read, *Victorian Sculpture, op. cit.*, 1982, p 95f.

61 *The Albion*, 22 October 1866.

62 *The Albion*, 29 October 1866.

63 See *The Albion*, 19 September 1870.

64 *Liverpool Mail* 5 November 1870.

65 *Liverpool Mercury*, 4 November 1870.

66 *Liverpool Mail*, 5 November 1870.

67 Picton ii, 2nd edition, p 508.

68 Mark Rathbone in *Liverpool Post and Mercury*, 25 March 1927.

69 *The Porcupine*, 29 February 1868, p 479.

70 *The Porcupine*, 14 March 1868, p 493.

71 E Baines, *History of the County Palatine and Duchy of Lancaster*, p 205.

72 *Liverpool Mercury*, 19 December 1876.

73 See N Pevsner, *South Lancashire*, 1969, pp 233–4.

74 *Liverpool Mercury*, 2 January 1877.

75 *Art Journal*, 1870, p 90.

76 Bruce-Joy had previously executed the statue of John Laird, shipbuilder and first (Conservative) MP for the town, in Birkenhead, of 1874.

77 Waller, p 516.

78 Waller, p 477.

79 *The Mersey Mission to Seamen 1856–1956*, p 17.

80 See Mawdsley's *Maps of Liverpool* for 1891 and 1897.

81 11 March 1899.

82 *Liverpool Daily Post*, 26 April 1899.

83 *Liverpool Mercury*, 30 June 1904.

84 *Liverpool Daily Post*, 20 April 1904.

85 *Liverpool Courier*, 15 October 1904.

86 *Liverpool Courier*, 21 October 1904, *Liverpool Mercury*, 22 October 1904.

87 *Liverpool Mercury*, 25 October 1904.

88 *Liverpool Daily Post*, 3 March 1904.

89 JCS files, Walker Art Gallery.

90 *Liverpool Daily Post*, 8 November 1902.

91 R Cannon, *Historical Record of the King's Liverpool Regiment of Foot*, (1904–5), p 550.

92 *Liverpool Daily Post and Mercury*, 21 February 1910.

93 Details of the setting up of this memorial come from composite accounts in the JCS Sculpture Survey files, Walker Art Gallery.

94 For Allen, see Mary Bennett, *The Art Sheds 1894–1905*, exhibition catalogue Walker Art Gallery, Liverpool, 1981.

95 'Jones' was unveiled in 1913, the 'Engine Room Heroes' in 1916. 'Edward VII', though dated 1916 was unveiled in 1921.

96 *The Liverpool Mail*, 5 November 1870

97 See eg B Read, *Victorian Sculpture, op. cit.* pp 85ff and elsewhere. I have treated the phenomenon in this country in more detail in an unpublished paper 'The Development of Public Sculpture in Britain 1790–1870'.

98 Compare for this period Glasgow (27), Manchester (22), Birmingham (18). These figures have a degree of approximation to them, but are the best available from various sources, especially observation.

SCULPTORS WORKING IN LIVERPOOL IN THE EARLY NINETEENTH CENTURY

Timothy Stevens

Liverpool in the early nineteenth century was a boom town where fortunes could be quickly made or lost. Architects, artists and craftsmen were attracted there from all over Britain. Their expectations were only partly fulfilled, as those enjoying prosperity seldom proved enlightened or adventurous patrons.

This lack of generous patrons presented problems for artists. Many needed to supplement their income from art by other activities. John Turmeau (1777–1846) the miniature painter traded as a print seller and dealt in artists' materials; his customers included John Gibson. Samuel Austin (1796–1834), the water-colourist, gave drawing lessons to young ladies. Sculptors could work on the architectural ornaments and marble fireplaces required by the numerous imposing neo-classical public buildings and houses then going up. F A Lege (1779–1837), who later worked for Chantrey in London, was employed by Messrs S & T Franceys in Liverpool. He carved the Royal coat of arms for the Union News Room in Duke Street and the panels of the former Lyceum Club built by Thomas Harrison 1800-2. The distinction between artist and artisan was blurred. The career of George Bullock (1782/3–1818) from Birmingham, who settled in Liverpool in 1801, shows how an entrepreneur of genius could diversify between cabinet-making, interior decorating and architecture. Eventually his other activities proved so successful that he abandoned sculpture. The difficulty of making a living drove many artists to try their luck in London and elsewhere. John Gibson realised that the only place where he could succeed as a sculptor in 'the pure classical style' was Rome.

In April 1810 a group of artists established the Liverpool Academy of Arts. Modelled on the Royal Academy in London the new body organised selling exhibitions, and provided instruction for budding artists. Several Liverpool intellectuals acted as lecturers. For instance, Thomas Stewart Traill (later Professor of Medical Jurisprudence at Edinburgh) was Professor of Anatomy at the Academy. From the outset the Academy was intended for the artist rather than the artisan.

The first exhibition, opened in 1810, followed the precedent set by those held by the Society for the Encouragement of Designing, Drawing and Painting in Liverpool in 1784 and 1787, when the local men exhibited together with artists from the metropolis. In 1810, Benjamin West, the President of the Royal Academy, William Etty, J M W Turner and Francis Chantrey showed alongside Charles Towne, John Gibson, George Bullock, Thomas Hargreaves and other local talent. The driving force behind this enterprise to improve the professional and social status of the artist was the ambitious George Bullock, who became the Liverpool Academy's first President. An early supporter of his, Henry Blundell of Ince Blundell (1724–1810), the collector of antique marbles and head of an old-established local landed family then beginning to benefit from the Industrial Revolution, was the Academy's initial patron. Blundell also provided £1,600 to commence its activities.

Following his death, Bullock and William Roscoe (1753–1831), a leading Liverpool lawyer, politician, poet and collector, successfully invited the most prestigious potential patron, the Prince Regent. The extensive coverage that the early activities of the Academy received in the local press was doubtless orchestrated by Bullock, always a most effective publicist of his own work. The scale of the activities of the Academy later fluctuated considerably. It was, for instance, dormant in 1820 and 1821. However, its importance in providing a show case for

local talent, particularly after 1822, was considerable. It is doubtful that William Spence (1793–1849), a sculptor from Chester and a friend of John Gibson, would have designed such pieces as 'Orpheus and Pluto', 'Theseus Killing the Centaur', 'Daedalus and Icarus' and 'Ulysses Bringing Briseis to Chryseis' without the opportunity of publicly exhibiting them at the Liverpool Academy in 1822. Charles Backhouse Robinson (1806–1894), the son of Nicholas Robinson, a successful corn merchant and mayor of Liverpool, had a similar taste for elevated subjects more suitable for exhibition than sale. His relief of 'The Flight into Egypt', which he never sold, is now on display at Sudley Art Gallery, the house built by his father.

The quality of teaching available in Liverpool for sculptors is more difficult to assess. Judging by the handful of drawings that have survived, most sculptors were well trained in this medium, and their drawings show an imagination and freshness that is often lacking in their finished sculpture. William Spence, who became Master at the Drawing Academy, used a variety of styles. His illustrations to Milton's *Paradise Regained* drawn in 1812 and published in lithograph by McGahey of Liverpool, show him following the then fashionable outline manner of Flaxman. In contrast his 'Socrates in the Studio of Phidias', a subject which expresses his admiration for Greek Art, is freer in approach. Edwin Lyon (1806–1853), a native of Liverpool, attended drawing classes at the Academy in 1827 and 1828. His *Outlines of the Aegina Marbles, drawn from the statues of the Royal Liverpool Institution* published 1829, are accomplished drawings, again following Flaxman. John Foster (1786–1846), the Liverpool architect who with C R Cockerell had discovered these carvings on their tour of Asia Minor between 1809–1816, presented a set of casts to the Liverpool Royal Institution. Lyon also worked as a 'painter of glass' to supplement his income. Eventually, after trying to establish himself in Ireland, he settled in America. Only John Gibson had the imagination to explore profitably the other great source of inspiration then in Liverpool, William Roscoe's comprehensive collection of old master drawings sold in 1817. Gibson, under Roscoe's tutelage, copied drawings widely different periods and techniques. The variety of his mature drawing style, sometimes in the broad scratchy manner of the seventeenth century Genoese artist, Luca Cambiaso, and sometimes in the neat precise style of the fifteenth century Florentine artist, Ghirlandaio, must surely derive from his study of Roscoe's collection. His use of coloured, prepared grounds for many of his drawings must also come from his study of fifteenth century Florentine drawings owned by Roscoe.

The outstanding example of a drawing by a Liverpool sculptor is undoubtedly 'The Fall of the Rebel Angels' by Gibson (Walker Art Gallery) which he showed in the Liverpool Academy of 1811. In his autobiography Gibson described how he drew this complex work, inspired by 'The Last Judgement' of Michelangelo, and under Roscoe's influence, changed his allegiance from Michelangelo to the Greeks.

> Having thus free access to Mr Roscoe's fine collections, I became well acquainted with the inventions of Michael Angelo and Raphael, and the genius of the former began to have an influence over me. Before I was nineteen I began to think of a large cartoon. The subject was the fall of Satan and his angels. I first drew the design on a small scale, which went through numerous changes before I was satisfied. It included several groups and single figures foreshortened in various ways, and falling in every direction I could think of, and was executed in light and shade with pen and bistre. My mode of proceeding was this: I modelled the principal groups and figures in clay and hung them up with a string; then taking the view I wanted I got them in as far as possible from nature, and traced the drawing upon the cartoon until the design was complete. The upper figures were lighted naturally from above, and for the lower groups, supposed to be lighted by flames of hell, I placed a lamp beneath my clay models and thus got a correct and beautiful effect.

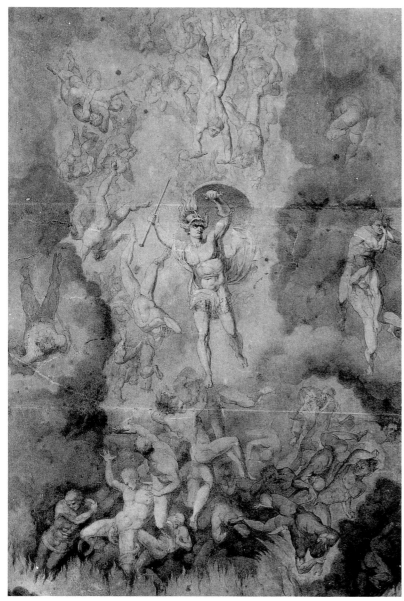

1. J Gibson, 'The Fall of the Rebel Angels', c.1811, pen and wash and pencil, Walker Art Gallery

2. S Gibson, 'Venus lamenting the death of Adonis', c.1812, terra cotta, Walker Art Gallery

Invention was my constant delight and has been through life; I have drawn more than sculptors do generally. When Mr Roscoe advised me seriously to form my style upon the Greeks' simple actions and pure forms, my taste became less rich, less various – in fact, less original[1].

Iconographically, the cartoon is extremely unusual. While Milton and Michaelangelo were regarded as 'sublime' in the late eighteenth century, the majestic characterisation of Satan is novel. Only a few writers such as Blake, Shelley and Hazlitt had claimed that Satan was the true hero of *Paradise Lost*. Whether this very individual interpretation of Milton is Gibson's own is doubtful. Perhaps Fuseli, a close friend of Roscoe's and a frequent visitor to Liverpool, on whose style the cartoon is dependent, suggested this novel interpretation to the young artist. The cartoon marks the peak of Michaelangelo's influence on Gibson.

Small scale works in plaster and terracotta were frequently shown by sculptors at the Academy exhibitions, but it is not known whether these were modelled in the schools or in the sculptors' own workshops. The *Liverpool Courier* reviewing the sculpture at the Liverpool Academy Exhibition of 1828 remarked on the lack of large scale sculpture and noted 'a few excellent busts and several spirited sketches in terracotta constitute the whole of this department; we rather lament that it is so scantily furnished'[2]. The *modelli* that are still identifiable included some of the most attractive pieces of sculpture produced in Liverpool in this period. Gibson's younger brother Solomon (about 1796–1866), modelled, apparently at the age of sixteen, a seated figure of Mercury which is very reminiscent of the marble of the same subject by Nollekens (Usher Art Gallery, Lincoln). His 'Venus Mourning the Death of Adonis with Cupid', exhibited at the Liverpool Academy in 1812, reveals a precocious facility of modelling and remarkable sensitivity to the tragedy of the story. The open, almost baroque composition may have been inspired by a drawing of the same subject attributed to Luca Cambiaso in the collection of William Roscoe. Lack of sympathetic patrons or his other interests such as ancient Welsh history may have inhibited his development as a sculptor. The handful of memorials by him are distinctly prosaic. Numerous models by William Spence are recorded, but none have been traced.

Some of these *modelli* such as Solomon Gibson's 'Mercury' (cast Liverpool Museum), appear to have been 'editioned', perhaps with the impecunious collector in mind. The most ambitious is 'A Bacchante warding off a tiger with her cymbals' (cast National Museum of Wales) by John Gibson which is in slip cast ceramic, probably fired at the Herculaneum factory in Liverpool. It was shown at the Liverpool Academy in 1811. Bullock, with his characteristic eye for a market for usable items, modelled a pair of figures (dated 1804), perhaps symbolic of Fire and Water holding gilt metal candlesticks (plaster casts Birmingham City Museum and Art Gallery). No Liverpool sculptor developed the small-scale terracotta into an independent work of art, as did the Leeds sculptor Joseph Gott (1786–1860) when faced with a lack of patronage in Rome. The surviving *modelli* also suggest a relaxed attitude to style and no rigid adherence to the tenets of neo-classicism.

The presence of an Academy did not persuade the well-to-do to entrust major public commissions to local men. Liverpool artists had to wait until the early twentieth century for such commissions when C J Allen modelled the memorial for Queen Victoria and Herbert Tyson Smith worked on the cenotaph commemorating the First World War. Liverpool was the first town to plan a memorial to Lord Nelson, but it did not patronise local talent for this purpose (see Yarrington on the monuments to Nelson, George III and Canning, p 25). George Bullock had submitted a maquette for the Nelson memorial and published a pamphlet explaining its elaborate, nationalistic programme. He failed to persuade the Committee to select his design although his extravaganza hit the right note with the reviewer in the *Literary and Fashionable Magazine*:

It is in fact what the model of a monument for a British admiral ought to be – British ... If we have succeeded in conveying to our readers an idea of Mr Bullock's grand and masterly design, we believe they will agree with us that it is more appropriate, or, in other words, more truly British than any of the models which we have before had occasion to notice. The artist has confined himself strictly to his subject. Nothing is introduced which does not tend to the illucidation of his story, and the idea of making the heads of the ships facsimiles of the men of war, which carried the victorious flag of Lord Nelson in his different engagements, cannot be too much commended. This is giving a monument, what it ought to have, the soberness of historical truth. Nothing can be conceived more ridiculous than the impropriety into which some artists have fallen, of representing the British Admiral standing on the prow of a Roman galley, or adorning his monument with the beaks of triremes, in imitation of the rostral column at Rome. Besides, the heads of our ships of war are frequently most exquisite and tasteful pieces of sculpture. We have seen the head of the Victory, and we can scarcely conceive any object which could form a more beautiful ornament for a piece of colossal statuary. The heads of the other ships in which this great man fought, the Captain, the Vanguard, and the Elephant, are, we dare say, equally highly finished and beautiful, and, together, cannot fail to form a most interesting and impressive group. While such materials as these are at hand, and while their merit and individuality must strike every observer of taste, we are surprised that any artist should be found so enamoured of the antique as to crowd the tomb of a British Admiral with Greek and Roman engines of war[3].

The marble bust with its antique overtones never enjoyed the same popularity as the painted portrait with Liverpool patrons. A successful bust, of a topical celebrity could, however, lead to lucrative sales of plaster casts, just as an oil portrait could be reproduced as a cheap print.

Master Betty, the young Roscius, appeared triumphantly on the stage in Liverpool in 1805. Both George Bullock and his brother William competed to exploit his celebrity. On 13 March 1805 both announced in the *Liverpool Chronicle* that they were displaying a bust of the boy actor, William soliciting 'subscriptions of three guineas each' for casts of his by Bahagan. In June George informed subscribers to his bust of Master Betty that 'copies are now ready for inspection and delivery'. For more staid clientele, George advertised in the *Liverpool Chronicle* a bust of HRH the Duke of Gloucester (1776–1834), commander of the forces in the district and then resident in Liverpool;

His Royal Highness the DUKE of GLOUCESTER having been graciously pleased to command a Bust of himself, to be modelled by Mr George Bullock, the Nobility and Gentry are most respectfully informed, that his Royal Highness has given permission for the same to be published.

Subscriptions will be received at the banking house of Messrs. Gregsons, Clay, and Co. and at the Grecian Rooms, next door to the Athenaeum, Church-street.

Price of the Bust Six Guineas each.

Such Ladies and Gentlemen as wish to secure the possession of a Bust of his Royal Highness, are requested to subscribe their names as soon as convenient, as the number is not to exceed the extent of the subscription, and the copies will be delivered in the strict order of subscription[4].

William Spence could not rival Bullock's promotional talent but he could equal him as a portraitist. After serving an apprenticeship beside John Gibson with the brothers Samuel and Thomas Franceys, who apear to have initially specialised in the manufacture of fireplaces, he took on the sculptural element of the business for the latter when the Franceys dissolved their partnership. Spence later became a partner and eventually proprietor of the business. Picton, the historian of Liver-

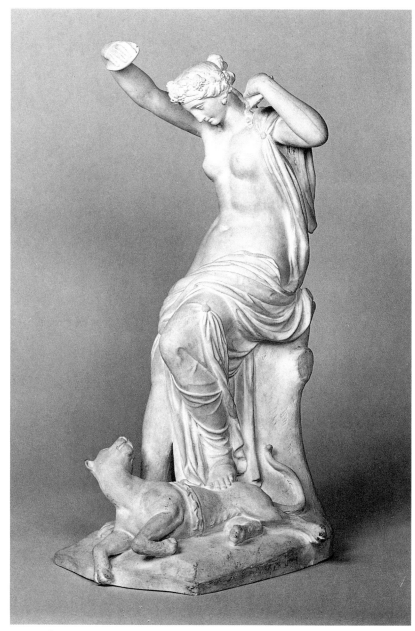

3. J Gibson, 'A Bacchante diverting the attention of a tiger with her cymbals', c.1813, ceramic, National Museum of Wales

4. W Huggins, 'The Sculptor's Studio', signed and dated 1841, oil on panel, Walker Art Gallery. The sculptor William Spence is shown modelling a bust of the painter Huggins

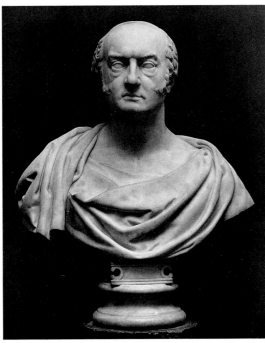

5. W Spence, 'George Canning', 1824, marble, Walker Art Gallery

pool, has left a vivid description of him –

> For unflagging, untiring, patient industry and thorough devotion to his profession there have been few men equal to him. Although necessarily absorbed in the mere manufacture of marble as a trade, he snatched every leisure moment he could steal for a loving devotion to art as such. For quickness in modelling and readiness in catching the expressive lines of a countenance he was surpassed by few ... Modest and gentle in his outward demeanour, he was in character and conduct one of the kindest and most unselfish beings it has ever been my lot to meet. He was never so happy as in his workshop, surrounded by his assistants, the sharp click of the chisel in his ears, the modelling tools in his hand, clad in a long grey duffel coat, his curling grey hair flowing over his shoulders. Here he would chat merrily with his friends, working assiduously all the time, his eye lighting up with pleasure as tidings came from time to time of his son's progress at Rome ...[5].

There is a portrait of him by William Huggins which shows him modelling a bust of the painter (Walker Art Gallery).

Spence was probably best known in his own lifetime for his busts of George Canning, MP for Liverpool in 1812–23. The latter was immensely popular with the Liverpool merchants who formed a Canning Club and named a street after him. Spence exhibited likenesses of this outstanding politician at the Royal Academy in 1824 and at the Liverpool Academy in 1824, 1828, and 1837. The marble bust dated 1824 in the Walker Art Gallery, perhaps the one exhibited at the Liverpool Academy that year, shows Spence's austere Roman manner at its best. The arrogant air of the sitter is well caught. The numerous small, signed marble and plaster versions of it were evidently produced to suit the various means of the politician's admirers. Spence seems to have made a speciality of miniature versions. A small version is also known of his elegant bust of John Foster Senior (c.1759–1821), the architect and surveyor to the corporation and engineer to the docks, shown at the Liverpool Academy of 1831 (Walker Art Gallery).

Other sculptors worked on a small scale to match the limited outlay which local patrons would countenance and to meet the taste for pieces on a domestic scale. John Gibson modelled small circular low reliefs of Matthew Gregson, the antiquarian and furniture maker (plaster cast University of Liverpool) and of William Roscoe (cast Walker Art Gallery), Bullock's accomplished wax of Blundell of 1801 (Leeds City Art Gallery) is the only wax known by him, although he doubtless made others in this very fashionable style. Small busts modelled in wax over a plaster core were something of a speciality with Edwin Lyon. His bust of Hugh McNeile, known in at least two versions (that in Walker Art Gallery is dated 1838), was no doubt made to tempt admirers of this controversial preacher.

Lack of sympathy and support for real talent afflicted the early career of John Gibson. The finest busts he modelled, apparently before he went to Rome, are those commissioned by George Watson Taylor of Erlestone Park, the friend of the Prince Regent. These represent Watson Taylor's family and William Roscoe. The former were modelled while Gibson was staying with him in the Isle of Wight but carved in Rome. The bust of Master John Walter Watson Taylor (dated 1816, Victoria and Albert Museum) is animated by his extraordinary manual dexterity and appreciation of the innocence of childhood.

There appears to have been little or no taste for high art so few sculptors had the opportunity to carve a Venus or Hercules in marble. The most ambitious piece now known is the Neptune Fountain carved for the Bankes family, in the stableyard of Winstanley Hall, shown at the Liverpool Academy in 1848. Like the Blundells, they were an old-established, landed family. Gibson's early days in Rome are remarkable for the lack of support which he received from Liverpool. His career was effectively launched in 1818 by the Duke of Devonshire's commission for 'Mars and Cupid' in marble for £500. Only the

sculptor C B Robinson, who had private means, could disregard patronage and afford on his own account and for his own pleasure the marble for such figures as 'Psyche' (Sudley Art Gallery), closely modelled on the simple standing figure of Thorwaldsen.

Carving church memorials provided the basis of most Liverpool sculptors' livelihoods. Monuments made in Liverpool can be found all over the north-west and in North Wales. The affluent sometimes spent vast sums commemorating their departed loved ones. Sir Francis Chantrey charged £1,000 in 1832 for the large and small monuments to the Nicholson family in the Oratory at St James's Cemetery, twice the amount that the Duke of Devonshire had paid Gibson for his life-size marble figure of 'Mars and Cupid'. Simpler monuments could be obtained for more modest prices, such as the £28.10s.0d charged by George Bullock for the monument to Robert Blundell in St Helen's Church, Sefton. T Franceys costed a wall tablet 5 ft high showing a mourning putto resting against a draped urn with books and globe at £126.

Unfortunately, only a handful of accounts for monuments in Liverpool survive. Monuments or parts of them were also shown in the

6. G Bullock, 'Henry Blundell', 1801, wax, Leeds City Art Gallery

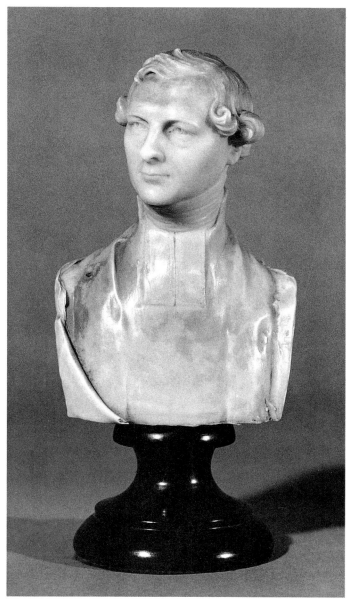

7. E Lyon, 'Reverend Hugh McNeile', 1829, wax and plaster, Walker Art Gallery

8. J Gibson, 'John Walter Watson Taylor', 1816, marble, Victoria & Albert Museum

Liverpool Academy exhibitions. Most were made in white and black marble or slate. Although the taste for coloured stones had declined since the eighteenth century, George Bullock used blue Mona marble to complement the simple monuments he made for the Reverend Glover Moore, died 1809 (St Cuthbert's, Halsall, Lancashire) and Anna Maria Bold, died 1813 (St Luke's, Farnworth, Lancashire).

His designs seem restrained when compared with the often ambitious monuments carved by the firm of S & T Franceys. This yard benefited from the fertile imagination and talented carving of John Gibson until he left for Rome in 1817 after the end of the Napoleonic Wars. Franceys also employed William Spence who shared Gibson's passion for the antique. As was often the practice, a successful design would frequently be re-used. The figure of 'Faith embracing a cross'[6] used on the memorial to Ursula Lloyd, died 1795, and other members of her family, (St Peter's, Llanbedr) was repeated on the memorial to John Ford, died 1807 (Chester Cathedral). Sometimes, the occupation of the departed was illustrated. For instance, on the monument to Joseph Brandreth, died 1815, physician to the Duke of Gloucester and Lord Derby and a founder of the Liverpool Dispensary, the Good Samaritan is shown caring for the unfortunate traveller. An outstanding example of this pattern is the monument to Dr William Stevenson, died 1853, by J A P Macbride (1819–1890), a student of William Spence. This represents Stevenson, the first medical man to settle in Birkenhead, holding a watch and feeling the pulse of a patient (formerly St Mary's Church, Birkenhead, now The Oratory, St James's Cemetery).

William Spence frequently utilised a standing female figure with crossed legs, resting one elbow on an altar. Examples include the monument to John Ford, died 1829, (St Mary's Church, Sandbach) and James Archer, died 1832, (St Leonard's, Middleton, Lancs.). The figure was adapted into Hope by the addition of an anchor for his monument to John Bibby, died 1840, (formerly St Thomas Seaforth now All Hallows, Allerton on loan from the Walker Art Gallery) to reflect the line on the tablet 'My flesh also shall rest in hope'. Appropriately for a merchant the corbels are carved with a beehive and hourglass. The lush and lively architectural detail and crisply carved portrait of the deceased are characteristic of Spence's work.

In September 1827 St James's Cemetery was inaugurated in a picturesque disused quarry. John Foster (1786–1846), the Liverpool architect, designed a chapel in the form of a temple which Mrs Lawrence told Gibson was 'an exquisite model, I believe of Grecian art'[7]. The monuments in its chaste interior are all of high quality and date mostly from the 1830s. In addition to Chantrey's two monuments to the Nicholson family there is the seated figure of William Ewart (1763–1823) by Joseph Gott (1786–1860) who, like Gibson, had settled in Rome. Gibson is represented by three monuments of the late 1830s for Liverpool patrons, which show him at the height of his powers.

An instructive comparison may be drawn between Gibson's monument to William Hammerton, died 1832, and his memorial to Henry Blundell, dated 1813 (St Helen's Church, Sefton). The latter, modelled when the sculptor was still working for S & T Franceys, shows the powerful influence of Michael Angelo. Blundell's figure is placed in a niche reminiscent of the seated figures of the Medici in the New Sacristy at San Lorenzo. Blundell is shown supporting the needy, represented by a woman and children, and the visual arts, symbolised by a nude figure reminiscent of the *ignudi* on the Sistine Chapel ceiling. Beside this figure lie a mallet, a palette and a carved torso. The relief below Blundell is derived from a sarcophagus in his celebrated collection. Gibson exhibited the nude figure at the Liverpool Academy of 1813 with the title 'Genius'.

In his monument to William Hammerton, this accumulated detail and elaborate composition is replaced by a clear narrative of Hammerton with bread and bowl of water striding to the assistance of a widow

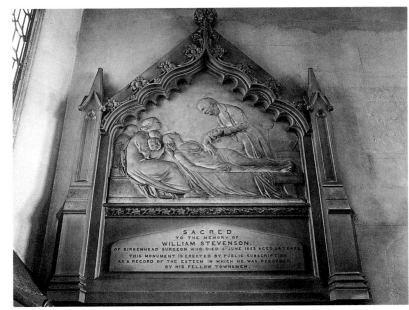

9. J A P Macbride, 'Monument to William Stevenson', died 1853, marble, formerly St Mary's Birkenhead, now The Oratory, St James's Cemetery

10. W E Spence, 'Monument to John Bibby', died 1840, marble, formerly St Thomas's Seaforth, now All Hallows Allerton, on loan from the Walker Art Gallery

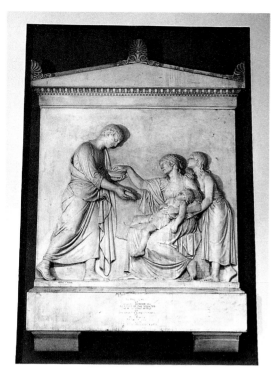

11. J Gibson, 'Monument to William Hammerton', died 1832, marble, The Oratory, St James's Cemetery

12. A Geddes, 'John Gibson', signed, dated and inscribed Rome 1830, oil on canvas, Walker Art Gallery. By the sculptor's side is the model for the Monument to Mrs Emily Robinson, died 1829, which he erected at his own expense in The Oratory, St James's Cemetery

and her children. The firm diagonals of the legs and arms of Hammerton strike a poignant comparison with the drooping lines of the exhausted mother and her children. Their drapery, arranged in small broken folds, contrasts with the broad straight folds of Hammerton's classical robe. The minimal architectural details and the tiny inscription emphasise the Greek character of the monument. Gibson charged £500 for it. His expenses he reckoned came to £125 for the marble, architectural details, the carving by his head workman, Baini and other incidentals.

The monuments to Mrs Robinson, died 1829, and to William Earle, died 1839, are more introspective in character. Emily Robinson had so inspired Gibson in his early Liverpool days to become a great sculptor in the Greek tradition that he erected this tribute to her at his own expense. Her sister, Mrs Lawrence, was deeply moved by his memorial. Earle, a member of a wealthy local family, spent much of his life in Italy. Wrapped in a great cloak, the elderly figure sits lost in meditation on a passage in the bible which he marks with his finger. The austere dignity of the figure contrasts with the rich ornament of the cresting.

The sculptural tradition that the Royal Academy embodied was not effectively transplanted by its counterpart in Liverpool. To succeed there, sculptors had to compromise, undertaking the carving of busts, church memorials and the like. Those with talent either left, as did Bullock and Gibson, or directed their energies towards the commissions available. In his monuments in the Oratory Gibson used his knowledge of antique art to create deeply moving monuments to the people of his own time. They are unsurpassed by his ideal figures from classical myth. The 1840s and 50s witnessed the appearance of numerous generous patrons of local talent such as the Naylors and the Sandbachs. However, the unique atmosphere of the boom town Liverpool had evaporated. Ironically but perhaps inevitably the next generation of well-to-do proved no more appreciative of the local Pre-Raphaelite school of painting than their predecessors had been of sculptors inspired by the neo-classical ideal.

NOTES

I should like to thank my colleagues at the National Museum of Wales – in particular Mark Evans and Mrs Sylvia Richards – for their help in the preparation of this note and MaryAnne Stevens and the staff in the library at the Royal Academy for giving me access to the Gibson papers. All quotes from the latter are made with the kind permission of the Royal Academy of Art. I should also like to acknowledge the help of Mary Bennett, the doyenne of scholars who have worked on the history of art in Merseyside.

1 Lady Eastlake, *Life of John Gibson, R.A. Sculptor* p 31

2 10 Sept 1828

3 May 1807, Vol 1, No VI, pp 388–389

4 15 January 1806

5 J A Picton, *Memorials of Liverpool*, Vol 11, pp 245–6

6 A drawing, attributed to Gibson, recording this design stamped *S & T Franceys Liverpool* is in the Victoria and Albert Museum (D 1880–9).

7 *Gibson Papers* G1/1/215 Royal Academy. Letter from Mrs Lawrence to John Gibson 18 December 1829.

VICTORIAN IDEAL SCULPTURE 1830–1870: MERSEYSIDE SCULPTORS AND COLLECTORS

Martin Greenwood

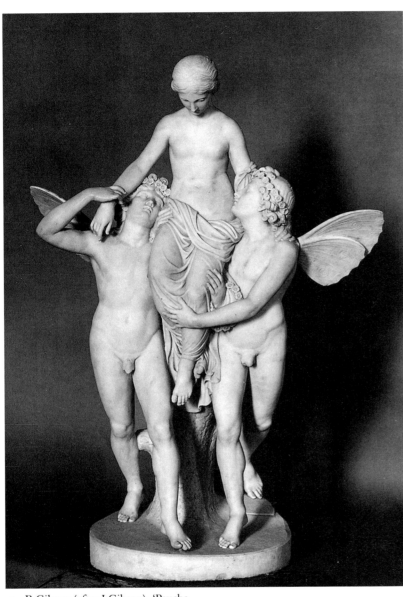

1. B Gibson (after J Gibson), 'Psyche and the Zephyrs', 1821, Walker Art Gallery

In 1827 a reviewer for the *Liverpool Mercury* wrote: 'Liverpool has some reason to be proud of its school of sculpture, and few towns in Britain, except perhaps the metropolis, can vie with our town in the number of sculptors that have been educated in it. Liverpool produced Deare and John Gibson, names well known even in Italy by their works; and William Spence, Edwin Lyon and the two younger Gibsons bid fair to emulate the productions of their senior townsmen'[1].

The school of sculpture which emerged in Liverpool in the first two decades of the 19th century holds an important place in the history of ideal sculpture in Victorian Britain. John Gibson, its leading figure, was the major neo-classical sculptor of the period and his work and reputation attracted a considerable national patronage as well as an important local following. His influence also encouraged Liverpool patrons to acquire the work of other neo-classical sculptors in Rome and his success inspired Liverpool sculptors to pursue careers in Rome. William Spence, Gibson's contemporary, was the leading sculptor resident in Liverpool in the first half of the 19th century and the two younger Gibsons, Solomon and Benjamin, and several other sculptors, including Edwin Lyon, George Bullock, William Brown and Charles Seddon, were active in the town. Spence's son, B E Spence, and Benjamin Gibson also worked in Rome from the 1840s and maintained the tradition for the patronage of ideal sculpture by Liverpool collectors into the second half of the 19th century.

The emergence of a school of sculpture in Liverpool was a product of the economic and cultural development which the mercantile port witnessed towards the end of the 18th century[2]. John Deare (1759–98), Liverpool's first important sculptor, had worked briefly in the town in the 1770s before establishing a successful career as a neo-classical sculptor in Rome. In the 1780s Henry Blundell of Ince began forming his collection of classical and neo-classical marbles and William Roscoe, the historian and collector, was active in encouraging local art. The latter's efforts culminated in the foundation of the Liverpool Academy in 1810 and the Liverpool Royal Institution in 1814 which provided, during the 19th century, venues for regular exhibitions, for a school of art and for a permanent collection. Local sculptors made considerable contributions to the Academy exhibitions and among its pupils were the younger Spence, Seddon and Lyon[3], while the Institution, from 1821, housed a permanent collection of plaster casts after the Parthenon and other Greek sculptures, which had been presented by George IV and John Foster to promote local taste. Roscoe also played an active role in the early careers of John Gibson, William Spence and George Bullock and the local firm of stonemasons, Messrs Franceys, provided Gibson and Spence with a practical education in sculpture.

The importance of Liverpool in the history of Victorian ideal sculpture rests primarily on the career of John Gibson as a neo-classical sculptor in Rome from the 1820s to the 1860s. Born in Conway, North Wales, John Gibson (1790–1866) was the son of a market gardener and he moved with his family to Liverpool in 1799[4]. At the age of 14 he was apprenticed to a local firm of cabinet makers, Southwell and Wilson, and soon afterwards began working for Messrs Franceys, marble masons of Brownlow Hill. There he assisted the Prussian emigré sculptor F A Legé and worked on the design of church monuments. He meanwhile exhibited drawings and statuettes at the Liverpool

Academy and in 1810 received his first commission for an ideal work, from William Roscoe, for a terracotta relief representing 'Alexander the Great depositing the books of Homer in the tomb of Achilles' (1810, Liverpool Libraries). He subsequently became a close friend of Roscoe's and a regular visitor to the latter's home at Allerton where he was encouraged to copy the old master drawings in Roscoe's collection and to study the sculpture of the Greeks. As Gibson later wrote 'Mr Roscoe and his counsels, versed as he was in the philosophy of Art, were to me an Academy ... Whenever my imagination glides to Allerton, it is with deep feeling of gratitude and respect, for it was there my inexperienced youth was led to the path of simple art; it was there it caught the flame of ambition; it was there that the suggestion of Rome was given birth to'[5]. Gibson soon resolved to study in Rome, the 'university of art', and in 1817, with letters of introduction from Roscoe and his influential friends, he travelled to Rome where he was to work for the rest of his life.

Soon after his arrival Gibson obtained a place in the studio of Antonio Canova (1757–1822), the leading neo-classical sculptor, and he studied at Canova's Academy and at the Academy of St Luke. His first work in Rome was a copy of Canova's statue of a 'Pugilist' in the Vatican Museum and his first original design 'The Sleeping Shepherd' (Walker Art Gallery, version, illus. p. oo). It was Canova who suggested to Gibson that he execute the latter in life size and 'as it advanced', Gibson recalled, 'he often came and corrected me, and made remarks which were invaluable to me'[6]. Gibson's debt to Canova is apparent in several of his early Roman works including the 'Mars and Cupid' (1819–22, Chatsworth) the 'Psyche and the Zephyrs' (1821, copy in the Walker Art Gallery, illus. 1) as well as the 'Shepherd'. The picturesque composition and sensual attitude of the latter can be compared, for example, to Canova's 'Sleeping Endymion' (1819, Chatsworth) while Gibson may also have studied antique sculptures such as the 'Barbarini Faun', which left Rome in 1819 (Munich), and the 'Endymion Sleeping', a Roman relief in the Capitoline Museum. Canova had advised the young sculptor not to study his works too closely: 'the best counsel I can give you', he said, 'is to copy nature, but at the same time you are working from the life, go constantly and look at the antique; not to model copies from any of the statues, but always examine them, and that carefully, until you have gained a perfect knowledge of their principles ...'[7].

Canova's words express one of the central principles of the 'ideal' as understood by 18th century neo-classical artists: the imitation of nature according to the standards of classical sculpture. As J J Winckelmann, the chief theorist of neo-classicism, had written in 1755: 'there is only one way for the moderns to become great ... that is by imitating the ancients', for the works of the latter revealed 'not only nature in its greatest beauty, but something more than that, namely, certain ideal beauties of nature ... which exist only in the intellect'[8]. Neo-classical theory dominated the conception and practice of European art in the late 18th and early 19th century and artists studied the works of antiquity in Rome and at the newly founded Academies of Art. Gibson, in the 1850s, referred to Winckelmann as 'our modern guide in sculpture' and described his own pursuit of the ideal: 'In the art of sculpture the Greeks were Gods, we with all our efforts feel it hard toil to creep upwards after them ... In the Vatican we go from statue to statue, from fragment to fragment, like a bee from flower to flower ... the fact is I never have been able to satisfy myself yet with any one work which I have produced, for in my imagination there is a degree of beauty which I am unable to reach'[9].

Canova also encouraged Gibson to go to the studios of other sculptors, 'and especially to as often as you can to that of Thorvaldsen, he is a very great artist'[10]. Gibson did seek Thorvaldsen's instruction, particularly after Canova's death in 1822, and many of the English sculptor's later works emulate the 'pure and severe simplicity' of Thorvaldsen's

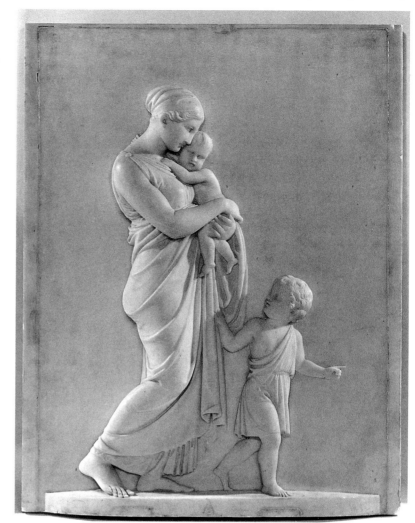

2. B Thorvaldsen, 'Christian Charity', 1810–34, Walker Art Gallery

work[11]. The 'Flora' (WAG) and 'Cupid in Disguise' (WAG), for example are comparable to statues by Thorvaldsen, such as the 'Hope' (1818), in their frontal composition, clear outline and simple drapery treatment. Bertel Thorvaldsen (1770–1844), a generation younger than Canova, had been much influenced by early Greek sculpture, particularly the recently discovered Parthenon marbles and the Aegina frieze (the latter of which he had restored) and Gibson's own reliefs, such as the 'Cupid pursuing Psyche' (WAG, illus. 3) and 'Christ Blessing Little Children' (WAG, illus. 4), can be related to the simple and naturalistic style of Thorvaldsen's work as well as to the classical and Christian themes of his sculpture (illus. 2)[12].

In 1819 Gibson received his first commission for a work in marble, the 'Mars and Cupid' (Chatsworth), from the Fourth Duke of Devonshire and over the following 20 years he enjoyed the patronage of some of the most eminent collectors of the day. They included George Beaumont, Lord George Cavendish, the Earl of Yarborough, Lord Grosvenor, Lord Prudhoe as well as the English Royal family[13]. By 1830 Gibson was the recognised leader of a small colony of British sculptors working in Rome which included R J Wyatt, Joseph Gott, Lawrence Macdonald and William Theed the younger. In the 1840s and 50s many Victorian sculptors of the following generation also worked under or were assisted by Gibson in their careers, among them Henry Timbrell, John Hogan, Alfred Gatley, George Gammon Adams, Mary Thornycroft and B E Spence[14].

In the 1830s the patronage of Liverpool collectors began. The tradition of purchasing sculpture in Rome established in the neo-classical period by the English aristocracy appealed to the newly rich merchants of the North; 19th century Rome provided numerous facilities for the

wealthy English traveller and the work and activities of resident sculptors were regularly publicised in contemporary guide books and periodicals. For Liverpool collectors the links with Rome were particularly strong as their townsman Gibson was the leading sculptor there.

Among the first of these were the Sandbachs, who lived at Hafodunos Hall in Conway, North Wales. Henry Robertson Sandbach (1807–1895) was a Liverpool West India merchant whose father Samuel Sandbach had established the trading firm of Sandbach, Tinne & Co in 1813. His wife Margaret was a poetess and the granddaughter of William Roscoe. They visited Rome in the winter of 1838–9, as Gibson recalled: 'Their stay being the whole of the winter, gave them ample opportunities of enjoying Rome, and its antiquities and its art; and gave me an opportunity of contemplating the talent and genius of the descendant of my old friend . . . I soon perceived her feeling and taste for my own art in particular. Every one of my compositions on paper I used to lay before her as well as those in clay'[15]. On that visit the Sandbachs commissioned two marble sculptures from Gibson, the 'Hunter and Dog' and the statue of 'Aurora' (National Museum of Wales, Cardiff), the latter a subject which the sculptor felt 'would be congenial with [Mrs Sandbach's] own poetic feeling'[16]. Over the following twenty five years Sandbach acquired many works by Gibson. These included the 'Wounded Amazon' (National Museum of Wales, Cardiff), the relief portrait of Mrs Sandbach (c 1852, WAG, illus.8) and the reliefs 'Cupid Pursuing Psyche' (1852, WAG, illus.3) and 'Christ Blessing Little Children' (1864–5, WAG, illus.4), some of Gibson's major works in marble. He also purchased several plaster sculptures by Gibson including the 'Pugilist', after Canova, and the small model of the sculptor's last and uncompleted work 'Theseus and the Robber'[17]. Sandbach also acquired works by Gibson's fellow sculptors in Rome including a version of R J Wyatt's 'Nymph preparing for the Bath' (WAG, illus.5), copies of reliefs by Thorvaldsen – 'Night' and 'Day' (WAG, illus.6 & 7) and 'Hector reproving Paris', a bust of 'Cicero' by Baini, Gibson's head workman in Rome and 'The Favourite' by B E Spence[18].

Sandbach's patronage was remarkable in that it was directed almost exclusively to the work of Gibson and to sculptors directly associated with him and it remained loyal and constant to the latter's death. Sandbach had a special sculpture gallery built at Hafodunos[19] and Gibson formed an intimate and elevating friendship with Mrs Sandbach. Her death in 1852 deeply affected him[20] and he carved the full-length relief portrait in her memory (illus.8). Whether Sandbach had any decided taste for neo-classical sculpture is not known (Hafodunos was built in the gothic style by Gilbert Scott) although Mrs Sandbach, the author of *The Amidei* and *Giuliano de Medici*, seems to have inherited some of the classical leanings of her grandfather. Family and local connections (Liverpool and Wales) were probably, as with many Liverpool collectors, the main consideration.

Another important Liverpool patron of Victorian ideal sculpture whose collection can be largely reconstructed was Richard Vaughan Yates. Yates (1785–1856), a Liverpool iron merchant, was the benefactor of Prince's Park to the town and a founder of the Liverpool Mechanics Institute[21]. From the mid 1820s he visited Italy regularly and by 1840 had formed a considerable collection of old master paintings[22]. His commissions for sculpture date from the late 1830s and early 1840s though he probably met Gibson earlier through their mutual friend William Roscoe.

Yates acquired several works by Gibson including the bas-relief 'Venus and Cupid' (c.1841)[23], busts of a 'Nymph' and 'Helen'[24], a plaster cast of 'Hylas and the Nymphs' (Liverpool Institute) and the marble statue 'Love Tormenting the Soul' (WAG, illus.9)[25]. The latter, which was first executed in marble for Lord Selsey in 1837, characterises Gibson's mature style in which classical allegory borders on genre.

Yates also owned a work by Joseph Gott, the 'Peasant Boy feeding a

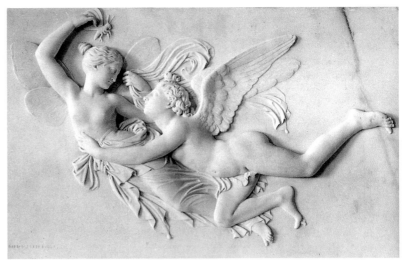

3. J Gibson, 'Cupid Pursuing Psyche', 1852, Walker Art Gallery

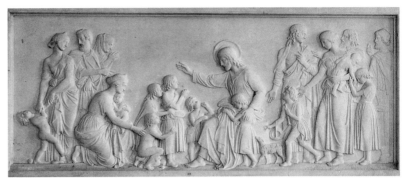

4. J Gibson, 'Christ Blessing Little Children', 1864–5, Walker Art Gallery

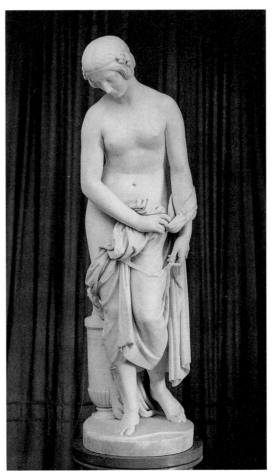

5. R J Wyatt, 'Nymph preparing for the Bath', 1838, Walker Art Gallery

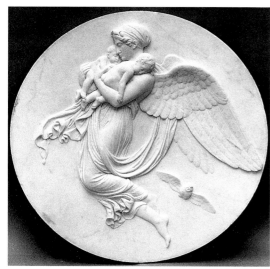

6. B Thorvaldsen, 'Night', after 1815, possibly 1825–6, Walker Art Gallery

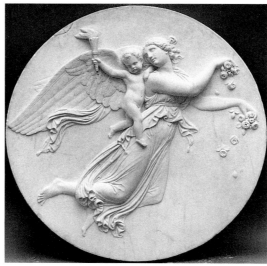

7. B Thorvaldsen, 'Day', after 1815, possibly 1825–6, Walker Art Gallery

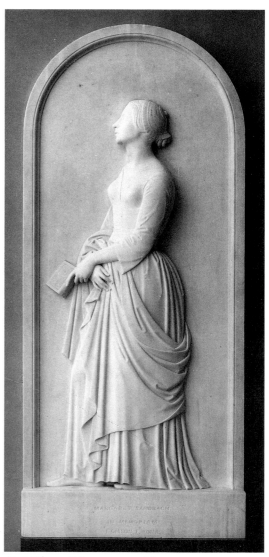

8. J Gibson, 'Monument to Margaret Sandbach', c.1852, Walker Art Gallery

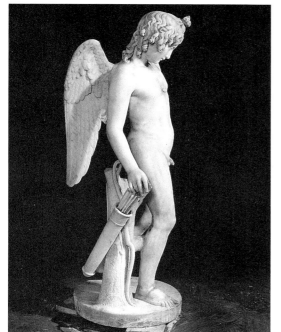

9. J Gibson, 'Love Tormenting the Soul', (first version 1837), Walker Art Gallery

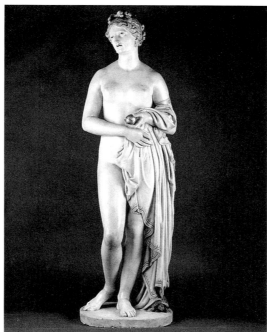

10. J Gibson, 'Tinted Venus', 1851–6, Walker Art Gallery

Rabbit'[26] and the marble group 'Psyche and the Zephyrs' (WAG, illus.1), a smaller copy of Gibson's early group by his brother, Benjamin.

Besides these, Yates also owned two works by 19th century continental sculptors, Emile Wolff's 'The Goat Herd' (1839, WAG) and Lorenzo Bartolini's 'Maternal Affection' (Liverpool Institute)[27]. Wolff, one of the leading German classicists working in mid-nineteenth century Rome, was a favourite sculptor of the Prince Consort, whom he portrayed in Roman military costume (1844, Royal collection, Osborne House) while Bartolini was the leader of the mid-nineteenth century Florentine reaction against neo-classicism. Though Yates, like Sandbach, owned a central core of works by Gibson his art collection was a markedly more cosmopolitan one than the latter's.

Perhaps the most famous Victorian ideal sculpture formerly in a Liverpool private collection is John Gibson's 'Tinted Venus', now in the Walker Art Gallery (illus.10). The design was based on an earlier statue, the 'Venus Verticordia', which was made in 1849 for Joseph Neeld of Grittleton Hall. While this was in completion Mr and Mrs Robert Preston of Liverpool visited the sculptor's studio in Rome and ordered a repetition which became the 'Tinted Venus'[28]. Gibson

worked on the statue between 1851–6 and then kept it in his studio for a further four years. When it was finally sent to England and shown at the 1862 London International Exhibition it provoked a storm of controversy 'with the consensus of opinion generally unfavourable to tinting.[29]. The *Athenaeum*, for example, described it as 'a naked impudent English woman . . . with enough vulgarity to destroy . . every sign of the goddess'[30] though the *Sculptors' Journal* thought it 'one of the most beautiful and elaborate figures undertaken in modern times'[31].

Gibson's authority for the colouring of statuary was from Greek sculpture and though he had previously applied touches of colour to sculpture, the 'Venus', with its waxed and flesh coloured body, blue eyes and gilt hair and jewellery, was his most ambitious statement in polychromy. Gibson had read the available literature on the subject, in particular the writings of Gottfried Semper and Jakob Ignaz Hittorf on Greek polychrome architecture[32] and though aware that 'it would be a very easy thing to produce a vulgar effect' felt that this was 'no argument against the judicious use of colour which when applied with prudence is in my view essential to sculpture'[33]. Gibson evidently took particular care over the work, carving it himself and reviewing and reworking it in his studio and the 'Venus' certainly retains the simplic-

ity of form and 'strong plastic character' which Gibson sought, combined with a colourful realism which may have been an attempt on his part to make classicism more appealing.

The correspondence between Gibson and the Prestons[34] over the commission details the difficulties which the purchasers experienced in trying to obtain the 'Venus'. At one stage Gibson considered buying the statue back from the Prestons when he heard that the Crystal Palace Company were interested in acquiring it for the nation. However, he feared hostile criticism in England and wanted to prolong the statue's stay in Rome so that the many distinguished visitors to his studio could see it (resulting in commissions for copies from the Marquis of Sligo and Matthew Uzielli). In one letter to Mrs Preston he said that he could not bear to be parted from his 'Goddess' and that it would be 'as difficult for me to part with her as it would be for Mr Preston to part with you'[35]. Mrs Preston finally elicited a written promise from the sculptor to send the statue and it arrived in August 1859 although Preston himself had died earlier in that year. The Preston correspondence was collected by Joseph Mayer 'as evidence of the great interest shown by the owner in this statue and his desire to exhibit it publicly and the reason why Mrs R B Preston devoted labour and money to carry out her husband's intentions – in defiance of opposition, advice and worldly opinion'[36]. When exhibited in 1862 the work certainly brought the Preston's name to public attention, although only for a while, as the statue was lost sight of until its recent acquisition by the Walker Art Gallery.

Two other Liverpool patrons of John Gibson were Richard Alison and John Leigh Clare. The former purchased the statues of 'Flora' and 'Cupid Disguised as a Shepherd Boy' (illus.11), now in the Walker Art Gallery, while the latter owned a version of the 'Hunter and Dog'. Both collectors expressed their enthusiasm in acquiring works by a local sculptor. Leigh Clare, of Toxteth Old Hall, described his pleasure in having ordered a work 'from a fellow townsman'[37] while Alison of Woolton wrote to the sculptor in 1844: 'I have . . . received the statue of Flora from London quite safe, which I assure you I shall prize very much, both on account of its being an exquisite work of Art, and also from it having been achieved by a townsman'[38].

Gibson maintained close links with Liverpool throughout his life not only through his private patrons but also through public commissions (such as the statues of William Huskisson MP for the Customs House and George Stephenson for St George's Hall), through his friends (including William Spence the sculptor, Dr Vose his old anatomy teacher and Joseph Mayer the antiquarian) and his family.

In 1837 Benjamin Gibson arrived in Rome to work as an assistant in his brother's studio. Some twenty years younger than John, Benjamin Gibson (1811–51) had exhibited busts and ideal pieces at the Liverpool Academy from the early 1820s[39] and produced several local monuments including that to Matthew Gregson (1829) in St John's church, Liverpool[40]. In Rome he designed several original works[41] and a number of copies of his brother's sculptures. Of the latter, versions of the 'Psyche and the Zephyrs' (illus.1) were purchased by both Yates and Preston in the 1840s[42], a copy of the 'Cupid Disguised as a Shepherd Boy' by William Jackson of Birkenhead (see below) and of the 'Wounded Amazon' by Mrs Huskisson, the wife of the Liverpool MP[43]. The production of marble replicas was widely practised in the neo-classical period and Gibson, as we have seen, produced many copies of his works. Often replicas were largely the product of the studio and only the finishing touches were provided by the autograph sculptor although some replicas, notably the 'Tinted Venus', were more carefully executed than their earlier versions. The fact that Benjamin Gibson was the brother of the original sculptor and was known as a sculptor in his own right would have invested some status in the work, particularly for Liverpool collectors.

Another Liverpool sculptor who began working in Rome in the

1840s was B E Spence whose career can be seen to usher in a second phase in the patronage of a Liverpool sculptor by local or locally affiliated patrons. His work also illustrates some of the main developments in ideal sculpture in the mid-nineteenth century.

During the period when Gibson was establishing his career in Rome a school of sculpture emerged in Britain whose aims were opposed to those of the traditional neo-classical school. In 1828 William Watson Taylor wrote to Gibson: 'As an absentee in Rome you are considered by a certain set . . . an alien competitor and the John Bull feeling in favour of native talent last year certainly stirred up to pronounce upon your group of Psyche and the Zephyrs as inferior to works which were notoriously not equal to yours'[44]. The domestic school took many of its concerns from the school of portraiture whose interests tended towards sculptural naturalism and the representation of modern dress. Sir Francis Chantrey, its chief practitioner, produced few ideal works and thought that a Roman training could 'spoil' a sculptor[45]. The orthodoxy of classical themes in modern sculpture also gave way to an interest in subjects taken from national history, literature and the Bible while neo-classical conceptions of the ideal were replaced by a concern with narrative, historical costume, naturalistic detail and 'sentiment'. In 1854 Mrs Jameson adopted the terms 'poetic' and 'picturesque' to describe works of sculpture which she saw as being 'suggested by modern associations and poetically but not classically conceived . . . which do not express an idea but rather aspire to represent in a more dramatic way, and often with the assistance of accessories, certain characters, actions, scenes'[46].

Benjamin Evans Spence (1822–66) was the son of the Liverpool sculptor William Spence and was admitted as a student to the Liverpool Academy Schools in 1838, the year he also began exhibiting at the Academy[47]. In 1846 he won the Heywood silver medal of the Royal Manchester Institution for a model of 'The death of the Duke of York at Agincourt' a work which he also showed at the 1844 Westminster Hall competition. He went to Rome around 1845 on the suggestion of Gibson and worked initially with Gibson and then under R J Wyatt. One of his first compositions in Rome was a statue of 'Lavinia', a subject from Thomson's 'Seasons', which was commissioned by Samuel Holme the Liverpool builder[48].

Holme was one of the first of a group of collectors with Liverpool connections whose patronage of Spence in the 1850s and 1860s seems to have rivalled the earlier patronage of Gibson in its scale if not in its reputation. Others included Thomas Brassey, William Jackson, Richard and John Naylor as well as Henry Sandbach.

The first of these, Thomas Brassey (1805–70), was a land surveyor and builder in Birkenhead who in the 1830s moved to London to become one of the great railway contractors of the Victorian age[49]. He was described by his biographer as 'a man of great natural refinement, with a keen taste for art and natural beauty' and, as his son recalled: 'He had a special appreciation of fine sculpture . . . Years ago he had been introduced to Gibson's meritorious pupil, Spence, the sculptor of that charming figure Highland Mary. Spence was a Liverpool man; and in the first instance, it may be, moved by old local sympathies, my father was a liberal patron of his art. Among the many works which Spence executed for him was a large group, the "Parting of Hector and Andromache" which occupied a place of honour at the International Exhibition of 1862'[50]. Of the 'many works' by Spence which Brassey is said to have owned none have been located although he is known to have commissioned a statue of 'Ophelia' (1850) and busts of Mr and Mrs Brassey which were formerly at Normanhurst Court in Sussex, one of Brassey's many homes.[51] Brassey's contracting partner at one time was William Jackson (1805–76) a resident of Birkenhead and Abergavenny who was created first baronet in 1869[52]. He owned a version of Spence's 'Psyche' as well as Benjamin Gibson's 'Innocence' and 'Cupid Disguised as a Shepherd Boy', the latter presumably a copy of John

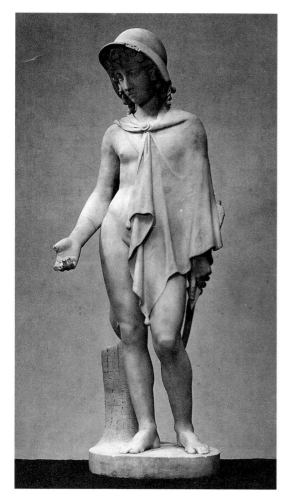

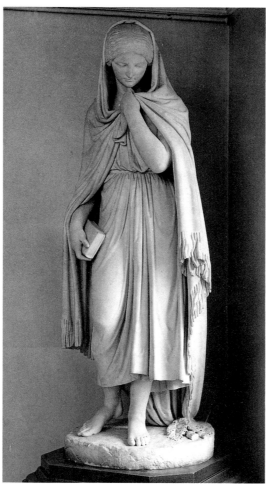

11. J Gibson, 'Cupid Disguised as a Shepherd Boy', 1837, Walker Art Gallery

12. B E Spence, 'Highland Mary', post 1852, Walker Art Gallery

13. B E Spence, 'Finding of Moses', 1862, from *The Art Journal*, 1864

Gibson's design[53]. Two other notable collectors of Spence with Liverpool connections were John and Richard Naylor.

Richard Naylor (1814–99) of Hooton Hall in Cheshire was a partner in his family's bank, Leyland and Bullins of Liverpool, and heir to its fortunes. In 1852 he retired and moved to Hooton where he formed a magnificent collection of fine and decorative art[54]. He had a large sculpture collection which included many antique pieces and 18th century French works. He also owned nineteenth century Italian sculptures by Rinaldo Rinaldi, 'The Wise and Foolish Virgins' (1855, Walker Art Gallery) and Antonio Rossetti, 'The Greek Slave' (1854) and 'Esmeralda and the goat' (1854). Among 19th century ideal works he acquired Richard Westmacott's 'Madonna and Child', John Gibson's 'Venus with the Apple', a version of the 'Tinted Venus' acquired from Matthew Uzielli, and B E Spence's 'Venus and Cupid'[55].

John Naylor (1813–89) was the brother of Richard and co-partner in the family bank.[56] He lived at Liscard Manor on the Wirral and in 1851 moved to Leighton Hall, near Welshpool, where his magnificent collection of modern paintings and sculpture was displayed. Among the latter he owned a version of Gibson's relief 'Phaeton and the Horses of the Sun', which had first been made for Lord Fitzwilliam, William Calder Marshall's 'Eve plucking the forbidden fruit' (1845), R J Wyatt's 'A Nymph of Diana taking a thorn out of a greyhound's foot' (possibly Royal Academy 1849) and several sculptures by B E Spence. These comprised two Naylor family portrait groups (now in the Sudley Art Gallery), ideal statues representing 'Spring' and 'Winter', a bust of 'Venus' and the marble ideal sculptures, 'Highland Mary' and 'The Finding of Moses', both now in the Walker Art Gallery.

'Highland Mary' (illus.12) is Spence's best-known work, first executed around 1852 for Charles Meigh of Grove House, Shelton and repeated at least five times, one of the versions of which was for the Prince Consort who commissioned it as a birthday present for Queen Victoria (1854, Royal collection). The subject is Mary Campbell, a maid servant of Auchenmore and the lover of the poet Robert Burns, who died shortly after they were betrothed. Spence portrays her as she appeared at their last meeting, on the banks of the Ayr, holding the Bible which Burns had given her. Although the poetry and legend of Burns were a popular source of subject in Victorian art it appears to have been a novel choice for a sculptor working in Rome. The *Art Journal*, reviewing the work, complimented Spence on his 'good fortune in having achieved so Scotch a physiognomy in classic Rome'[57] though Spence's treatment, particularly of the face and drapery, remains indebted to neo-classicism. Only the plaid and thistles at Highland Mary's feet identify the Scottish subject-matter.

John Naylor also purchased Spence's 'Finding of Moses' (1862, illus.13) which was shown at the International Exhibition of 1862, and the subject and treatment of this work demonstrate how far Spence, in the 1860s, had departed from the ideal style of Thorvaldsen or Gibson. Its biblical source, elaborate historical costume, detailed carving and narrative setting come closer to the work of contemporary British sculptors such as J G Lough or F M Miller than to neo-classicism. The *Art Journal* described the group as more 'pictorial' or 'picturesque' than statuesque and thought that it had 'carried sculpture into that Pre-Raphaelite finish that has long become the vogue in the sister art of painting'[58]. W B Scott in his *British School of Sculpture* defined Spence's contribution: 'He departed from the classic in subject, and having that kind of inventive fancy that more frequently belongs to the painter than to the sculptor, he endeavoured to produce groups and figures of a new and popular character This originality of Spence in opening a new field for his art recommends itself to us at once, but we cannot help feeling immediately also the great difficulty with regards to costume'[59]. To Scott the over-elaboration of costume displayed in some of Spence's work overstepped the proper limits of the sculptor's art.

The 'Finding of Moses' is representative of the last phase of Victorian ideal sculpture; one which was to be succeeded, in the 1870s, by the work of the British 'New Sculptors' whose influences came from contemporary French sculpture and the Italian Renaissance rather than from neo-classicism. Spence's death in 1866, the same year as John Gibson's, marks the end of the high Victorian era for the production and patronage of ideal sculpture in Liverpool. Reviewing the sale of Spence's sculptures after his death, where his works fetched relatively low prices, the *Art Journal* wrote: 'there is little or no taste for, and less desire to acquire, ideal sculpture on the part of our patrons'[60]. The records of bequests to the Walker Art Gallery, which opened in 1877, show that local patrons were in the last quarter of the century collecting examples of the 'New Sculpture', many of them purchased at the newly instituted Liverpool Autumn Exhibition. The important local school of sculpture fostered in the early nineteenth century by Roscoe, centred on John Gibson and patronised by major local collectors can thus be seen to have given way to the broader, less committed patronage of B E Spence in the mid 19th century. In recent years the National Museums and Galleries on Merseyside have been acquiring ideal works of the period and re-displaying them, notably in the new Sculpture Gallery at the Walker Art Gallery, and it is appropriate that one of the most recent acquisitions was a version of the 'Sleeping Shepherd', John Gibson's first work in Rome.

NOTES

I would like to thank Timothy Stevens, Edward Morris and Benedict Read for their help and interest.

1 *Descriptive and Critical Catalogue of the Liverpool Academy Exhibition of 1827* collected from numbers of the Liverpool Mercury, 1827, p 17.

2 See Mary Bennett, *Merseyside Painters, People and Places*, Liverpool, 1978, pp 4–17: John Willett, *Art in a City*, London, 1967, pp 23ff: Henry A Ormerod, *The Liverpool Royal Institution: a Record and Retrospect*, Liverpool, 1953, pp 32ff, 76ff: H C Marillier, *The Liverpool School of Painters*, London, 1904, pp 1ff.

3 See the entries for these artists in Rupert Gunnis, *Dictionary of British Sculptors 1660–1851*, London, 1951.

4 The principal biographical sources for John Gibson are Lady Eastlake, *The Life of John Gibson*, London, 1870 and T Matthews, *The Biography of John Gibson, RA*, London, 1911.

5 Matthews, *op. cit.*, pp 26, 36.

6 Eastlake, *op. cit.*, p 53.

7 Matthews, *op. cit.*, p 50.

8 J J Winckelmann. *Reflections on the Painting and Sculpture of the Greeks*. 1755, English edition, London, 1765, p 2.

9 Matthews, *op. cit.*, pp 89–95, 128, 161.

10 Eastlake, *op. cit.*, p 54.

11 ibid, *op. cit.*, p 64.

12 See Jorgen B Hartmann, 'Canova, Thorvaldsen and Gibson' in *English Miscellany*, vol 6, Rome, 1955, pp 205–235.

13 See Matthews, *op. cit.*, pp 241–7 and Eastlake, *op cit.*, pp 248–55.

14 See the entries for these sculptors in Gunnis *op. cit.* Gibson was instrumental in obtaining the patronage of the English Royal family for Macdonald, Theed, Timbrell and Thornycroft.

15 Matthews, *op. cit.*, pp 96–7.

16 ibid.

17 List of Sculptures at Hafodunos Hall dated 15 February 1933. MSS National Museum of Wales: Catalogue of the sale of the contents of Hafodunos Hall, 1933: Matthews, *op. cit.*, pp 241–7: Eastlake, *op. cit.*, pp 249–55. The 'Theseus' and the 'Hunter and Dog' are illustrated in the 1933 Sale catalogue.

18 List of Sculptures at Hofodunos Hall, *op. cit.* Sandbach also owned copies of antique sculptures and busts by Edmonia Lewis (b 1843), an American sculptress who worked in Rome.

19 Letter from John Gibson to J B Crouchley, Mayer Papers, National Library of Wales, Aberystwyth, MSS 4915, 2 Sept 1854.

20 Eastlake, *op. cit.*, p 200.

21 Sea S A T Yates. 'The Late Richard Vaughan Yates Esq.' in *Memorials of the Family of the Rev John Yates*, Liverpool, 1890: Caroline Kerkham. 'Richard Vaughan Yates 1785–1856: Traveller in Wales', *The National Library of Wales Journal*, XX no 3, summer 1978, pp 265–272.

22 Yates lent many of his paintings to the Liverpool Mechanics Institute's exhibitions in 1840, 1842 and 1844.

23 Letter from John Gibson to J B Crouchley. Mayer Papers, National Library of Wales, Aberystwyth. MSS 4915, July 1841

24 John Gibson's Account Book, MSS Royal Academy of Arts. The former was lent to the Liverpool Mechanics Institute Exhibition in 1840 (no 322A). Other versions of these busts are in the collection of the Walker Art Gallery.

25 Presented to the Walker Art Gallery by Colonel Belcher of 10 Fulwood Park, Liverpool, 1916.

26 Formerly in the Walker Art Gallery but destroyed during the second world war. See T Stevens and T Friedman. *Joseph Gott 1786–1869*, exhibition catalogue, Liverpool, Walker Art Gallery and Leeds, Temple Newsam House, 1972, cat no G114.

27 'Maternal Affection' was exhibited at the Liverpool Mechanics Institute in 1840, 1842 and 1844. The original was a marble group of 1824 entitled 'La Carita Educatrice' c.f. M Tinti, *Lorenzo Bartolini*. vol I p 116, vol II, pl xxxviii, Rome, 1936.

28 See Jeremy Cooper, 'John Gibson and his Tinted Venus', *Connoisseur*, Oct 1971, pp 84–92: Benedict Read, *Victorian Sculpture*, NewHaven and London, 1982, pp 25–6; the Gibson and Preston correspondence in the National Library of Wales, Aberystwyth, Mayer Papers, MSS 6767D: Matthews, *op. cit.*, pp 179–186: Eastlake, *op. cit.*, pp 209–214.

29 Matthews, *op. cit.*, p 230.

30 *Athenaeum*, 3 Feb 1866, p 172.

31 *The Sculptors' Journal and Fine Art Magazine*, vol 1, no 1, Jan 1863, p 14.

32 Matthews, *op. cit.*, pp 182ff: Eastlake, *op. cit.* pp 280ff: Cooper, *op. cit.*, pp 89, 91.

33 Cooper, *op. cit.*, p 89.

34 Mayer Papers, *op. cit.* and Gibson Papers in the Royal Academy. GI/1/285–95.

35 Matthews, *op. cit.*, p 185.

36 Mayer Papers, *op. cit.*

37 Letter from J Leigh Clare to Gibson, dated Feb 28 1865, Gibson Papers, Royal Academy, GI/1/75.

38 Letter from Richard Alison to Gibson, dated Feb 16 1844. Gibson Papers, Royal Academy, GI/1/4.

39 Liverpool Academy Exhibition catalogues.

40 Gunnis, *op. cit.*, p 170

41 *ibid*.

42 Mayer Papers, MSS National Library of Wales, Aberystwyth, MSS 4915D letter to J B Crouchley dated 18 Oct 1840.

43 Gunnis, *op. cit.*, p 170

44 Matthews, *op. cit.*, p 69.

45 *ibid* p 53.

46 Anna Jameson 'A Handbook to the Courts of Modern Sculpture' in *The Fine Arts Courts in the Crystal Palace*, London, 1854, p 9.

47 For B E Spence see Gunnis *op. cit.*, p 362: Timothy Stevens, 'Roman Heyday of an English Sculptor', *Apollo*, vol 94, Sept 1971, pp 226–231: *Art Journal* 1866, p 364.

48 *Art Journal*, 1849, p 95.

49 See the *Dictionary of National Biography*: Arthur Helps, *Life and Labours of Mr Brassey*, London, 1872.

50 Arthur Helps, *op. cit.*, pp 286–7. The 'Hector and Andromache' is otherwise unrecorded.

51 Gunnis *op. cit.*: *Art Journal* 1866 p 364. Brassey also appears to have owned Joseph Gott's 'Greyhound and pups', see T Stevens and T Friedman, *op. cit.*, cat no G86.

52 Helps, *op. cit.*, pp 177, 184: B G Orchard, *Liverpool's Legion of Honour*, Birkenhead, 1893, p 416.

53 Gunnis, *op. cit.*, pp 170, 362: *Catalogue of the Art treasures of the United Kingdom, collected at Manchester in 1857*, London, [1857], no 26 ('Psyche').

54 *Catalogue of the whole of the Magnificent Contents of Hooton Hall, comprising the gallery of fine modern sculpture*, Messrs Christie, Manson and Woods, Aug 2 1875 and following days.

55 *ibid*.

56 See Edward Morris, 'John Naylor and Other Collectors of Modern Paintings in 19th Century Britain', *Walker Art Gallery, Liverpool, Annual Report and Bulletin*, vol V, 1974–5, pp 72–119: T H Naylor, *The Family of Naylor from 1589*, London, 1967.

57 *Art Journal*, 1854, p 352.

58 *Art Journal*, 1862, p 324, 1864, p 70.

59 W B Scott. *The British School of Sculpture*, London, 1871, p 132.

60 *Art Journal*, 1870, p 221.

JOHN GIBSON'S
'THE SLEEPING SHEPHERD BOY'

Recently acquired for the
Walker Art Gallery

Timothy Stevens

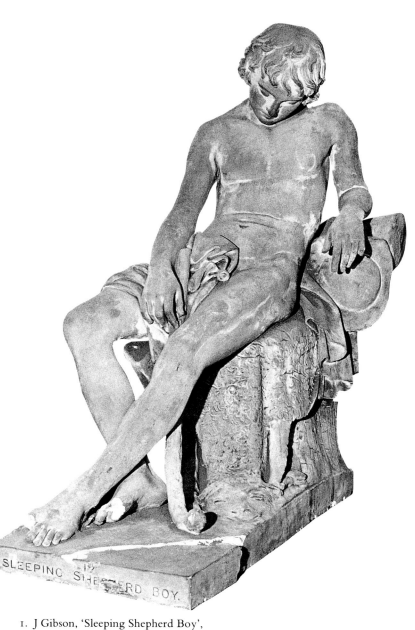

1. J Gibson, 'Sleeping Shepherd Boy',
original plaster, Royal Academy of
Arts, London (record photograph)

On the 20 October 1817 John Gibson (1790–1866) arrived in Rome from Liverpool determined to be a sculptor 'in the pure, classical style'[1]. Aged 27 his training to this end had previously been no more than rudimentary. Apprenticeship in the yard of the monumental masons S & T Franceys of Liverpool had given him basic technical skills, to judge from his own account of his subsequent training in Rome. His knowledge of the theory and history of art had been acquired under the enthusiastic but rigid guidance of William Roscoe, the Liverpool poet, banker, collector and philanthropist. Armed with letters of introduction from Roscoe's friend, the painter Fuseli, Lord Brougham, a politician with close Liverpool links and General d'Aguilar, the brother of his Liverpool patroness Mrs Robinson, he presented himself to Canova. With characteristic warmness, 'The first sculptor in the world'[2] welcomed him into his studio, oversaw his practical and theoretical education and used his influence to launch him as a sculptor.

In his autobiography, Gibson recalled Canova's advice over the first works he modelled in Rome.

My master then gave me to understand that the sooner I began to model a figure of my own invention, life-size, from nature, the better, and that I should take a studio. His foreman found me one near to his own, that he might have me always under his own eye.

Among the clay sketches which I had been composing was one of a sleeping boy, which Canova said I might execute life-size; he often came to correct me as it advanced, and his remarks were of course most invaluable to me. The sleeping shepherd was finished, and I had copied nature pretty close, as the subject admitted the imitation of individual nature.

I soon began to be haunted with the idea of attempting a higher subject. I showed to my master clay sketches of several groups, but he advised me to keep to a single figure until I had more knowledge of style, and experience in form. I made, however, a small model of Mars and Cupid, which he approved of, and said that I might model it on a large scale. His advice to me was, to take care not to imitate his style, nor to study his works too much; he added, "the best counsel I can give you is to copy nature, but at the same time you are working from the life, go constantly and look at the antique; not to model copies from any of the statues, but always to examine them, and that carefully, until you have gained a perfect knowledge of their principles, and are aware of all their perfection". He also added that I must go often to the studios of the sculptors around me; all their studios being open, "but", he said, "first of all go as frequently as you can to Thorwaldsen; he is a very great artist"[3].

'The Sleeping Shepherd Boy' was under way by May 1818 when Gibson wrote to William Roscoe about Canova's reactions to it, 'At present I have in hand the model of a shepherd-boy sleeping (my own design), which I have been studying from nature. The Marquis was so good as to come to my studio to see it, and he seems much pleased with it. He says that I have made the body and the head beautifully'[4].

Canova persuaded the 6th Duke of Devonshire, a leading British patron of sculpture, to visit the studio of his protégé in 1819. The Duke ordered a marble of 'Mars and Cupid', still at Chatsworth, for £500. His action gave Gibson the prestige so important in the attraction of

further commissions. At the time no patron wanted a marble from the full-scale plaster of 'The Sleeping Shepherd Boy' (Royal Academy Gibson Studio Collection), but in 1824 the Duke's uncle, Lord George Cavendish, visited Rome. Perhaps at the instigation of his nephew, Cavendish ordered a marble of this piece for £240[5]. The carving of the marble was not carried out expeditiously by Gibson judging from his patron's correspondence with him. From Burlington House Lord George wrote on 12 May 1824, 'I received your letter and was glad to hear that you were proceeding with my statue, which I hope will be safely placed here before this time twelve months'. On 7 November he continued that he would arrange for the pedestal to be made in London and 'hoped The Shepherd Boy is in a state of forwardness'[6]. A few days before the twelve months were up he wrote on 7 May 1825, 'Understanding by your last letter that The Shepherd Boy would be finished in the course of last November I have been anxiously looking for its arrival and am desirous of ascertaining what may have become of it. I should be glad if you would lose no time in forwarding it to England as I am impatient to have it home'[7].

Lord George had to wait until the late autumn for its arrival and on 17 November 1825 he was able to write, 'I have been lately so much engaged that I have not been able sooner to acquaint you of the safe arrival of The Shepherd Boy. It has been unpacked and placed on a temporary pedestal by Mr Chantrey's people. All who have seen it admire it extremely, and Mr Cunningham who supervises the arrangement and movement of Mr Chantrey's works and consequently is a bad judge, informed me that it was his opinion that there was more originality (to use his own words) about it than the best statue of modern times that he had seen imported from Italy. The statue ('Mars and Cupid') that you did for the Duke of Devonshire, arrived safe at the same time. I should be much obliged to you for a cast of Psyche and Zephyrs'[8].

Reassured by the unexpected praise of Allan Cunningham, well known for his prejudice against sculptors working in Rome, Lord George acted as intermediary over Gibson's first commission from Lord Yarborough – the latter subsequently became one of Gibson's most important patrons.

At least two further orders were placed for the figure in marble. The earlier of these, for Lord Prudhoe (1792–1865) of Stanwick Park, Yorkshire, has recently been bought by the Walker Art Gallery (illus.1)[9]. The exact date when Prudhoe (4th Duke of Northumberland from 1847) placed the commission is not known. A list dated July 1830 of patrons for whom the sculptor had works on hand, includes him[10]. Another list, dated 1st May 1834, records that £300 was to be received from Lord Prudhoe[11]. This sum is identical with the price given on an undated entry for Prudhoe's 'Sleeping Shepherd Boy'. Accordingly, it is probable that the commission was received in 1830 and discharged by 1834.

Gibson's Account Books are uneven in the information they give on individual works. Very precise costings are recorded for some, particularly the monuments. No details have been traced for Prudhoe's figure, although its pedestal cost 80 crowns and a mason was paid 3 *louis* and a polisher 6 *scudi* for work connected with it. Lord Prudhoe had planned 'The Sleeping Shepherd Boy', titled in brass 'Repose' on its pedestal, to pair with a standing figure of 'A Boy and Dog' by Joseph Gott, similarly titled 'Action' on an identical pedestal. Special care was thus taken over the bases. Joseph Gott wrote to William Gott in Rome describing his, 'I made one for Lord Prudhoe's boy & dog, of Marble, a tint darker than the groupe [sic] which has a good effect'[12]. Prudhoe's marble was probably that shown at the Royal Academy in 1835 (1048). *The London Literary Gazette and Journal of Belles Lettres, Arts, Sciences, etc.* in its review of the exhibition[13] described it as 'conceived with great taste, and executed with equal skill; but a shepherd – man or boy – ought to be watchful'. Gott's figure had been finished by 1832 and was shown at

the British Institution in 1834. After his elevation as Duke of Northumberland, Lord Prudhoe continued to patronise both sculptors. From Gibson he acquired a relief of 'Cupid Pursuing Psyche'.

The account books suggest that the third recorded marble of 'The Sleeping Shepherd Boy' was executed in 1851 for £300 for Col James Lenox (1800–80) of New York who passed it to the Lenox Library which later became the New York Public Library[14]. This order is revealing in that it demonstrates both the willingness of the sculptor to produce, and the desire of a patron to commission, a version of a statue modelled over 30 years earlier. Similar repetitions were made on demand by most sculptors in Rome who had little sense of the proprieties of stylistic development as they are understood today. The account books record that the pointing cost 90 *scudi* and that Baini, Gibson's head workman was paid 84 *scudi* for carving. Ercoli, who is later recorded in connection with the pedestal for 'The Tinted Venus' was paid 1.2 *scudi* for an unspecified task. The value of these sums may be estimated from the 1862 exchange rate of the *scudo* 4s.3¼d, or 22p.

'The Sleeping Shepherd Boy' and 'Mars and Cupid' occupy an important place in the history of British sculpture of the 19th century and in the evolution of Gibson's style. The only pieces modelled by a British artist directly under the supervision of Canova, 'Mars and Cupid' and, especially, 'The Sleeping Shepherd Boy' bear the impress of Gibson's distinctive style.

It is instructive to compare the latter with Canova's 'Sleeping Endymion' acquired by the Duke of Devonshire for Chatsworth, for which the model was completed by 1819. The Shepherd whose beauty entranced Diana is depicted stretched out on the ground sleeping comfortably, watched by his faithful dog. This figure has a sensuousness and amplitude of scale which the younger sculptor carefully eschews. Gibson seldom tackled subjects which required the portrayal of strong emotions. Characteristically, he confined himself to an anonymous shepherd sleeping on a sheepskin. Following Canova's instructions to blend careful study of the living model with antique precedents he derived the pose of the boy from the celebrated antique relief of 'The Seated Endymion seated on Mount Latmos' in the Capitoline Museum which he considered the work of a 'great master'[15]. The pastoral, rather passive character, simplicity of composition and modesty of scale are hallmarks of Gibson's early mature work. A comparison with a 'Shepherd Boy' by Thorwaldsen modelled in July–October 1817 is similarly telling. The alert characterisation and complex open pose of this statue were rejected in favour of a deliberate 'antique' character. In 'The Sleeping Shepherd Boy' Gibson arrived at a coherent style and a working method which he was to follow almost without exception for the next quarter century or so. His 'Narcissus', shown at the Royal Academy in 1838 (1255) and his diploma piece, is a similarly careful amalgam of a study from Roman street life, the living model and antique prototypes. His vision of Greek mythology may seem too decorous, timorous in comparison with the work of those giants Canova and Thorwaldsen; too much Mrs Tighe and too little Apuleius. However, his tenacity of purpose and narrowly focussed concept of Greek art permitted the production of a group of work often remarkable for its intensity of feeling, clarity of design and quality of execution. His early supporters in Liverpool, who worked so strenuously to send their protégé to Rome, would have been much gratified that this early piece has joined the 'Tinted Venus' on display in their city.

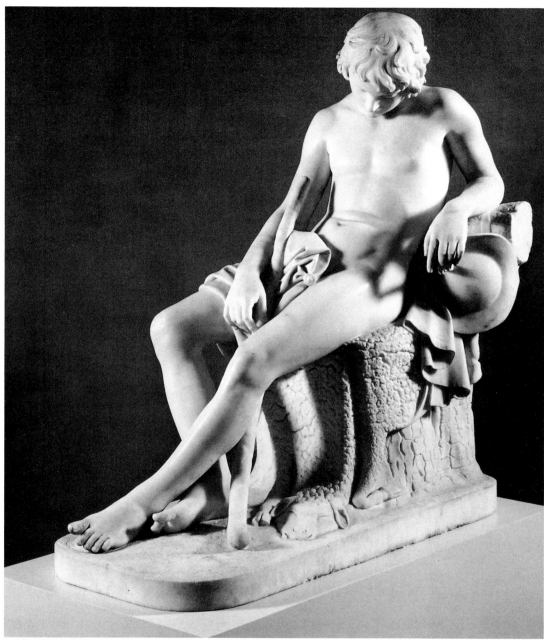

2. J Gibson, 'Sleeping Shepherd Boy', marble, 1830–34, Walker Art Gallery, acquired with the assistance of the National Art-Collections Fund (Fulham Fund)

NOTES

I should like to thank my colleagues at the National Museum of Wales – in particular Mark Evans and Mrs Sylvia Richards and also Mary Bennett for their help in the preparation of this note and MaryAnne Stevens and the staff in the library at the Royal Academy for giving me access to the Gibson papers. All quotes from the latter are made with the kind permission of the Royal Academy of Art.

1 T Matthews *The Biography of John Gibson RA, Sculptor, Rome*, London, 1911, p 31. The author quotes extensively from the manuscript autobiography of the sculpture (private collection).

2 *ibid*, p 40.

3 *ibid*, pp 49–50.

4 *ibid*, p 50.

5 Possibly the version sold Sotheby's Monaco SAN 24 June 1985 (855), apparently unsigned. Reference kindly supplied by Iona Cairns.

6 *Gibson Papers* Gi/1/58 Royal Academy.

7 *Ibid*, G1/1/60 Royal Academy.

8 *Ibid*, G1/1/61 Royal Academy.

9 Duke of Northumberland, sold Christie's 29 October 1988 (307).

10 Account Books, *Gibson Papers*, Royal Academy.

11 *Ibid*.

12 Terry Friedman and Timothy Stevens, *Joseph Gott 1786–1860 Sculptor*, Exhibition catalogue, Leeds and Liverpool 1972, pp 53–54. Letter from Joseph Gott to William Gott 26 May 1832.

13 27 June 1835, p 411.

14 With Daniel B Grossman Inc New York 1988.

15 Matthews, op. cit, p 165.

THE UNIVERSITY OF LIVERPOOL

Janice Carpenter

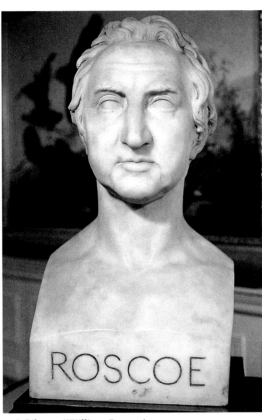

1. J Gibson, 'William Roscoe'

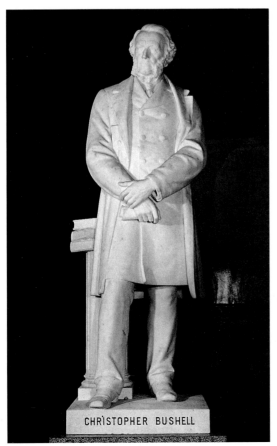

2. A Bruce-Joy, 'Christopher
Bushell', unveiled 1885

Liverpool University was conceived at a Town Meeting in 1878 and opened its doors in 1881 to less than a hundred students. From the beginning it had 'the whole-hearted backing of the citizens and the City Corporation', a commitment which is reflected in its art collections.

It was the successor of several earlier institutions, among them the Liverpool Royal Institution which had been established in 1814 under the presidency of William Roscoe (1753–1831). Roscoe's collection of early Italian paintings is now one of the prizes of the Walker Art Gallery. He also wrote the biography of Lorenzo de' Medici and fostered the early career of John Gibson (1791–1856) who, with Canova and Thorwaldsen, was one of the best neoclassical sculptors of Europe. Just before he left for Italy, Gibson was commissioned to make a portrait bust of William Roscoe. He took the model with him to Italy where he did two versions in marble, one of which he presented to the Liverpool Royal Institution in 1827 'as a grateful tribute to my first patrons, and those who enabled me to study my profession'. He described Roscoe elsewhere as 'a tall magnificent looking old gentleman, his hair white as snow, aquiline nose, thick brows', and this patrician image bears out the description (illus. 1).

The early years of the University College (it did not achieve independent University status until 1903) was a period of growth, and eight major new building projects were completed between 1884 and 1902, mostly funded by merchants and manufacturers, individually or in groups. Several sculptures were presented to specific departments including a life-sized portrait of the dapper little Duke of Albany by his cousin Count Gleichen (1833–91), presented by Lady Walker in 1889 to embellish the Walker Engineering Laboratories and received by the Principal, who expressed the opinion that 'the interest of the building will be enhanced by the statue which will be suitably placed in the Entrance Hall'. More relevant is the heroic-sized statue of Christopher Bushell (1810–87), a philanthropist with a particular interest in elementary education who (with William Rathbone) was one of the first Vice-Presidents of the University Council. The sculpture is by Albert Bruce-Joy (d. 1924) (illus. 2), and was paid for by subscription as a memorial to commemorate his services to education in the City. This was unveiled by the Archibishop of York in the William Brown Library in 1885 but was always destined for a place in the University and the apse of the Victoria Building entrance hall (1892) was designed to frame it. A chair of art had been endowed in 1882 but by 1895 this had been transformed into the School of Architecture and Applied Arts. The Department of Applied Arts (known after its accommodation as the 'Art Sheds') was to be the liveliest and most forward-looking of the art institutions in the City for eleven years. The statue of Christopher Bushell was soon joined by portrait plaques and busts of founders, many by exponents of the 'New Sculpture' including a plaque to George Holt (1824–96), a leading city merchant and benefactor of the University, by George Frampton (1860–1928) and a bust of Henry Tate (1819–1904), the sugar refiner and also a benefactor, by Alfred Gilbert (1854–1934), but mostly by Charles John Allen (1863–1956), a friend and colleague of Frampton who joined the Art Sheds in 1895 and made his career in Liverpool. The elegant plaque to Francis Gotch (1853–1915) (illus. 3), Holt Professor of Physiology, was made in his first year, its use of a low relief style derived from the fiteenth century Italian Renaissance is in marked contrast to the late Classicism of mid-

3. C J Allen, 'Professor Francis Gotch', 1895

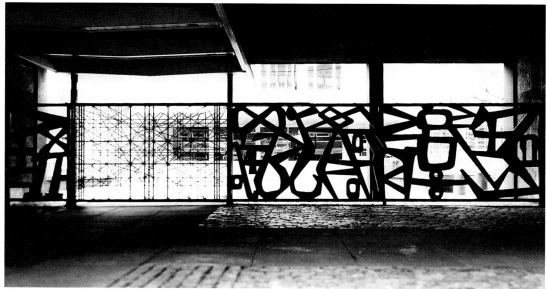

4. J McCarthy, Gate: Mathematics and Oceanography building, 1961

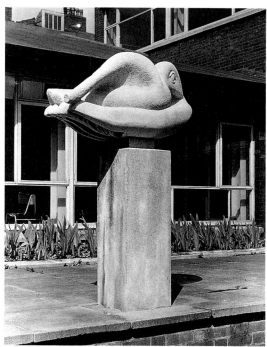

5. M Solomon Cunliffe, 'Quickening', 1952

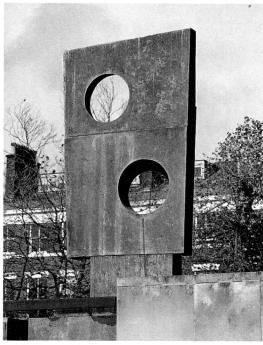

6. B Hepworth, 'Square with Two Circles', c.1963

Victorian works. Frampton and Allen also designed medals for the University, some in conjunction with Herbert MacNair (1868–1955), a founder of the Glasgow School of Art Nouveau, several of which are still in use. Allen shared the contemporary view that sculptors should involve themselves in architectural decoration, providing a terracotta panel with personifications of Physiology and Pathology (said to be modelled from the wives of the relevant professors) to enhance the Thompson Yates Laboratories. His latest work for the University was the War Memorial, a classical design made in 1926.

The sculptural decoration of buildings continued, there are figures on the facade of the Edwardian baroque Ashton Building, the high relief figure on the Harold Cohen Library (1938) was sculpted *in situ* by Eric Kennington (1888–1960) and after 1945 there are still more, the screen and gate to the Mathematics and Oceanography building (1961), for example, was designed by a sculptor, John McCarthy (illus.4), making use of mathematical symbols to create an open-work screen.

The University expanded dramatically after the second War, and a Development Committee was appointed in 1946 to prepare a comprehensive plan for future building. Professor Myles Wright, then planning consultant, stated in 1967 the belief that 'students who will form the future leaders of the nation need to be brought into contact with works of art, and all the more so if these have been lacking in the environment from which they come'. It was on this principle that the University started to buy works of art to embellish its Precinct. These works include tapestries, paintings and prints as well as sculpture, some of which is on a monumental scale. The first significant post-War building was for Civic Design (1950–51) and three abstracted organic forms by Mitzi Solomon Cunliffe (b.1918) relieve the rectilinear severity of its lines, 'Quickening' (illus.5) is the largest, and is placed in the courtyard. This pattern was repeated several times over the years of expansion, which lasted until the late 1970s. Barbara Hepworth's (1903–75) 'Square with two circles' (illus.6) was purchased from the artist for the Senate House (1969) on the understanding that not more than three copies of the work were cast. Hepworth's work has an assured position in twentieth century British art alongside that of

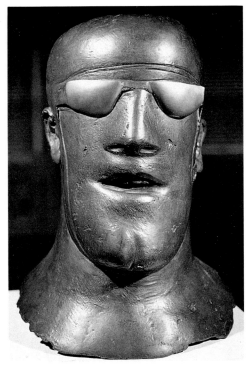

7. E Frink, 'Gogglehead', 1967

8. P King, 'Red Between', 1971

9. J Epstein, 'Oriel', 1931

Henry Moore. It is more abstract, but shows a similar concern with the perfection of form and interval. Sculpture on the scale of 'Square with two circles' developed comparatively late in her career. The funds for this and subsequent purchases have included a substantial contribution from the Arts Council. A smaller work, 'Gogglehead' (1967) by Elisabeth Frink (b.1930) (illus.7), was also purchased for the inside of this building but is now in the University Art Gallery. 'Gogglehead' is a well-known example of her work, which is powerfully expressive of her responsiveness to humanity in all its aspects. Among the latest of the monumental works associated with a new building is Phillip King's (b.1934) 'Red Between' (illus.8), which was made in 1971 and installed by the artist on the ramp outside the Sydney Jones Library in 1977. One of the 'New Generation' of sculptors, King's work opened out in the 1970s, becoming elaborate assemblages of disparate elements. Colour is always important in his work and there are two companion pieces, 'Yellow Between' (Sydney Opera House) and 'Blue Between'. Once an object of much criticism in the University, it has become an accepted feature of the Precinct.

The University has been the recipient of many private gifts and bequests over the years, and small-scale sculptures have come to it in this way, some of which are now displayed in the University Art Gallery (founded 1977 in a late Georgian terraced house, 3 Abercromby Square). A bronze statuette after G F Watts (1817–1904), 'Physical Energy' (1899 *et seq.*) was bequeathed by Sir Sydney Jones (1872–1947), a shipowner and a considerable benefactor to the University and its collections throughout his life. Two other sculptures in the collections prized both for themselves and in memory of the giver are Jacob Epstein's 'Einstein' and 'Oriel' (illus.9), the third and best he made of this subject and a very good example of his vital and sensitive modelling style. They were presented by Lord Cohen CH, a graduate of the Medical School, a brilliant clinician and one of the architects of the National Health Service.

The collection of sculpture built up in these various ways is part of the history of the University, and also reflects the attitudes of the times in which they were acquired: portraits of their founders and members are traditional in Universities; the attitudes to architectural decoration taken up in the late nineteenth century and perpetuated thereafter are those of the New Sculptors; and the concept of spending a small percentage of the cost of a building on art was current after the second War, particularly on the Continent. The number of monumental sculptures is small in relation to the number of buildings on the Precinct. In the early years, when the City itself was acquiring fine buildings luxuriously decorated, the University was acquiring quite modest sculpture in terms of both size and numbers – the bronze bust of William Rathbone (1819–1902), one of the prime movers in the foundation of the University, by Charles John Allen should be compared with the bronze of heroic size of the same subject by Frampton in St John's Gardens to point the contrast. The reasons are not far to seek: in the early years the University was of modest size and its funds came entirely from individual benefactors, these same benefactors also gave sculpture and other works of art, they were generous but their resources were not limitless and they were engaged in raising the great buildings of the city centre at the same time. The number of monumental sculptures acquired since 1945 is larger, reflecting the increased size and financial independence of the University in a city struggling first with the aftermath of war and later with declining prosperity.

The sculpture collection is a monument to the determination of the University and its benefactors to provide its students with an education in the culture as a whole, not simply in their chosen subjects.

PHILIP HENRY RATHBONE 1828-95

His involvement and influence on the
sculptural decorations on St George's Hall

Anne MacPhee

Philip Henry Rathbone was a member of the influential Liverpool merchant family. His elder brother was William Rathbone, Liberal MP for Liverpool and one of the founders of University College Liverpool. The family were well known Unitarians and philanthropists who had supported the abolition of the slave trade. After a career in insurance adjusting, Rathbone joined Liverpool Town Council in 1867 as a Liberal. For 28 years he was a member of the Council Committee overseeing the arts in Liverpool. He effectively controlled the Walker Art Gallery from its beginning in 1877 until his death in 1895 by his influence as treasurer, chairman or deputy chairman of the Arts and Exhibitions Sub Committee.

Rathbone's own taste in art was eclectic and catholic, he was keen to promote avant-garde art[1]. This is shown by his commissioning of the sculptor Jules Dalou to make a bust of his wife Jane[2], between 1871 and 1877. The bust is now in a private collection on Merseyside. Rathbone was involved in a number of controversies where his more advanced artistic taste was in opposition to that of his fellow committee members, Liverpool City Council and the Liverpool public in general. One such controversy surrounded the commissioning of decorative panels for St George's Hall for which Rathbone's father when he was Lord Mayor of Liverpool had laid the foundation stone in 1838[3].

Following the family tradition of civic duty and philanthropy it was Rathbone who brought to the attention of the City Council the fact that the exterior of St George's Hall was still without the sculptural decoration that the architect Harvey Lonsdale Elmes had envisaged in 1840. In response to this an open competition was held by the Council in 1882. A circular was issued to artists who were invited to compete for the decoration of 28 panels. There were 39 entries. The winner was Thomas Stirling Lee who was 29 years old; he had been initially trained at the Royal Academy Schools and then at the Ecole des Beaux-Arts in Paris and later in Rome, where he accompanied Alfred Gilbert. Lee's enthusiasm for French naturalism made him an uncharacteristically avant-garde choice for Liverpool[4]. After he had won the competion, Lee both designed the panels, and drew up a grand scheme for sculpture to fill the vacant bases, panels and friezes of the Hall, thus making a bid to fulfil the original design concept of the architect. At that point it was decided by the Council to begin the commission with 12 low reliefs. A provisional contract was given to Lee for the first two reliefs only. He had submitted rough designs in a sketchbook for the first five designs, and was still working on the sixth[5]. The theme, with written explanations, was 'The Progress of Justice'. The subjects were all connected with the development of Justice conceived as a series of allegorical reliefs tracing the growth of a woman personifying Justice. The theme was appropriate given that one function of St George's Hall was permanent law courts.

The first completed panel was sent to Liverpool in 1885, it had been carved directly from Istrian marble. The subject was: 'Joy follows the Growth of Justice led by Conscience directed by Wisdom'. It was criticised as being out of keeping with the building by the Liverpool Society of Architects; more importantly it provoked hostility and derision from the general public[6]. The principal source of the controversy centred round the allegorical use of a poor, naked 10 year old girl child to represent Justice. A move was made by the Council to end Lee's contract but it was outvoted and he continued with the second panel. The Council sent Rathbone to London to report on it.

Panel 1. T Stirling Lee

Panel 2. T Stirling Lee

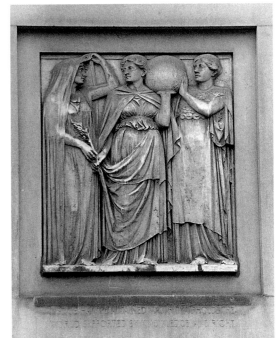

Panel 3. T Stirling Lee

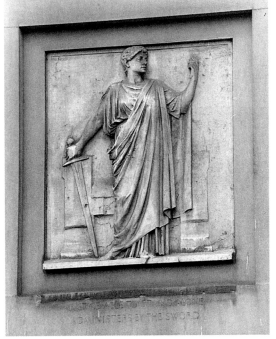

Panel 4. T Stirling Lee

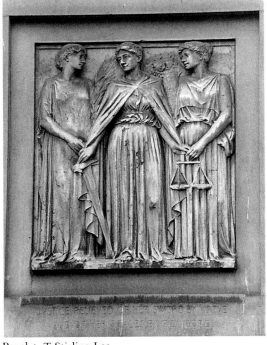

Panel 5. T Stirling Lee

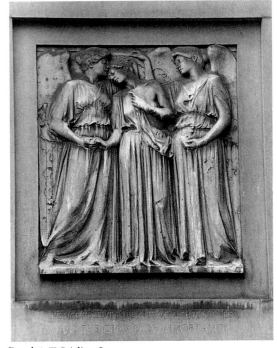

Panel 6. T Stirling Lee

Justice was again depicted as naked, symbolising her purity. Lee had entitled it 'Justice was not to be diverted by Wealth and Fame'. Rathbone was enthusiastic about the panel. He found support for his argument from Thomas Armstrong, director of the South Kensington Schools. Armstrong thought that 'the breasts required stiffening in order to look more monumental and virginal'[7]. Rathbone wrote that 'the composition was good and the panel in my opinion generally satisfactory[8].

The first two panels were unveiled together and provoked more strong public reaction. The hostility was directed at the realism of the naked figures and the idea that Justice could be interpreted as a vulnerable 'gutter child'[9] or an adolescent girl verging on womanhood. It was stated in the local press that the panels were obscene and would encourage the sale of pornography. The Council felt that the strong reaction from the public had to be acknowledged, so the project was stopped and the contract with Lee terminated. However, the scheme did not die here, for Rathbone received support for his advocacy of Lee's sculpture from the Professor of Art, W M Conway of University College Liverpool, whose chair had been principally endowed by Rathbone in 1886.

According to Conway's own *Memoirs* it was partly in order to gather broader support for the sculpture that it was decided to hold an Art Congress in Liverpool, intended to be the first in a series of Congresses to fulfil for art the function performed for science by the British Association. With Rathbone's help the Lord Mayor of Liverpool gave his backing to the Congress and a council meeting was held in which the necessary resolutions were passed. Professor Conway raised one thousand pounds towards the costs. The next step was to approach the President of the Royal Academy, Frederick Leighton, for his support, which was eventually given provided the Royal Academy should not be attacked at the Congress[10]. Once Leighton had been recruited others followed and Conway then formed the National Association for the Advancement of Art and its Application to Industry. The Art Congress was held in Liverpool in December 1888[11]. Philip Rathbone was one of a committee of eighteen. He was also secretary to the section for the National and Municipal Encouragement of Art. The Congress was attended by a thousand members and the section meetings gave rise to intense debate, especially in the Sculpture Section. The question of St George's Hall was raised and very strong criticism of the action of

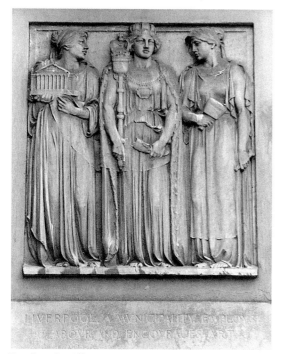

Panel 7. C J Allen

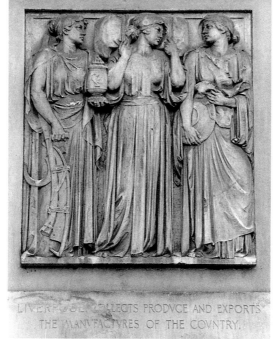

Panel 8. C J Allen

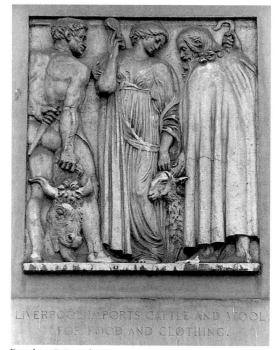

Panel 9. C Dressler

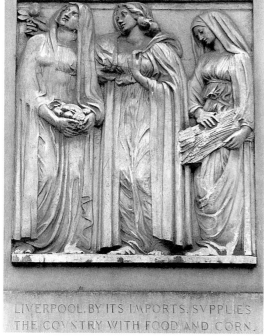

Panel 10. C Dressler

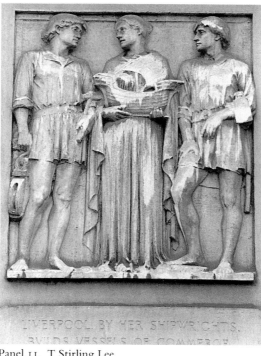

Panel 11. T Stirling Lee

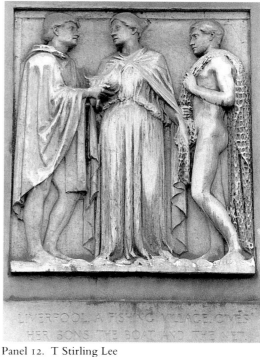

Panel 12. T Stirling Lee

Liverpool City Council was expressed. Although Conway suggests in his Memoirs that this was the secret purpose of the whole meeting it is difficult to believe that a conference of such size would have been arranged and so well supported if it was not responding to the needs and wishes of interested individuals with much broader concerns than the Liverpool commission. By some blunder no resolution was passed, and the City Council ignored the adverse opinion[12].

In the following year the Congress was held in Edinburgh. The St George's Hall question was again brought up and this time a resolution was drawn up to be passed, first by the Sculpture Section then by the whole Congress. It called upon Liverpool City Council to reverse its action in terminating the contract with Stirling Lee. The resolution was duly adopted, circulated and received the support of almost the whole Congress. Philip Rathbone presented it to the City Council which then gave up its opposition and the work was ordered to proceed[13]. Rathbone meanwhile had offered to pay for the remaining four panels which cost £2,000 and the Council accepted his offer.

In 1894 a letter was sent by Rathbone to the Finance Committee declaring that the remaining four panels were completed and that they should be handed over into the charge of the Finance Committee as trustees for the Corporation. He also wrote that the Committee should not remove or add drapery to the panels for two years; this stipulation had been agreed when the council had initially accepted his offer[14].

Professor Conway had by now left Liverpool for London and followed the progress of the four remaining panels, visiting Lee regularly at this London studio. At the unveiling ceremony Philip Rathbone in his address said 'I cannot forget that I am standing here where 56 years ago my father first laid the stone of this great temple of justice and art of which today we are so proud. I cannot thank you too much fellow citizens, for allowing me to continue the work that my father began'. He continued 'I am only too grateful that you have allowed Mr Stirling Lee to have expressed so worthily and in so dignified a manner ideas which without the aid and sympathy of a great town, might have died for ever'[15]. Stirling Lee was then asked to speak. He began by thanking his patron. 'As an artist, I have come to know that the same spirit that moved the citizens of old to beautify their town is not dead but lives on in its fulness in Alderman Philip Rathone'. He ended 'I thank you again my Lord Mayor, Alderman, people of Liverpool, Alderman Philip

Rathbone I have no words to express what I owe you both as an artist and as a man'[16].

Professor Conway could not be present at the ceremony but sent a letter to Rathbone: 'I congratulate the artist, yourself and Liverpool upon the completion of the first half of a most important work destined to be for, I hope, countless generations a valuable possession to the city and a monument of enlightened liberality'[17]. Rathbone was presented with an illuminated vote of thanks from the city council for his gift.

There was little in the subsequent four panels to arouse controversy. They lacked the dynamism and energy of the first two panels which invite a sequential interconnected reading from left to right. The next four panels had instead a hieratic self-contained frontal depiction using more traditional and, perhaps more importantly, clothed figures. One wonders whether Lee was playing safe with a view to gaining an extension of the commission in order to complete his ambitious proposal for the remaining sculpture for the Hall. Lee had, in his initial winning scheme of 1882, proposed that he would fill the vacua above the panels with winged figures relating to each of the panels. Over each of the first five panels there would be the Spirits of Wisdom, of Counsel, of Strength, of Justice, and of Peace, and over the last an idealisation of Eternal Light[18].

By June of next year, Rathbone had written a report on the proposed completion of the St George's Hall decoration which was published in the local Press. The object of the report was to urge upon the City Council the desirability of completing the series of bas reliefs on the east side of the Hall at once and after that of completing the statues, friezes and pediments in the grand scheme envisaged by Harvey Lonsdale Elmes. Philip Rathbone wished to secure the services of the best young English sculptors, Thorneycroft, Bates, Onslow Ford and Gilbert[19].

Hostility to the report was expressed in the local Press. An anonymous spokesman of the architectural and sculptural profession who signed himself 'Armac' declared that 'there were several local men quite competent to execute the proposed work on St George's Hall and that it was not necessary for Alderman Rathbone to go to London to get it executed nor for buying men from London to Liverpool to undertake it'[20].

To reinforce 'Armac's view, 'Liverpudlian' wrote a few days later that 'whenever a work of art is to be executed certain individuals in authority go straight to London to have it done without even consulting local artists. Alderman P H Rathbone is credited with being one of the chief offenders in this respect'[21]. The report was possibly intended to keep both the City Council's and public interest alive in finishing the decorative scheme for St George's Hall. By 25 August 1895 Rathbone, in a private letter to Stirling Lee, asks him to make two panels of the remaining six and he mentions that he has asked Charles Allen, the local Professor of Sculpture, to do two to satisfy the 'localists' and 'to prevent the work being thrown to open and public competition'[22], as this would have delayed completion. Rathbone expressed concern that a change of Council members might lead to a drop of interest in the completion of the project[23].

It is clear from the letter to Stirling Lee that Rathbone wished to move as rapidly as possible to ensure quick completion of the remaining six panels with a view to commencing the statues as soon as possible. From the tone of the letter it is clear that Rathbone was moving in opportunist and pragmatic lines. Of the remaining six panels, two were done by Lee, two by Professor Charles Allen and two by Conrad Dressler who had local connections. Dressler worked with Harold Rathbone, Philip Rathbone's son, at the Della Robbia pottery in Birkenhead. Rathbone writes 'I should try to start the statues which I am very anxious as I know you are also and of which I should try my utmost to do'[24]. This comment was particularly poignant as his own death occured less than three months later. It is possible that Rathbone may have known that he was ill and been aware that no member of the

Council or other Liverpool citizens would take up his advocacy and financial support of the scheme. It is clear from Philip Rathbone's letter that despite the difficulties over the panels he was determined to see the completion of all the sculpture for the Hall. Rathbone hoped that it might be possible to induce the great commercial societies each to undertake one of the set symbolising the trades by which the prosperity of Liverpool has been secured. Some sense of the importance that he attached to the completion of the sculpture is conveyed by his comparison between it and the Renaissance decoration 'in the Church of Orsan michele at Florence'[25].

The remaining six panels on the North end of the east facade were completed by 1899 at a cost of £3,000 to the Council[26]. Their theme was National Prosperity represented by the commerce that gave rise to Liverpool's growth. Allegorical figures were used; they could be identified by images of food and corn, of cattle and wool and of ships and nets. These last six panels, executed by Stirling Lee, Professor C J Allen and Conrad Dressler, lack the poetic symbolism of Lee's first two panels. St George's Hall still awaits the completion of the sculptural decoration envisaged by its architect.

NOTES

1 Edward Morris, 'Philip Henry Rathbone and the Purchase of Contemporary Foreign Paintings for the Walker Art Gallery Liverpool 1871 – 1914', *Liverpool Bulletin*, Vol VI, 1975 – 6.

2 Dalou, the French artist, and friend of the painter Alphonse Legros, was forced to flee Paris for the part he took in the Commune of 1871. He was in England for eight years and taught at the South Kensington Schools with Legros. They had considerable influence on late nineteenth-century English art introducing a greater naturalism by working directly from life.

3 The money for the Hall was in the first place raised by means of subscriptions. The shares were offered at £25 each; within a few months £25,350 had been raised. This sum, however, was for a concert hall only. The total cost as a dual function building incorporating law courts was more than £300,000. The Law Courts Committee of the Council undertook both the building costs and the future management costs.

4 According to Susan Beattie in *The New Sculpture*, New Haven, 1983, other entrants included Hugh Stanus (Alfred Stevens' pupil) and W S Frith, a teacher of Sculpture at Lambeth School of Art, who came third. Most were second rate sculptor-decorators.

5 Liverpool Record Office, St George's Hall Album, Vol 1.

6 *Builder*, 1890, vol 58, p 179. Liverpool Recc ro Office, St George's Hall, Album Vol 1.

7 Philip Rathbone, letter, 23 July 1896 addressed to the Finance Committee. (St George's Hall Album, Vol 1).

8 *ibid*

9 Joseph Boult in a paper prepared for the Liverpool Art Congress of 1888 and never delivered. See *British Architect*, 1888, vol 30, pp 429–30 and Susan Beattie, *op.cit*.

10 According to Professor Conway, Liverpool was considering buying a picture by Leighton at that time. See Lord Conway of Allington, *Episodes in a Varied Life*, London, 1932, pp 84–87.

11 The Congress was attended by William Morris, Holman Hunt, Onslow Ford, Alma Tadema, Alfred Gilbert and Walter Crane.

12 Conway, *op.cit*.

13 See John Willett, *Art in a City*, London, 1967.

14 *Liverpool Mercury*, 25 May 1894.

15 *Liverpool Mercury*, 25 May 1894.

16 *Liverpool Daily Post*, 24 May 1894.

17 *Liverpool Mercury*, 25 May 1894.

18 *Liverpool Daily Post*, 24 May 1894.

19 *Manchester Guardian*, 5 June 1895. The original report by Rathbone appears in the *Liverpool Mercury*, 1 June 1895.

20 *Liverpool Mercury*, 5 June 1895.

21 *Liverpool Mercury*, 8 June 1895.

22 Walker Art Gallery Archives, Rathbone Letters; 25 August 1895.

23 *ibid*.

24 *ibid*.

25 *ibid*.

26 *Liverpool Mercury* 6 June 1895, report of the City Council Meeting of 5 June 1895 agreeing to expend £3,000 on the completion of the panels.

JAMES SMITH OF LIVERPOOL AND AUGUSTE RODIN

Edward Morris

1. Auguste Rodin (1840–1917), 'L'Amour qui passe', bronze, height 39 cm, NMGM, Walker Art Gallery (Inv. 3176). Bequeathed by James Smith 1927.

In 1908 James Smith[1], a Liverpool wine merchant, bequeathed most of his art collection to the Walker Art Gallery; on his death in 1923 and on that of his widow in 1927 these collections passed to the Gallery; they included six sculptures by Auguste Rodin which Smith had bought between 1899 and 1907. Smith was born in Paisley in 1831; his family, who were not wealthy, moved to Ireland in 1836 and then to Liverpool in 1851; in Liverpool his success as a wine merchant soon enabled him to support his family – he was a pioneer in the importation of light Mediterranean wines and was stated to have been the best judge of claret in England; politically he was a 'well informed and hearty Non-conformist Liberal'. Like another contemporary Merseyside collector, W H Lever, later the first Lord Leverhulme, he was a pioneer in the use of 'artistic advertising' but unlike Lever he did not allow his collecting to be influenced by his advertisements. In 1881 while on holiday at Moniaive in Dumfriesshire he met James Paterson, one of the 'Glasgow Boys' and he became one of Paterson's first patrons. However, at first he was more attracted by English idealism than by Paterson's Scottish blend of French realism and between about 1890 and 1905 he bought some thirty paintings by G F Watts, many directly from the artist but also some from the Rickards, Carver, Leighton, Galloway and Leighton sales. A considerable number of these paintings were small replicas or sketches of earlier works but they identify Smith as one of the last representatives of the well established – and often despised – tradition whereby northern business men patronised contemporary British art. Watts's paintings were however anything but meretricious and undemanding and the two old men corresponded extensively between 1890 and Watts's death in 1904 with the artist occasionally elucidating for Smith's benefit the meaning and purpose of his paintings; after 1904 it was Watts's widow who had to explain to Smith – for example – that the horse in Watts's 'Rider on the Red Horse' did in fact have ears but that they are 'laid back as flatly as vice could lay them'[2]. Watts was charging Smith around £500 for each small picture – explaining that he needed the money to pay for his wife's philanthropic and building schemes – and visitors to the Watts Gallery and Mortuary Chapel should be aware that they were partly financed by the profits of the Liverpool wine trade. Smith valued Watts's artistic judgment and sought his opinion on his favourite artists – W L Windus, A J T Monticelli and D A Williamson – but there is no evidence in the surviving letters that Watts recommended Rodin to him. Rodin did not visit Watts until after Smith had started buying from him and in any event Watts's opinion of Rodin was not high[3] – even Rodin's 'Le Penseur' was insufficiently intellectual for Watts – but perhaps at least the seriousness of purpose discernible in Smith's choice of his sculptures by Rodin was derived from the Liverpool wine merchant's discussions on art with Watts.

However, it was to Paterson's Glasgow that Smith turned in order to buy his first sculpture by Rodin; in 1899 Alex Reid[4] sold to him 'L'Amour qui passe' (illus.1), one of Rodin's small bronzes. Reid's father was a minor Glasgow art dealer and Reid himself went to Paris in 1886 to re-start the ailing family business; there he became a close friend of Vincent van Gogh who encouraged him to buy paintings by Monticelli. Monticelli, much admired by van Gogh, had just died releasing a large number of his paintings on to the market and he was already popular in Scotland where he was well represented both at the Edinburgh International Exhibition of 1886[5] and at the Glasgow Inter-

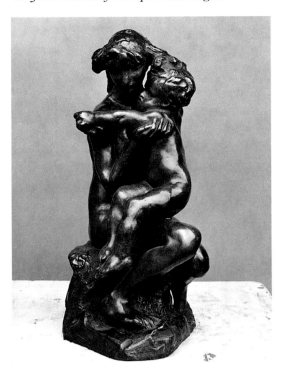

2. Auguste Rodin, 'Frère et Soeur',
bronze, height 39 cm, NMGM, Walker
Art Gallery (Inv. 3177). Bequeathed by
James Smith 1927.

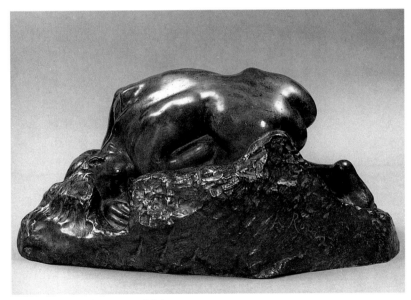

3. Auguste Rodin, 'Danaïde', bronze,
height 30.5 cm, NMGM, Walker Art
Gallery (Inv. 4179). Bequeathed by
James Smith 1927.

national Exhibition of 1888. Late in 1888 Reid returned to Glasgow with a considerable number of paintings by Monticelli, bought through Monticelli's Paris dealer Joseph Delarebeyrette, as well as works by Corot, Courbet, Daumier, Boudin, Degas and Barbizon artists – thus occasioning an angry outburst from van Gogh who accused him of preferring dead artists to the living. Back in Glasgow in the 1890s Reid sold his pictures by Monticelli for high prices[6] to William Burrell of Glasgow, to W A Coats of Paisley, to Alexander Young and to James Smith who bought at least three from Reid between 1892 and 1902[7]. In 1892 Reid started buying small bronzes by Rodin from the artist and, subsequently, from Parisian dealers[8]; he liked the playful two figure intimate groups inspired by late 18th Century art but with a preference for the domestic rather than the erotic types[9]. By 1901 Burrell, like Smith, owned a version of one of these, the 'L'Amour qui passe'[10], and it is probable that he, as well as Smith, was buying works by Rodin from Reid in the 1890s. Smith's wine importing business presumably took him frequently to Paris and his wife could write in French with reasonable ease; thus it is not surprising that, having bought one Rodin bronze from Reid in 1899, he should have acquired in 1901 his second work by Rodin, a bronze 'Frère et Soeur' (illus.2) from Glaenzer, a Parisian dealer[11] – although it was very much of the same type that Reid was selling and, indeed, Reid had bought versions of this bronze group from Rodin in 1892–93 and in 1900. Glaenzer did not have a bronze 'Frère et Soeur' in stock and so had to order one from Rodin for 2100 francs – Reid had been paying 1200–1400 francs for these small bronzes in the early 1890s but in 1901 seems to have driven Rodin down to 1000 francs each, indicating perhaps that his profit margin on Rodin bronzes was considerable. Smith evidently was pleased with his 'Frère et Soeur' as only about two months after receiving it he sought permission through Glaenzer to see Rodin's recent work, a request repeated in 1902 and 1903. It is not clear whether or not he was successful in 1901 and 1902 but the two men certainly met in 1903. Back in the autumn of 1901 however Smith seems to have seen in the Luxembourg museum a marble version of Rodin's 'Danaïde' (illus.3) and he immediately placed an order for a bronze version of it through Glaenzer to whom Rodin quoted a price of 3325 francs. Due to an accident during casting it was not delivered to Glaenzer until 31 December 1902. In the same year Smith bought from Rodin a bronze 'Eve' (illus.4) probably having seen it at the 1901 Venice Biennale where Rodin exhibited twenty works including (as no.15) 'Eva (bronzo)'. It was on 25 September 1903 that Smith, now the owner of four Rodin bronzes[12], seems to have first visited the artist's studio where he saw and immediately ordered a marble 'Mort d'Athènes' (illus.5) at a price of 12,000 francs; by 26 October it had been delivered to The Knowle, Smith's home at Blundellsands, near Liverpool. Thereafter Rodin and Smith corresponded fairly regularly at least until 1907[13] and met on a number of occasions both in London and Paris[14]; on 9 November 1905 Rodin sent to Smith a photograph of his bust 'Minerve au casque' (illus.6) which Smith ordered after only a few days' hesitation; the price was 6,000 francs but there were again problems at the foundry with the helmet and the bust did not reach Blundellsands until the autumn of 1907. Smith then, having first been attracted to Rodin's small decorative bronzes in Britain, saw in Paris and Venice the more powerful and expressive works derived from 'The Gates of Hell' and was deeply impressed; so indeed was Rodin's first English biographer, Frederick Lawton, at about the same time, and his description of the 'Eve' and of the 'Danaïde' published in 1906 may be quoted in default of Smith's. Of the 'Eve' he wrote[15]:

> The sculptor has represented the traditional first woman standing with the weight of her body supported on the right leg, while the left foot, resting on a stone, raises the left leg slightly in a pose of shamefastness that accords with the stoop of the shoulders, the bent-down head, and the arms crossed over the palpitating bosom. All the

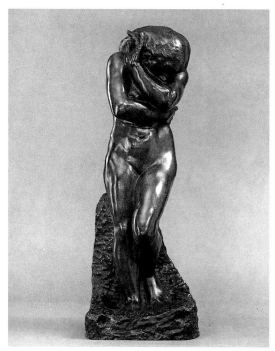

4. Auguste Rodin, 'Eve', bronze, height 76 cm, NMGM, Walker Art Gallery (Inv. 4180). Bequeathed by James Smith 1927.

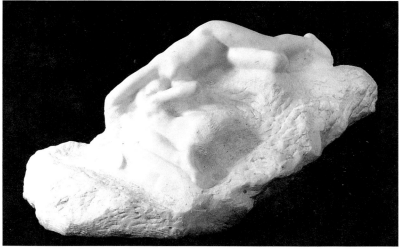

5. Auguste Rodin, 'La Mort d'Athènes', marble, height 42 cm, NMGM, Walker Art Gallery (Inv. 4182). Bequeathed by James Smith 1927.

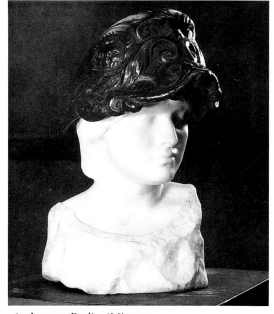

6. Auguste Rodin, 'Minerve au Casque', marble and bronze, height 48 cm, NMGM, Walker Art Gallery (Inv. 4181). Bequeathed by James Smith 1927.

figure is seen to be stirred and thrilled with the presentiment of coming motherhood. This was the first full-length and full-size female statue that Rodin had put on public exhibition. Many others were to follow, yet without depriving it of its right to rank among the best. There was the same mastery of feminine physiology as he had shown of the masculine, the virile being transformed into soft melting grace.

He found the 'Danaïde' no less moving[16]:

> The 'Danaïde', in marble, which visitors to the Luxembourg will remark as one of the suavest female forms which the sculptor has begotten, was finished also towards the end of the eighties. It is the nude figure of a young and beautiful woman lying sideways on some rocky ground, and in a paroxysm of woe. It is the classic myth which is embodied, and humanly. The face is half-buried; the dishevelled hair trails round it and over the broken water-jar; the fair limbs are weary of their external toil in Hades. There is exquisite research of rhythm in the contours of this masterpiece. Its subdued pathos softly touches more than one chord of the heart.

By contrast the 'Mort d'Athènes' and the 'Minerve au casque' represent perhaps the more relaxed classicism of Rodin's maturity and the aged Liverpool wine merchant can easily be imagined sitting under Watts's philosophic canvases and spinning round the 'Mort d'Athènes' and the 'Danaide' on the two turntables which he ordered from the sculptor for the display of the sculptures in his home amidst the opulent north Liverpool suburbs.

Although Smith was among the earliest of Rodin's British patrons he was by no means a pioneer in the international acceptance of Rodin who had already become by about 1900 probably the first sculptor since Canova to have a European reputation. He was well represented at the first exhibition in London of the International Society of Sculptors, Painters and Gravers in 1898 and at the Vienna Secession Exhibition of the same year while in 1899 a travelling exhibition of his work went to Brussels and Amsterdam; in 1901 his work could be seen on a considerable scale at the Berlin Secession and at the Venice Biennale; he organised a major retrospective exhibition of his sculpture at the Place de l'Alma in Paris in 1900 in association with the Exposition Universelle. In Britain plasters by Rodin had been purchased for the Glasgow City Art Gallery at the 1888 and 1901 Glasgow International Exhibitions while in 1902 a group of subscribers presented a bronze version of the 'Saint Jean-Baptiste prêchant' (illus.7) to the Victoria and Albert Museum. In 1903 Rodin became president of the International Society of Sculptors, Painters and Gravers and he was in London in

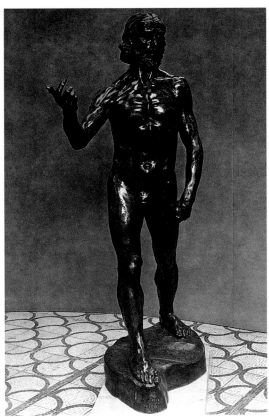

7. Auguste Rodin, 'Saint Jean-Baptiste prêchant', bronze, height 201 cm, Victoria and Albert Museum. Presented by subscribers 1902.

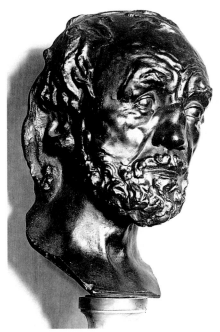

8. Auguste Rodin, L'Homme au nez cassé', bronze, height 31.5 cm, Museum of Art, Rhode Island School of Design, Providence (Inv. 21.341). Gift of Mrs Gustav Radeke (formerly in the Ionides Collection).

1902, 1903, 1904, 1906 and 1907 either in connection with his official duties in this capacity or as the recipient of formal banquets, honorary degrees, royal interviews and aristocratic commissions. These public accolades and the international private patronage which went with them were of considerable importance to Rodin as they enabled him to abandon official work in favour of the development of his highly personal imagery during the last fifteen years of his life – just as fifty years earlier cosmopolitan clients had emancipated Ary Scheffer and Paul Delaroche from the Salon and from public commissions. Thus, the origins of Rodin's reputation in Britain, which lay in the less exalted world of literary cliques and artistic tuition, are of considerable significance.

British enthusiasm for French art in the 1870s and in the early 1880s was deeply indebted to the literary circle of Robert Louis Stevenson and of his brother R A M Stevenson, a circle which included W E Henley, Edmund Gosse and Sidney Colvin; all five wrote on contemporary art in these years – probably from necessity rather than choice as there was a ready market for art criticism in late Victorian Britain – and their taste was avowedly Francophile. However, Rodin's first links with England reflected the Parisian orientation of an earlier and greater poet: Robert Browning. Browning's son, Robert Wiedeman Browning, seems to have become a pupil of Rodin as early as 1877 or 1878 possibly on the advice of his father's French friend and commentator Joseph Milsand[17]; later poet and sculptor met in Paris, exchanged letters on the progress of Robert Wiedeman and a cast of 'L'homme au nez cassé' (illus.8) was already in the poet's collection by 1882[18]. By this time, however, Browning's interest in French art was confined to the career of his son and it was another poet, W E Henley, who established Rodin's reputation in England. Henley first met Rodin in London during the late summer of 1881, the introduction having been effected by Alphonse Legros, a fellow student of Rodin at the Petite Ecole in the 1850s but by the 1880s a professor at the Slade School; Henley introduced Rodin to Robert Louis Stevenson in Paris that same autumn and by November 1881 he had, like Browning, a version of 'L'homme au nez cassé' – of which indeed a cast was exhibited at the 1882 Grosvenor Gallery exhibition and ten casts had been sold in England by 1889 including one acquired by Frederick Leighton[19] – and when Henley took control of the *Magazine of Art* in 1881, with Sidney Colvin monitoring his performance, its readers were immediately informed that Rodin was 'perhaps the greatest of living sculptors'. Henley and his contributors lavishly praised[20] Rodin and all the sculptures exhibited by him in England until 1886 when Henley's advocacy of advanced French art lost him the editorship of a journal heavily dependent on middle class taste[21]. French sculpture was principally admired in Britain for its realistic modelling but even when discussing a portrait bust Henley was more enthusiastic about Rodin's expressive powers: 'It is realistic in the highest sense of the word – an expression of nature which while literally exact in form, is literally exact in spirit also; a presentment of fact alike external and essential'[22]. Edmund Gosse, the other member of the Stevenson circle deeply interested in contemporary French sculpture, saw Rodin quite differently, criticising Rodin's picturesque and painterly surfaces: 'these broken lines and exaggerated forms' and seeing only 'cleverness', together with 'a dry and tortured composition' in the 'Saint Jean-Baptiste prêchant'[23]. Henley had been converted to art by seeing Millet's late and Romantic 'Gardeuse de dindons, l'automne' (illus.9) with R A M Stevenson at the newly opened Hanover Gallery in London in 1880; he wrote about the picture to Colvin: 'O Colvin, Colvin! Why will you not make an art critic of me? I am not a bloody fool, for I can feel and see and be religious over great art. We went and looked through the Grosvenor afterwards and Lord! how poor it all seemed! Beside that solemn fateful figure, those mysterious birds, that fatidic landscape, that prophet's tree – but why do I rave?'[24]. In the following year his introduction to a volume of

9. Jean François Millet (1814–1875), 'Gardeuse de dindons, l'automne', canvas, 81 x 99.1 cm, Metropolitan Museum of Art, New York (Inv. 17.120.209). Bequest of Isaac D Fletcher 1917, Mr and Mrs Isaac D Fletcher Collection.

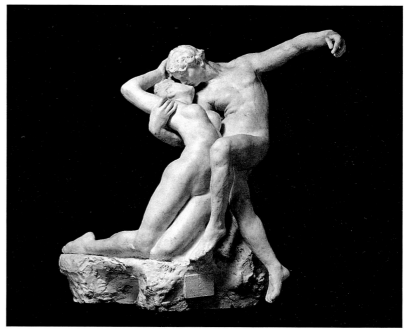

10. Auguste Rodin, 'L'Eternel Printemps', plaster, height 66 cm. Inscribed: *A R L Stevenson–au sympathique–Artiste au grand–et cher poète A Rodin*. Philadelphia Museum of Art Rodin Museum (Inv. 53–26–1). Given by Paul Rosenberg (formerly in the collection of R L Stevenson).

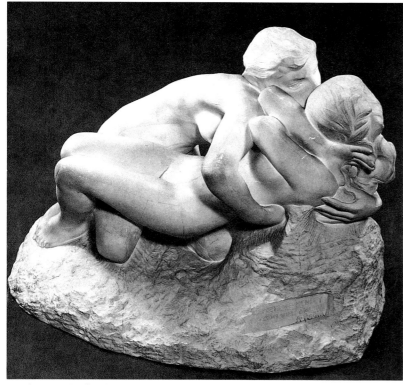

11. Auguste Rodin, 'Les Métamorphoses d'Ovide', plaster, height 34 cm. Inscribed: *Au poète W E Henley–son vieil ami–A Rodin*. Victoria and Albert Museum (Inv. A.117–1937). Bequeathed by Charles Shannon.

reproductions of Millet's prints published by the Fine Art Society was described derisively by Ruskin as 'an expression of the influence of the Infinite and Michael Angelo on a mind innocently prepared for their reception'[25]; Ruskin's article was in effect an attack on French Romantic literature and Henley's expertise in this area made his Catalogue of the 1886 Edinburgh International Exhibition[26] probably the first coherent account in English of French Romantic art; if, therefore, Rodin is seen as the last – or at least the greatest – Romantic sculptor, Henley's enthusiasm, which does not seem to have extended to any other contemporary French artist, seems consistent; 'Rodin's art' he concluded, 'is an expression of passion'[27]. Robert Louis Stevenson, whom Henley had introduced to Rodin, admired Rodin for the same reason: Edward Armitage had written to *The Times* in 1886 condemning Rodin as a mere coarse realist and Stevenson replied insisting on his 'noble expression of noble sentiment and thought'; he went on: 'The public are weary of statues that say nothing. Well here is a man coming forward, whose statues live and speak, and speak things worth uttering.' Significantly Rodin sent to Stevenson a plaster version of 'L'Eternel Printemps' (illus.10), one of the works which Stevenson had praised for its high mindedness in his letter to *The Times*[28]. Similarly, Henley owned a plaster version of Rodin's 'Les Métamorphoses d'Ovide' (illus.11) and both works had that urgent passion which the two writers so much admired in Rodin. As for Henley his own poetry was noted for its violence of form and expression but any relationship between it and his enthusiasm for Rodin would be hard to establish; he condemned Decadence and Aestheticism yet admired Whistler's Thames paintings – at least for their sense of Romantic evocation[29].

Henley's final and most considered plea on behalf of Rodin was a brief, improvised article of 1890 in *The National Observer*[30] but the two men continued to correspond until Henley's death in 1903[31] and Rodin's bust of Henley, begun in 1884, was one of the poet's most prized possessions; in 1907 a version of the bust was placed on the poet's tomb in St Paul's Cathedral (illus.12) and an *éloge* by the sculptor read out[32].

Another eminent British man of letters to spread Rodin's fame in England was the Symbolist poet and critic Arthur Symons – like

12. Auguste Rodin, *Monument to W E Henley*, bronze and marble, St Paul's Cathedral, London. Copyright Courtauld Institute (Conway Library, negative No. A84–254). According to Lawrence Weaver, *Memorials and Monuments*, London, 1915, p 142, the niche was also designed by Rodin.

Henley very much in the circle of Edmund Gosse[33]. Symons first met Rodin in 1890 but did not write about him until 1902; his first published art criticism was appropriately devoted to Odilon Redon – and he later wrote on Gustave Moreau as well as on Blake and Watts – thus, he emphasises in Rodin's work not only passion and ecstasy but also symbolism and thought: 'Rodin is a thinker, as well as a seer; he has put the whole of his intelligence into his work not leaving any fragment of himself unused. And so this world of his making becomes a world of problems, of symbols in which life offers itself to be understood'. Indeed, Symons emphasised Rodin's more Symbolist works – the 'Main de Dieu' or the 'Penseur' – as well as the erotic drawings which 'have the distinction of all abstract thought or form'. Rodin gave Symons four drawings which were bequeathed to the Tate Gallery; the Tate Gallery however declined them all and the British Museum would only accept one[34].

But Rodin did not need Symons's or Henley's support after the 1880s – and admitted as much in his 1907 *éloge* of Henley – indeed, he did not exhibit at the major London exhibitions or visit England again during the 1890s. When he did return to England in the first decade of the 20th century he was already a celebrity but now it was a younger generation who took the initiative; his carriage was pulled across London by students of the South Kensington schools but more significantly his principal London agent was now no longer a poet but one of his former students, John Tweed, described by Charles Ricketts as Rodin's 'terrible bear-keeper'[35]. English men of letters were attracted to French art by its passion and meaning, English art students were drawn to Paris by its tuition; eminent British artists were rarely prepared to teach but glory or profit induced many of their French counterparts to open teaching studios; the educational inadequacies of the Royal Academy and of the South Kensington schools contrasted sharply with the fame of the Ecole des Beaux Arts particularly after its 1863

reforms: women found adequate instruction hard to obtain in England although the Slade School of Art gave them some encouragement. Thus, Rodin was one of many French artists to cultivate British students. Robert Wiedeman Browning may have been a special case thanks to his father's Parisian contacts but other English students, particularly amateurs, followed. For example, Gustav Natorp was born in Hamburg, educated in America but settled in London; he studied under Rodin between 1881 and 1883 and in 1883 Rodin stayed with him in London[36]. Natorp was a close friend of J S Sargent in Paris and if, indeed, he introduced Sargent to the Vickers family enabling the then little known American to gain in 1884 the crucial commission for 'The Misses Vickers' (now Sheffield City Art Galleries[37]) he was certainly a major figure in the development of artistic links between Paris and London. Bertram Mackennal[38] and Harry Bates[39] studied under Rodin in 1883–1884, William Goscombe John[40] in 1890 and John Tweed[41] in 1893. As early as 1883 he was cultivating English amateur female pupils[42] – the names of Jessie Lipscomb and Miss Fawcett have survived from this early period and Rodin stayed with the Lipscombs in England in 1886[43], but no doubt there were others as well. Of course, Rodin had friends teaching art in London who could recommend English pupils to him; Dalou suggested to Bates that he should go to Rodin and Legros recommended Rodin to Natorp, but Dalou returned to Paris in 1880 and Legros[44] generally dissuaded his pupils from studying in France; it is also striking that all of Rodin's four English professional students began their careers as artisan carvers rather than as art students – as indeed had Rodin himself. Despite his English pupils and despite the advocacy of the Stevenson circle Rodin's influence on British art and taste was probably slight. Clarles Ricketts observed that the English only really admired Dalou for his eighteenth century qualities[45] and Rodin rarely achieved this prettiness of effect; indeed, Ricketts's small bronzes of around 1905 were probably the first British sculptures to be directly and immediately influenced by Rodin – although perhaps Frederick Leighton's 'Sluggard' of 1886 and Goscombe John's 'Morpheus' of 1890 do just reflect Rodin's 'Age d'airain' which had been exhibited at the 1884 Royal Academy. The 'New Sculptors' never distanced themselves far enough from neo-classicism – despite Gosse's claims – for Rodin to be acceptable to them and in England Rodin was admired not imitated; James Smith, the obscure Liverpool wine merchant who may have not read anything by Henley, Stevenson or Symons, was one of his most enigmatic enthusiasts.

NOTES

1 There is a small collection of documents relating to Smith in the Walker Art Gallery, Liverpool. H J Tiffen, *A History of the Liverpool Institute Schools*, Liverpool, 1935, p 177, and B G Orchard, *Liverpool's Legion of Honour*, Birkenhead, 1893, p 638, contain brief biographies of Smith. There is an obituary of Smith in the *Liverpool Post and Mercury*, 17 April 1923.

2 Some sixty letters from Watts to Smith and some fifty from Watts's wife to Smith are in the Watts Gallery, Compton. I am indebted to Richard Jefferies and to David Stewart for assistance in studying these letters.

3 See W Blunt, *England's Michelangelo*, London, 1975, p 196.

4 See Scottish Arts Council, *A Man of Influence, Alex Reid*, Edinburgh, 1967 and *Alex Reid and Lefevre 1926–1976* London, 1976, pp 4ff.

5 Some of the Monticelli paintings at Edinburgh were lent by Daniel Cottier who was the real pioneer in introducing progressive French and Dutch paintings into Scotland – see Brian Gould, *Two Van Gogh Contacts*, Bedford Park, 1969, pp1ff. At Edinburgh the modern French and Dutch pictures hung in a separate room and had a considerable impact on Scottish taste – see J L Caw, *Scottish Painting Past and Present*, London, 1908, p 349. W E Henley, who introduced Rodin to Britain, both wrote the catalogue of the Edinburgh exhibition and the obituary notice on Cottier in the Durand Ruel Sale Catalogue of

Cottier's stock on the dealer's death (Galleries Durand Ruel, Paris, 27–28 May 1892). For Monticelli's fame and influence – he was a Marseille artist not well known in Paris – see Carnegie Institute *Monticelli*, Pittsburgh, 1978, pp 82ff, and particularly Roger Lhombreaud, 'Monticelli and one of his British Admirers: Arthur Symons', *Scottish Art Review*, v (1954), pp 2ff.

6 Camille Pissarro wrote to his son Lucien on 26 December 1891 of Reid: 'This is the man who sold Monticellis at such high prices in Glasgow' (Camille Pissarro, *Letters to his son Lucien*, ed Rewald, London, 1972, p 191).

7 See Walker Art Gallery *Foreign Catalogue*, Liverpool, 1977, pp 133–134.

8 Some letters from Reid to Rodin are now in the Musée Rodin; they cover the years 1892–1904. I am indebted to Mme Monique Laurent and to M. Alain Beausire for access to these and to other letters in the Musée Rodin.

9 Reid's letters to Rodin give the titles as 'Femme avec un amour', 'Femme et enfant', 'Frère et Soeur', 'Mère et enfant'. There is little consistency in the early titles given to Rodin's works so they cannot all be identified with certainty.

10 Glasgow International Exhibition 1901, No 186. Richard Marks, *Burrell*, Glasgow, 1983, p 79, p 86.

11 There are 22 letters, receipts and orders sent by Glaenzer to Rodin and covering the years 1901–1910 in the Musée Rodin.

12 The Smith papers in the Walker Art Gallery record Smith's purchase of a bronze 'Le Baiser' by Rodin through Glaenzer in 1901. There is no reference to this bronze in the extant letters sent by Glaenzer to Rodin in 1901 nor was the bronze among those bequeathed by Smith to the Walker Art Gallery.

13 The letters from Smith to Rodin are now in the Musée Rodin. Some of the letters from Rodin to Smith are in the Walker Art Gallery.

14 Smith's obituary in the *Liverpool Post and Mercury*, 17 April 1923, states that he visited Rodin every year until 1914; this seems to have been an exaggeration.

15 Frederick Lawton, *The Life and Work of August Rodin*, London, 1906, p 109.

16 Lawton, *op.cit.*, p 79.

17 Maisie Ward, *The Tragi-Comedy of Pen Browning*, New York, 1972, pp 62ff; R E Gridley, *The Brownings and France*, London, 1982, p 289, gives 1878 as the date when the poet's son became a pupil of Rodin but it should be noted that Gustav Natorp claimed to have been Rodin's first pupil in 1881 and in 1877–1878 Rodin had only just returned to Paris from Brussels and was not well known even in France.

18 Lawton, *op.cit.*, p 243; *Learned Lady: Letters from Robert Browning to Mrs Thomas Fitzgerald*, ed McAleer, Cambridge, 1966, pp 135–138.

19 Graham Balfour, *The Life of Robert Louis Stevenson*, London, 1906, p 192; John Connell, *W E Henley* London, 1949 p 5; Lawton, *op.cit.*, pp 238ff; A E Elsen, *Auguste Rodin, Readings on his Life and Work*, Englewood Cliffs, 1965, pp 87–88; F E Grunfeld, *Rodin*, London, 1987, p 134ff. Legros' cast is in the Ashmolean Museum.

20 *Magazine of Art*, 'Art Notes', December 1881, v (1882), p ix; v (1882), p 352; 'Art Notes', May 1882, v (1882), p xxv; 'Art in October', 1882, vi (1883) p i; vi (1883), p 75; 'Art in June', 1883, vi (1883) p xxxiii; vi (1883), p 431–2; vii (1884), pp 351–352. Henley's *Magazine of Art* was not the only periodical to defend Rodin's sculptures exhibited in London between 1882 and 1884; *The Academy* and *The Saturday Review* found in Rodin not only realism but also spiritual power, expression, imagination, energy and character; see in particular Cosmo Monkhouse in *The Academy*, 17 June 1882, xxi, (1882), p 439, and 31 May 1884, xxv, (1884), p 392, together with the unsigned review in the same periodical, 23 June 1883, xxiii, (1883), p 444; see also the anonymous review of the sculpture of 1884 in *The Saturday Review*, 24 May 1884, lvii, (1884), p 678; other commentators were respectful if less enthusiastic and Rodin's rejection at the 1886 Royal Academy, (for which see Musée Rodin, *Correspondance de Rodin*, i, 1860–1899, ed Beausire and Pinet, Paris, 1985, pp 75, 245) was out of character with his general reception in Britain and probably to be explained by an unusually severe jury that year.

21 W H Low, *A Chronicle of Friendships*, London, 1908, p 326.

22 W H Henley, 'Two Busts of Victor Hugo', *Magazine of Art*, vii, (1884), p 132.

23 E Gosse, 'The Salon of 1882', *Fortnightly Review*, 1 June 1882 (1882), pp 735ff and 'The New Sculpture', *Art Journal* (1894), p 202. Gosse and Henley very much disliked each other; in 1904 during a speech at a dinner in honour

of Rodin Gosse admitted how wrong he had been in 1882; the speech is quoted in Lawton, *op. cit.*, pp 253–4.

24 E V Lucas, *The Colvins and their Friends*, London, 1928, p 122. The Hanover Gallery exhibition is described in *The Athenaeum*, 24 April 1880, (1880) p 544. Millet's painting is now in the Metropolitan Museum of Art, New York.

25 John Ruskin, 'Fiction – Fair and Foul', *The Nineteenth Century*, October 1881, (1881) p 519.

26 It was not in fact published until 1888 and was reprinted in W E Henley, *Views and Reviews: Art*, London, 1902. See also J H Buckley, *William Ernest Henley*, Princeton, 1945, pp 119–120.

27 Henley, 1902, *op.cit.*, p 160.

28 Grunfeld, *op.cit.*, pp 260–265. Stevenson took the plaster to Samoa where the natives found it anything but high minded – see Grunfeld, *op.cit.*, p 345.

29 See *The Cambridge History of English Literature*, ed Ward and Waller, xiii, part II, Cambridge, 1932, pp 213–215 for George Sainsbury's judgment; there is a more modern defence of Henley's poetry in Margaret Stonyk, *Nineteeth Century English Literature*, London, 1893, pp 257–260; the relationship between Henley's poetry and painting is discussed by Buckley, *op. cit.*, pp 188–190.

30 Henley, 1902, *op. cit.*, pp 154ff; Connell, *op. cit.*, p 177.

31 Letters are quoted in Lawton, *op. cit.*, pp 105, 206–208, 239–249, in K Williamson, *W E Henley*, London, 1930, pp 141–143,251–253,284, Grunfeld, *op. cit.*, pp 155,346,386,465.

32 Williamson, *op. cit.*, pp 142–143. The *éloge* was printed in *The Henley Memorial*, Edinburgh, 1908, pp 8–10. The poet's own cast of this bust is now in the National Portrait Gallery.

33 See Roger Lhombreaud, *Arthur Symons*, London, 1963, pp 66,201.

34 Arthur Symons, *Studies in Seven Arts*, London, 1906, pp 19,22. The drawing given to the British Museum by Symons is reproduced in Catherine Lampert, *Rodin, Sculpture and Drawings*, London, 1986, p 235, No. 215; two more of these drawings are reproduced in Arthur Symons, *From Toulouse Lautrec to Rodin*, London, 1929, pp 220, 228. See Lhombreaud, *op. cit.*, p 319, for further details.

35 Charles Ricketts, *Self Portrait*, London, 1939, p 97. There is no evidence that Henley lost interest in Rodin's later work but J S Sargent, who had known the sculptor for even longer than Henley, much preferred Rodin's early realism – see E Charteris, *John Sargent*, London, 1937, p 199, and William Rothenstein, *Men and Memories*, i, London, 1931, p 371. Ricketts too saw Rodin's late work as 'having fallen into the baroque' with its emotional force descending to 'clap trap' (Ricketts, *op. cit.*, p 284). Claude Phillips was another early admirer of Rodin's work who found the later 'Balzac' unacceptable, see Lampert, *op. cit.*, p 203.

36 Lawton, *op. cit.*, pp 241–243. *Correspondance de Rodin*, *op. cit.*, p 58.

37 See James Hamilton, *The Misses Vickers*, Exhibition at the Mappin Art Gallery, Sheffield, Sheffield, 1984, p 23, for a review of the evidence.

38 M H Spielmann, *British Sculpture and Sculptors of Today*, London, 1901, p 132.

39 Walter Armstrong, *Mr Harry Bates*, *The Portfolio*, xix, (1881), p 171.

40 National Museum of Wales, Cardiff, *Goscombe John*, 1979, p 11.

41 John Tweed, *A Memoir*, London, 1936, pp 61–64.

42 Armstrong, *op. cit.*, p 171.

43 Grunfeld, *op. cit.*, pp 214ff; Frederick Leighton introduced a Miss Gwyn Jeffreys to him (L and R Ormond, *Lord Leighton*, London, 1975, p 93) and Ottlie Maclaren studied with Rodin in the late 1890s.

44 A S Hartrick, *A Painter's Pilgrimage*, Cambridge, 1939, p 10.

45 Charles Ricketts, *Pages on Art*, London, 1913, pp 129–130.

GEORGE FRAMPTON

Timothy Stevens

1. George Frampton in his studio at 32 Queen's Road, St John's Wood, London (from *The Ladies' Field*, 18 October 1902). The sculptor poses by the wax head now in the Walker Art Gallery (illus. 19). To the left of the fireplace stands the model for 'William Rathbone' (illus 10)

'The Lord Mayor wore her crimson robes, the bandmaster had his whitest gloves, the sky was tinged its deepest blue – and nobody made a single speech. If all public ceremonies went off like that how rich the world would be'. So noted the *Liverpool Post and Mercury* in its report on the unveiling of the cast of the statue of Peter Pan by George Frampton in Sefton Park on the 17 June 1929.

The event was unusual in that it was one of the very few municipal occasions of the time which passed off without a speech, perhaps due to the good sense of Alderman Mrs Margaret Beavan, the first woman to be Lord Mayor of Liverpool. The belief of the younger guests in fairy magic was no doubt confirmed when they saw close together the statue of Eros by Gilbert surrounded by lawns and flower beds rather than the hurly-burly of Piccadilly and the figure of Peter Pan which as every nanny knew was in Kensington Gardens. The ceremony, held just after the sculptor's death, also marked the end of a productive relationship with Merseyside which stretched back nearly forty years.

These two casts of London's most popular statues, presented by George Audley to his native city, are only part of the outstanding group of 'New Sculpture' on Merseyside. Every significant artist of this movement, except Alfred Gilbert, is well-represented, in particular George Frampton (1860–1928), Edward Onslow Ford (1852–1901) and William Goscombe John (1860–1952). The latter two sculptors were admired and collected by the 1st Viscount Leverhulme, the builder of Port Sunlight whose purchases of their sculpture are now mostly in the Lady Lever Art Gallery.

The purpose of this note is to draw attention to the quality and range of Frampton's work, both of that commissioned and of the pieces acquired for the Walker Art Gallery, on Merseyside. Where possible, the histories of the commissions have been briefly re-constructed as they are informative about contemporary practice and contribute to a fairer appreciation of the sculptor's work.

Frampton was not 'discovered' by Liverpool. He was an established sculptor when the Liverpool public commissions began. He did though have the talent to provide works which matched the cultural aspirations of a city undergoing its final phase of aggrandizement. It should not be overlooked that the Pierhead Buildings, including the Liver Building, which give Liverpool its visual identity were being constructed at this time. While his life style lacked the glamour and tragedy of Alfred Gilbert, his businesslike approach, professionalism and sense of humour enabled him to build a *rapport* with the numerous committees and other bodies with which he had to deal.

The style of this star of the Lambeth School of Art and the Royal Academy Schools and student of the French sculptor Antonin Mercié, was formed by the innovations of Gilbert, the mystical paintings of Edward Burne-Jones, Italian Renaissance sculpture and contemporary French sculpture. At the time of his first work on Merseyside at the age of 29, the reredos for St Clare's Church, he is still absorbing these influences. The Merseyside holdings show his style maturing and being adjusted to meet the special requirements of the task in hand.

As a young man Frampton executed several commissions for architectural carving and decorative work both for ecclesiastical and secular buildings. Some of these jobs were carried out in partnership with Robert Anning Bell (1863–1933) with whom he was sharing a studio. The two men had many ideals in common. Both were members of the Arts and Crafts Exhibition Society and both were to be Masters of the

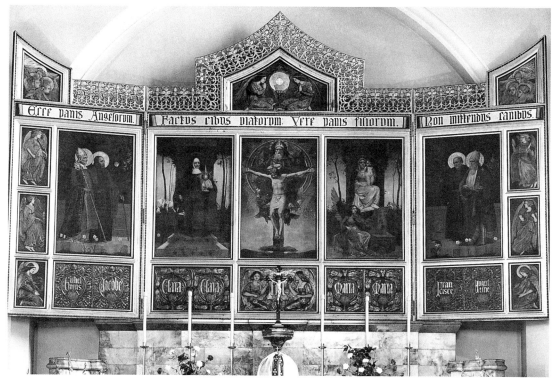

2. G Frampton and R Anning Bell,
reredos in the Church of St Clare,
Arundel Avenue, Liverpool

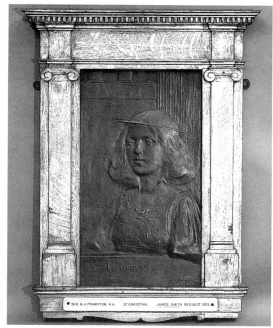

3. G Frampton 'St Christina', bronze,
1889, Walker Art Gallery

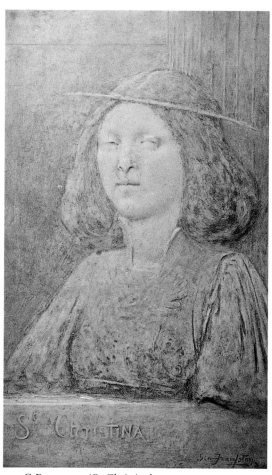

4. G Frampton, 'St Christina',
coloured plaster, 1889, private
collection

Art Workers' Guild. Liverpool is fortunate in having an outstanding example of their joint work in the reredos at the Roman Catholic Church of St Clare in Arundel Avenue, where Frampton may also have carved the stone figures of St Clare and St Frances for the south and west porches. The architect, Leonard Stokes, (1858–1925) who showed his scheme for the church at the Royal Academy in 1889 used the Gothic style in a very free and imaginative manner. Taking their cue from his approach, Bell and Frampton designed for the reredos, a vast triptych which combines painting and coloured low relief sculpture and freely draws on Northern and Italian Renaissance precedents both in its layout and for its style. For instance, the central panel of the Trinity is closely based on the Trinity in an altarpiece by Pesellino (c.1422–1457) in the National Gallery (727). The panels are crowned with an elaborate pierced gilt cresting of formalised lilies. The rich effects of the reredos in the plain church make the high altar a sumptuous focal point for the congregation.

Shown at the Arts and Crafts Exhibition of 1890 as a joint undertaking, the reviewer for *The Builder*[1] noted 'some of the sculpture is from the hand of Mr Bell the painter while some of the brushwork is from the hand of Mr Frampton, the sculptor'. The middle angel panel on the right shutter is jointly signed 'R A Bell 1890 Geo Frampton'. The reviewer went on to note perceptively that 'in treatment the whole recalls to mind Donatello's labours of the 15th century'. The exact division of labour is now uncertain though the panel of two angels holding censers with a shield bearing the sacred monogram under the Trinity is by Robert Anning-Bell as it is reproduced as his work in *The Studio*[2]. Fred Mellor, opens his article 'George Frampton ARA – *Art Worker*', in *The Art Journal* for 1897[3] with the telling statement – 'George Frampton is an all-round craftsman and prefers to be known as an art worker, and not by the more restricted title of sculptor'. Frampton always emphasised the importance of being able to work in many media. He himself could with ease paint (for which he had been trained), produce an enamel pendant, a silver presentation casket, carve a wooden figure or model a lifesize bronze figure. His sculpture often combines different materials although there is nothing on Merseyside to show this aspect of his work.

The bronze bas-relief of 'St Christina' (signed and dated 'Geo Frampton 1889') in the Walker Art Gallery shows, like the angels on the reredos of St Clare's, the preoccupation of Frampton with the techniques of Donatello and his circle. The obscure early Christian saint (if correctly identified) is shown, following legend, seated at a window of her father's house. Moved by the sight of the poor and sick in the street, she broke up the gold and silver idols belonging to her father, a Roman patrician and gave them to the needy. Outraged, her father

tried to have her martyred but died in the attempt. Eventually she was put to death. St Christina was much venerated at Bolsena in north Italy. The relief is an amalgam of influences which are perhaps clearer in the coloured plaster version shown at the Royal Academy in 1890 (private collection) than in the bronze exhibited there the following year. The composition of the half-length figure of the saint with long red hair, placed immediately behind the ledge of the window recalls Renaissance portraits, in particular those of Bellini and early 16th century Venice. In the system of very low relief used to create the illusion of a room with walls, columns and curtain, much as a painter might, Frampton is following the principles of 'relievo stiacciato', a method of pictorial relief perfected by his hero, Donatello in the fifteenth century. The remote, wistful look of the saint and the decorative use of colour, pay homage to another of his heroes, Sir Edward Burne Jones, whose half-length, soulful portraits of ladies, often sitting behind ledges, Frampton surely must have had in mind. Talking of Frampton's student days in Paris, in his memorial address to the Art Workers' Guild (1 June 1928), Anning Bell said 'he has since told me that he was sorry that he did not go to Italy at that time. I quite expected that he would as he was becoming strongly influenced by Donatello and the Florentines of his school'.

Both bronze and plaster versions of the relief were widely exhibited and well-received by the critics. *The Saturday Review*[4] praised the bronze at the Royal Academy in 1891 – 'A very pretty piece of accomplished archaism is Mr Frampton's extremely low relief of Saint Christina'. The same journal covering an exhibition at the New Gallery where a plaster was shown (3 October 1892) enthused – 'rarely does one see a more decorative panel than George Frampton's coloured relief of Saint Christina. The head is most delightfully modelled and the colour scheme a beautiful harmony in purple and green and gold'. The Walker Art Gallery's relief in a gold frame with ionic pilasters in which the cast was shown at the Royal Academy in 1890, was bequeathed to the Gallery in 1927 by James Smith of Blundell Sands who had bought it from W B Patterson in 1896.

The ideas and fascinations which Frampton explored in the relief of 'St Christina' are brought to maturity in the plaster bust 'Mysteriarch' of 1892 (signed and dated Geo Frampton 1892). Long regarded as one of the masterpieces of British sculpture it marked, as the obituarist of Frampton in *The Times*[6] recognised, 'his revolt from white sculpture.' Photographs of Christabel Cockerell, a fellow-student at the Royal Academy Schools, whom the sculptor was to marry on the 7th June the following year, suggest that she was the model for this idealised bust which recalls the exquisite busts of Renaissance masters such as Francesco Laurana or Bernardo Rossellino. Aware of French symbolist art and, still under the influence of the work of Burne-Jones, Frampton has sought to model a piece which evokes a mood rather than portrays a specific event. He avoids though the overt sensualism of French symbolism or of his British contemporary Aubrey Beardsley.

The word 'Mysteriarch' simply means 'one who presides over mysteries'. Press coverage of the bust when it was shown at the Royal Academy in 1893 (1787) was restrained and puzzled. *The Builder*,[7] gave a long, detailed description, perhaps derived from the sculptor himself.

The bust thus entitled, ... occupied a central position on the south wall of the lecture-room at this year's Royal Academy Exhibition, where it attracted a good deal of attention. It is an attempt to express in the head and in the accessories the ideas of one who presides over mystery, a kind of priestess such as might have given out the oracular message at Dodona. The face is dreamy and self-contained in expression, the wings and the drooping hair in which the head is framed serving to increase the effect of mystery, the expression of something weird and inexplicable. The mask and the batwings on the bust subserve the same effect. The head is relieved in front of a surface partially gilt and broken up into curling lines of slight relief, which

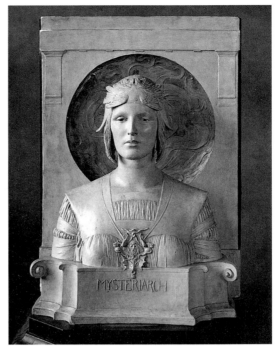

5. G Frampton, 'Mysteriarch', plaster, 1892, Walker Art Gallery

forms a kind of nimbus behind the head, the broken up surface preventing the effect from being too hard and pronounced, while it symbolises the smoke which always accompanied the utterances of the oracle. The architectural accessories are well treated, and the work altogether is one of unusual interest, both in idea and design.

Claude Phillips in *The Magazine of Art* (1903) was less enthusiastic about what he called 'the Anglo-Florentine renaissance in sculpture' which he described as 'being founded on a fearless realism, corrected and rendered decorative by reference to the Florentine renaissance of the quattrocento'. He continued – 'A Neo-Florentine of the Gilbert school is Mr George Frampton, whose decorative bust, with the attractive title "Mysteriarch" – it is a disquieting, androgynous figure, with cuirass and helmet like that of a Verrocchio bust, or like one of Mr Gilbert's own figures – makes so imposing an effect on its low plinth in the Florentine mode, that its weakness of modelling in certain essential parts only by degrees makes itself felt'.

The intense, pent-up emotion of the bust is heightened by the direct frontal gaze, and the almost perfect symmetry of the left side with the right side. The 'architectural backboard', a device he was to use later in the bust of his wife Christabel holding their son, Meredith, allows him to silhouette the uncoloured plaster head against a gold halo. The hand which designed the simplified architecture is already clearly that of the pedestals for the public memorials in Liverpool. 'Mysteriarch' is a *tour de force*, never repeated. Frampton continued to model the occasional 'Renaissance' bust throughout the nineties but either through lack of interest from collectors or his own wish to cultivate different fields, they do not form a major part of his output. 'Mysteriarch' remained unsold until 1902 when it was bought from the Liverpool Autumn Exhibition for £30 by the Walker Art Gallery.

The question of Frampton's commitment to the Continental symbolist movement has been much discussed in connection with the coloured plaster relief 'My thoughts are my children' shown at the Royal Academy in 1894. The same year, Frampton sent 'Mysteriarch' and 'Saint Christina' to *La Libre Esthétique* Exhibition in Brussels where his fellow exhibitors included symbolists such as Odilon Redon, Eugene Carrière and Gauguin.

The source of the title, 'My thoughts are my children', if it is a quotation, is obscure, as is the exact meaning of the subject – a young woman with bare breasts holds in her hand a Madonna Lily, usually

interpreted as a symbol of innocence or purity, while above her, in front of a rising sun, is an older woman, protectively enveloping three children. The subject may simply be a young woman's thoughts of her future role as a mother of children. Perhaps, as Susan Beattie suggests, the subject of the relief reflects Frampton's own domestic life, the passage of his wife from a bride into the mother of his family. His first, and in the event his only, son, Meredith, was born in March 1894. Claude Phillips in his review of the year's sculpture for *The Magazine of Art* (1895) was unimpressed and baffled.

> The strange upright bas-relief, "My Thoughts are my Children", by Mr George J Frampton, ARA, is a more definite expression of that pseudo-mysticism which coloured the "Mysteriarch" which he sent to the Academy last year. Its attempt to give back what, if anything, is a dream-vision – one, however, which I shall not attempt to unravel – in all too human shapes of a studied naturalism, recalls the fantastic, half-realistic, half-idealistic French art of to-day, which has for the moment taken the place of realism pure and simple. Some passages of modelling show an increased familiarity with the difficult art of bas-relief, but the composition as a whole is too disjointed, too little expressive, while the facility shown is rather that of the modeller in clay than of the sculptor dealing with the more enduring and less tractable material.

In 1984, Meredith Frampton, generously gave to the Walker Art Gallery a bronze cast made around 1900 of the missing plaster which had had pride of place for many years in his father's studio. The bronze gives the visual impression that the subject belongs firmly to the home-grown symbolist camp rather than that of the Continental exponents. The very tall, thin format, (it measures over 10 feet high), recalls immediately the narrow, upright paintings of Burne-Jones, for instance 'King Cophetua and the Beggar Maid' (Tate Gallery). The swirl of drapery, which unites the figures and gives a strong surface pattern , can also be parallelled in the work of this artist. In a photograph of Frampton's studio, reproduced in 'The Tatler'[8] the bronze relief is shown surrounded by small, framed reproductions of Frampton's favourite pictures. Most of these can be identified and include 'The Mirror of Venus' by Edward Burne-Jones, 'Portrait of a Lady' by Botticelli (Florence), 'Portrait of a Lady' by Ambrogio de Predis (Ambrosiana, Milan), 'Portrait of Margaretha van Eyck' by Jan van Eyck (Bruges), and 'Primavera' by Botticelli (Florence). There is no modern foreign work. A comparison with the relief of 'St Christina' shows how Frampton's attitude to relief has developed and changed. In place of minute detail and strict adherence to 'relievo stiacciato', forms and planes are now simplified. They are treated more as abstract, decorative shapes. The balance between plain and decorated surfaces which becomes a hallmark of his style is evident here.

Frampton's first solo commission from Liverpool came in 1897, when the recently founded University College decided to commemorate its major benefactor, George Holt (1823–1896). No doubt through the prompting of his friend Anning Bell who was then teaching there it turned to him. Holt, a Liverpool shipowner, art collector and philanthropist had founded the chairs of Physiology and Pathology. The plan for the memorial is reported in considerable detail in *The Liverpool Mercury*[9] – 'President Rendall drew attention to the proposed memorial to the late George Holt. Professor Lodge was the Hon. Secretary of the Committee and Mr Robert Gladstone, the Hon. Treasurer'. The following circular had been issued:

> A Committee appointed jointly by the Council and Senate to initiate a memorial to Mr George Holt and determine its most suitable form, have decided that it should be of permanent artistic value, and that it should be connected both with the college and the medical school, for which he did so much. Accordingly, they propose to provision for – (a) a bronze or silver or marble profile portrait in low relief, surrounded by a decorative border with an inscription, to be

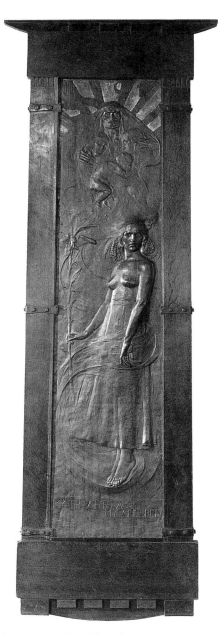

6. G Frampton, 'My Thoughts are my Children', bronze, 1894, cast c.1900, Walker Art Gallery

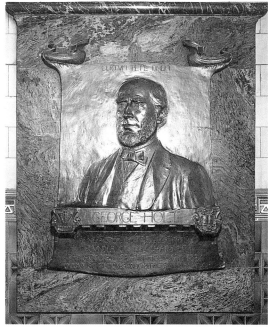

7. G Frampton, 'George Holt Memorial', bronze, 1897, University of Liverpool

hung in some suitable place in the college; (b) a die for a medal to be given annually to distinguished students of the medical school, having on the obverse some other well-executed design to be settled in consultation with the artist. Desiring that the portrait should be executed in the best possible manner, the committee hope to place the work in the hands of such a man as Mr Frampton ARA, or M Legros; and the total cost in that case could hardly fall short of £300 and might easily exceed that sum. If there were a surplus the committee would proceed to consider . . . – (e) An endowment to provide for the expenses of the annual medal, or for some other object to be decided on at a later meeting of the committee, after hearing from such of the donors as may wish to express an opinion. The committee are circulating this statement among members of the court of governors, the council, and the senate of University College, and do not propose to make any wider public appeal. At the same time, contributions will be welcomed from any personal friends who may like to take part in the commemoration.

As Legros was well-known for his etchings and paintings rather than for his sculpture, it is likely that Anning-Bell had put this artist's name forward knowing full well that the commission would, by default, go to Frampton.

The memorial (signed and dated George Frampton 1897) is a variation on the successful design of Frampton for the memorial to Charles Keene of the previous year (Tate Gallery). Renaissance prototypes lie behind the design. The conceit of allowing the sitter's coat to fall over a ledge can be exactly paralleled in the relief bust of Bernardo Giugni on his monument by Mino da Fiesole. A typical Frampton touch is the two 'medieval' ships sailing on waves emerging from the background which recall Holt's business interests. The marks of the modelling tools and the artist's fingers are not smoothed away but are deliberately preserved in the cast. They give the surface of the bronze cast a liveliness when light plays over it which is often conspicuously absent from the bronzes of Frampton's contemporaries. The handcrafted inscription and University and Holt arms strike a just balance between formality appropriate to a memorial and an object lovingly wrought by hand. The unveiling of the memorial in May 1898 is recorded in the University student magazine *The Sphinx*.

In addition to this commission, Frampton executed the George Holt Medal for Physiology (signed and dated 'Geo. Frampton 1897') which is still awarded annually to students in the General and Pre-Clinical Professional Examinations (Part II) in Physiology. Frampton was keenly interested in medals which he produced for Glasgow University and Winchester College and other bodies. Some of his views on medals were recorded in an interview with E B Spielmann for *The Studio* in 1896.

'. . . I am particularly interested in medalling – it seems to me a branch of art we have neglected in recent years. Look at our ordinary coinage, for instance; how mean and poor most of it is by the side of any other work, whether you take mediaeval or classic examples for comparison . . .'

'You believe very strongly, I think, in the importance of the right placing of the lettering and the decorative effect of inscriptions, in clear, well-designed alphabets?' I said

'Certainly I do', Mr Frampton replied; 'it is a matter of the highest importance'; and he went on to explain those principles of decoration which he illustrates so finely in his own work . . .'

The commission for the first of four public monuments in Liverpool came in 1899 when the inhabitants of the town, through a public subscription, took the rare step of ordering from Frampton a statue of a living citizen – William Rathbone VI (1819–1902) MP (signed and dated George Frampton 1899). Rathbone, the head of a long-established Liverpool Unitarian family of merchants, was a tireless worker for the good of Liverpool, particularly for the poor. The

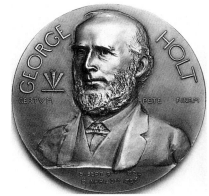

8. G Frampton, 'George Holt Medal for Physiology', 1897

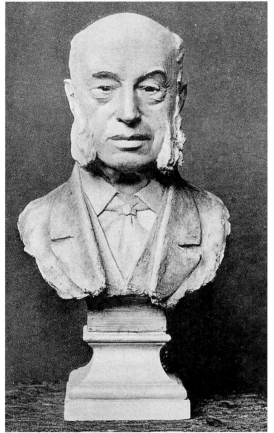

9. G Frampton, 'William Rathbone', plaster, 1899, from *Royal Academy Pictures*, 1899

bronze inscription panel, added after his death, records that he 'instituted the Training School for Nurses and brought trained nurses into the homes of the poor and suffering, first in Liverpool and later throughout the whole country' and was 'a Founder of the University of Liverpool and of the University of Wales'.

The progress of the commission and debate over the setting for the statue can be followed in the local papers. Frampton kept no records. His son, Meredith, recalled 'I remember that my Father kept his accounts on rough pieces of paper and threw them away when the account was settled'.[12] On the 30 May 1899 the *Liverpool Mercury* reported that Frampton had been chosen as sculptor. For the Committee's approval Frampton modelled a bust now belonging to the Queens Nursing Institute London which was shown at the Royal Academy 1899 and a detailed model about 18 ins high which, judging from its appearance in studio photographs such as that reproduced in *The Tatler*[13], corresponded exactly with the full scale plaster. Frampton wrote to William Rathbone on 7 July 1899[14] to tell him that 'The sketch for the statue was passed by the committee some weeks ago –

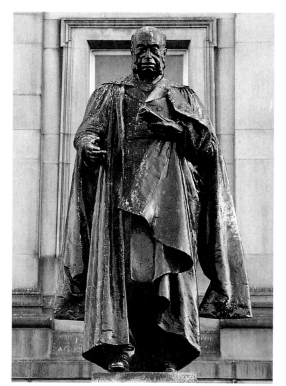

10. G Frampton, 'William Rathbone',
1899, Liverpool, St John's Gardens

11. St John's Gardens today

12. G Frampton, 'Nursing in the
Home', 1900, relief on pedestal of
'William Rathbone'

they liked the design very much'. Frampton had used Rathbone's
gown so he added a postscipt 'I trust you received your gown in good
condition − I shall be glad to have it again when convenient'. The
plaster of the statue was receiving its finishing touches in November
that year[15].

When the commission was initiated no location for the figure had
been agreed. The *Liverpool Mercury*[16] reporting on this lack of a site
stated that it was likely to be St John's Gardens where the church of St
John had recently been demolished. The paper also noted that a
number of sculptors, including Frampton, had been asked to enter a
limited competition for the design of a memorial to Gladstone and that
all the sculptors had declined to enter a competition. The pattern of
white marble figures of local heroes inside St George's Hall had already
been broken with the erection of the bronze statue of Benjamin Disraeli
by Birch on the north side of the hall.

Early in 1900, Frampton, on his own initiative, took the unusual step

of preparing a design for the St John's Gardens site and submitted a
detailed model of it to the Corporation. The *Liverpool Mercury*[17] repor-
ted that his layout for the gardens was to be ornamented also with
statues of Gladstone and A B Forwood. Like other 'New Sculpture'
exponents, Frampton was passionately concerned to integrate sculp-
ture and architecture. The St John's Gardens site also offered him the
opportunity to design both a sympathetic setting for public monu-
ments and a public garden which would be enjoyed by the commu-
nity, something much in sympathy with the philosophy of the Arts and
Crafts movement. These gardens are still a haven in the summer for
local office workers.

The 'Finance' and 'Parks and Gardens' Committees interviewed him
about his design and took the practical step of referring the whole
matter to their surveyor, Thomas Shelmerdine, an architect much in
sympathy with the objectives of the New Sculptors. Frampton's pro-
posals were described by *Outlook*[18]

Mr Frampton has worked out a plan for laying out a public garden
in Liverpool. It is full of interesting details furnishing telling pos-
itions for several existing and projected statues, and has an amphi-
theatre in the centre, surrounded by a raised terrace and flanked on
either side by a pair of lofty columns surmounted by gilt ships carry-
ing electric lights. The city should not by any accident allow so
unique an opportunity to slip by. The little sketch done in plaster to
scale, with avenues of sponge trees cut to shape and coloured green,
is most fascinating.

The *Liverpool Daily Post*[19] enthusiastically reported,

Mr Frampton, ARA, has prepared a very beautiful model of a
scheme for utilising the space at George's Dock [sic]. The suggestion
includes an open garden space, a terrace for promenading, beautiful
shelter-houses and resting-places. One of the marked features of the
design is a golden ship, which is intended to be one of the sights of
Liverpool; at any rate, if there is any prospect of the scheme being
adopted it will be one of the most remarkable evidences of the
development of public taste and of municipal enterprise, and on a
hot summer's day − if anyone can imagine such a thing now-a-days −
a lounge under Mr Frampton's trees will be most agreeable.

Shelmerdine's own design, which widened the scope of the scheme
to include re-modelling William Brown Street, adopted much of

Frampton's layout. The design of the balustrade of the terrace and the detailing of the seats in the amphitheatre are so close in feeling to the pedestals of Frampton's bronze figures that they must surely be by the sculptor. He may also have designed the ironwork which formerly went between the boundary piers. The gardens which were opened 29 June 1904 did not meet with universal approval. They were described as a 'stoneyard' and Frampton had to write to the *Liverpool Daily Post*[20] pointing out that while he had produced a scheme he had not been responsible for the final design or supervised the layout.

As was characteristic of Frampton's working practice, progress on the statue of Rathbone was smooth. On 2 July 1900, the *Liverpool Mercury* noted that the statue was nearly complete. The plaque of 'Nursing in the Home' is initialled and dated 1900. The statue was unveiled on 26 July 1901 and met with wide approval. The *Liverpool Courier* on the following day declared 'the sculptor has done his work with striking success and both in face and figure the statue is an amazing likeness of the man whose memory it is intended to fix in "brass impregnable"'.

Frampton, perhaps because he had innate sympathy for the sitter and his endeavours, had produced one of his most effective public memorials. Essentially, the statue follows the well-tried, traditional nineteenth century pattern of an over-lifesize statue on a free-standing pedestal decorated with commemorative reliefs. A comparison between the marble statue of Rathbone's father by J H Foley, with reliefs by Thomas Brock (1847–1922) unveiled in 1877 in Sefton Park highlights the differences and similarities between the ideas of Frampton and his generation and the older school, deeply imbued in the classical tradition. Whereas Foley avoids texture, Frampton revels in the soft, slightly creased silk of Rathbone's gown of honorary Doctor of Letters at University College. Rathbone catches it over his right forearm thus creating a pattern of folds and discreetly partially hiding the sculptural problems of handling a nineteenth century coat and trousers. The high quality of the cast preserves the details of the silk gown and the finger and tool marks of the sculptor. The light playing over this rich varied surface gives the figure a physical living presence which Foley did not achieve in his figure of 'William Rathbone V'. The small reliefs, inset in the pedestal, very modest in comparison with the large bombastic plaques by Brock on the pedestal of Rathbone's father's statue, show scenes illustrative of Rathbone's achievements in education, nursing and public life. Modelled in low relief with exceptional freedom and clarity the scenes become almost impressionistic in effect. That showing a sick woman taken care of in her own home by a district nurse – Rathbone's most successful innovation, is particularly beautiful. A wide stone plinth around the pedestal which can be used as a seat is a very practical touch of which Rathbone would certainly have approved.

Frampton's master plan for the gardens, although not completely carried out, gave Liverpool a superb 'sculpture garden'. By the end of the decade two more memorials by him had been added, as well as work by Brock, Goscombe John and Pomeroy, making a 'Valhalla' for the great of Liverpool which is now recognised as one of the major groups of outdoor public monuments of the early 20th century.

On 22 June 1900 a public meeting of citizens resolved to commemorate Sir Arthur Bower Forwood Bart (1836–1898) by a statue paid for by public subscription. Although still busy with the statue of 'William Rathbone', Frampton was selected for the task of modelling a memorial to this 'staunch Conservative' councillor and MP who had taken a particular interest in housing conditions. The maquette, ready by 1902 when it was illustrated in a studio photograph in *Cassell's Magazine*[21] shows the sitter in modern dress, Frampton's first attempt to use trousers and coat without academic gown or other masking device. The statue, (signed and dated 'Geo Frampton RA 1903') was unveiled by Lord Derby in St John's Gardens on 21 July 1904. *The Liverpool*

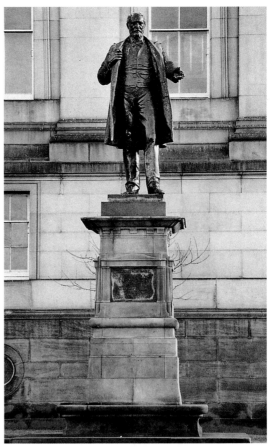

13. G Frampton, 'Sir Arthur Bower Forwood Bart', 1903, Liverpool, St John's Gardens

Courier[22] reporting on the ceremony noted 'Sir Arthur is represented in his favourite pose when delivering a speech, with his left hand held forward and his right hand on the breast lapel'. The statue is dignified but prosaic, lacking the human warmth of the figures of Rathbone and Canon Lester.

The statue of Canon T Major Lester (1829–1903) one of 'the Rescue Trinity of Liverpool' was Frampton's final contribution to St John's Gardens. Lester, for 50 years Vicar of St Mary's Kirkdale, a poverty-stricken part of Liverpool, had been 'a pioneer in founding homes and schools where destitute children could be fed, clothed, educated and started in life' as the inscription on the pedestal records.

The history of the commissioning and execution of the sculpture follows the now familiar pattern which can be re-constructed from reports in the local papers. The movement for commemorating Canon Lester began in August 1903 with a letter to the press. A group of citizens including such well-known figures as Robert Durning Holt, the shipowner and Sir Alfred Jones a local entrepreneur who was later to be commemorated by a monument by Frampton, requested that the Lord Mayor convene a public meeting which took place on 3 October 1903. At this meeting it was resolved to raise 'a permanent memorial to Canon Lester in the shape of a statue'. £1,750 was raised by public subscription and a statue commissioned from Frampton for £1,500 in March 1904[23]. The balance was given to Lester's widow. Why the Committee chose Frampton who was already extremely busy with other Merseyside commissions is not known. Brock, Pomeroy and Goscombe John who had been given commissions for sculpture in St John's Gardens would all have been possible candidates. The Committee may well have found the professionalism and straight-forwardness of the sculptor extremely reassuring. His work also seems always to have been within budget and delivered on time.

Frampton, following the practice of the Rathbone commission, submitted to the Committee on December 20th 1904, 'a plaster model of the statue and a large bust, prepared from photographs of the deceased

14. G Frampton, 'Canon T Major
Lester', 1907, Liverpool, St John's
Gardens

15. G Frampton, 'Queen Victoria',
1902–4, Southport, Promenade

and the descriptions of some of his friends and relations . . . the clothing
is that of a clergyman with the addition of a flowing robe, which is
intended by the sculptor to add distinction to the figure and to indicate
his position in the church'.[24] Frampton explained to committee mem-
bers 'that the idea of the statue was to show the late Canon in the actual
performance of the work with which he had been identified. The idea
was that he had met a child by the wayside and had taken it up into his
arms and was carrying it to some shelter'.[25] The large plaster model
from which the bronze was cast was completed by early 1905 (1907
Royal Academy). It was reproduced in *The Liverpool Courier* 29 March
1907.

The bronze statue (signed and dated Geo Frampton RA 1907) was
unveiled by Lord Derby on 25 May 1907. Tactfully, perhaps, after a
contretemps over the use of a foreign foundry for the statue of Queen
Victoria at Southport, the casting was done by Burton's Foundry at
Thames Ditton. The pedestal designed by the sculptor was constructed
by Kirkpatrick Bros of Trafford Park, Manchester, his regular base
makers.

By showing Canon Lester holding a sleeping, shoeless waif in his
arms the sculptor has made an immediate and very telling image for
Liverpool. Following the formula of the statue of 'William Rathbone',
academic gown and hood have been used to conceal the problems of
coat and trousers and to give the figure an interest from a variety of
viewpoints in the garden. The plain pedestal with its simplified mould-
ings, sets off the rich modelling and simple composition of the statue. A
comparison with Pomeroy's statue of the 'Rt Rev. Monsignor Nugent'
(1822–1905), another member of the rescue trinity, unveiled 1906,
underlines Frampton's ability to design a statue with a clear, simple
composition. The comfortable solidity of the figure, in his heavy coat
and trousers, is a convincing image of a large-hearted man who did not
care to be hampered too much by rules and regulations.

Throughout the reign of Queen Victoria, towns and cities of Great
Britain and the Empire put up statues of her husband, the Prince Con-

sort and herself as expressions of their loyalty and patriotism. Liver-
pool, for instance, had commissioned from Thomas Thornycroft the
delightfully informal equestrian figures which still grace St George's
plateau. As the concept of monarchy changed from the domestic to the
regal, so the character of the monuments and busts of her Majesty
altered. The Golden and Diamond Jubilees of 1887 and 1897 brought
sculptors a rich crop of orders. The 'Golden Jubilee Monument' to
Queen Victoria by Alfred Gilbert at Winchester gave brilliant visual
expression to this new cult of Monarchy. The Queen with crown, orb
and sceptre is seated on a throne of unprecedented magnificence, decor-
ated with exquisitely modelled allegorical figures. Sculptors, including
Frampton, could not escape the influence of this magnetic new image.
In 1897, Frampton was commissioned by Calcutta to model a figure of
'Queen Victoria' to mark the Diamond Jubilee. With the benefit of
sittings from the Queen, he produced a distinguished variation on
Gilbert's Winchester figure. The Queen is similarly dressed and shown
seated on an elaborate throne. On the back of this is a lion in high relief
set against a radiant sun in low relief.

Following the Queen's death in 1901, many towns turned to
Frampton for their memorial, not only because of his excellence as a
sculptor but also because it was known that the Queen had approved
his likeness. On Merseyside, St Helens and Southport have memorials
to Queen Victoria by him which were also their first pieces of public
sculpture – that in Southport was the earlier.

Frampton, in Southport in October 1901 visiting his friend, J J
Barlow, happened to call on the mayor who wondered whether he
would be willing to supply a cast of the figure of Queen Victoria he had
made for Calcutta. The sculptor told the mayor that Lord Curzon was
unwilling to allow this, but he offered to make an even better figure for
Southport for three or four hundred pounds more[26]. A committee to
erect a memorial was therefore established which raised £1,760 by
public subscription and commissioned a statue from Frampton. The
organisers stipulated that the Queen's appearance should be of 1887 or

before[27].

One of the more unusual features of Frampton's Merseyside public statues was that the commissioning committees rarely had a definite site for the work when the public subscription was being raised. The sculptor did not therefore work with a definite site in mind. Apparently, this caused no great difficulty in Liverpool, but in Southport it did. Initially, Frampton wanted the memorial to be put up in Lord Street[28] but by January 1902 when the statue was in an advanced state, he favoured London Square and provided a model on the lines of that he had supplied for St John's Gardens in Liverpool[29]. The Corporation jibbed at the cost of moving a cab shelter, an electric transformer and undertaking other work and put forward a site at the Promenade end of Neville Street. To accommodate new developments this site was also changed and foundations for the statue were laid in another part of Neville Street. However, a substantial number of the subscribers, led by Henry Taylor through a series of letters to the press and a public meeting held 12 March 1904 bullied the Corporation into abandoning this site as they felt the statue would be out of scale and, more importantly, the Queen would either turn her back on the town or the sea. A compromise site outside the Atkinson Art Gallery was agreed where the statue was finally unveiled on 13 July 1904 to the sounds of Elgar. The *Southport Guardian* reported the total cost as £2,000 which was made up of £1,700 for the statue and the balance of £300 for the pedestal designed also by the sculptor. £150 of the cost came from the rates. The statue did not remain for long outside the Art Gallery and it was moved to its present site on the Promenade in 1912. A photograph of the full-scale plaster shows a figure of St George on the orb which has now been replaced with a conventional cross.

16. G Frampton, 'Queen Victoria', 1901–5, St Helens

The site was not the only difficulty that Southport had to face. Much to the embarrassment of the Committee, in view of the anti-German feeling then prevalent, the national press on the 8 and 9 July 1903, ran a story that the statue had been cast in Germany and might as required under the Merchandise Marks Act bear the inscription 'made in Germany'. In fact, the statue had been cast in Brussels. The *Liverpool Daily Post* did come to the defence of the artist's use of the Belgian Foundry and declared on 16 November 1903 'so delicate was the work connected with the statue that the very finger prints of those who had the work in hand are observable'. The *Post* could very well have made the general comment that all Frampton's bronzes are exceptional for the quality of their casting. While dignified and regal, the standing figure of Queen Victoria is not one of Frampton's most imaginative works. Perhaps this subject intimidated him.

By contrast, the history of the statue of 'Queen Victoria' for St Helens is straightforward. In 1902, Colonel W W Pilkington of Messrs Pilkington, the glass makers, offered to present a statue of the Queen to commemorate his year as mayor of the borough. Whether at the request of Pilkington or the suggestion of the artist, a cast of the figure of Her Majesty which Leeds had commissioned in 1901 was provided. Col Pilkington had shown the town council a photograph of a proposal in October 1903[30]. To give the monument individuality, the simple throne used at Leeds was replaced by one of arts and crafts design similar to that at Calcutta. A plain base was substituted for the elaborate seventeenth century style plinth, designed by Leonard Stoke for Leeds. Frampton repeated this re-use of the Leeds figure in his 'Victoria Memorial' in Winnipeg (unveiled 1904) although again a new throne was provided. Both the St Helens and Winnipeg thrones have the same figure of St George on their backs which can be related to the Boer War Memorial at Radley College. To our age, much concerned with originality, Frampton's reshuffling of motifs may appear reprehensible. He was, though, following well-established sculptural practice which, for instance, Thornycroft had followed with his equestrian figures of Queen Victoria and the Prince Consort. Judged against Gilbert's 'Queen Victoria' at Winchester, Frampton's figures are not outstand-

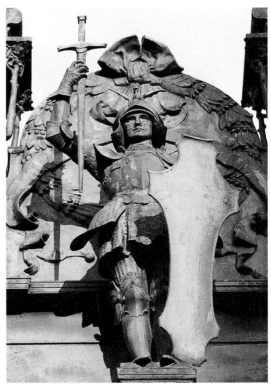

17. G Frampton, detail of 'St George' on throne of St Helens 'Queen Victoria'

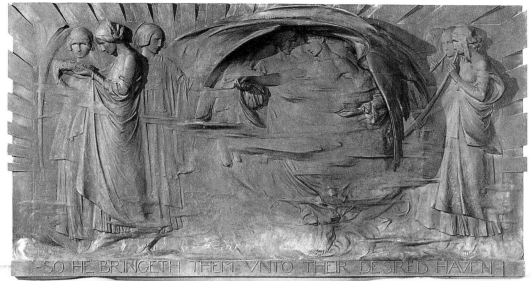

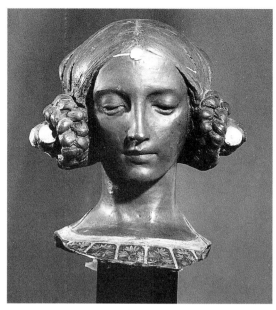

18. G Frampton, 'So he bringeth them unto their desired haven', relief from the memorial to Frederick Pattison Pullar, bronze, 1902, Walker Art Gallery

19. G Frampton, 'Bust of a Woman', wax, c.1902, Walker Art Gallery

ing but if compared with C J Allen's figure of Victoria in Liverpool, they are extremely able. The memorial (signed and dated 'Geo Frampton RASc 1905') was unveiled by Lord Derby on 15 April 1905. In the context of a Merseyside survey of Frampton's work, the memorial has a special place as the finials of the throne are decorated with the 'Frampton Tree' which developed from the tree capitals carved and probably designed by the sculptor for a fireplace used by C Harrison Townsend in 1896 in Linden House, Düsseldorf. The low relief tree could be used to divide up a frieze or decorate a panel. It is one of the most frequently-used motifs of the period. Frampton employed it with great success on numerous occasions.

Just before Frampton started work on the memorials to Queen Victoria, the new office of Lloyds Register of British and Foreign Shipping designed by T E Collcutt, begun 1898, was being completed in London. The building expresses perfectly the harmonious partnership between sculpture and architecture which the 'New Sculptors' sought. The sculptor contributed a frieze of figures connected with shipping and four bronze standing female figures holding ancient sailing and modern steam ships. The relevance of this decorative scheme, one of Frampton's masterpieces, to Merseyside, is that the approach to design used and the calm intensity of feeling achieved is similar to the relief commemorating Frederick Pattison Pullar which came to the Walker Art Gallery from Meredith Frampton in 1984. Frampton appears to have had a special affection for the Pullar relief, as in addition to the cast put up on the grave of the deceased in Blair Logie Cemetery near Bridge of Allan, Frampton had a bronze cast made for himself. There are also numerous photographs of him modelling the relief (Frampton Archives). In 1901, while skating on Airthrey Loch, Pullar, lost his life attempting to save a drowning girl who had fallen through the ice. The inscription 'So he brought them unto their desired haven' is taken from Psalm 107 verses 29 and 30.

The relief is an outstanding example of Frampton's mature style. The quiet and dignified maidens with their embroidered garments are beautifully related to each other, some in profile, some in three-quarter view. The arrangement has clarity as the figures are placed precisely in parallel planes. The participants are divided into three interlocking groups – the young hero in the centre is being conveyed by angels who extend some of their wings to protect him through wisp-like clouds. In front of this group, a maiden holds a palm of victory while another intently studies his laurel wreath. A third holds the hand of the hero.

Bringing up the procession are maidens blowing shawms. Through this dreamlike mystical world the youthful hero, a Christian Arthurian knight, is being escorted to everlasting bliss. The background is filled by the dramatic rays of the rising sun. Some critics took exception to the use of patches of gold which emphasised the flatness of the relief and recalled the use of gilding by Renaissance sculptors.

No definite documentation or date can be put forward for the red wax head with a plaster core (bequeathed to the Walker, along with the Pullar relief, by the executors of Meredith Frampton in 1986). Frampton thought highly of it as it appears in numerous studio photographs including one reproduced in the 'Lady's Field' for October 1902. The head is very similar to that on the statue holding a sailing ship on the Lloyd's Registry. Both have similarly braided hair and wear a hair comb with bead-like finials. Frampton showed two closely related wax busts at the Royal Scottish Academy in 1902 which are either studies for or development from other heads from the Lloyd's Registry. One wonders whether he used a basic plaster core on which wax could be freely modelled to produce heads which are generically very close yet have unique features.

Winston Churchill, for the unveiling of the memorial to Sir Alfred Jones (1845–1909), Frampton's final commision on Merseyside, sent the following telegram –

> I greatly regret that I cannot be present at the unveiling of the statue of Sir Alfred Jones. His extraordinary energy and enterprise, his public spirit, his pride and faith in British Empire advanced the development of our West African and our Indian possessions in many directions, and fully justify the monument which his fellow citizens of Liverpool and Lancashire have raised to his memory. In his daring enthusiasm and his tireless practical activities he revealed some of the qualities by which the greatness of Lancashire has been achieved – WINSTON CHURCHILL.[31]

Churchill sums up the career of this extraordinary Welsh entrepreneur and philanthropist. Jones had carved for himself a brilliant career in shipping in Liverpool, becoming a partner in the Elder Dempster Line. The twin thrusts of his business activities had been the development of Liverpool as a port and the opening up of West Africa. He had had the vision to establish the Liverpool School of Tropical Medicine which made his African dream a practical possibility.

To commemorate this 'great imperialist' as Lord Derby called him when he unveiled the monument on 5th July 1913, Frampton

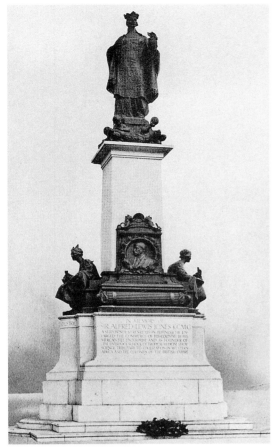

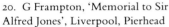

20. G Frampton, 'Memorial to Sir Alfred Jones', Liverpool, Pierhead

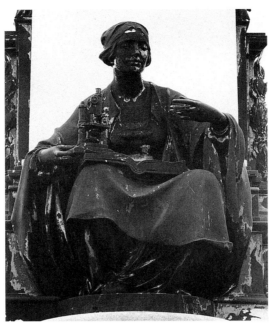

21. G Frampton, 'Research', figure on 'Memorial to Sir Alfred Jones'

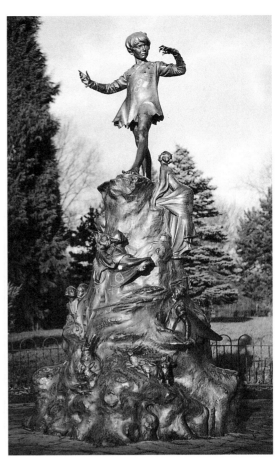

22. G Frampton, 'Peter Pan', 1911–12, this cast c.1927, Liverpool, Sefton Park

modelled an allegorical work rather than a portrait sculpture. The sculptor, as long ago as 1905, in a conversation with the *Southport Guardian* had expressed his preference for this approach. 'When a monument is put up to a man, we do not want to see his frock-coat or the particular coat he wore, but we want a fine, symbolic monument. If his portrait is required a medallion would serve the purpose.' Whether the commissioning Committee, which as usual managed the project and raised the funds, had an influence on this changed approach is not known. A report in the *African Mail* on the 2nd August 1910, suggests that both parties may have preferred the new approach. 'Although no definite scheme has so far been decided upon, the Committee are favourable to a device which will be symbolical of Sir Alfred Jones's shipping interests and his philanthropic and social aspirations, ... Sir George Frampton has been entrusted with the design of the memorial ...'

The Committee would also have been well aware of the 'Memorial to the King's Regiment' by William Goscombe John in St John's Gardens which included an over-life-size free-standing female figure very similar in function to Frampton's figure of Liverpool. A single portrait figure of the commemorated could no longer provide the glamour required to match the new imperialist vision epitomised by the recently constructed Docks and Harbour Board building which was to be the backdrop for the memorial. Frampton met the new mood magnificently. The figure representing Liverpool stands majestically on a high plinth. She wears a tabard modelled with the arms of Liverpool and a crown in the form of a castle, perhaps recalling the city's own medieval castle. She holds in her right hand a globe supporting a ship floating on toy-like waves. The globe also has been decorated with characterisitic waves and with trees to suggest land. The distant gaze, the hieratic quality makes her very distinctly by the same sculptor as the 'Mysteriarch'. The figures seated at the foot of the pedestal are very much of

the type frequently used by the 'New Sculptors', particularly their bandeaued heads and poses. Only their attributes, in particular the book and microscope of one and the basket of fruit and caduceus held by the other, allow them to be identified respectively as allegorical figures of research, recalling the School of Tropical Medicine and the fruits of industry and commerce, Sir Alfred's other great interests. The figures were cast as usual by A B Burton of Thames Ditton and the stonework for the plinth and pedestal by Messrs Kirkpatrick is very simple and austere so that the complexity of the detail in the bronze is shown up to best effect.

While the many sources which contribute to the style of the monument can be identified, particularly fifteenth- and sixteenth-century Florentine sculpture, in this piece Frampton shows how well he has digested them and has evolved a style uniquely his one. The quiet elegance, the sense of balance between decorated and plain surfaces and the powerful sense of unifying design are entirely his own, confirming that his contemporaries were right in recognising him as one of the outstanding artists of his day.

While modelling the memorial to Sir Alfred Jones, Frampton was working on 'Peter Pan' for J M Barrie, who planned to present it to Kensington Gardens. Nina Boucicault, the actress who had first played the character was the model for the figure. Peter stands on the top of a tree trunk, playing a pipe. His music attracts fairies and the rabbits and mice who live in burrows below him. In sculptural terms the tree trunk plinth is the ultimate solution to the 'New Sculptors' obsessive interest in integrating figure and base. Only in Gilbert's 'Eros', which Frampton surely had in mind, are base and figure so completely interlocked. Barrie must be congratulated on judging that Frampton could create such a light-hearted piece. The bronze, of which the plaster was shown at the RA in 1911 was installed in Kensington Gardens in 1912. A handful of full-scale casts were produced for Brussels and other

towns. George Audley, a benefactor of the Walker Art Gallery, bought a cast for Sefton Park (signed 'Geo Frampton') in 1927 for £1,750. Frampton undertook to control the work of erection and reckoned that casting into bronze might 'take more or less nine months. The time would depend upon whether I was satisfied with the casting and whether the founder kept his word as to time or not'[32]. Frampton's death the following year brought to an end this fruitful association with Merseyside.

The purpose of this survey has been to provide an exploratory commentary on Frampton's Merseyside works. It is premature to consider his ultimate position in the history of English art around the turn of the century until his contemporaries, Pomeroy, Brock, Goscombe John and Onslow Ford have been investigated in detail. One cannot perhaps do better now than to reprint Marion Spielmann's assessment of Frampton and exhort the reader to look with unprejudiced eye at Frampton's contribution to the sculpture on Merseyside.

A man of exceptionally high artistic instincts, Mr Frampton has great powers as a designer, and hardly less as a modeller, though he does not allow his technique to intrude upon the eye. The surface of his work is quiet. His big, broad, simple undecorated surfaces are as valuable as his ornamental ones; his spacing-out is always interesting, and the shapes are well considered. Mr Frampton loves to contrast his surfaces, placing side by side a very plain band or space, and another richly ornamented, in some works, perhaps, jewelled. His lines are simple and severe, and strongly opposed. He thus makes us feel the architectural character in what he does.

His work is essentially decorative; it is creative, and always refined. It reminds us somewhat in its character of the early Italian masters, whom he must surely have studied deeply, yet his own performances are strongly individual and original. More than that, he may be pronounced a *tête d'école* – a leader, an inventor in his architectonic work, personal in the sentiment of his art, whether in its structural, polychromatic, or decorative characteristics. The structural portions are always simple and in good taste, and the architectural features to which he pays so much attention are not less good than the ornament which adorns them.

There is a kind of sadness, of pathetic gravity, in Mr Frampton's art which is fascinating. Its stillness and repose have their charm. It never startles the spectator as many clever works are apt to do; it rather welcomes him and soothes him with its silent message.[33]

NOTES

My primary debt is to Rowan Watson and his colleagues at the Archive of Art and Design, Victoria and Albert Museum who kindly made available George Frampton, Archives (AAD 13–1988). I have quoted extensively from the press cuttings in this archive.

The survey of Merseyside sculpture carried out in 1977 by a job creation team organised by the Walker Art Gallery yielded essential information. Alex Kidson and Edward Morris at the Walker Art Gallery and Mary Bennett responded generously to numerous requests for assistance. As usual, my colleagues here, Sylvia Richards and Mark Evans rallied round.

1 *The Builder*, 17 May 1890.

2 *The Studio*, 1893, vol 1, p 55.

3 *The Art Journal*, 1897, pp 322–4.

4 *The Saturday Review*, 27 Jun 1891.

5 *ibid.*, 3 October 1892.

6 *The Times*, 22 May 1928.

7 *The Builder*, 23 September 1893.

8 *The Tatler*, 16 April 1902.

9 *The Liverpool Mercury*, 18 May 1897.

10 *The Sphinx*, May 1898, vol v, No 7, P 249.

11 *The Studio*, 1896, vol 6, p 209.

12 Letter to author, 13 September 1984.

13 *The Tatler*, 16 April 1903.

14 University of Liverpool Rathbone Papers IX 7 127.

15 *The Liverpool Mercury*, 15 November 1899.

16 *ibid.*, 15 November 1899.

17 *ibid.*, 5 February 1900.

18 *Outlook*, 10 February 1900.

19 *The Liverpool Daily Post*, 20 February 1900.

20 *The Liverpool Daily Post*, 25 October 1904.

21 *Cassell's Magazine*, August 1902.

22 *The Liverpool Courier*, 22 July 1904.

23 *The Times*, 17 March 1904.

24 *The Liverpool Daily Post*, 21 December 1904.

25 *The Liverpool Courier*, 21 December 1904.

26 *The Southport Visiter*, 3 October 1901.

27 *Ibid.*, 30 October 1901.

28 *The Morning Post*, 19 December 1901.

29 *The Southport Visiter*, 25 January 1902.

30 *St Helens News*, 13 October 1903.

31 *The Liverpool Journal of Commerce*, 7 July 1913.

32 Frampton in letter to Arthur Quigley Curator, Walker Art Gallery Archives.

33 *British Sculpture and Sculptors of today*, London 1901, p 95.

MEMORIALS TO THE GREAT WAR

Ann Compton

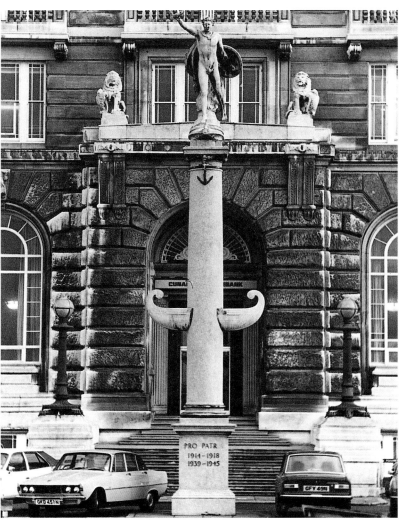

1. Willink and Thicknesse (archs) and H Pegram (sc), 'Cunard Memorial', 1921, Liverpool, Pierhead

The people of Liverpool and its environs were generous patrons of war memorials. Thirty are documented in the city alone and there are certainly many more[1]. In addition to a number of military memorials Liverpool is typical in having numerous monuments commemorating the civilian lives of the dead. There are memorials to inhabitants of boroughs and municipalities, to employees from private companies and public institutions, members of church congregations, societies and clubs, to ex-scholars of schools and the university and people involved in many other organisations. Some of these monuments can be singled out as having an aesthetic distinction. Most have no special artistic merit. Nevertheless all serve to indicate the widespread wish to honour the war dead. Inevitably there exists an element of duplication between the military and civilian memorials. In particular, memorials built at home are dedicated to soldiers also commemorated by the Imperial War Graves Commission (IWGC) overseas. But then it is the style of remembrance not the numbers actually killed which is under discussion. Moreover a comparison between the methods of commemoration adopted in Britain and abroad reveals there was little similarity in approach. At home numerous groups gathered in separate initiatives to build a memorial financed locally each with its own identity. In contrast the IWGC had a centralised programme funded by the government designed to promote a consistent perspective on the war and its dead. Yet for all these essential differences the work of the IWGC did much to shape the basic principles which were to guide the design and construction of war memorials in Britain. In previous wars the burial of the dead had been administered by the army or relatives and disease had been a more frequent killer than the bullet. The enormous death toll on the battlefields in the First World War demanded a new approach. A graphic illustration of this change exists in the casualty lists on two particularly fine local memorials designed by Sir William Goscombe John RA. The monument in St John's Gardens records 357 members of the King's (Liverpool) Regiment lost in three major campaigns: Afghanistan, Burma and South Africa. They are easily outnumbered by the 400 employees of Lever Brothers killed in action in the Great War and commemorated at Port Sunlight.

The IWGC originated in the attempts of a Red Cross worker, Fabian Ware, to coordinate and monitor the burial of the dead on the western front. The enormity of the task demanded a Government backed scheme which, after some opposition, was set up in 1917. The IWGC, as its name indicates, embraced the burial and commemoration of both colonial and British troops. In defining the IWGC's role Parliament confirmed the earlier ban on repatriation of the dead, which had originated in the need to keep ships free for troops and suppplies, and also decreed that military burial grounds should be bought at the front after the War. This debarred the dead from being dispersed to family graves and assured a collectivist approach to burial. In 1917 a committee of three architects was appointed comprising: Sir Reginald Blomfield, Sir Edwin Lutyens and Sir Herbert Baker. They were asked to provide a standard design for the headstones and cemeteries and also to design the memorials to the missing. The classical solutions they produced literally constructed order and harmony where previously chaos and disorder had reigned.

An important consequence of the IWGC's principle of equality in death, signified by the standardised graves for all ranks, creeds and nationalities, was to make it appropriate for memorials at home to

commemorate a loss to community rather than to an individual or family. Inevitably there were exceptions: Liverpool has one in the tablet to Sergeant David Jones VC unveiled at Heyworth Street School in 1917. But for the most part the rule was adhered to. The IWGC's adoption of classicism as the official language of mourning was carried through in the national memorial, Sir Edward Lutyen's cenotaph in Whitehall. It was also confirmed in as many words by the Royal Academy whose advisory leaflet on war memorials published in March 1918 urged 'simplicity, scale and proportion' 'rather than a profusion of detail or excessive costliness of materials'. Certain places in the area responded to the call, notably neighbouring Southport, which produced an outstanding example of the war memorial as classical pavilion. Taken overall, however, the region favoured an independent line, opting for sculpted memorials some of which attempted to confront the historical specifics of the war and introduced a human element.

Decisions of this sort fell to local committees and individual designers. The popular contribution was a purely financial one. Most memorials involved an element of public subscription, the proportion varied considerably as, of course, did the cost of monument. Memorials erected by businesses, public employers, or municipal authorities might receive a greater element of corporate funding than purely charitable concerns. When and where required there were tremendous numbers of people willing to subscribe to memorial funds and often surprisingly large amounts were raised. At Hoylake and West Kirby around £7,000 was contributed for the local memorial and in the City around £4,500 was raised to build the 'Engine Room Heroes' memorial. There could be problems, though: the Birkenhead memorial, which cost approximately £5,000, was only saved from debt by last minute donations.

The choice of artist, materials and scale of the monument were made by a small committee in a traditionally paternalistic fashion. Particularly prestigious memorials such as the 'Engine Room Heroes' and the Liverpool cenotaph had the added privilege of Lord Derby's patronage. In a few instances, of which the Lever Brothers memorial is the outstanding local example, decisions were made by the director alone. Even civic monuments, which might be expected to be more democratic, did not involve direct public consultation except in so far as basic decisions regarding cost and site had to be passed by the relevant council committees. Generally speaking both information about and protest at plans were channelled through the local press. However there is no evidence that letters of protest published in newspapers had any influence over memorial schemes. Serious opposition could only come from local councillors working through official channels and there are few examples of their having been successful. Interestingly the bulk of objections concerned the size and site of monument; objections to interpretation or content are unusual.

For obvious reasons many committees liked to keep their memorials a purely local affair. Hence a Liverpool team comprising the architect Lionel Budden and the sculptor Herbert Tyson Smith won open competitions for the Birkenhead and Liverpool civic memorials and individually they worked on many others in the region. Where there was no competition the designer might be selected on recommendation. This was the case with Charles Sargeant Jagger who was proposed by the committee's distinguished artistic adviser, Sir George Frampton for the Hoylake–West Kirby commission[2]. Alternatively the artist might be personally known to the committee as was the case with Sir William Goscombe John RA who was a friend of Lord Leverhulme and so was invited to design the Lever Brothers memorial in 1916.

The paternalism of committee proceedings was not the only aspect of war memorials to echo the practices of Victorian Britain. Indeed the mass commemoration of the dead, especially such features as the Armistice Day observance introduced in 1919, owes much to the pomp and circumstances of the Victorian cult of mourning. Conscious of this there were those who rejected all the ceremonial: 'Lawrence Binyon's

noble words "they shall not grow old as we who are left grow old" took on an ironic meaning in the mouths of speakers who were well content to grow old and fat. As time went on . . . I wished that all the formal ceremonies might be abandoned, and that this commemoration might be left for whom it had some personal meaning'[3]. From the standpoint of an ex-serviceman, the historian E L Woodward, war memorials had become an anachronism since 1914. After all, the traditional concept of the war memorial was based on a moral certainty of 'God and my right' and how could this be reconciled with the bitter reality of Europe's first modern war? It is clear from the number of monuments which repeated traditional symbols of victory, like the Cunard memorial at the Pierhead and the Crosby memorial, that this was not a universal concern. If the inappropriateness of this approach seems obvious today with the reality of trench warfare publicised on television and in the cinema this was not necessarily so clear at the time. Although the loss of friends and family was a mass concern, the combined effects of government propaganda and the reticence of those on active service meant many civilians did not know what the trenches were like: 'By 1918 there were two distinct Britains . . . the fighting forces and the rest, including the Government'[4]. The 'rest' also included most of the councillors and businessmen who sat on memorial committees and many of the architects and sculptors who designed them. So it was only those whose artistic training, sensibilities and experience were sympathetic to the problem of creating a contemporary memorial who made their designs appropriate to the historical context. Even then artists and architects were circumscribed by an unspoken assumption that the public should be spared a graphic description of the full horrors of war.

The Cunard shipping company unveiled their memorial to staff killed in action on Armistice Day 1921. From a conceptual, if not a stylistic standpoint, this memorial could have been erected fifty years before. Henry Pegram ARA, sculptor of 'Victory', was in his late fifties at the end of the war and was neither of an age or temperament to depart radically from his earlier ideal and decorative work (see 'Eve', 1890, Walker Art Gallery).

The firm of architects employed, Willink and Thicknesse, had previously designed the Cunard building, an austere and imposing edifice reminiscent of an Italian Renaissance palazzo. Since the memorial was to be sited in front of the building's main entrance Willink and Thicknesse wished to achieve harmony between the two. Their solution was a reworking of the rostral column adapting its scale to match the lower storey of their building. The historical associations of the column to ancient Rome and victories of the Punic war must have been flattering to the managers of Cunard. On the other hand Henry Pegram's intention of a nude 'Victory' created some anxiety about the company's image. At the last moment Cunard's director ordered Henry Pegram to cover the figure's vital parts with a fig leaf. Not surprisingly this soured relations with the sculptor who resented such direct interference. As was typical of most reports of unveilings of war memorials the press were more or less indifferent to the monument's aesthetic merit and concentrated largely on the ceremonial. (Presumably then as now newspapers were sold for their human interest and glimpses of glamour and only to a lesser extent for their ideas.) In any case the advent of the fig leaf went unremarked as did the noticeably weak integration of the memorial's constituent parts. There was also no comment on what must even then have been evident to some observers: the memorial lacks obvious relevance to First World War maritime warfare.

This same criticism could be applied to the work of the Liverpudlian sculptor, Herbert Tyson Smith who worked on many memorials in the locality[5]. Unlike the elderly Henry Pegram young Herbert Tyson Smith had served in the war. However, Tyson Smith was not a soldier artist in the same way as Gilbert Ledward and Charles Sargeant Jagger because as a gunsmith in the Royal Flying corps he did not go into

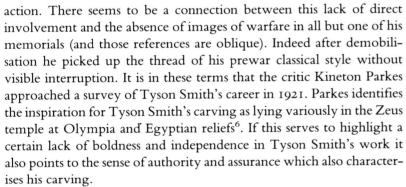

2. Grayson, Barnish and A L
McMillan (archs) and H Tyson Smith
(sc), War Memorial, 1927, Southport,
Lord Street and Nevill Street

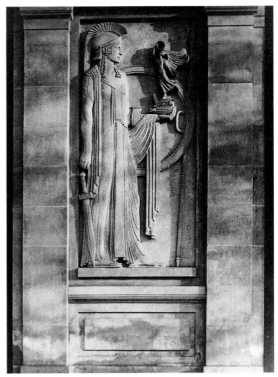

3. H Tyson Smith, detail of carving
on Southport Memorial, 1927

action. There seems to be a connection between this lack of direct involvement and the absence of images of warfare in all but one of his memorials (and those references are oblique). Indeed after demobilisation he picked up the thread of his prewar classical style without visible interruption. It is in these terms that the critic Kineton Parkes approached a survey of Tyson Smith's career in 1921. Parkes identifies the inspiration for Tyson Smith's carving as lying variously in the Zeus temple at Olympia and Egyptian reliefs[6]. If this serves to highlight a certain lack of boldness and independence in Tyson Smith's work it also points to the sense of authority and assurance which also characterises his carving.

Amongst the seven or more classical memorials around Liverpool by Tyson Smith his embellishments to the one at Southport may be singled out as the most important. In keeping with the memorial's mixture of an Ionic and Doric order designed by Grayson, Barnish and A L McMillan (another firm of Liverpool architects) Tyson Smith's vocabulary and draperies are Grecian in origin. At the same time there is a hint of the Egyptian in such details as the way Athena's feet are placed along the foreground plane and more generally in the shallow etching of the reliefs.

Central to Tyson Smith's career was his close involvement with architects and architecture. This can be traced back to his first commission; a scale model of Port Sunlight village. More significantly Tyson Smith was associated with Liverpool University's School of Architecture from its foundation at the turn of the century. From this connection arose a number of his local collaborations, in particular the joint project with Charles Reilly, Professor of the School of Architecture, for the Post Office memorial (Victoria Street, unveiled 1924) and a partnership with Lionel Budden (Reilly's assistant and successor to the Chair) to work on the Birkenhead memorial and the Liverpool cenotaph. Tyson Smith believed his carving gained from learning 'architectonics' from architects. He preferred to work on site with only a small-scale sketch in clay, bringing traditional craftsman's skills to the job in hand. This is reflected in the fact that his work is seen to best advantage where there is a dominant architectural context such as at Southport or Birkenhead. Those commissions for a figure in the round, such as Britannia in mourning on the Post Office memorial, tend to be

4. Professor C Reilly and H Tyson
Smith, 'Post Office War Memorial',
1924, Post Office, formerly Victoria
Street, now Whitechapel

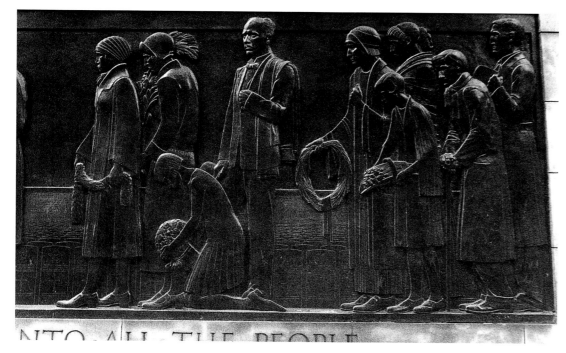

NTO ALL THE PEOPLE

5. Lionel Budden and H Tyson Smith, detail of Cenotaph, 1926–30, Liverpool, St George's Plateau

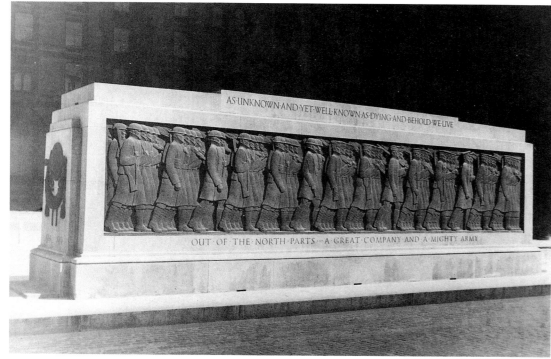

AS·UNKNOWN·AND·YET·WELL·KNOWN·AS·DYING·AND·BEHOLD·WE·LIVE

OUT·OF·THE·NORTH·PARTS —·A·GREAT·COMPANY·AND·A·MIGHTY·ARMY

6. Cenotaph, Liverpool, St George's plateau

rather dull and lifeless. Kineton Parkes offered the more generous assessment of 'stately'.

Craftsmanship and a sympathetic approach to architects and buildings won Tyson Smith commissions around the country, including the prestigious job of designing the Royal Academy war memorial. But it was Liverpool's civic memorial, the cenotaph on St George's plateau, which earns him a place of distinction. The success of the monument has its basis in the 'dignity, simplicity and reserve' of Lionel Budden's design[7]. He won an open competition in 1926 judged by his predecessor as professor of the university's school of architecture, Charles Reilly. The original plans which include rough sketches of the two long reliefs flanking the monument and other sculpted ornaments are only signed by Budden. In this design one relief shows mourners clad in rustic costume gathered around a draped body and the other represents naturalistic groupings of marching soldiers. Tyson Smith was involved in the project from an early stage but judging by the uncharacteristic naturalism of the draftmanship he may not have contributed to these first designs for the reliefs.

There was an interval of four years between the choice of design and its unveiling on Armistice Day 1930. The delay was partly due to the necessary rearrangement of the site: Disraeli's statue had to be moved. There was also unsuccessful opposition from councillors and members of the public who wished to keep St George's plateau unaltered. A further delay was caused by the sheer scale of the project: each bronze relief was thirty one feet in length. Afterwards Tyson Smith said that he had worked two years exclusively on this project[8]. He may have taken longer than usual because his familiar medium was stone carving rather than modelling in clay for casting. Anyway the memorial in its completed form is a well matched collaboration. Budden stripped his altar-like cenotaph of the rather fussy classical details submitted in the original plan. This is a much better foil for Tyson Smith's two massive reliefs which dominate the memorial. Modernity has crept into the handling of the original themes. The mourners are now dressed in contemporary clothes and are located in an Imperial War Graves Commission cemetery around a 'stone of remembrance'. The soldiers on the other face are placed in a continuous stream of serried ranks. Both friezes maintain a familiar hieratic style of composition but with a new sense of modernity, especially in the rhythm of the marching soldiers which is almost futurist.

Remarkably the Liverpool cenotaph is extremely rare amongst Brit-

ain's civic memorials to take up the theme of mourning in such a contemporary style. It is not unusual to see a figure like Britannia in mourning: Tyson Smith's memorials for the Post Office and Wavertree are two local examples of this. Presumably therefore it was a wish to avoid the temporality of fashion or to keep grief symbolic that led sculptors to omit contemporary dress. There may also be a spiritual dimension: memorial inscriptions, whilst avoiding specific references to resurrection, manage to imply a kind of immortality. Rudyard Kipling established the archetype for use in IWGC cemeteries: 'Their name liveth'. In these terms memorial designers had to handle grief with great care so as not to undermine public confidence in the notion of the 'glorious dead'. Tyson Smith may have felt these constraints less acutely in the cenotaph commission than others because by the late twenties the war had lost some of its immediacy and the committee was anxious to play down the religious aspect of the memorial. Predictably, perhaps, this caused more controversy than it avoided. The committee planned a non-denominational unveiling ceremony along IWGC lines projecting the sacrifice of life in patriotic rather than religious terms. Members of the Anglican diocese were outraged because they believed the Roman Catholic church had influenced the committee's decision. Despite strongly worded protests the ceremony proceeded as planned but it ended the life of the memorial committee on a bitter note.

The quarrel is a reminder that religious sectarianism played an integral part of life in the city. The Anglican community had already made a substantial memorial by dedicating the north transept of the new cathedral to the fallen of the Liverpool diocese and district. In a wider context we may assume that religious sectarianism affected not only parish memorials but also those constructed by secular communities such as businesses, districts and branches of the war services. So the cenotaph, in avoiding sectarianism, stands as the exception to prove the rule.

Of all the sculptors working on war memorials the one who most successfully met the broadly popular notion of the 'tommy' and all he symbolised was Charles Sargeant Jagger. His memorial on Grange Hill, West Kirby justly earned him a national reputation and was the springboard for many other commissions. The tommy figure was exhibited at the Royal Academy in various states between 1920 and 1923 and thereafter demonstrated its success by a small scale version known as 'Wipers' being sold in an edition of at least a dozen. Its popular appeal lies in the cleverly balanced combination of a man of action, his bayonet fixed, who nevertheless remains unthreatening because he stands at ease with his helmet pushed off his head. This informal portrait is based on first hand experience. Jagger first saw action at the débâcle of Gallipoli and then again on the Western Front in 1917. Jagger's Rome Scholarship of 1914 had been lost to active service and so his work came of age via the trenches. Few other sculptors, and none working in the locality, went on to achieve such success and recognition on the basis of this unorthodox training. Indeed the only leading sculptor of the period whose career closely mirrored Jagger's own was his former student rival Gilbert Ledward.

Letters from the Gallipoli period reveal Jagger already planning war sculptures. In fact his first major project was started while recovering at home from wounds in 1917. This sketch developed into the extraordinary bronze relief, 'No Man's Land'. Jagger was funded to work on 'No Man's Land' by the British School at Rome in lieu of his 1914 scholarship and it was given to the Tate Gallery in 1923. On the West Kirby obelisk the heroic realism of the tommy is paired with 'humanity': a female figure symbolic of mourning motherhood. The relative lack of assurance and somewhat heavyhanded symbolism of 'humanity' reveals Jagger's failure to bring this aspect of his prewar studies under Professor Edouard Lantéri at the Royal College of Art to equal maturity.

In contrast to the youthful Charles Sargeant Jagger, William Goscombe John RA, born in 1860, belongs firmly to the (by then old)

7. C S Jagger, 'War Memorial for Hoylake and West Kirby', 1922, West Kirby, Grange Hill

'New Sculpture' movement. In 1894 Edmund Gosse, the art critic and publicist of the 'New Sculpture', had declared Goscombe John and his student contemporary George Frampton to be the youngest and therefore last artists to emerge within the movement. Yet even though this places Goscombe John broadly within the same tradition as the sculptor of Cunard's 'Victory', Henry Pegram, their approaches to monumental commissions could not have been more different. Goscombe John's work enacts Edmund Gosse's appeal voiced in 1895 for sculptors to 'come to us untrammelled, in all your forms, give us the best you have to give, be broad, versatile, modern'[9]. More specifically Gosse had urged sculptors to get away from the convention of portraits or classical figures as the stock in trade of public sculpture and instead to include people's deeds as subjects (being often more memorable than their faces) and urged artists to make each monument appropriate to its situation. This adaptability is very evident in John's work. Perhaps this originated in the unevenness, noted by Gosse, between his natural facility in modelling and his weakness in composition. Lacking the vision of Alfred Gilbert or Hamo Thornycroft he may have been more open to the demands of individual commissions. Certainly whatever Goscombe John may have missed in terms of first hand experience he made up for by a thorough and sympathetic consideration of his subject.

Goscombe John's major work from the First World War is at Port Sunlight, but looking first at two earlier memorials the way in which interpretation follows subject is more clearly revealed. The King's (Liverpool) Regiment memorial sited in St John's Gardens was the first of many works Goscombe John made in Liverpool. Since his election

to ARA in 1899 he had received many commissions which furnished him with the necessary credentials. One of two models he submitted was accepted in 1903 and work was completed in 1905 in good time for the unveiling ceremony on 9 September. Britannia occupies a central position; she is depicted stripped of arms and mourning the dead. A curved parapet leads down on either side from Britannia's pedestal to two figures representing the regiment. One is a swashbuckling cavalier from 1685, the year of the regiment's foundation, and the other is dressed in the khaki of 1902. At the back of the memorial is the most remarkable figure in the composition, a seated drummer boy of the period of Dettingen, beating a call to arms. In 1925 Goscombe John said the drummer boy was his most popular and successful work: it was sold as a small bronze in a large edition. The sculpture's success lies in vividly expressing the fear and excitement of the charge. The whole work is exceptionally fine and all the more so because the Boer war produced very few memorials that avoided both sentimentality and blatant patriotism. Nevertheless the soldier figures display a confidence and certainty which evidently Goscombe John recognised did not suit subsequent events.

This is very evident in John's next Liverpool memorial the 'Engine Room Heroes' at the Pierhead. Originally intended as a monument to the 32 men from the engine room of the Titanic who gave their lives to keep the ship afloat so others could escape, the memorial was given a broader dedication in 1916 as a tribute to war time casualties. Goscombe John responded to the modernity of his subject with a massive granite obelisk freely designed to be in keeping with the neighbouring Royal Liver building. The base of the memorial is flanked on either side by pairs of stokers, mechanics and engineers faithfully depicted with the tools of their trade. Above, symbolic figures representing the elements acknowledge the marriage between earth, air, fire and water in the work of the ship's engineer. Edmund Gosse had hoped for just such monuments, arguing with some foresight that industry might change and so what had been important to one age should be recorded for the next in memorials to the working man. Evidently few people shared either this recognition of change or the need to commemorate labour because the 'Engine Room Heroes' is one of the few monuments of its type and was anyway commissioned for special reasons.

In 1916, the year the 'Engine Room Heroes' was completed, Goscombe John was invited by his friend Lord Leverhulme to design the memorial at Port Sunlight. Lord Leverhulme was greatly interested in how the war would be commemorated and also realised there would be a rush to engage the best sculptors after the hostilities ended, hence his early bid for Goscombe John's services. Leverhulme was a paternalist of the old school, strongly believing that investment in the well being of his employees was a good use of company resources. From Lever Brothers a pals' battalion[10] was raised in 1914 and Leverhulme used his wealth and influence to provide extra resources for their comfort. Like so many others the high level of casualties led to the battalion being disbanded later in the war. Apart from the poignancy of this fact the pals' battalions are interesting in demonstrating the essentially territorial basis for recruitment. There is an obvious connection between these community ties in the services and the construction of so many memorials to employees and other civic associations after the war.

In 1919 Goscombe John exhibited his model for the Port Sunlight memorial at the Royal Academy. The chosen theme was defence of the home which is of course singularly apt for its setting in Port Sunlight village. Surprisingly this was not a subject often chosen by sculptors and no others are on such an impressive scale. The memorial incorporates eleven figures in the central grouping around the cross and twelve reliefs on the outer parapet. Goscombe John was given a free hand with the design and so was responsible for the architectural elements. Here he is less successful than usual, there is a certain lack of grandeur about

8. W Goscombe John, 'King's (Liverpool) Regiment Memorial', 1903–5, Liverpool, St John's Gardens

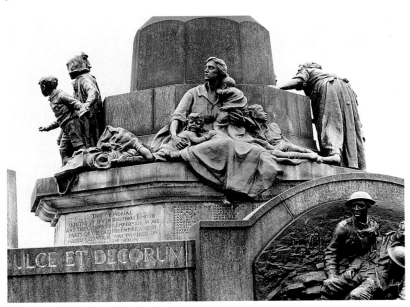

9. W Goscombe John, detail of
'1914–18 War Memorial', 1919–21,
Port Sunlight

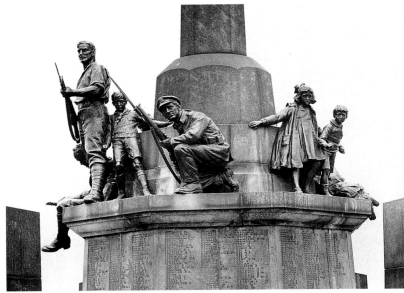

10. Detail of Port Sunlight War
Memorial

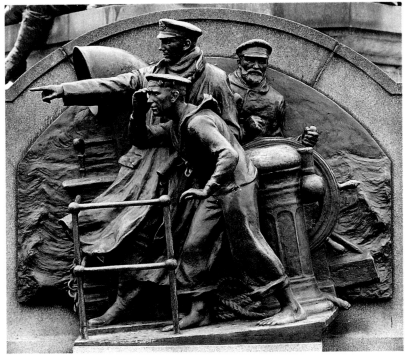

11. Detail of Port Sunlight War
Memorial

the stonework which weakens the impact of the memorial. On the other hand an architect might not have been happy with John's sculptural approach. The figures in the round are placed on the central plinth without any regard for the 'architectonics' so important to Tyson Smith and Charles Sargeant Jagger. Instead Goscombe John has treated the cross and plinth as an emblem of home which the soldiers, mothers and children are using as a refuge and defence just as if the enemy were advancing into the village. What the memorial loses from this naturalistic effect in its impact at a distance is outweighed by the interest and unusualness of the composition viewed at close quarters.

Another special feature of the memorial is that overall there are more children than adults represented. In addition to those included in the main group there are pairs of reliefs of children carrying wreaths and other tokens of commemoration at each of the four entrances to the memorial. There is a touch of sentimentality in the portrayal of the children but they also serve to underline the main theme of the memorial and to remind future generations what they owe to the past. The remaining reliefs are a carefully studied reworking of a standard theme; they illustrate the work of the armed services and civil defence.

Today the Port Sunlight memorial, as is to be expected in this architectural and historical showpiece, is unusually well cared for. Unfortunately this is not true of all the region's war memorials. In this respect the area is not unusual: public sculpture everywhere is a target for graffiti and abuse. The more general neglect war memorials have suffered reflects the lack of interest they have attracted as art objects and the gradual decline of public involvement in the commemoration of the nation's war dead. This can be traced back to the end of the Second World War when interest focussed on building a better future rather than monuments. There was a general feeling that there were already a great many war memorials and more were not needed.

Hence the names of the war dead were usually added to memorials from the First World War. The Royal Navy memorial at the Pierhead, designed by Stanley Smith and C F Blythin with carvings by Tyson Smith, is a local exception and reflects the special significance of the war at sea in Britain's defences.

In recent times memorials have either been ignored or abused: within the time of researching and writing this article Goscombe John's King's (Liverpool) Regiment memorial was daubed with white paint. Restoration work was hastily carried out in time for the seventieth anniversary of Armistice Day. Presumably it is due to a lack of funds that the method used to treat such problems is to paint the bronzes with bitumen. This achieves the object of obliterating the graffiti but at the

expense of losing the sculpture's original patination and after several coats also blurs the finer details.

A few memorials have been badly treated by uprooting them from the site they were designed to occupy. Admittedly this has not always been disadvantageous as is true of Joseph Phillip's News Room memorial which is now situated at one end of Exchange Flags. In fact the memorial is more accessible in its present site than it was formerly in the news room of Derby House. The only unfortunate consequence is that it is now outshone by the remarkable monument to Nelson by Mathew Wyatt and Richard Westmacott which dominates the square. Elsewhere resiting has been less well managed. F D Wood's Cotton Exchange memorial stands forlornly in the courtyard of the company's glass and concrete office building constructed in the sixties to replace their former headquarters in a classical revival style. Not only is the memorial out of keeping with its new architectural setting but the sculpture has been stripped of its pedestal and most of its patina.

In marked contrast, sensitive restoration work on some monuments has been carried out. Notably the stonework of the 'Engine Room Heroes' has been cleaned and regilded where necessary. It is a fine beginning to a much needed programme of restoration.

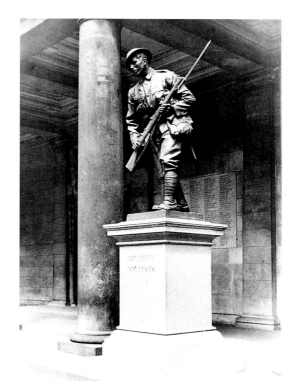

12. F Derwent Wood, 'Cotton Exchange War Memorial', 1922, Liverpool, Cotton Exchange

NOTES

1 Basic information concerning the title and location of Liverpool's war memorials can be obtained from the publications catalogue of the local history library and record office (a department of Liverpool Central Libraries) and from an illustrated survey of sculpture on Merseyside undertaken by the Walker Art Gallery with assistance from the Manpower Services Commission in 1976. A useful album of photographs of war memorials is housed in the local history library.

2 Sir George Frampton was a member of a Royal Academy executive committee formed in July 1918 to advise memorial committees on all aesthetic questions. Having completed several commissions for statues in the city of Liverpool before the war, Frampton was familiar with the locality. The choice of Charles Sargeant Jagger arose out of Frampton's membership of the British School at Rome committee which funded the making and casting of 'No Man's Land' (see essay). This project was in hand at the time the Hoylake/West Kirby committee approached Frampton. In later years Jagger was quick to acknowledge the importance of Frampton's support.

3 E L Woodward, *Short journey*, London, 1942, p 114.

4 Robert Graves and Alan Hodges, *The long weekend: a social history of Great Britain, 1918–1939*, London, 1940.

5 The record office in Liverpool Central Libraries holds the Tyson Smith papers. These comprise seven tea chests, nine deed boxes, two cardboard boxes, one bundle and one large design for the cenotaph. At present these are unsorted and the time available to write this essay was too short to undertake extensive research in the archive.

6 Kineton Parkes, 'Modern English Carvers IV – H Tyson Smith', *Architectural Review*, October 1921, pp 151–152.

7 Professor Charles Reilly, adjudicator of the cenotaph competition, quoted in the Liverpool *Post and Mercury*, 16 October 1926.

8 A Brack, 'George Henry Tyson Smith – 70 sculpting years', *Lancashire Life*, vol 16, April 1968, pp 48–51.

9 Edmund Gosse 'The place of Sculpture in daily life III Monuments', *The Magazine of Art*, 1895, pp 407–10.

10 Pals' battalions were formed by mass recruitment amongst friends from social clubs (like the Boy's Brigade) or colleagues from offices and factories. Having both a civilian and military connection was felt to foster group loyalty and comradeship. The battalions were an effective aspect of Kitchener's recruitment campaign; altogether a quarter of a million men enlisted in this way.

THE SCULPTURAL SCHEME IN THE ANGLICAN CATHEDRAL: SCULPTING TO ORDER?

Penelope Curtis

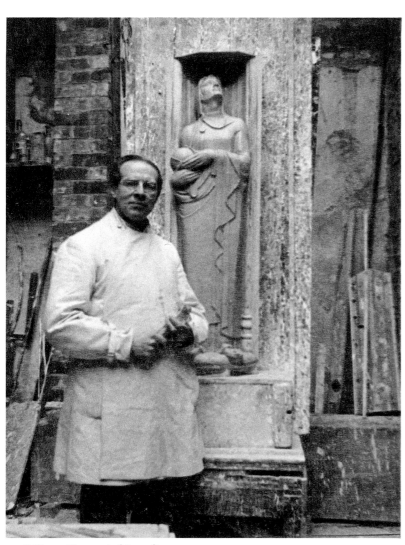

1. E Carter Preston in his studio at work on one of the clay models for the carvings in the Anglican Cathedral

'You will have heard of our discovery of Carter Preston, the sculptor here. Scott was much impressed by a piece of his work which Dwelly showed him, and has given Carter Preston a commission for Stations of the Cross in a church in a building somewhere. I rather hope you will get designs from him for your 4 figures. Carter Preston who is the finest kind of agnostic wandered into the Cathedral on Christmas Day and said to Dwelly afterwards "You came very near to the ineffable". He is a kind of prophet like Blake and lives very high.'
The Bishop of Liverpool to Frederick Radcliffe, 8 January 1931.

'I hope a decent sculptor can be found. True the figures are high up, but they are visible.'
Frederick Radcliffe to Giles Gilbert Scott, 2 March 1931.

'So that is why Carter Preston wanted critical books on the early church – he is a reticent man and never breathed a word of this to me, but I loaned him the latest critical books as well as Lightfoot and Chase. I am glad you are considering him for some figures, though I do not know that his style fits in with Phillips, indeed I should doubt it. All the work of Carter Preston that I have seen in sculpture is far more severe and restrained but it may be that you are looking for this, if so, then you have found him.'
Dean Dwelly to Frederick Radcliffe, 17 April 1931.

'As you know, I agree with you entirely in regard to your feeling as to the character of sculpture generally: the difficulty is to find a man with all the qualities a sculptor should possess.'
Giles Gilbert Scott to Frederick Radcliffe, 29 January 1932.

'*Sculpture*: I am very glad to know you were pleased I certainly think Carter Preston is a "find".'
Giles Gilbert Scott to Frederick Radcliffe, 4 February 1932.

Edward Carter Preston was born in Walton, Liverpool in 1885. He studied art briefly at the newly founded University School of Architecture and Applied Arts and his period at the 'Art Sheds' coincided with that of Augustus John around 1902. He made his name as a medallist, winning first and second prizes in the government competition for a plaque for the next of kin of those lost in the First World War[1]. His career as medallist was long and successful. Like his brother-in-law, Herbert Tyson Smith, Carter Preston was a skilled letterer and carver of inscriptions. Carter Preston was also an ardent watercolourist, working generally from landscape. Although he had modelled portrait busts, his employment as 'sculptor to the cathedral' was exceptional within his career[2]. Such a large-scale and extended project would be exceptional even for an artist who, unlike Carter Preston, was first-and-foremost a sculptor. Having embarked on the project, Carter Preston moved from his Sandon Society studio in the Bluecoat chambers, up to a new house at 88 Bedford Street South. In the converted coach-house there he executed all his models for the Cathedral sculpture. This work lasted from 1931 to 1955, beginning with the memorial to Bishop Ryle[3] and ending with the figures of the Queen Mother and George VI. The 1930s were the busiest years, during which Carter Preston modelled figures for the window mullions, the tympanum to the Baptistery, sixteen figures for the interior porches of the Great

Central Space, ten figures for the Rankin and thirteen for the Welsford Porch[4], and carved figures for the font and the pulpit. Apart from the memorial to Ryle, he carved other bas-reliefs and tablets to Sir Max Horton, Dr A J M Melly, Helen Swift Neilson and Robert Jones, and his last memorial – to Dwelly, First Dean of Liverpool – was unveiled in 1960.

In 1941, after a decade's involvement with the sculptural scheme for the Cathedral, Carter Preston wrote some notes on his experience:

He, that is Radcliffe, acted between myself and the committee in matters of symbolism, Sir Giles acted in a similar capacity in the matters relating to the fitness of the designs to his architecture. It turned out to be a very efficient method of getting things done and also saved me a good deal of worry. As you will realise a group of laymen can be very awkward when they have direct power where the arts are concerned and when I suggested that Sir Giles and Sir Frederick should relieve me from such onerous duties, they most graciously complied, to, our mutual benefit, I believe.

You will see that the job has been unique; sculptors usually are not given such freedom.

He went on to describe how he had seen his job as a sculptor working on a Cathedral designed by Sir Giles Gilbert Scott.

I felt that the essential demand was for the figures to fit into their places with the least ostentation. Each bay was designed whole. The ensemble was assured before any cutting was done in the fabric ... all cast in the same alembic, like a theme with variations. This was to try to avoid the eye being detained on any particular detail, when the bay was viewed as a whole.

Having received these notes in which he was referred to appreciatively Radcliffe wrote to Mr Wynne Jones at the end of February 1942: 'A very agreeable experience it was to deal with so quick and fertile and understanding and so accomplished an artist as Mr Carter Preston.' Radcliffe went on to praise Carter Preston's loyal acceptance of the limitations imposed by the architecture: 'There is no straining after the creation of an individual effect in his work – as who should say "look at me"'.

In December 1948 Carter Preston looked back on 'The fruitful years, when we were working together on the Cathedral sculpture. I count myself fortunate in having had work of such sustained interest and so continuous duration'.

In 1937, after his work on the Rankin porch was over, Carter Preston had thanked Radcliffe. Radcliffe was proud enough of Carter Preston's thanks to enclose them in a letter to Giles Gilbert Scott 3 days later of 16 October 1937. He wrote: 'I feel rather proud of the enclosed letter, I think he has been very long suffering and pleasant.'

Despite this mutual admiration, the relationship between Radcliffe and Carter Preston as revealed in their correspondence did not always run smoothly. It was this relationship, however, (and to a lesser extent that between the sculptor and Scott) which was absolutely central to the execution of the whole sculptural project. As he reported, Carter Preston did not have to work with a committee but rather with two men, and it was this triangular relationship that struck the rhythm over several decades. Carter Preston's tact and diplomacy must account in part for his long-standing engagement as sculptor.

Sir Frederick M Radcliffe KCVO LLD was appointed to the Liverpool Cathedral Committee in 1901. From 1901 to 1913 he acted as Honorary Treasurer, and from 1902 acted concurrently as Vice Chairman. From 1913 to 1934 he was Chairman, and thereafter was Honorary Secretary. Although he retired as Chairman in 1934, this did not mean that he stepped down as the creator of the iconographical schemes for the sculptural decoration of the Cathedral. He was closely involved in the Cathedral until his death in 1953. The following decade saw the demise of the major protagonists in the long history of the building of the Cathedral: in 1957 Carter Preston's friend Dean Dwelly, in 1960 Giles Gilbert Scott, and in 1965, the sculptor himself.

While Radcliffe was responsible for and extremely anxious about every detail of the symbolism of the sculptures modelled by Carter Preston, Giles Gilbert Scott had a much freer and more relaxed attitude towards Carter Preston's work. It would appear that Giles Gilbert Scott was frequently the mediator between Radcliffe and the sculptor, despite Carter Preston's 1941 report: 'When any new symbolism was introduced it was submitted to Sir Frederick who sat in judgement on it. I must say he was a most sympathetic critic and we had very little friction, particularly so when one considers the fractious nature of the business in hand'. Scott was responsible for formal concerns; when it came to iconographical detail he was often inclined to allow more freedom to the artist than was Sir Frederick.

The following letter is typical of many that he wrote to Radcliffe: 'With reference to the figure of St Barnabus, I have received a letter from Carter Preston. Unless you or the Bishop has very strong views I would suggest that it might be as well to leave the matter to Carter Preston's own decision'. (13 April 1931) This clearly did not allay Radcliff's fears, for just over a month later on 17 May Scott wrote again: 'As regards St Barnabus, I note what you say and am writing to Carter Preston accordingly. I am giving him a pat on the back for having made the suggestions he did, and I agree with you that we should certainly encourage this interest in symbolism, which will probably in most cases result in more interesting figures. The two models he has already prepared for the transept windows promise to be very good, but before the photographs are submitted I will inspect the models themselves'.

Questions of symbolism and iconography continued to trouble the otherwise smooth relationship of Radcliffe and Carter Preston. On 27 May 1931 Scott wrote to Radcliffe: 'I am enclosing a copy of a letter from Carter Preston with reference to his models for the figures on the transept window mullions. In view of what he says, I should think we might leave to his judgement the various matters of detail which have been questioned'.

Two days later Scott wrote again obviously determined to work out a standard method of procedure whereby such increasingly common problems could be dealt with: 'With reference to future figures, I think that the best plan will be for you to deal direct with Carter Preston so far as symbolism, etc is concerned; when this aspect of the case has been satisfactorily settled, I can then come on the scene and deal with the purely aesthetic side of the matter'. This procedure was reiterated by Scott in a letter to Radcliffe of 10 February 1933: 'I note that you have sent a copy to Carter Preston, and I quite agree that it is less cumbersome for you to correspond direct with him now that the matter has reached the present stage'.

Radcliffe and Scott had divided their responsibilities satisfactorily between them, and clearly it was easier for Radcliffe to tackle iconographical points directly and at an early stage. For information about Carter Preston's work, Radcliffe and Scott (who both lived in the south) were reliant on small three-dimensional models of Carter Preston's early ideas, and on photographs for the finished models. The models were sent by railway in crates. (On 18 June 1934 Carter Preston wrote to Radcliffe: 'Today I despatched two boxes of small models to you per LMS railway, I trust they will arrive in order – am sending a brief description of the symbols etc'. Another batch of cases was despatched to Radcliffe on 24 July 1936. Carter Preston wrote: 'Today I have sent to you by rail two cases containing four each of the sketches for the figures. You will see I have kept very close to your descriptions and have only changed from your suggestion when I could not make them fit into the scheme'.) Whenever either Scott or Radcliffe had occasion to be in Liverpool, they attempted to arrange a viewing in the studio. As Scott wrote to Radcliffe on 10 February 1933: 'I have received photos of his preliminary models for angels with censers – I

saw these models when last in Liverpool, and I think they came out quite well'.

Clearly the full scale models were also used for scrutiny, for on 22 June 1933, Scott's secretary Crimp wrote to Radcliffe: 'I have written to Carter Preston, reminding him of the arrangement that only two of the full size models should be done for the moment, and I have asked him whether he can manage to have these ready in time for the next meeting of the executive 31 July'.

It was Carter Preston who had added to the elaboration of the procedure in February 1933. On 10 February he wrote to Radcliffe: 'In conclusion, you suggest that it might be well to have one figure of each series in the first instance. As an alternative I wish to suggest that we make the sets complete of each series in miniature, rough sketches similar to those I have made for the few figures already made for you, starting with the most debatable matter, as the Active Life series'.

There were obviously limitations to judgement by photograph as Giles Gilbert Scott pointed out to Radcliffe on 8 January 1934 in reference to the figure of *Bounty*, about which he felt bound to make one or two minor criticisms: 'I am arranging to call and inspect the actual model. I may then find out that the grounds for my criticisms are due to the lighting effect in the photograph'. Certainly Carter Preston was alert to the problems of photographs and would point out any of their drawbacks. He was also aware of the problems in the procedure as a whole: 'I do not want to be tied too firmly to the forms if when I come to the full size figures I can see a simpler way out'. (18 June 1934) As he stressed in a later letter to Sir Frederick of 5 August 1935: 'I consider it essential that the working model and the finished article should be different and distinct'.

It still fell to Scott to intervene on various occasions, as for instance in May 1935 when Radcliffe was perturbed by the appearance of hemlock in Carter Preston's figure of Medicine. Scott told Radcliffe on 23 May: 'I am writing to Carter Preston (as tactfully as possible!) asking him to give me some little explanation of the symbolism of the Hemlock. I personally feel that provided it has some appropriate significance, it does not in the least matter whether it is used in modern medical practice'.

In June 1933 Radcliffe had been concerned that Carter Preston had used female figures in all cases except Fortitude for the porch series. Giles Gilbert Scott took this matter up with Carter Preston and, having received his reply, wrote to Radcliffe on 19 June 1933: 'I think what he says is reasonable and I am sure we can safely leave the matter in his hands. From what I have seen of his work, I think it is quite safe to assume that the figures will not suffer from excessive femininity or lack of robustness'.

Radcliffe clearly welcomed Sir Giles' interventions to the sculptor on his behalf, and on 25 February 1935 wrote: 'Oh you may think it better to make, as from yourself, the suggestion as to the words on the scroll. What you say goes! What I say infuriates him, especially if his dyspepsia, which I am sorry to say plagues him, happens to be especially troublesome. I really feel relieved at the excellence of this figure as I feared his inspiration might peter out over a long series. Hence my enquiry the other day as to whether you propose him for Welsford porch'.

Given both parties' approval, the interval between model and carving could be very short. The process could be very smooth indeed. As Scott wrote on 11 December 1935: 'Dear Sir Frederick, I am sending you herewith the photos of Carter Preston's model for the figure of St Paul. I think it is very good. Let me know whether you agree with me in liking the figure, so that I may have it sent to the Cathedral for cutting in stone'.

Occasionally it is clear that Scott overruled Radcliffe's slight criticisms on questions of symbol. He wrote on 13 December 1935: 'I fully appreciate the criticisms you make but your opinion of the figure as a whole is definitely favourable. I am therefore giving permission for the model to be sent to the Cathedral, so that the cutting in stone may be put in hand'. It appears likely that Scott was frequently pressurised by time, and by the difficulties of keeping together a full team of experienced masons and craftsmen. There are several reports in Committee minutes testifying to his sense of urgency over the carving of the models.

There are clearly occasions when Carter Preston must have felt that he was the servant of two masters; obliged to work within Giles Gilbert Scott's overall architectural vision and yet obliged to heed Radcliffe's minutiae with regard to symbolism. Radcliffe wrote to Scott on 13 August 1936: 'I see his difficulty – that he wants the long line. If you forbid legs it looks as though we should have to reconsider the series.' He continued, 'I want you first to decide – legs or no legs? If you say these are permissible, the series is possible'. Scott replied on 18 August: 'I am very anxious to leave Carter Preston as free a hand as possible in his interpretations. My own feeling is: I have no intrinsic objection to displaying the legs of these figures, but I do strongly feel the necessity for "verticality". I think it would be a pity to give up the selected subjects'. Radcliffe then threw the question open to Carter Preston on 25 August as follows: 'But since Sir Giles does not make long robes a *sine qua non* it is now for you to be kind enough to consider the question in the light of his and my observations.' Having consulted his own books and acquaintances as to whether the people in question (ie figures representing the active life in Biblical times in the East) could have worn long robes when at work, and having made the models, Carter Preston was obviously loathe to start again, and replied to Radcliffe on the 29th: 'I hope you will not think of changing the subject matter'.

Radcliffe went on to write about Carter Preston to Scott on 17 September 1936: 'I am sure we must be careful. He was not instructed to illustrate certain traits directly, but to illustrate them via the parables he must have a reasonable regard to the eastern costume'. The question seemed to be resolved when Scott wrote to Radcliffe on 25 September: 'I called on Carter Preston yesterday, to talk over the question of the costume in his sculpture and I have agreed with him to modify those of some of the figures by shortening the skirt-like garment so that it does not fall over the feet'. Carter Preston agreed in his letter of the same date to Radcliffe: 'I think I may be able to do what you wish and still retain something of our perpendicularity'. By October Carter Preston was becoming slightly irritated with Radcliffe and wrote: 'May I say in my own defence that I have a moderately sound body of working knowledge in the subject what I would like to feel was that I had your complete faith in my ability ... An artist must have a certain amount of liberty, not that he may evade criticism ... I am anxious you should know the sketches were not just thrown off'. Radcliffe capitulated, and wrote to Carter Preston five days later: 'since you accept the challenge of it rather than ask for a change, I entertain no doubt that you will come out triumphantly'. It is clear however that he wished he had maintained his original reservations, for when he received one of the early models for the series ('The Servant') early the following year he felt impelled to write to Scott (24 March 1937): 'I greatly regret that my repeated suggestions were declined that I should substitute quite another series of subjects for the parables. But I am not to blame for this difficulty, but the artist's acceptance of the task despite my forbodings. Mr Carter Preston's genius is quite capable of overcoming the difficulty and it is not for me to suggest how'.

Although Carter Preston's finished work was seen by the public in stone within the fabric of the Cathedral, the sculptor himself worked in his studio in clay. He worked with the stone in mind, tooling the clay in a manner apposite for stone. His full size clay models were cast by a visiting plaster caster of Italian extraction, Peter Bartolommei. The casts were in solid plaster with armature and scrim. The coarse sacking used for the scrim is quite visible in the casts still stored in the Cathedral.

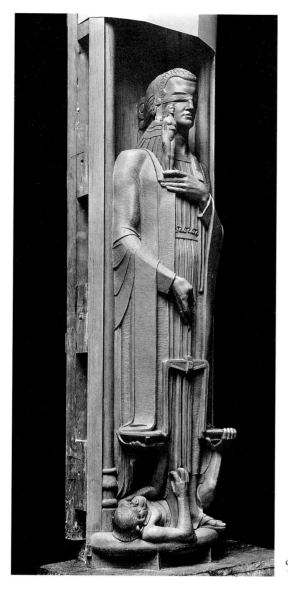

2. E Carter Preston,
clay model for
'Justice and Injustice'

3. E Carter Preston,
clay model for
'Temperance'

These casts were painted green, and transferred into stone by a carver using a pointing machine. The notion, therefore, that formal problems could be avoided by Carter Preston carving on site was misplaced. Vere Cotton, the chronicler of the Cathedral, appears to be labouring under this misconception in a letter to Radcliffe of 10 May 1937, where he is concerned about the illumination of the figures in the porches. He wondered if there were still a 'possiblity of his working on them in the Welsford porch where the lighting will be identical to that in the Rankin porch. He probably would not like working there unless he could be given protection but I do firmly believe those sculptors such as Gill and Epstein who insist on carving decorative figures in situ are right'.

As Radcliffe pointed out to Scott on 12 May 1937: 'Of course Eric Gill whom he quotes as insisting on carving in situ is a different thing. Carter Preston is not doing this, and the best he can do is to go over the mechanical reproduction of this models'. He reassured Cotton, 'Scott has it clearly in mind that, when the surroundings are ready, Carter Preston shall go over the lot and, where necessary – give a deeper cutting to any of the figures'.

On the whole it appears that Carter Preston was completely satisfied by the reproduction of this models by pointing machine.[5] As he wrote in a letter of 16 July 1936 to Radcliffe:

You seem to be apprehensive that there will be a visible difference between the models and the final carvings; I am very glad to say that so far the stone carving has given me every satisfaction, they are as like as it is possible to get them and to my own mind they are very much improved by the colour of the stone, the minor details take their proper place whereas, in the plaster they often appear too

obvious, one of my major difficulties lies in the discrepancy between the whiteness of the plaster and pinkness of the stone and making just allowance for this.

However there is an incident in 1932 to which the Bishop refers in this letter to Radcliffe:

Thank you very much for taking so much trouble to meet my concerns. I do not think Carter Preston objects to the machines. He realises that the execution of his design is in itself a mechanical job, and he knows that accidents can happen to anybody. But the essence of the matter was the selection of a man to work the machines. I am pretty sure that Pittaway is not the man to select craftsmen for particular jobs. I can quite see that the artist need not necessarily have the final word in that selection, though I do not think there is anybody who knows Liverpool craftsmen and their capabilities better than Carter Preston himself' (21 March 1932)[6].

The clerk of works Pittaway told Radcliffe on 30 March 1932:

With reference to the carver who was pointing the figure on the mullion of the south transept window. This man did similar work on the completed section of the building. Mr Carter Preston considers that he was not cutting the figure to the model. I have now set another man, who is a figure carver to finish this figure, and to test the work already done.

And on the 9th of the following month The Bishop of Liverpool wrote to Radcliffe: 'Thank you heartily for the discreet action you have taken. I really am greatly relieved that the choice of executant craftsmen will not in future be entirely left to Morrison or Pittaway'.

Giles Gilbert Scott explained to Radcliffe on 6 April 1932:

With reference to your enquiries as to the sculpture, the carvers who

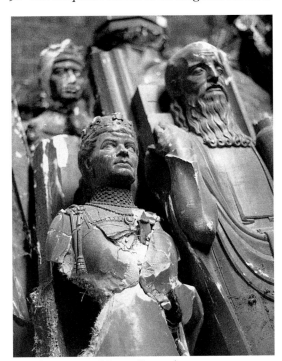

4. Plaster casts of Carter Preston's
models, now stored in the Cathedral

translate Carter Preston's models into stone are employed by Morrisons[7]. It is true the man originally employed on the first of the transept windows figures was not entirely satisfactory. He has, however, now been replaced by a good carver who was formerly employed at the Cathedral and who, as a matter of fact, was recommended by Carter Preston himself. I think there was a little misunderstanding at first because Pittaway, who knows exactly the surface and texture which I wish imparted to the sculpture, was a little inclined to resent instruction from Carter Preston. You may rely on the sculpture being carried out faithfully and sympathetically from the model.

The tablets and memorials by Carter Preston for the Cathedral followed a rather different procedure, for they were carved by the sculptor himself in his own studio. Their finesse, their execution in very shallow bas-relief in a much finer, harder stone, reveals a very different kind of skill to that maintained by Carter Preston through the various stages of his architectural sculpture.

The stone used in the Cathedral – a hard coarse-grained Woolton stone – made the task of translation from his models more difficult, and the problems involved in carving it had clearly caused Carter Preston some anxiety at first. Johnstone told Radcliffe in a letter of 31 July 1933 that he had visited the sculptor in his studio: 'He seemed a shade anxious as to whether some of the fine detail would be possible to be reproduced in a relatively coarse grained stone we use ... it might have been worthwhile to have had the carver cut in actual stone the small figure. The models are so fine in all their detail that one wonders how much they would lose'.

The question of stone was discussed by Radcliffe and Pittaway the clerk of works. Carter Preston suggested the alternative St Bees stone which, as he wrote in a letter of 26 July 1933 to Radcliffe, is much finer in texture than Woolton and would allow the delicacy of his work to 'be realised more definitively'. 'However', he went on, aware of Sir Giles Gilbert Scott's aesthetic concerns, 'the one advantage of cutting the figures in the existing stones is, they would grow logically in the niches (I feel Sir Giles may think this very important, esthetically)'. (In the same letter he also suggests the use of grey Derbyshire stone, although Pittaway had already approved of the suggestion of St Bees stone as much more suitable than Woolton stone for delicate work on figures.) Carter Preston was right to expect Sir Giles to make some criticism. In a letter of 26 July 1933 to Radcliffe he wrote: 'I do not at all

like the idea of having the figures flanking the entrance doorways in a more finely grained stone. To my mind, the comparative coarseness of the Woolton stone is very valuable in giving the more interesting texture. I think you can rely on it that the figures will look, not only as well in the stone as in the plaster but a great deal better'.

With the aid of the Marquess of Salisbury the Cathedral Executive Committee had bought Woolton quarry in the early 30s and thus a supply of this stone was assured. Although Carter Preston came to be satisfied with the carving of his figures, it is clear that the use of Woolton stone did not make the carver's task easy. As Carter Preston wrote to Radcliffe on 20 April 1934:

It is difficult to get men who are familiar with the stone and who are sufficiently good at figure work – there is little work from nature done in sandstone. We have decided to try another method, instead of York, the man who has done everything of mine so far doing all the work, we are to try another man taking the rough away and York to finish after him; I think the method should work. It will speed up the job, if it turns out satisfactorily.

The time factor was always important, and as there were two stages in the process – the modelling and the carving – it was very important to work out how long each stage would take. In a letter of March 1935 Pittaway answered Radcliffe's questions as to how long he thought the models would take to carve. He wrote that it would take them from March until September to finish seven figures and continued: 'Mr Preston considers that it will take him approximately 18 months to complete each set of figures (i.e. three years). From what he tells me regarding the work in these figures I should say it would take two and a half to three years to carve'.

In an earlier letter of 27 November 1933 Radcliffe had made Scott a party to his concern:

Statues on porches: it has been pointed out to me that the figure of justice has taken over ten weeks to carve in stone. At the same rate of progress it would take six years to complete the 33 figures included in this scheme for the two inside porches and exterior of the Rankin porch. This is assuming no strikes or other delays and assuming Carter Preston's models are all provided as required. Ought a search to be made for another carver to translate the models into stone so as to have two going? It would be a pity to *hurry* the one man who is doing good work well.

Delays could not always be attributed to the craftsmen but were instead caused by problems with content and style. In the meeting of 28 September 1934 Sir Giles Gilbert Scott stated that the work on the models had been somewhat delayed owing to discussion on details of symbolism. It is clear from his memorandum of suggestions for schemes as to the statuary that Radcliffe left Carter Preston very little room for manoeuvre, and on the visual side Sir Giles Gilbert Scott's overall conception of the Cathedral and its architecture was similarly limiting. As Radcliffe wrote in a memorandum dated 7 February 1933 about his suggestions for the statuary of the Rankin porch: 'Here I had thought Active Life with special reference to the life of the diocese but to this there are two objections. First, Sir Giles Scott dislikes the idea of kneeling figures as lessening the perpendicular effect at which he aims'.

Carter Preston was aware that he was the servant of two masters, and aware of the implicit requirements of each. In his comments on Radcliffe's 1933 scheme for the porch statuary he wrote (10 February 1933): 'I will have to meditate before offering any opinion on any individual item. Most, if not indeed, all of the subjects can be rendered satisfactorily in sculpture; that is, if one is allowed enough latitude in the treatment. They can be tempered to suit the singular nature of the form used by Sir Giles in his treatment of the Architecture, his application of a modern manner to a traditional style'.

In his own discussion of the King and Queen models put forward by Carter Preston, Sir Giles Gilbert Scott confided to Radcliffe (20 June

1934): 'I see no objection to the elongated type of figure as found on Chartres Cathredral though we need not be quite so extreme as these'. He clearly felt that Carter Preston was sympathetic to the overall needs of his architecture and in a letter to Radcliffe of 26 November 1934 wrote: 'In reply to the query at the end of your letter, I should certainly like Carter Preston to do these figures, as I have yet to find anyone who is able to give us a better interpretation or one more suited to the character of the building'.

It would appear that Carter Preston found the restrictions working on the Cathedral sculpture to be a challenge. In a letter of 2 March 1935 to Radcliffe he wrote: 'As for the narrowness of the figures; I think this can be very easily a distinct advantage from the architectural view point; and I will enjoy the restricted space available, it has great aesthetic charm. The height of the figures will of course be decided by Sir Giles'. He reiterated similar sentiments in several letters such as this one to Scott of 20 March 1935: 'To accept the limitations and overcome the difficulties is the artist's main problem ... that is why the job is so interesting'.

It would appear that Radcliffe was more nervous about the narrowness of the figures and nervous also about possible similarities of style to other sculptors. Carter Preston reassured him in a letter of 2 May 1935 that, as for the figures on the Welsford porch:'I am expecting to have a very interesting time with them; both symbolically and plastically. I think you may rest assured that there will be nothing to remind you of Claus Sluter. He was prodigiously clever and I believe much admired by devotees of Gothic art but I don't think his style would fit easily in Liverpool Cathedral'.

Carter Preston endeavoured to please both Scott and Radcliffe, and clearly felt that this was feasible. As he wrote on 25 September 1936 to Radcliffe: 'However this is all beside the point; after the talk with Sir Giles, I think I maybe able to do what you wish and still retain something of our perpendicularity'. The limitations were always there, and on 21 May 1940 Carter Preston wrote: 'As for the Queen's statue, I think it looks really well within the strict limitations we have imposed on the statuary as a whole'.

Occasionally Carter Preston's patience was stretched. He wrote on 25 May 1935 to Scott: 'I recognise the advisability of using signs that have become familiar through constant usage but where there has not been a fixed image, I think the artist has usually used his judgement and applied what he felt best suited his needs. I would like to know that I had that liberty'. It was from Sir Frederick Radcliffe that he required that liberty. In a letter to him of 14 June 1935 Carter Preston emphasized: 'as you have realised before I am not trying to do anything odd, but, trying to find the thing that suits our needs most exactly'. In one discussion over the employment of a particular symbol, Carter Preston told Radcliffe (30 May 1934): 'I could employ the wheat; but this I would be doing under compulsion'. In view of Radcliffe's distress at Carter Preston's use of the word 'compulsion' the sculptor wrote to Radcliffe on 7 June: 'As to the word compulsion it is an unfortunate word and it would have been better had it not been used'.

Similar problems occurred at regular intervals. Radcliffe was to be displeased with the female sex of many of the figures used by Carter Preston in his series. On 10 September 1934 Carter Preston felt that he was, 'Now able to make a "dispassionate reply"' in the face of Radcliffe's criticism. He wrote: 'I do not want to be tied down permanently by tradition. Part of the joy of this job is in its freedom, or rather shall I say in fixing one's own limitations. ... Your objection to artists imitating archaic work. I quite agree it is pernicious to imitate an archaic style merely to be strange. There *are* reasons for looking at archaic work which cannot be too strenuously defended'. He continued: 'I went into all the problems you have posed before I started on the models. Yet I hope to have made a case for their presentation in their present form'. Such protestations were not sufficient to woo Radcliffe, who wrote on

5. Plaster cast of Carter Preston's model, now stored in the Cathedral

6. Detail of illus. 5

7. The carved version in place in the
Cathedral interior; figure of 'Prudence'

21 September: 'Nonetheless I should like you to consider whether, if you really desire four female figures, you would not lessen the risk, by using some of them for arts and sciences not specially associated with female pagan divinities'.

Sir Giles once again appears to have acted as the mediator, for Carter Preston reported to Radcliffe on 29 September: 'Sir Giles thought we should keep the female figures as I have them in the sketches especially as we have a precedent in the Chartres figures'. Radcliffe retained the victory on the other contentious point, and Carter Preston acknowledged: 'Sir Giles agrees with you that the figure of medicine is rather reminiscent of Asculapius and has suggested that I think of a different treatment, this I shall endeavour to do'.

In his 1941 summary of his work of the Cathedral, Carter Preston pointed out that he had never been to Chartres while working on the statues although 'the figures are on the severe side, not to say austere, and do not reflect what is usually considered as Gothic, but have some relation to Early church sculpture, particularly to the Chartres figures'. Although he describes this similarity as 'fortuitous', he was certainly aware of Chartres and indeed of medieval French Cathedrals in general. He was a learned man and continually went to sources and sought out books deliberately to supply him with precedents. In a letter of 17 May 1933 to Radcliffe, Carter Preston wrote: 'I believe Malé [sic] has investigated the virtues and vices. I will be glad to have the book'. And two days later he thanked Radcliffe for the 'Emile Male's "L'Art Religieux du treizième siècle en France"' which had arrived. He wrote that he had also 'been looking at I E Marriage "The sculpture of Chartres Cathedral" (1909)'. Radcliffe recommended him to look at Gardner's *Medieval Sculpture in France*. Radcliffe himself used Mâle whenever he was struggling with a particular problem. In his discussions about the presentation of the King and the Queen figures he wrote to Cotton: 'I thought of certain Kings of England. But at page 344 of Emile Mâle's "L'Art Religieux du treizième siècle" he showed that this was not done and the reasons against it. I have had a discussion with Hamilton Thompson on this and he sent me a most learned letter upon it'. He enforces the view Cotton had proposed that more figures from the real world who had made notable achievements in various areas of the arts and sciences should be represented in the Cathedral, but, Radcliffe wrote, 'There is grave danger of descending to the level of a Comptist church, with its "Religion of Humanity" and busts of all who have made a figure in the world; or to a sort of Museum of "Comparative Religions". I know the peril, because the idea of including in the glass the great sages of all religions tempted me 25 years ago, and it was Chavasse who convinced me of its unsuitability'.

As Carter Preston wrote: 'I do not pretend to be able to satisfy the aesthetic needs of all and sundry; if I succeed in gaining the confidence of yourself and your committee together with that of Sir Giles, I consider I will have done rather big things'(18 March 1933).

Edward Carter Preston enjoyed the role of 'sculptor to the Cathedral' for three decades. There is work by other sculptors[8] in the building, but it was very much Carter Preston who enjoyed the confidence of its architect and administrators. His friendship with Dean Dwelly was close, and surely influential on the sculptor's connections with the Cathedral[9]. It is, however, his relationship with Scott and Radcliffe which has been preserved for us in the Radcliffe papers; an exceptional testimony to an exceptional project.

8. The carved versions in place on the Cathedral exterior; the Welsford Porch

NOTES

I would like to thank Julia Carter Preston for her interest in and help with this piece.

1 Charles Wheeler came second in the 'next of kin' competition, and William McMillan was among the runners-up. Carter Preston also designed the Distinguished Flying Cross, Her Majesty's Duchy and County Palatine of Lancaster seals, and the 1939–45 war medal among many.

2 The other notable large scale sculptural project in Carter Preston's career is that of 'The Winds' for Cambridge University Library which was 'well on the way to completion' in November 1933. On only one occasion is it recorded that he was actually in need of work, when in the Executive meeting of 31 August 1943 'the architect was asked to consider the possibility of employing Mr Carter Preston, who found himself at the moment very short of commissions'.

3 It seems possible that Carter Preston was brought in to carve 'Ryle' because the sculptor previously employed at the Cathedral, David Evans, had left for America. In October 1930 the Committee were looking for another sculptor for the 'Ryle'. This first work seems to have been more of a collaboration with Scott than was later to be the case. On 21 January 1931 Scott reported, 'A small scale model of the figure has been prepared, from my instructions, by Mr E Carter Preston of Liverpool'.

4 Radcliffe had devised the schemes of 'The Ressurection' for Welsford Porch and 'The Active Life' for the Rankin. The interior figures represented the Arts and the Sciences.

5 Carter Preston had reservations about the effects of the joints between the stones for his figures, but on 16 July 1936 was able to write: 'I don't think they show in the finished work'. The fact that the exterior figures were in one block was more significant in terms of ease of carving, allowing 'greater freedom in the placing of the hands'.

6 The Bishop of Liverpool was clearly a supporter of the sculptor. In the debate over modern costume for the 'Active life' series, he wrote (18 February 1933): 'I believe there are sculptors who can do it without drawing attention to clothes, and I should think CP [sic] is one of them'.

7 Morrisons' costs for each figure were almost equal to the fees paid the sculptor for his models: £45 of the £100 for each figure went to Morrisons (in 1933).

8 The memorial to Bishop Chavasse was designed by Scott, modelled by David Evans, and carved in the latter's absence by Mr Induni. Evans is the only other sculptor named in contemporary minutes.

9 Dean Dwelly retired in 1955. Family sources record his friendship with Carter Preston as being the most obvious outward sign of the sculptor's connection with the Cathedral.

SOURCES

The Radcliffe papers, Liverpool Central Libraries. The bulk of this correspondence has been catalogued under F.86 (Fo.1), (January 1931 – February 1933), F. 86 (Fo.2) (January 1934 – December 1935) and F.86 (Fo.3) (February 1935 – February 1942). Isolated letters about the sculpture are filed in F.97, F.94, F. 60, F.101 (Fo 10), F.65, F.85, F.73, F.47, and F.111

Minute Books of the Cathedral Executive Committee for the years 1929 to 1965.

Liverpool Cathedral Committee Bulletin, numbers for March-September 1933, December 1937, March 1938, June 1939, June 1940, October 1957, December 1957, December 1960

Vere E Cotton, *The Book of Liverpool Cathedral,* Liverpool, 1964

EPSTEIN'S LIVERPOOL COLOSSUS

Evelyn Silber

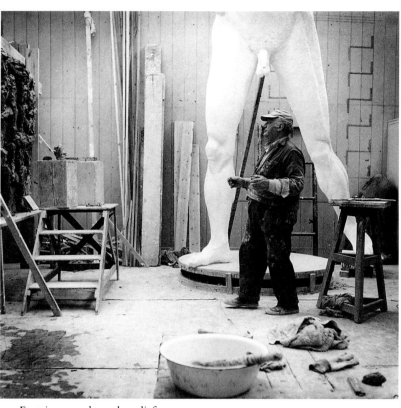

1. Epstein at work on the relief 'Children Playing' in front of the plaster 'Adventure' in the Royal College of Art studio

On 20 November 1956 a fanfare of trumpets of the Lancashire Fusiliers heralded the arrival of Lord Woolton at the new Lewis's store in Liverpool to unveil an 18 foot 6 inch bronze nude and three *ciment fondu* relief panels by Sir Jacob Epstein (illus.2)[1]. The strident optimism of brass was appropriate since the 'heroic bronze statue' symbolised 'the struggle and determination of the City of Liverpool to rehabilitate itself after the destruction of war'. It was also a unique commission marking the centenary of Lewis's store group, founded in Liverpool by David Lewis and still largely run by his descendants[2]. It remains one of the very few public sculptures, other than war memorials, commissioned for Liverpool during this century[3]. The sculpture, officially, if variously, entitled 'Resurgence', 'Liverpool Resurgent', 'The Spirit of Youth' and 'Adventure', immediately became a popular local landmark and was unceremoniously rechristened 'The Liverpool Giant' or, in humorous reference to the sculpture's most prominent characteristic, 'Dicky Lewis'. Given the dearth in Liverpool of both recent public sculpture and the outdoor sculpture exhibitions then becoming established elsewhere in Britain, it was audacious of Lewis's directors to have commissioned a monumental bronze to be sited above the main entrance of their new store. That they should have chosen Jacob Epstein for the task was still more daring: though then in his seventies, recently knighted and receiving a late windfall of public commissions, Epstein remained a name calculated to engender controversy, not least in Liverpool.

In 1909 a Liverpool artist, James Hamilton Hay, had been one of the first to identify the young American as one of the leading sculptors in Britain and to recommend the purchase of his work to the Walker Art Gallery, but he had to wait until the 1930s for them to act upon it[4]. From 1920 Epstein exhibited his bronze portraits intermittently at the Walker's Autumn Exhibitions but, in 1926, when he showed a group of four outstanding portraits, the influential local patron and Chairman of the Art Gallery Committee, Lord Wavertree, made a widely reported attack on the sculptor in his opening address; 'if these are Mr Epstein's best, then a poor artist would have done better if he had submitted his worst'[5]. When Wavertree died in 1932, leaving £20,000 for art purchases to the Walker, the sculptor suspected that the gift might have included a proviso excluding his work from consideration, but happily this was not the case and the following year the Gallery purchased its first Epstein, a portait bust of 'Mrs Sonia Heath', 1931[6].

Despite Lord Wavertree's disapproval, Epstein's reputation in Liverpool was by no means completely negative, even in the thirties when, with the exception of his portraits, he was seen as a provocative and isolated figure. On 19 May 1931 his lifesize marble carving and archetype of expectant motherhood, 'Genesis', had gone on show at Bluecoat Chambers in aid of the Bluecoat Society of Arts building fund[7]. Liverpool was not its only provincial venue. After the work made its public debut at the Leicester Galleries, London, in February 1931, it was sent on tour by its new owner, Alfred Bossom MP, to cities including Manchester, Birmingham, Leeds, Halifax, Edinburgh and Chester, in aid of a variety of charitable causes. In Liverpool, as elsewhere, the advent of this highly controversial work, which had been the subject of cartoons and scathing attacks in the press, caused considerable excitement; its arrival in the city, the cumbersome unloading and installation complete with black velvet hangings, protective barrier and special lighting, were chronicled in the local papers along with

the irreverent comments of passers-by[8]. Not surprisingly it attacted large crowds. 1,649 at 6d. a time came on the first day but, contrary to expectation, several local critics came out strongly in support of the work. On 20 May the *Liverpool Echo* critic hailed 'Genesis' as 'one of the most beautiful sculptures in the world', praising its contour and rhythm of line and associating 'the frankness and marvel of it' with the artist's Jewish origin. On 29 May the 'Liverpool Day-by-Day' columnist in the *Liverpool Post* spent some time observing the visitors of 'all ages and classes and both sexes'; he noted that, though drawn partly by curiosity, 'all seemed quietly interested. The sculpture may be provocative but I saw no sign that it was being treated lightly or frivolously'. The organisers too reflected on the visitors' reactions; the leading local sculptor, Herbert Tyson Smith, who had been one of those responsible for arranging the exhibition, made a white plaster replica which took centre-stage in the Sandon Society cabaret and solliloquised on the visitors and their comments ('It do make a girl think. I'm telling my boyfriend I'd rather have a career after all'[9]).

By the end of the month-long showing, 49,687 visitors had seen the sculpture and Epstein was so impressed by its warm reception on Merseyside that he agreed to lend his lifesize bronze 'Madonna and Child', 1926–7, to the Walker Art Gallery[10]. This was a handsome gesture since only two years earlier a potential Liverpool patron, Archibshop Downey, commenting on possible works of art for the new Roman Catholic Cathedral, declared, 'It would be calamitous if in an attempt to express the twentieth century spirit you merely achieved something Epsteinish'[11]. He probably had in mind both the 'Madonna and Child' and the 'Risen Christ', 1917–19, which had caused even more contention than 'Genesis'.

Ironically, it was the belated recognition of Epstein's stature as a sculptor of religious works for architectural settings that led directly to the plentiful commissions of his last decade. In May 1953 his 13 foot lead 'Madonna and Child' for the Convent of the Holy Child Jesus in Cavendish Square, London, was unveiled by the Chancellor of the Exchequer, R A Butler, before a large crowd. It received the rare accolade of praise from patron, public, critics and the press, leading Epstein to comment, 'No work of mine has brought so many tributes from so many diverse quarters'[12]. Among the religious commissions which followed were a huge 'Christ in Majesty' for the nave of Llandaff Cathedral, portrait busts of 'Stafford Cripps' for St Paul's Cathedral, 'Bishop Woods' for Lichfield and 'William Blake' for Westminster Abbey and, finally, monumental figures of 'St Michael and the Devil' for Basil Spence's Coventry Cathedral. There were numerous secular commissions too, over and above the portrait bronzes which had been the mainstay of his income and reputation since the 1920s; in 1954 when he began work on the Liverpool figure he had recently completed a monumental bronze of 'Jan Smuts' for Parliament Square, and was about to dispatch to Philadelphia his bronze group 'Social Consciousness'[13].

In spite of the sculptor's fame and the prominence of the site, the development of the Lewis's sculpture is ill-documented. No letter commissioning the work, no correspondence with the directors and no contract have yet come to light. What Epstein was paid for it even is unknown. Nearly all those closely concerned with the evolution of the project are no longer available for interview so that its history has to be pieced together from photographs, press cuttings, the oral memories of those peripherally involved, and a few drawings[14].

There was no provision for exterior sculpture when Frazer Son and Geary's plans for rebuilding the store, largely destroyed in the blitz of 3–4 May 1941, were published in 1947. These show a stolid, neo-classical design for a steel-framed building faced with Portland stone. The composition, with its tower and corner entrance, broadly followed 'house style', established with the building of Lewis's Manchester, Liverpool and Birmingham stores in the 1880s and subsequently

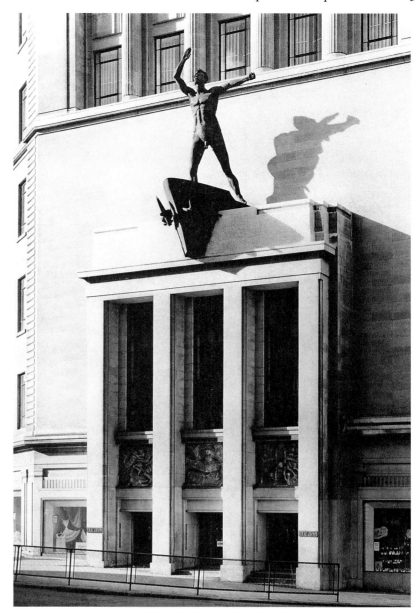

2. Epstein, 'Adventure' (bronze) and three reliefs of 'Children' (*ciment fondu*) at Lewis's Store, Liverpool, at the junction of Ranelagh and Renshaw Streets

adopted in most of the twentieth century rebuilding schemes[15]. One of the most promenent features of this style was the angled entrance portico cut into one corner of a rectangular, multi-storey block. A feature stimulated less by aesthetic than by commercial considerations, the angled facade provided a clearly visible, welcoming and impressive main entrance which usually faced onto an intersection where pedestrian traffic would be busiest[16]. For the new Liverpool store at the junction of Ranelagh and Renshaw Streets and facing Lime Street, the architects proposed to make the angled entrance facade concave with a convex, almost semi-circular entrance portico several storeys high projecting from it[17]. The design was only altered while the building was under construction, possibly as late as 1954, and specifically to accommodate the sculpture which the directors of Lewis's had by then decided to commission. From the client's point of view the site immediately over the main entrance where their name normally appeared would have been a natural choice for the sculpture.

That Lewis's took such an initiative seems to have been due primarily to two directors – Rex Cohen, one of several directors descended from the store's founder, and George Breeze, who was responsible for the buildings. For the Cohen family the rebuilding of the home store was of great sentimental and symbolic significance, so much so that still scarce building materials intended for work on their other stores were diverted to ensure its completion; this achievement and the firm's forthcoming centenary in 1956 deserved some special commemoration. The initial suggestion for a sculpture and the weight of influence that ensured the commission went through probably came from the Cohens. However, George Breeze had a long-standing interest in the arts and had been instrumental in commissioning a variety of work; he had known Epstein for several years and owned a cast of one of his best known portraits, 'Albert Einstein', 1933[18]. It was probably he who introduced Epstein to his colleagues and liaised between architects, builders and sculptor.

The new design replaced the complex entrance portico with a plain, rectilinear structure, some forty feet high, projecting from a flat facade. The portico itself is dominated by the four strong vertical accents of the piers which rise to the projecting cornice which in turn supports a solid attic. Between the piers, in perfect symmetry, three doorways, surmounted by plain slabs of stone with tall windows above, provide the store's entrance. In essence the design is that of a classical triumphal arch of exaggerated height and modernist architectural pretensions. It contrasts unhappily with the more conventional fenestration and engaged columns on the upper facade. The overall effect of the portico is of soaring height and planarity, combined with comparatively shallow depth, all ill-calculated to provide a sympathetic setting for sculpture other than low relief. The challenge for the sculptor was to provide a figure or figures on a scale sufficient to carry to the spectator some forty or fifty feet below without letting the figures either disappear beyond the cornice or appear about to fall off the roof.

Epstein had worked on not dissimilar projects many years before; his eighteen nude figures for the third storey of the British Medical Association building in the Strand, 1907–8, were designed to be seen from a comparable distance below, while the 'Night' and 'Day', 1928–9, were placed only about twenty feet up, above two entrances into the London Underground Headquarters at St James's. In both cases, however, the sculpture was carved rather than modelled and cast in bronze. Furthermore, the sculptor had been able to work closely with the architect, Charles Holden, to develop sculptures well integrated into architectural settings designed for them[19].

It was at first suggested that the subject of Lewis's sculpture should be a family group, appropriate both to the building's function as a department store and to recurrent themes in Epstein's work[20]. However, this idea must quickly have been abandoned; neither drawings nor maquettes appear to have been made and no reference to it appears in

the sculptor's letters to either his daughter, Peggy Jean, or to his brother, Isidore, letters in which he invariably commented on his current work as well as swapping family gossip. It is possible that the cost in time and materials of producing a group rather than a single figure was the crucial factor, but the difficulty of siting such a group on the portico roof may also have played a part. Eventually patron and artist settled on a far more ambitious idea which would transcend purely domestic and commercial preoccupations. A monumental sculpture symbolising the regeneration of Liverpool after wartime devastation would be a triumphal theme designed to raise morale in a city still counting the cost of victory. It would allow the artist considerable freedom of interpretation while at the same time enabling Lewis's to identify themselves as leaders and partners in the City's revival. The lack of documentary evidence for the development of the project is particularly tantalising at this point for it would be fascinating to know whether the triumphal arch form now adopted for the portico was a stimulus for or a response to the sculptural theme.

Epstein was supplied with a scale model of the facade and portico, which was installed in his studio at Hyde Park Gate[21]. True to his usual practice Epstein appears to have made few, if any, preparatory drawings. With characteristic directness he began modelling straight away, making small plasticine maquettes which could be tried out on the mocked-up facade, inspected from various angles and judged for scale. It was on the basis of a plasticine maquette modelled to scale, placed on the architectural model, and shown to a committee of Lewis's directors, that the design was approved, but it is not clear when this model was made or at what point Epstein decided on the appropriate embodiment for the agreed theme[22]. A letter to his daughter in July 1954 provides the sculptor's first description of the heroic nude figure; 'I have started a large figure for Lewis's Stores in Liverpool. This will take the shape of a youth (colossal size) rising from the sea and will symbolize Liverpool's recovery from the "blitz" '[23]. By September he was writing, 'I have started the Liverpool work and so far have done the upper part of the figure which will be a full length nude of a youth in action. The whole work will be so large I am looking out for a studio or workshop that will be high enough to let me get on with the colossus'[24]. Shortly thereafter the upper part of the figure was moved to a large studio at the nearby Royal College of Art, kindly lent him by John Skeaping, Professor of Sculpture. By November he had abandoned the idea of a figure arising from the sea and was describing how 'the figure will stand on the prow of an ocean liner as its base'[25].

Epstein may have recalled the fabled Colossus, that wonder of the Ancient World which dominated the harbour at Rhodes, when conceiving an apt symbol for the rebirth of another great maritime city. He could also look back on the earlier instances in his own career when he had chosen to express youthful creative energy through nude male figures in action – the dancing youths on the British Medical Association Building, his eight foot alabaster 'Adam', 1938, and most recently, the lifesize bronze inspired by a Chinese model of exceptional physique, 'Youth Advancing', 1949–50, commissioned for the Festival of Britain. The striding pose and far-seeing gaze with head thrown back certainly owes something to the latter piece but the Liverpool Colossus is a far more dramatic figure. One arm is raised as if pressing back an invisible barrier obstructing the youth's impetuous upward movement, while the other arm is wildly outflung. It gives a somewhat awkward impression of impending flight and the sculptor may have been attempting to translate into a freestanding figure the gestures conventionally symbolic of flight in relief carving.

During the late Twenties, Epstein had worked on the new London Underground Headquarters at St James's with other sculptors, including his erstwhile friend, Eric Gill, and the young Henry Moore who was then Epstein's protégé. While Epstein carved 'Night' and 'Day' the others had worked on large bas reliefs of the Winds to be placed high

on the building; Moore, Gill, Rabinovitch and Aumonier had all employed similar gestures – one arm bent before the face, the other outstretched along the body – to give an impression of dynamic forward movement in a restricted architectural setting[26]. Epstein himself had employed the gesture in one of his Old Testament watercolours, 'The Spirit Moving on the Waters', 1930[27]. In the modelled figure, the left arm is outflung rather than stretched back aerodynamically along the body, but this too has a compositional function, echoing the dominant horizontal line of the facade behind it.

Using a projecting ship's prow as a plinth was a more ingenious and successful solution to some of the difficulties posed by the site and the subject. It both focused and arrested the figure's forward movement so that it was in no danger of appearing about to walk off the building. At the same time it introduced another possible level of meaning, beyond the obvious allusion to Liverpool's status as a port. 'Go West, young man' had long been part of a popular idiom which associated youthful enterprise with travel to new worlds, an idiom particularly resonant to Epstein who had been brought up amongst the burgeoning New York immigrant communities and retained a lifelong admiration for Walt Whitman, the poet of pioneer America.

The making of the sculpture posed a considerable physical and emotional as well as an intellectual challenge. Epstein was then in his mid seventies and already affected by the heart disease which caused his death in 1959. Working alone, he was daily carting around the studio masses of clay and the heavy, damp cloths needed to keep the clay moist until the modelling was complete. He was also working simultaneously on the equally huge Llandaff 'Christ in Majesty' and on a variety of prestigious but often uninspiring commissioned portraits. His letters to his daughter, Peggy Jean, then living in America, refer with increasing frequency to his weariness, his need for a holiday and his unwillingness to turn down major commissions when he had been so long without them. Over and above this 1954 had been a year of public triumph but private disaster; in July he received his knighthood from the hands of the Queen Mother, but in the course of the same year he had also suffered the loss in tragic circumstances of two of his children, his beloved youngest daughter, Esther, and his artistically talented son, Theo. The theme of the Liverpool work – rebirth, optimistic youth – was an especially poignant one and it was hard for him to feel real optimism. In January 1955 he wrote, 'I worked at the College all through Christmas when nobody was there except for a hidden caretaker, and so I managed to get my big Liverpool figure finished enough for casting in plaster which is now going on ... Sometimes in moments of depression I don't know how I can get through anything single-handed. I keep in good health and can cope with things but time is short and I don't want to scamp work'[28].

It seems to have been at this low point, when there are hints in the recollections of studio visitors that he had reservations about the site and his colossal figure, that he made a remarkable offer to model at his own expense three bas reliefs of children to replace the large rectangular panels over the main doors. In a classical triumphal arch there would, as a matter of course, have been relief sculpture in the spandrels over the arches. The analogous panels above the shop entrance were well placed for sculpture, readily visible but protected from the weather. Only a month later he was writing in much more committed mood to announce that he would be postponing his planned trip to the States, even though his 'Social Consciousness' group had just sailed for its new home in Philadelphia's Fairmount Park and he was being encouraged to come at once. He saw no point in going to Philadelphia before it was set up;

in any case I am right in the midst of my sculpture for Liverpool. I have finished in plaster a figure 18 feet high of a youth nude which will go on the front of the building and am now starting on three panels to go above the doors, each one 6 feet square. These I am

3. Epstein, 'Children Fighting', pencil, 16.5 × 26 cm inscribed 'For Irving from Epstein'; (Collection Dr and Mrs Martin Evans)

5. Epstein, *Child in Pram*, pencil, 16.5 × 26 cm, (Collection Dr and Mrs Martin Evans)

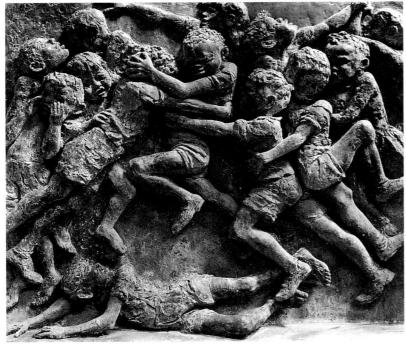

4. Epstein, 'Children Fighting' (left panel), *ciment fondu*, 167 × 198 cm

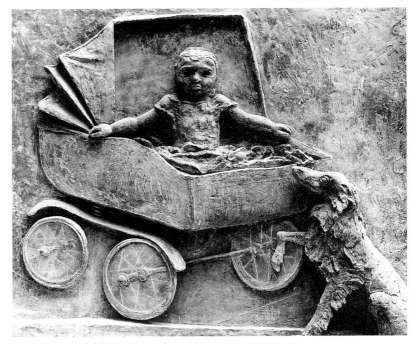

6. Epstein, 'Child in Pram with Dog' (centre panel), *ciment fondu*

filling entirely with children and I will use of course many of the studies including those of you[29].

He wrote in the same vein to his brother, Irving, of his work on the panels, 'they will add a note of gaiety to the sculpture'[30].

Children had always been one of Epstein's favourite sculptural themes.' He enjoyed their spontaneity and unselfconsciousness, so refreshing after many of his adult sitters. In his autobiography, published in 1940, he devoted a whole chapter to them, expressing his admiration for the Florentine Renaissance sculptors – Donatello, Verrocchio and Desiderio da Settignano – who were among the few artists to have done them justice. He had made dozens of drawn and sculpted studies of his own children and grandchildren, notably of Peggy Jean and of the mischievous Jackie, his younger son, as well as outstanding portraits of children, both commissioned and uncommissioned – charming, affectionate but unsentimental.

I regret that I have not done more children, and I plan some day to do only children. I think I should be quite content with that, and not bother about grown-ups at all. I would love to fill my studio with studies of children. Children just born. Children growing up. Chil-

dren nude. Children in fantastic costumes *en prince*, with pets of all kinds, and toys. Dark children, Piccaninnies, Chinese, Mongolian-eyed children[31].

Now he seized his opportunity to fulfil this dream, building on the numerous portrait studies which littered the Hyde Park Gate studio and putting to good use everything he had learnt from his Renaissance predecessors, especially Donatello whose Singing Gallery panels with their dancing *putti* in Florence Cathedral he had long admired.

Three small drawings (illus.3, 5, 7) which he gave to his brother, Irving, sketch the main compositional ideas. That for the left panel, 'Children Fighting' (illus.3), is a roughly pyramidical composition of boys' heads, arms and flailing legs with an unfortunate fallen boy sprawled across its base. The sculpture itself is much more clearly organised, its carefree energy expressed in the splendid linear rhythms set up by the children's lithe and bony limbs. Epstein's gifts as a portrait sculptor are deployed with discretion to evoke the anxiety and bewilderment of those caught up willy-nilly in the conflict and the fierce enjoyment of the protagonists. There are reminiscences of many of his child portraits – 'Jackie', 'Victor', 'Roland', 'Anthony' and others – but

7. Epstein, 'Children Playing', pencil, 16.5 × 26 cm (Collection of Dr and Mrs Martin Evans)

9. Epstein modelling 'Children Playing' at the Royal College of Art, 1955

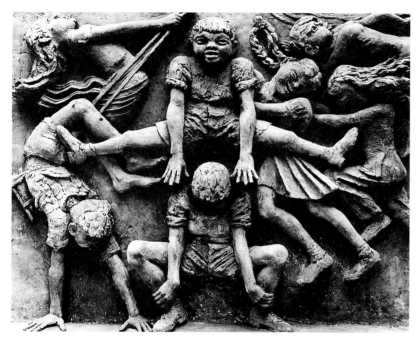

8. Epstein, 'Children Playing' (right panel), *ciment fondu*, 167 × 198 cm

there are also distant echoes of the abstract lines of force which characterised his 1913–15 drawings. By contrast the drawing for the central panel is calm and static; a single infant with arms outstretched gazes out from a pram (illus.5). The child's forlorn expression and pose is certainly developed from his portraits of his son, Jackie, and his granddaughters, Leda Hornstein and Annabel Freud, and also contains a clear echo of the child Christ in his recent 'Madonna and Child' for Cavendish Square[32]. In the sculpture, the additional figures, hinted at in the sketch, have vanished (illus.6). The pram has been swung round to face the spectator so that the half-raised hood frames the child, reinforcing its poignant isolation. The relief was initially modelled complete with pram handle but after a discussion with the photographer, Geoffrey Ireland, who was visiting the studio frequently in order to shoot work in progress, it was removed. Ireland observed that, had he been photographing the same scene he would have made sure the handle did not obscure the child; a few days later it had gone and Epstein's Highland sheepdog, Frisky, had been introduced into the scene to balance the composition[33]. The right hand panel, 'Children Playing' (illus.7, 8), is another riotous assembly, this time of games – leap-frog, hand-stands,

swings, chases and pick-a-back. The drawing catches only the essence of the composition, omitting the swing, and missing altogether the articulation of the limbs and mechanics of the figures in motion, all of which appear to have been worked directly in the clay with the assurance of a master (illus.8).

Though the reliefs were small enough to have been carried out in his own studio in Hyde Park Gate, Epstein was still working at the Royal College (illus.1), as he described to his brother;

> You know I have heaps of studies of children and these come in very handy as models. The size of these panels is 6′ 6″ by 5′ 6″ so you see the work is large and requires my constant attention. I am still at the College where they look on me as a fixture. I like being among the students, all earnest and hard-working and some of them with considerable talent. The Professor, John Skeaping, is a very sympathetic person and a fine sculptor who has given me a great welcome[34].

The panels were not complete until June, just before he left for the USA to attend the unveiling of 'Social Consciousness' at the Philadelphia Museum of Art and to enjoy a short holiday[35].

Resuming work in October with the main figure and the three

10. Epstein, 'Ship's Prow', clay or plasticine maquette (destroyed)

11. Bill Olds and Jan Smith dismantling plasters ready for the foundry

reliefs already complete, he now tackled the plinth. A maquette, which may date from the previous year when he first decided on a ship's prow as a plinth for the figure, shows the prow of a liner with two funnels and an almost indecipherable mass of what could be chains or writhing figures which cascade from its bow (illus.10)[36]. The design seems vaguely reminiscent of Alfred Stevens's allegorical figures for Wellington's Tomb at St Paul's or of the entwined figures in Rodin's 'Gates of Hell'. It is far removed in style and handling from the hard-edged solution Epstein now adopted[37]. Perhaps prompted by his own recent Atlantic crossings and the leisure these would have given him to study the massive steel structure cleaving through the water, he adopted for his plinth the jutting, mechanistic profile and proportions of a real prow with anchors projecting to port and starboard. This was an abrupt and surprising renewal of Epstein's interest in the industrially manufactured form as sculpture, an interest abandoned since the First World War and the death of his friend, T E Hulme, whose machine aesthetic he had briefly espoused with 'Rock Drill', 1913–15 (Tate Gallery). The smooth mechanistic prow had a credibility which no more softly modelled form was likely to attain; moreover it fitted remarkably well with the character of the portico; the whole structure, measuring some 13′ 6″ long, 9′ wide and 7′ 6″ tall, fills the full depth of the attic and rises above it to conceal part of the figure's lower limbs. Epstein was assisted by his usual plaster moulders, Bill Olds and Jan Smith. Jan Smith recalls that a large amount of this work was left to them; they constructed the prow and anchors in hardboard and faced them with clay before piece-moulding them in plaster (illus.11). All the plasters were then taken to Morris Singer's foundry in Dorset Road, Lambeth for casting which took from November 1955 to October 1956[38]. Meanwhile the reliefs were cast in *ciment fondu* (Lafarge's aluminous cement) by Bill Olds before being sent for storage to Liverpool.

As the sculpture neared completion and the date for the unveiling approached, public curiosity about the work was roused through tantalising snippets in the press. At the end of May 1956, the *Liverpool Post* featured Lewis's Centenary celebrations and, under the headline 'Rising from the Ashes of War', reported progress on the rebuilding and decoration of Lewis's store; 'a feature of the building when it is completed will be a giant sculpture by Sir Jacob Epstein depicting a man on the prow of a ship representing Liverpool rising from the flames of war'. Even two months before the unveiling, however, the sculpture remained nameless; as late as 2 October when George Breeze chaired an earnest meeting about the detailed arrangements for the transport and installation of the sculptures, it was being referred to simply as the 'Epstein statue'. The general conception of the figure was clear enough but an exact title was the subject of anxious consideration, all wasted in the event since Liverpool provided its own nomenclature. The sculptor, when asked, simply replied 'rinascita' – rebirth – a title which the directors of Lewis's, already somewhat taken aback by the scale and virility of their heroic youth, considered open to gross misinterpretation![39] 'Liverpool Resurgent' was the title apparently first given to the sculpture on 6 November, when the *Liverpool Post* reported on the 'secret of Epstein's resurgent Liverpool statue' which had arrived in the city, swathed in tarpaulins and supported by scaffolding, on 3 November. The title remained uncertain even after the unveiling, since the official press release, which gave the name as 'Resurgence', reserved the sculptor's right to alter the name subsequently. Interviewed by the *Liverpool Echo* immediately after the unveiling, Epstein told them, 'The theme is Liverpool resurgent but if you want another title for the work I think it could be "Adventurous Youth"'[40]. The following day the work had acquired two names, 'Liverpool Resurgent' in the *Liverpool Post* and *Evening Express*, 'Adventure' in the *Daily Telegraph*, *The Times* and *Manchester Guardian*.

The public were less concerned by the names than agog at the aggressively male nude which now dominated the approach to the

store. Traffic ground to a standstill. Doggerel verse, angry and enthusiastic letters arrived in quantity on the desks of newspaper editors and Lewis's directors. At the unveiling itself, the *Liverpool Echo* had found public comment 'generally appreciative'; Hugh Scrutton, Director of the Walker Art Gallery, though privately unenthusiastic about the work, voiced public support, 'I think the work is very impressive indeed. Treating the nude figure on a scale so large as this is a most difficult task. I think Epstein has brilliantly achieved the feat of infusing into the work an intense feeling of restless energy in getting something done.' Many younger spectators pooh-poohed the prudish horror of their elders and welcomed the presence of sculpture in the street rather than the gallery. A Mrs Jones wrote with humorous cynicism that she doubted there would have been the same outcry over a female nude; women were often embarrassed by nude displays in public so it was pleasant to see the tables turned and men embarrassed![41] Many others, however, were appalled by the huge and assertively virile sculpture and said so in terms which frequently echoed uncannily attacks made on Epstein fifty years earlier. In 1907–8 he had carved eighteen overlifesize figures representing the cycle of life from conception to old age from the British Medical Association Building in the Strand. The male and female figures, nude or semi-nude, included a pregnant mother carrying a child in her arms and it was this figure more than any other that had caused a public outcry. The *Evening Standard* had fulminated, 'they are a form of statuary which no careful father would wish his daughter, or no discriminating young man, his fiancée, to see,' and gone on to argue that such work should be confined to art galleries where people knew how to look at them[42]. Now, in 1956, in Liverpool, irate correspondents complained that the work was a sign of public decadence and immorality; a surgeon wrote to call it 'a monstrous piece of vulgarity'. Mr J Crawford, a past President of the Liverpool Grocery and Provision Traders Association, wrote to Lewis's management to argue that 'This type of structure *may* be tolerated in a Museum or Art Gallery, it should not be permitted to shock the public gaze in the centre of our city.' The same line was adopted by local councillor, Alan Skinner, who engaged in a public debate about it with William Stephenson, principal of Liverpool College of Art, on Granada Television's 'Sharp at Four'; 'This is not a sculpture I would like my wife and daughters to stand and gaze at'[43].

The hotly argued and ribald reception accorded the work effectively pushed aside any serious consideration of its sculptural quality and resulted in the three reliefs of children, which had been unveiled at the same time, being almost completely ignored. The *Liverpool Post* art critic found little to say, merely praising the whole ensemble as 'an integral part of the surroundings, a very gracious and dynamic furnishing to the city of Liverpool'. He went on 'The lines are generalised and monumental yet there is a vitality and energy suggesting movement which Liverpool would want to claim as a symbol'[44]. Only the *Manchester Guardian* correspondent took a longer look;

> Seen from the Bold Street side it gives a curious effect of attenuation and elongation; from the corner of Lime Street it is without qualification magnificent. Below it are three concrete panels each six feet square, showing the children for whom the new Liverpool is being planned. In the flanking panels they scuffle and turn cartwheels and play leap-frog; in the centre a dog guards a homely pram in which sits up a baby whose large eyes and extended arms have a hint of the child Christ in Cavendish Square[45].

There is no indication that any of this much disturbed the sculptor who had long become inured to the perennial battle between puritans and libertarians which always erupted when his large-scale sculpture went on show. He was in any case far too busy to brood over it; only two weeks before he had attended the unveiling of his sculpture of 'Jan Smuts' in Parliament Square and the following week he had the novel experience of having three of his bronze portraits exhibited at the Royal Academy[46]. Even these signs of official approbation were distracting trifles; his real work was carving the massive Roman stone 'TUC War Memorial', begun in March and completed shortly before Christmas that year, and then starting on 'St Michael and the Devil' for Coventry Cathedral.

The fuss soon died down; 'the statue exceedingly bare' entered Liverpool folklore and is now passed largely unnoticed. But the example set by Lewis's in commissioning a major public sculpture was significant: though not taken up by other Liverpool firms, shops and offices were increasingly important patrons of public sculpture during the 1960s[47]. Epstein himself was approached by the John Lewis Partnership almost immediately after the unveiling of the Liverpool sculptures to undertake a commission for their Oxford Street store, then under construction[48]. Two meetings took place at Hyde Park Gate during which the sculptor proposed a work in granite on the theme of 'the brotherhood of man in industry', proposals which were accepted by M J Grafton, Director of Building, and the Chairman, Sir Bernard Miller. Though the project fell through, first on account of Epstein's other commissions, and then because of his death, a sculpture by Barbara Hepworth, 'Winged Figure', 1963, was commissioned for the building. Interestingly, however, the original brief, stemming directly from the earlier discussions with Epstein, that the sculpture 'should express the idea of the firm's partnership' was abandoned as too restrictive to the sculptor; rather the work would be 'an exercise in pure form designed as an aesthetic embellishment to the building'[49]. The change was indicative of the complete transformation that had taken place in sculpture; Epstein with his traditional materials and figurative, humanistic outlook was the heir to a tradition going back to the nineteenth-century and beyond; Hepworth, constructing a purely abstract composition, was part of the post-war development which rejected all imitation of natural appearances as a basis for sculpture.

Public sculpture in this century had had a patchy history, not least because architects, sculptors and patrons were uncertain about what it was meant to be and what it could or should say, or even whether it had any function at all. Many sculptors, like Henry Moore, had rejected the subordinate, decorative role allotted to them by architects, while architects increasingly designed buildings upon which sculpture of any kind seemed out of place. Epstein's 'Liverpool Resurgent', though born of good will on all sides, can be seen as a victim of this dilemma. The half-hearted modernism of the entrance facade and portico, belatedly altered, is fundamentally flawed as a setting for a free-standing bronze sculpture. In this instance patron and sculptor were agreed on what the work should be about; its heroic and celebratory character stemmed from the optimism of the clients and the habitual grandiloquence of the artist faced with a large-scale symbolic theme. The architects, on the other hand, had not expected a sculpture at all and their triumphal arch portico is an awkward and uncomfortable response to the needs of the moment. Epstein was one of the greatest architectural sculptors of this century, and carried out three of his most important architectural projects during his last decade – the Cavendish Square 'Madonna and Child', the Llandaff 'Christ in Majesty' and the 'TUC War Memorial'. Yet despite his highly professional and characteristically bold attempt to grapple with the demands of setting and subject, the Colossus is disappointing – well scaled for its site, but stiffly articulated, its heroic rhetoric a touch overblown and undermined by the undue emphasis given to the genitalia when viewed from below. The real triumph of the commission, all too often overlooked, lies in the *ciment fondu* panels of children which were the sculptor's own gift to Liverpool and his private commentary on the theme of the City's hope for the future. Not for nothing had Epstein begun his artistic career sketching from life on New York's Lower East Side and illustrating the everyday occupations of the immigrant communities there[50]. The reliefs take up themes devoid of symbolism and pomposity but with an immediacy

and humour almost totally lacking in public sculpture. Superbly judged in scale, depth of relief and placing, demonstrating all the artist's skills as a modeller, these are among his finest late works and, despite or perhaps because of their spontaneous naturalism, should rank as some of the most original public sculpture produced since 1945.

NOTES

1 F J Marquis (1883–1964) had become joint Managing Director of Lewis's in 1928 and had been Chairman from 1936 to 1951. In 1956 he was Chairman of Lewis's Investment Trust. F J Marquis, *The Memoirs of the Rt Hon. the Earl of Woolton*, London, 1959.

2 A Briggs, *Friends of the People; the Centenary History of Lewis's*, London, 1956.

3 Lewis's press release for the unveiling (courtesy of M Benson, Lewis's Archivist). For Liverpool's public sculpture, see J Willett, *Art in a City*, London, 1967.

4 The other sculptor recommended was Charles Ricketts, Liverpool, Walker Art Gallery, *An Exhibition of the Works of James Hamilton Hay*, 1973, p 6. As early as 1905, before he had exhibited a single sculpture in England, Epstein's name had been put forward as possible professor of Sculpture (alongside Augustus John for Painting, Elgar for Music and D S McColl for the Chair of Art History and Aesthetics) in an ambitious, unrealised scheme for a University Faculty of Fine Art at Liverpool University. E Morris, 'Paintings and Sculpture', *Lord Leverhulme*, Royal Academy exhibition, 1980, p 27. My thanks to Alison Yarrington for bringing this reference to my attention.

5 'Joseph Conrad', 'R B Cunningham-Graham', 'Mrs Epstein' and 'Anita'; J Epstein, *Let There Be Sculpture*, London, 1940, p 140.

6 Epstein's suspicion and correspondence on the purchase in the archives of the Walker Art Gallery.

7 W S MacCunn, *Bluecoat Chambers*, Liverpool, 1956, p 31.

8 *Liverpool Post* 9, 15, 18, 19 May 1931; R F Bisson, *The Sandon Studios Society and the Arts*, Liverpool, 1965, p 174.

9 R F Bisson, *The Sandon Studios Society and the Arts*, 1965, p 174.

10 E Silber, *The Sculpture of Epstein*, Oxford, 1986, no 175. Reported in the *Liverpool Post*, 17 June 1931 and lent to the Autumn Exhibition, 1933, no 1372.

11 Quoted with the sculptor's letter of reply in A Haskell, *The Sculptor Speaks*, London, 1931, p 37, and repeated with variant wording in J Epstein, *op. cit.*, 1940, p 141.

12 J Epstein, *Epstein An Autobiography*, London, 1955, p 236.

13 For details of these commissions, E Silber, *op. cit.*

14 I am extremely grateful to Mike Benson, Archivist of Lewis's plc., Colin Hunt of the *Liverpool Post* and *Echo*, Hugh Scrutton, former Director, and Edward Morris, Curator, of the Walker Art Gallery, Dr Terry Friedman, Leeds City Art Gallery, Leslie Cohen, formerly of Lewis's, the photographer Geoffrey Ireland, Jan Smith who was one of Epstein's plaster moulders, and George Breeze, Director of Cheltenham Art Gallery, for their assistance. Dr Martin Evans kindly gave me access to letters from Epstein to his father; Mrs P Lewis gave access to letters from her father (now Tate Gallery Archive). Mr Neville Ebsworth allowed me to consult his tape-recorded interview with the late Bill Olds.

15 A Briggs, *op. cit.*

16 One-way road systems, pedestrianisation and the sheer accumulation of city traffic have vitiated the strategic significance of most of these designs by displacing pedestrian access away from crossroads; in Liverpool, the Renshaw Street and Ranelagh Street junction is no longer the main entrance.

17 Architect's drawings published in *Liverpool Echo*, 20 May 1947; *Evening Express*, 20 May 1947.

18 Obituary, *Manchester Guardian*, 3 December 1956.

19 For more detailed accounts of the development of both projects see R Cork, *Art Beyond the Gallery in Early Twentieth Century England*, New Haven and London, 1985, chapters 1 and 6; E Silber, *op. cit.*, nos 9 and 189.

20 I am grateful for Mike Benson for this information derived from former employees of Lewis's.

21 Illustrated in the background in G Ireland, *The Sculptor at Work*, London, 1957, pl 10.

22 E Stewart, formerly in Lewis's publicity department, reported that the Board had seen the maquette and approved it but they were shaken by the final outcome (information courtesy of M Benson). The maquette and architectural model were subsequently destroyed with the exception of the head of the figure which was given by Epstein to his assistant and plaster moulder, Jan Smith.

23 Epstein to Mrs P Hornstein, 23 July 1954, Tate Gallery Archive 8716.32.

24 Epstein to Mrs P Hornstein, 3 September 1964, Tate Gallery Archive 8716.33.

25 Epstein to Mrs P Hornstein, 27 November 1954, Tate Gallery Archive 8716.35.

26 R Cork, *op. cit.*, pls 316, 323, 325, 356.

27 R Buckle and Lady Epstein, *Epstein Drawings*, London, 1962, pl 51.

28 Epstein to Mrs P Hornstein, 17 January 1955, Tate Gallery Archive 8716.37.

29 Epstein to Mrs P Hornstein, 16 February 1955, Tate Gallery Archive 8716.38.

30 Epstein to Dr I Epstein, 27 February 1955 (courtesy of Dr M Evans).

31 J Epstein, *op. cit.*, 1940, pp 202–5.

32 E Silber, *op. cit.*, nos 261, 305, 438, 452.

33 G Ireland, Notes to the author, 1983.

34 Epstein to Dr I Epstein, 16 April 1955 (courtesy of Dr M Evans).

35 Epstein to Mrs P Hornstein, 28 June 1955, Tate Gallery Archive 8716.42.

36 E Silber, *op. cit.*, no 477.

37 Epstein to Mrs P Hornstein, 20 October 1955, Tate Gallery Archive 8716.

38 J Smith to the author, 25 July 1988; D S James, *A Century of Statues; A History of the Morris Singer Foundry*, Basingstoke, 1984, pl 83, illustrates the sculpture in the foundry, but incorrectly dates the casting to 1953–4.

39 Information courtesy of Louis Cohen and Mike Benson.

40 *Liverpool Echo*, 20 November 1956.

41 Mrs E Jones to *Liverpool Echo*, 1 December 1956.

42 *Evening Standard*, 19 June 1908, reproduced in J Epstein, *op. cit.*, 1940, p 35; see also R Cork, *op. cit.*, chapter 1.

43 Reported in *Liverpool Post*, 1 December 1956.

44 Liverpool resurgent', *Liverpool Post*, 21 November 1956.

45 'A City Resurgent, Epstein's "Adventure" in Liverpool', *Manchester Guardian*, 21 November 1956.

46 'Smuts' was unveiled 7 November, E Silber, *op. cit.*, no 483. The sculptor had not exhibited at the Royal Academy since 1920; the Winter Show, which comprised 1,000 portraits, placed his work with that of Augustus John, Henry Lamb, Matthew Smith, Stanley Spencer, Meredith Frampton, Graham Sutherland and Pietro Annigoni whose famous portrait of Her Majesty the Queen was on view; reported in the *Manchester Guardian*, 23 November 1956.

47 R Calvocoressi, 'Public Sculpture in the 1950s', *British Sculpture in the Twentieth Century*, London (Ed. N Serota and S Nairne), 1981.

48 Letter to the author from J Carpenter, John Lewis Partnership, 15 November 1982. A letter from Grafton to Epstein, 28 February 1957 (in the author's possession) presses him to indicate whether his other commitments make it impossible for him to accept the commission or whether he may be able to undertake it at a later date.

49 R Calvocoressi, *op. cit.*, p 147, note 40, citing *Sunday Telegraph*, 22 April 1962.

50 H Hapgood, *The Spirit of the Ghetto*, New York, 1902, illustrated by Epstein.

LIVERPOOL GARDEN FESTIVAL
AND ITS SCULPTURE

Penelope Curtis

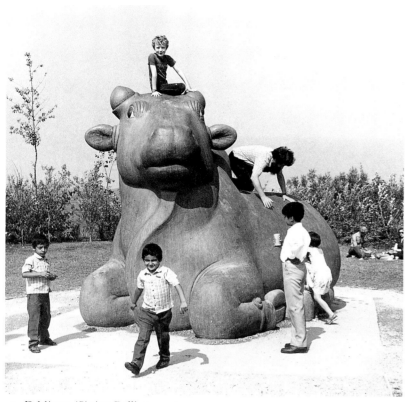

1. D Mistry, 'Sitting Bull', concrete,
paint, 1984

2. N Hicks, ' "But You Had the
Explorer" whined Claud', fibreglass,
1984

In July 1980 the Department of the Environment put out a paper entitled *Garden Exhibitions and the United Kingdom* as a result of promptings from the British Association of Landscape Industries (BALI). This profession had gathered information about the phenomenon of garden festivals abroad – in Switzerland, Holland, Austria and Canada – but principally about those held in Germany since the end of the last war. The bulk of their information, derived from German sources, aimed to propose the suitability of garden festivals for the British inner city. The German Bundesgartenschau is held for six months every two years, and is closely linked to the Central Horticultural Association which represents the variety of related commercial interests. This association decides on future sites for the shows up to a decade in advance. The winning town forms a company with the Association, which retains one quarter control, and after the show the park reverts to the city. The paper concluded that the net cost of the park is equivalent to that which it would have cost without a show. However, it pointed out, less obvious advantages accrue. Shows tended to hasten the creation of parks, otherwise prey to political vagaries. They 'help to promote the city, giving it a lot of free publicity'. Mannheim was quoted as an example where 'the show helped a great deal to change attitudes towards the city, amongst both residents and outsiders'. They could also combat chronic planning problems within the layout of a city centre. The tradition of restoring war-torn cities continued with the creation of new parks.

Turning to the advisability of adopting the garden festival in the UK, the paper considered that 'the idea could thus be of greatest benefit to a declining inner city area in need of regeneration'. The British 'gardening' tradition was considered to support the concept, though it was felt that an umbrella horticultural association like the one in Germany would have to be founded. The time span posed problems: 'the first show would need to be regarded as a pilot: but assuming a reasonable degree of success there seems to be no reason why the idea should not be repeated, and the second show planned for say five years later'. The paper assumed that the public sector could not provide resources on a German level. It therefore suggested that a site be selected where 'a park was already planned and budgeted for in the usual way, taking into account any central government grants normally available for such purposes such as derelict land grant and inner cities money where relevant; together with, hopefully, some sponsorship. The aim of the show would be to be self-supporting'.

In August 1980 interested cities were invited to submit applications. Merseyside made two submissions; one from Merseyside County Council with Knowsley Borough Council proposing Huyton as a site, the other from the City Planning Officer who suggested the waterfront. The Department of the Environment came back to Merseyside, but via the Merseyside Development Council (in process of formation at that point, and legally founded in March 1981), asking for a follow-up to these two proposals (the City and County Councils had thereby been effectively by-passed). The riverside option was preferred, because it already had money set up for it, but in the event the festival was put into the hands of the MDC and taken out of those of the City Council. The MDC was not without links, however, with either the City Council or the County Council, for it had on its board the chairman of each. By spring 1981 the MDC had secured the Merseyside representation; the Secretary of State then required the two cities under

3. H Moore, '3 Piece Reclining
Draped Figure', bronze, 1975

4. G Ibbeson, 'The Walrus and the
Carpenter', fibreglass and mixed media,
1984

consideration, Liverpool and Stoke-on-Trent, to submit a feasibility study, which they did that summer. In July 1981 there were the riots in Toxteth. The MDC already owned the site proposed for the garden festival, and the line of funding was already there, and although in any terms Liverpool was ahead of Stoke, the civil unrest cannot but have secured the government's decision in Liverpool's favour. The MDC specified the opening deadline – before the next general election was due in May 1984. The Royal Horticultural Society – very much forgotten in the discussions up to this point – finally endorsed the show in September 1981. Another endorsement, from the Association Internationale des Producteurs de l'Horticulture, gave the Liverpool Garden Festival another boost in giving it international status (an International Garden Festival occurs only every ten years and enjoys an effective monopoly).

Sculpture was not part of the brief proposed to the Department of the Environment by the BALI; nor does it appear to have been part of the feasibility studies submitted. When Dr John Ritchie (then Director of Development in the MDC) was visiting the German Garden Festival in Kassel in 1981 in preparation for the Merseyside feasibility study, he was struck by the Documenta art show being presented simultaneously in the town. The surprise combination sowed an idea in his mind which he took back with him to Liverpool. Sculpture in the German garden festivals themselves was minimal; the regular competition for memorial sculpture was perhaps its most prominent role. As the Liverpool plans were developing from park to exhibition to festival, John Ritchie was able to carry the sculpture idea through. He talked to Timothy Stevens, then Director at the Walker Art Gallery, who was himself keen to hold a large-scale British sculpture show such as was impractical at the Walker and continue the Liverpool tradition of outdoor sculpture while forging links outside the gallery. They then asked Alister Warman of the Arts Council's Art in Public Places scheme for advice as to the next step. It was Alister Warman who advised the appointment of an outside 'sculpture' advisor, and put forward the name of Sue Grayson-Ford who, though based at the Serpentine Gallery in London, was known to be thinking about moving north. Ritchie brought together an *ad hoc* 'visual arts' committee comprising himself, Timothy Stevens, and Professors Graham Ashworth and Noel Boaden (both now on the MDC board) from the university. Their 'vetting' session of Sue Grayson-Ford's selection of slides ended in their

handing over effective control to her. John Ritchie created a sculpture budget out of the horticultural budget; in the end MDC had to cover £87,700 of a total sculpture budget of £137,000. The Arts Council offered a grant of £30,000, and Merseyside County Council made available £20,000 grant-in-kind.

Because of her commitment to the Hayward's 'Sculpture Show' of 1983, Sue Grayson-Ford was only able to devote herself single-mindedly to Liverpool from the autumn of 1983. Her late appointment was to be the biggest handicap for the project, though Stevens believes it made for a certain immediacy and freshness. (The landscape architects and organizers would make a similar complaint; the British garden festivals have had planning periods of between three and six years, about half that of their foreign counterparts.) Sue Grayson-Ford's day-to-day negotiations involved Rodney Beaumont, Senior Partner of William Gillespies and Partners, one of the few large landscape practices in the UK. Beaumont had been chosen as Design Coordinator from a shortlist of submissions by three practices, themselves chosen from an original six or seven contenders. The involvement of Gillespies has been a notable point of continuity for the three festivals.

Because this was the first of the festivals, and because the visual arts were only considered at a relatively late stage, artists were not alerted to the potential of the situation. Unlike her later counterparts, Sue Grayson-Ford did not receive a flood of applications from artists wishing to be considered. A garden festival was not immediately recognized by sculptors as a 'market opportunity' and indeed there appears to have been an oddly secluded air to the selection process. Time did not allow for advertisement or for much commissioning, and instead Sue Grayson-Ford relied on her prior knowledge to seek out artists whom she could envisage using. Some local sculptors were included, but there was nothing like the pressure that there was on Isabel Vasseur, for instance, to use the Glasgow Garden Festival as a showcase for Scottish sculptors. The few commissions, notably Stephen Cox's, had in fact been initiated before Sue Grayson-Ford arrived. Her role was in effect reduced to 'furnishing' the park with ready-made pieces, rather than letting the park inspire her and selected artists in a more gestational manner. Her role was also circumscribed initially by only being offered a very small patch of ground out of the total 125 acres on which to place sculpture. Thus an initial achievement was to break out of this boundary, and to have sculpture placed throughout the festival site. Indeed

in the first Festival Guide only fifteen lines were devoted to the sculpture section, which at that point consisted simply of a sculpture zoo.

Eleven works were commissioned, and 39 were loaned by the artists. (The commissions cost £71,000, and remained the property of the MDC.) A few of the commissions were exceptions to the rule in that the artist was consulted early in the preparations for the festival. Stephen Cox had been approached by one of the landscape architects, and had visited the site before Sue Grayson-Ford arrived. His piece was unusual in being designed with a particular location in mind. In this case the architects were obliged to heed the sculptor rather than the reverse. (Similarly, for the Glasgow Garden Festival, the only apparently naturally integrated sculptural piece was Ian Hamilton Finlay's 'Stiles', and Finlay had been commissioned before Vasseur arrived.) In Liverpool Graham Ashton (Walker artist-in-residence), John Clinch and Nicholas Pope also worked in tandem to a certain extent with the development of the gardens. Two other commissioned artists – Allen Jones and Dhruva Mistry – were perhaps the success stories of sculpture at the Festival. Allen Jones's 'Tango' was his first public sculpture, and he was pleased with the result. As for Mistry, the Garden Festival commission ('Sitting Bull') could well be seen as the turning point in his career. The bulk of the remaining commissions might be termed architectural sculpture; they were essentially to decorate the Festival Garden buildings.

The time scale was a bigger limitation than was financial constraint. Although Sue Grayson-Ford was forced to be penny-pinching by the end of the preparatory period, financial considerations did not curtail the initial planning stage. The bulk of the budget went to the artists: firstly in commission fees, then in loan fees and expenses. The remainder went on fees for supervision and design, transport costs and repairs to works. Various national and local bodies and companies gave help-in-kind. Each successive sculpture co-ordinator, for each of the festivals, has been brought in a little earlier than the one before – Vivian Lovell began at Stoke in February 1985, and in Glasgow Isabel Vasseur had eighteen months' grace – but all have been brought in well after the planners began work, and well after many of the most fundamental decisions had been made. However, much of the greater time made available to the coordinators has been devoted to finding sponsorship, and much of the sculpture at Glasgow was only there because of sponsorship. Vasseur began with £75,000, and ended with pledges to the value of £500,000. That half the Glasgow sculptures were specially commssioned is therefore a reflection of this extra time and money.

The zoo idea came about because the area assigned to sculpture in Liverpool was initially extremely circumscribed. The limitation on space, combined with Grayson-Ford's wish to incorporate as much sculpture as possible, and her observation that much recent sculpture was based on animals, led her to create a 'sculpture zoo' in this area using the restrictions inherent in the show to its advantage. The zoo concept meant that sculptures worked together where otherwise the space would have seemed cramped.

Two thirds of the 44 loaned sculptures were by artists under forty years of age; over a third were by artists under thirty. The only two 'Masters of Modern Sculpture' in the Festival were Moore (lent by the Moore Foundation) and Hepworth, while established figures – in this case Frink, King, Pye, Tucker – were very much in the minority. It is notable that in the Glasgow festival several artists were represented by more than one work; in the case of William Turnbull, and more especially, Eduardo Paolozzi, the number, and date of the works lent a more museum-like air to the exhibition. The wealth of sculpture by younger sculptors was one of the highlights of the festival, but it also led to a few disappointments. Inexperience sometimes meant that the work did not stand up to a large outdoor space, or to the weather. However, Sue Grayson-Ford was particularly pleased that she had brought to the garden festival sculpture on a more varied and domestic scale than had

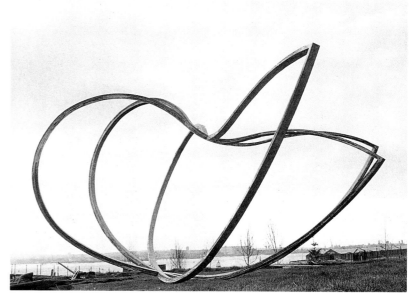

5. R Deacon, 'Like a Bird', timber, 1984

often been the case with the continental festivals, and pleased also that it was by much younger and less well-established artists. This trend has been continued in Stoke and Glasgow, though perhaps a little diminished. If we compare the figures for Glasgow, we find that just over half of the 44 artists are under forty, and that 12 are under thirty. All three festivals were predominantly British; none used the festival as a forum to show international modern masters, or contemporary developments abroad. At Liverpool all of the sculptors lived in Britain, even of those few born abroad. It is interesting to look at which artists featured in the first festival are also present in the next two. Is there a body of artists common to the festivals? Might we look for signs of lessons learnt and for a recognition by the sculptor that he or she is working within a specific arena, a limited tradition perhaps, but a tradition nonetheless? How the biannual garden festivals may have affected individual artists and their production is a huge question; some undoubtedly have benefited from the series. Their work may have anyway been suitable, or they may have adapted it knowingly. Yet only a few names are common to all the exhibitions: Kevin Atherton, Raf Fulcher, Dhruva Mistry, and Henry Moore. Zadok Ben-David, Chris Campbell, George Carter, Hilary Cartmel, Judith Cowan, Andrew Darke, Lee Grandjean, Mike Grevatte, David Mach, David Petersen and Graham Ibbeson showed in Stoke after Liverpool. The overlaps between Liverpool and Glasgow are fewer, only Richard Deacon, David Kemp and William Pye. However, Stoke had over 100 sculptors, while Glasgow had only 44. Whether or not a body of sculptors have adapted themselves to the opportunities presented by the series of garden festivals, it is not an option that is going to be long-lived. After Gateshead and Ebbw Vale the series will be brought to a close.

A contributor common to both festivals in a more significant way is the firm of designers William Gillespies and Partners; if one might have hoped that they would have learnt by their experience with sculpture the answer is clear – for the planners sculpture is a long way down the list of priorities. Nevertheless, both Grayson-Ford and Vasseur expressed some satisfaction in having, to a certain extent, brought the planners round to their way of thinking, if only after the event. George Mulvagh of the Gillespies team involved in Glasgow admitted in an interview reproduced in the catalogue: 'There are very few pieces here generated by the site or the event itself. You would have to start much further back in the design process to do that. I wish now I had the time over again and thought more about it earlier'. It was perhaps because of the insubstantiality of the rest of the festival that some of the sculpture had an enhanced impact on eyes that had previously been indifferent to

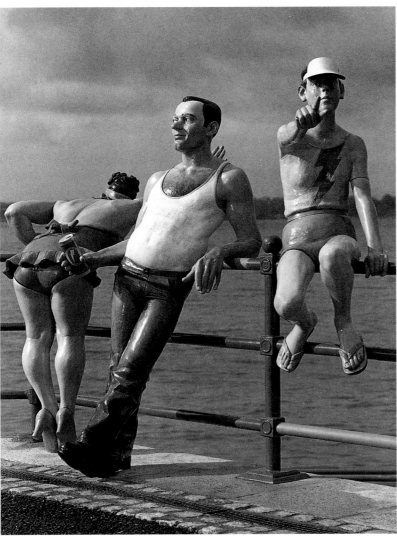

6. J Clinch, 'Wish you were here',
fibreglass, 1983–4

it. In this essay we do not have to go any further into the sadly un-garden like quality of the garden festivals (especially the Glasgow festival). Criticisms of the landscaping aspect belong elsewhere, but it appears oddly possible that the very poverty of the gardens worked both to the advantage and the disadvantage of the sculpture.

The fact that the landscape architects were already well under way by the time Sue Grayson-Ford arrived meant that she had to jettison any idea that sculptors might work in a creative partnership with them. Nor were the created landscapes even able to provide inspiration for the sculptors, for their works were generally acquired and then 'placed' in the gardens in a manner more reminiscent of gallery installation. We cannot therefore look at the sculpture of this garden festival as 'environmental sculpture', or as sculpture inspired by the landscape. Most of the 'landscape', moreover, was not ready until the opening – thus making a nonsense of the concept that the landscape might inspire either artist or organizer. Even when complete, it had an artificial 'toy-town' aspect to it. It was at the opening of the Festival, and thereafter whenever immature nature appeared unable to cope with the challenge of the weather, that the sculptures came into their own as constants which could be relied upon to look good. The sculpture also helped a landscape that was brashly new, almost 'naked', in the opening weeks. Even the two sculpture residencies in the festival gardens did not feed off the site in any symbiotic way. Instead, the two sculptors had their materials imported into the site; the residency meant no more than that they were a spectacle that could be watched at work. Even if only indirectly, sculpture thus came to be respected for itself, for qualities that could not be otherwise achieved. Sue Grayson-Ford judges it a particular achievement to have forced the realisation upon the landscape architects that a three-dimensional conceit was not necessarily 'sculpture', and that sculpture was a separate discipline to be pursued by sculptors. The sculptor's job is distinct, and he or she cannot be replaced. Despite her battle against the proliferation of three dimensional decoration, it often cropped up at the very worst time – on the eve of the opening. Visually 'busy' additions spoilt areas, backgrounds or sightlines which she had previously judged suitable for the sculpture. The whole notion of sympathetic and sensitive siting, carried out by the sculptor and/or the visual arts organizer was thereby thrown to the winds. Such vulnerability is perhaps encapsulated by an incident at the Glasgow Garden Festival of 1988 when a block of portable lavatories turned up next to the prize site – the Richard Deacon 'Nose to Nose' – at the very last moment. Like Sue Grayson-Ford, Isabel Vasseur had been continuously on the lookout for such clashes, but last minute arrivals tend to triumph. Richard Deacon's work ('Like a bird, Like a ship') had also suffered from its siting at the Liverpool Festival; Deacon was appalled, as was Sue Grayson-Ford. It might be thought that if visual atrocities happen unexpectedly, then so might visual serendipities. Questioned on this point, Sue Grayson-Ford remembered only the pleasing combination of the Henry Moore beside the giant glass conservatory, which seemed to echo its lines.

The Liverpool sculpture zoo reflected the larger ambiance of the gardens in which it was situated. It was a place for family relaxation and entertainment. Such an ambiance was a key premise for the organizer, and it was this that provided most of the satisfaction which Sue Grayson-Ford derived from the project. For the sculptors too, it was the public's response that occasioned most pleasure. Three and a half million people visited the festival. Parks are a place for relaxing, and sculpture encountered in this environment is approached in a different way than it would be in a gallery. The fact that people liked to have their photographs taken beside the sculpture (notably beside John Clinch's 'Wish You Were Here') was seen by her as a kind of test of success, in that it indicates people's incorporation into the sculpture. This is exactly the kind of test that is not posed in the gallery environment, and the reason why Sue Grayson-Ford is so strongly commited

to working with art outside it. The nature of the site, and its audience, necessarily affected her selection of the sculpture, but she did not feel that she had been obliged to compromise herself in the selection.

Part of the Festival Gardens has continued to be run as a park with limited success. The commissioned sculptures – those by Atherton, Cox, Pope, Jones, Mistry, and Clinch, and the decorations by Fulcher and Carter – are still there. The year after the festival a still impressive 500,000 people paid to enter the gardens, now run by a private consultancy (Leisure and Recreation Services) on franchise from the MDC. No figures survive from 1986 when Transworld ran the franchise. In 1987 130,000 visited the gardens once again administered by L & R, and in 1988 the franchise holders Maximum Entertainment Ltd recorded 87,000 visitors. It is unlikely that the site will continue to be used this way, and the MDC is looking to make it over to private developers. It had originally been intended that the city council would take over 45 acres of the park, along with the arena and the festival hall, to have been made into a sports hall. In November 1984 the City Council pulled out of this plan, as it had earlier, in May 1983, formally declined the opportunity to develop a part of the site as specifically its own.

The first garden festival changed no artist's working practice. If approached with the expectation of seeing sculpture growing out of and working with the landscape (no ridiculous hope) it and the other garden festivals have been great disappointments. If we look at the relationship the other way around, taking the festival first, rather than the sculpture, we might arrive at more sanguine a conclusion. The appointment of Sue Grayson-Ford, and her success in installing sculpture in the festival, meant that sculpture asserted its right to be part of, and remain part of, the British garden festivals (Stevens notes his surprise that later festivals have not extended the brief to include painting and crafts.). It is perfectly possible that sculpture might never have entered into them, or certainly, that it might never have become a live issue, widely debated in relation to each festival. Although for those who have gone to the garden festivals expressly to see the sculpture, the experience has often been disappointing, it is worth bearing in mind that (in their short history) we have nevertheless come to associate the garden festivals with sculpture, and that this is surely no mean feat. In the light of the millions who have gone to the festivals with no such intention, but have come up against and enjoyed the sculpture, this 'feat' must be a meaningful one.

LIST OF ARTISTS EXHIBITED

Jane Ackroyd, Christine Angus, Graham Ashton, Kevin Atherton, Alain Ayers, Zadok Ben-David, Sven Berlin, Kate Blacker, Rosemary Burn, Geoffrey Butt, Chris Campbell, George Carter, Hilary Cartmel, John Clinch, Judith Cowan, Stephen Cox, Edward Cronshaw, Andrew Darke, Richard Deacon, Barry Flanagan, Elisabeth Frink, Andy Frost, Stuart Frost, Jonathan Froud, Raf Fulcher, Rex Garrod, Lee Grandjean, Mike Grevatte, Alan Grimwood, Kevin Harrison, Barbara Hepworth, Nicola Hicks, Tim Hunkin, Graham Ibbeson, Allen Jones, David Kemp, Phillip King, Patrick Kirby, Peter Logan, Michael Lyons, David Mach, Gina Martin, Dhruva Mistry, Henry Moore, David Petersen, Andy Plant, Nicholas Pope, Neil Powell, William Pye, Peter Randall-Page, Ted Roocroft, Yoko Terauchi, Susan Tebby, William Tucker, Michael Winstone.

SOURCES
Interviews with Sue Grayson-Ford, Isabel Vasseur and Dr John Ritchie

Department of the Environment, advice notes, *Garden Exhibitions and the United Kingdom*, July 1980, and *National Garden Festivals*, 1988.

Liverpool, International Garden Festival, 2 May – 14 October 1984, *Festival Sculpture*, with a preface by Councillor Ben Shaw (MCC) and Leslie Young (MDC), a foreword by Sue Grayson, and an introduction by Richard Cork.

Stoke, National Garden Festival, 1 May – 26 October 1986, 'Sculpture at Stoke', reprinted from *Art & Design*, May 1986, with an introduction by Chris Bailey.

The National Galleries of Scotland Guide to Sculpture at the Glasgow Garden Festival 1988, (28 April – 26 September), broadsheet.

Art in the Garden, Installations, Glasgow Garden Festival, Edinburgh, 1988, with contributions by Thomas Joshua Cooper, Isabel Vasseur, Richard Cork, Yves Abrioux and Walter Grasskamp.

CHARLOTTE MAYER'S 'SEA CIRCLE'

Alex Kidson

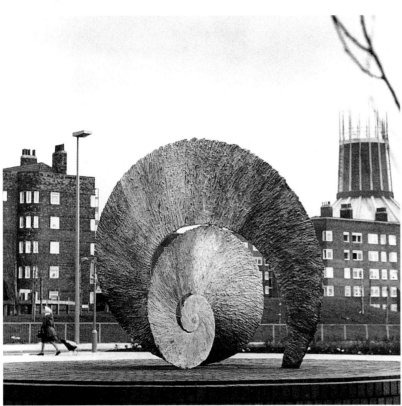

1. C Mayer, 'Sea Circle', bronze, 1984, Liverpool, junction of Seymour Street and Copperas Hill

If the Garden Festival works reflect the more obviously groundbreaking aspects of sculptural activity in 1980s Liverpool, one further piece commissioned at the same time may in retrospect tell us more about the existing conditions for public sculpture patronage in the city. Charlotte Mayer's 'Sea Circle', situated on a landscaped roundabout on Seymour Street at the junction with Copperas Hill above Lime Street station, was commissioned by Merseyside County Council, out of funds accounted for in an orthodox manner to local ratepayers, and as part of a routine project perceived as fulfilling an identified 'local' strategy. Prominently sited at the top of a hill near the centre of the city, the work was classically integrated with the local community (illus.1), and at the same time presided, from the opposite viewpoint, over a wider panorama of city, river and sky, symbiosis of Merseyside. In terms of social, political and geographical context, its contrast with the Garden Festival sculptures could hardly be more striking. These, conceived for a new population of tourists and leisured visitors under the auspices of the Whitehall-funded Merseyside Development Corporation, were doomed to a loss of impact as they were moved from their original sites, or as these sites dwindled in public appeal or became inaccessible.

The man responsible for commissioning 'Sea Circle' was John Barry, a Development and Planning officer with Merseyside County Council. Previous experience working at Harlow New Town (where expenditure on outdoor sculpture had been built into budgets as a proportion of expenditure on dwellings) had nurtured his interest in sculpture as a design feature in the urban environment. Barry had a positive commitment to contemporary sculpture and his own ideas about what types of sculpture were appropriate to the modern urban context; in Liverpool, however, he had no official brief to commission sculpture and in effect found his scope limited to involving himself, when the County Engineers' Department budget permitted, in highway improvement schemes. Another of these, begun slightly earlier than 'Sea Circle', resulted in the erection of part of a warship's mast on a new traffic island at the Pier Head, directly between the Liver Building and St Nicholas' Parish Church (illus.2). A compromise solution to an originally more ambitious plan, this 'sculpture' provides a graphic illustration of the problems inherent in Barry's position. Its palpable opportunism, its strange effect of latterday private folly, bear testimony to a quite specific view of the appropriateness of sculpture conditioned by a limited and short-term budget, a 'given' site, and a consciousness of the potential scepticism of colleagues.

A similar solution, involving a disused railway signal, was proposed for the site above Lime Street station but here Barry was determined to commission a proper sculpture. In the summer of 1983 he approached the Director of Merseyside County Art Galleries, Timothy Stevens, for advice about possible artists. Barry had initially contemplated commissioning a local sculptor, probably for political reasons, but Stevens, whose concurrent involvement with the Garden Festival commissions was heavily London-orientated, seems to have dissuaded him from this. Barry acted upon Stevens's suggestion that he should visit the 'British Sculpture Show', then being held at the Hayward and Serpentine Galleries, for ideas; but this exercise was largely cosmetic. In Barry's words, 'when you were involved with the avant-garde, there were always loads of headaches explaining it to people', and Stevens's own reputation within the City Council as an uncompromising advocate of the inexplicable was always likely to make his advice, for

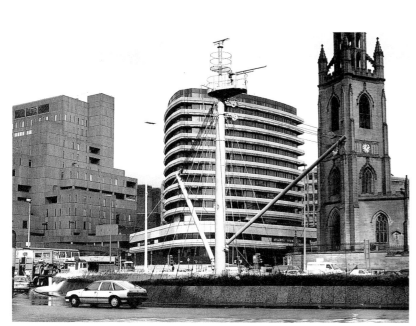

2. Warship's Mast, Liverpool, junction of New Quay and Chapel Street

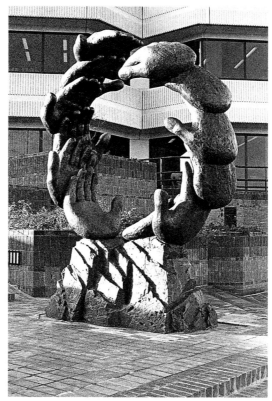

3. C Mayer, 'Care', bronze, 1982, Johnson and Johnson, Slough

Barry's purpose, too dangerous to follow.

Barry next approached Mike McDonald of the St Albans-based sculptors' agents McDonald Rowe. He had had no previous dealings with this firm and was simply following up an advert he had seen in a small art magazine. McDonald sent to Liverpool a large dossier on the sculptors he represented, which Barry put before a team of departmental colleagues; but when this failed to provide a consensus, he finally selected his own short-list of four possible candidates with one project assistant, Brian Griffiths. It is clear from this list that at this stage Barry and Griffiths had no precise idea of the type of sculpture they wanted; of the four, two concentrated on relatively realistic representations of the human figure (one was indeed a portraitist proper); the other two on more symbolic forms, one or several stages removed from figuration. What was more important was the type of actual sculptor: London-based but not identified with the 'avant-garde' gallery scene. 'They weren't of national standing', Barry said, 'but we thought we could work with them'.

Barry and Griffiths called on the four sculptors in their studios, visiting Charlotte Mayer on 30 September. Mayer was a versatile sculptor with a Royal College training who had experience of working in stone, wood and metal; in each case on the largest and smallest of scales. She had exhibited with Elizabeth Frink in the 1970s and had obtained regular commissions since from both the public and private sectors. She was disappointed by her meeting with the two men; their look at the works in her studio seemed perfunctory and she felt out of sympathy with their own ideas about the Seymour Street project. She was very surprised when, after an interval of several weeks, and without her having been asked to submit any actual proposal for a work, Mike McDonald relayed a phone call offering her the commission and asking what her terms would be. On her pointing out that she had never seen the site of the proposed sculpture and had no conception of the scale required or the work's context, she was invited to Liverpool.

Barry's and Griffiths' choice of Charlotte Mayer and their assumptions about what the new work would look like seem to have been based largely on her previous outdoor piece, 'Care' (illus.3). 'Care' had

been a commission from Johnson and Johnson (of baby powder fame) in 1981–82 and was a work which Mayer herself did not regard as an unqualified success. But its direct and boldly-stated theme, the need for mutual support and interdependence among all members of a human community, was obviously of particular relevance in post-Toxteth Liverpool; indeed, Mayer had said at the original interview that working on the piece during the Toxteth riots had left her with a keen desire to make a work on a similar theme for Liverpool itself. It was Barry's and Griffiths' turn to be surprised when Mayer arrived in Liverpool at the end of October with a small maquette of 'Sea Circle' which she had cut out of tinfoil in the studio the night before. They liked the work as she explained the idea behind it: the form, a combination of shell and spiral symbolising at once the city's timeless seaboard character and the life of its sailors setting out on voyages and returning home again. But they were worried by what they saw as a significant change in her style (in fact, it hardly was); and also by her idea, mooted on this occasion, of participating with local people in making the piece. 'It needed a bit of nerve', Barry recalled, 'to stick with her'.

Charlotte Mayer heard no more about the commission until April 1984, but in spite of their private reservations, Barry and Griffiths had felt sufficient enthusiasm for her proposal to proceed, and required the interval to obtain formal decisions from their superiors. For them, this was the key phase of the commission. It could be argued against them at this point that they were going ahead on the basis of a tiny maquette which gave no idea of the finished work's scale, colour or surface finish and which (despite the artist's own feelings on this issue) had in fact been conceived without actual reference to the specific site: that in effect they were going on because they had contrived to reduce their options to the point of no return and because, any further negotiation with artist (or artists) threatened the momentum of the project beyond repair. It was to their credit, however, that Barry and Griffiths were able to turn this delicate position to decisive account. It served to strengthen their own personal commitment to 'Sea Circle' and its sculptor; as they saw it, they had a sculpture whose visual effect was immediate and arresting, and whose idea and meaning were direct and

4. C Mayer, 'Sea Circle', plaster
version, 1984

easily explained. These were the crucial factors. Colleagues were convinced; and Charlotte Mayer too found herself warming to their unswerving enthusiasm for the project and their open-minded willingness to take the job as·they found it. 'They were very sympathetic and attuned to what I was trying to do', she remembered, 'and the making of the piece was a very happy time for me'. She re-visited Liverpool in June 1984 to submit the official maquette (requested in April) for inspection by council sub-committee; and finished the work in plaster (illus.4) at the end of August. It was then cast in bronze and was installed on 7th December 1984. Mayer received a fee of £9,000 and the bronze metal and casting cost a further £6,000. These sums were paid as part of the costs of the roundabout scheme by the County Engineers' contractors, Norwest Holst.

After installation, the work was virtually ignored. The only feedback Charlotte Mayer herself had was one phone call from a reporter on the *Liverpool Daily Post* (this may have been the art critic, Roderick Bisson) who said he admired the piece and asked for a photograph. John Barry recalled a certain amount of adverse publicity: a local news programme described the work unflatteringly as 'a piece of orange peel'; Liverpool MP David Alton publicly condemned it as a waste of money; there was hostility too within the council from the Liberal and Conservative minorities. Barry himself took a certain pride from these controversies: they seemed to be a sign of the work's power to arouse interest and debate. But they were short-lived. The abandonment of the larger-scale urban renovation along Seymour Street of which the landscaped roundabout formed only a small part, seriously compromised the sculpture's fundamental theme of organic growth and renewal. The work was completely passed over by the artistic community on Merseyside.

That 'Sea Circle' had such a negative reception and impact was obviously in part owing to the recent proximity of the Garden Festival sculptures, many of which were by artists of international repute and nearly all made in an up-to-the-moment idiom. 'Sea Circle' was neither; by their side, the work could not fail to be regarded as an anti-climax and even seem to represent a missed opportunity. Even worse from the art-historical point of view was that the commission betrayed such superb indifference to professional criteria, to standard principles of selection and organisation. That there was in fact some awareness of this within the Development and Planning and the Engineers' Departments of the County Council can be gauged from their joint approach to a follow-up commission in the early months of 1985. This was intended for a site on Hunter Street, behind the Walker Art Gallery, again in the context of a major highways scheme. On this occasion, Barry was to have had the disposal of no less than £50,000. Three sculptors (including William Pye) were to have been commissioned to visit the site and produce maquettes and these were to have been submitted for relevant committee inspection before a decision was reached on employing an artist. Issues of site-specificity and sensitivity to the environment would have been aired in committee and above all the sculpture was to have been completed before the highway works were undertaken, rather than the reverse. Had the scheme proceeded, the mixture of ingenuous opportunism and sheer political pragmatism which distinguished the Council's patronage of Charlotte Mayer would have been, if not eliminated, then at least substantially watered down.

To dwell, however, upon the shortcomings of the Council's performance as a patron of sculpture in this episode already seems inappropriate and presumptuous. Even leaving aside Charlotte Mayer's own feelings about the artist-patron relationship that she enjoyed, it is no longer possible, after five years in which the city has seen no successor to 'Sea Circle', to view John Barry's enthusiasm and commitment as merely naive. Fashions in sculpture have changed. 'Sea Circle' and the Garden Festival commissions have weathered into their very different environments. In that time, the contrasts between them have ceased to be a simple question of aesthetic preference; they have taken on the cogency of a dynamic historical counterpoint.

THE FORMATION OF THE TATE'S COLLECTION OF MODERN BRITISH SCULPTURE
Part I

Ronald Alley

When the Tate Gallery (then known as the National Gallery of British Art) was opened in 1897 there was no special provision for sculpture, but a small sculpture hall was added two years later at the expense of Sir Henry Tate, as part of the second stage in the development of the building. Situated a short way beyond where the Duveen Gallery begins now, it was more or less square in ground plan and divided into two halves by a colonnade. But for many years there was little of much merit to put into it.

As the Tate did not receive an annual purchase grant until 1946 and had very little purchase money from any other source, it was largely dependent on gifts for the first fifty years or so of its existence. The main source was the Chantrey Bequest, a trust fund administered by the President and Council of the Royal Academy which had been bequeathed to the Academy by the sculptor Sir Francis Chantrey for the purchase of paintings and sculptures of the highest merit executed within the shores of Great Britain. It was Chantrey's intention that the works purchased out of the income from the bequest (at first about £3000 a year, then a substantial amount) should serve as the basis for a national collection of British art, and when the Tate Gallery was opened all the paintings and sculptures which had already been acquired since the bequest first came into effect in 1877 were vested in the Tate, which also received the further purchases from then on. In practice most of the acquisitions were made from the Royal Academy's summer exhibitions and the purchases reflected the Academy's very conservative point of view. For instance, in the years 1903–11 the sculptures included W Robert Colton's 'The Springtide of Life' (two children playing by the seashore, the elder restraining the younger), Henry Pegram's 'Sibylla Fatidica' (an old sibyl in a hooded cloak gazing into a crystal globe and reading the future to a naked woman who has fallen across her knees in despair) and Sir William Reynolds-Stephens' 'A Royal Game' (Queen Elizabeth I of England and Philip II of Spain playing chess with ships). Some of these pieces now look extraordinarily quaint and dated: they tend to be life-size and anecdotal in character, with symbolism of a morally improving kind, and they are mostly executed in a debased, neo-classical style. This at a time when Rodin was already at the height of his fame and when Picasso was painting, or about to paint, 'Les Demoiselles d'Avignon'.

Protests soon began to be made about the way the money was being spent and at the exclusion of the more avant-garde artists who chose to exhibit at the New English Art Club or the London Group instead of at the Academy, but it was not until after the creation of a separate Board of Trustees for the Tate in 1917 that the Gallery was given any say in the choice of works; and at first this consisted simply of the right to comment on the advisability of adding to the collection works proposed by the Academy sub-committees and to offer suggestions. In 1922 the consultation on the choice of works for purchase was made more definite by forming two committees for painting and sculpture, each composed of three members of the Academy and two of the Tate Board, but the power of approval or rejection still rested with the Academy Council. Although this change of procedure resulted in the acquisition of a few unquestionably worthwhile works, such as two bronze heads by Epstein in 1922 and 1934, and two sculptures by Sir Alfred Gilbert in 1925 ('Model for Eros') and 1934 (a portrait head), most of the purchases were of academic or near-academic pieces by such artists as Richard Garbe, Gilbert Ledward, William McMillan, Alfred Turner, F

Derwent Wood and Sir Charles Wheeler. Though in some cases not without merit, their work is timid and lacking in vitality by international standards.

Apart from occasional gifts from private benefactors, the main source of more avant-garde British sculptures was the Contemporary Art Society, which had been founded in 1910 for the purpose of acquiring notable examples of modern art to be lent or presented to public collections in London and the provinces (and which treated the needs of the Tate as a high priority). It was, for instance, from the CAS that the Tate received its first sculptures by Epstein in 1917, Eric Gill in 1920, Frank Dobson in 1929 and, much later, Henry Moore in 1939. It was also as a gift through the CAS that the Tate received its first three sculptures by Gaudier-Brzeska in 1930.

Sophie Brzeska, the artist's mistress, had died intestate in March 1925 and in the following year these three sculptures ('Singer', 'The Red Stone Dancer' and 'The Imp') from her estate, as well as seventeen drawings, were placed on permanent loan at the Tate Gallery through the Treasury Solicitor. This was arranged at the instigation of Jim Ede, who was then working at the Tate as Assistant, and who became a great admirer of his work. Then in 1930, the year Ede's book on Gaudier was published, they were purchased by Frank Stoop and presented through the CAS. At any rate the gift was made in Frank Stoop's name, though Ede now says that, as far as he can remember, he put up at least part of the money himself. (Years later, in 1966, he presented a further eleven sculptures and six drawings by Gaudier-Brzeska in the name of Kettle's Yard Collection, Cambridge).

Unfortunately Ede left the Tate in 1936 and there was no one else on the small staff who shared his enthusiasm for contemporary art. The attitude of J B Manson, who was Assistant Keeper from 1917–30 and Director from 1930, can be gauged from the fact that one of his last official acts was to advise H M Customs in March 1938 not to admit a group of sculptures by Arp, Brancusi, Calder, Duchamp-Villon, Laurens and Pevsner as works of art, thereby damning at one blow the work of six of the greatest sculptors of the twentieth century. He retired shortly afterwards from ill-health after a public outcry, and was succeeded by Sir John Rothenstein.

Discussions had begun with Lord Duveen as early as 1927 about the possibility of his paying for a larger sculpture hall to replace the original one, and the new gallery now known as the Duveen Gallery was finally opened in June 1937. Situated in the central spine of the building it is about 300 ft long by 34 ft wide by 50 ft high. Its massive proportions and especially its enormous height, combined with a lack of provision for showing works in isolation, have made it a difficult place to exhibit modern sculpture to advantage. Various different solutions have been tried over the years but none has been wholly satisfactory. At times the gallery has been used solely for sculpture, at other times the walls have been partly boarded over so that they can be hung with large paintings; but often there has been a combination of the two. It has to be said that most 20th century sculptures except the very largest tend to look better in the ordinary galleries than in the vast towering space specially intended for them, which has far too much the air of a mausoleum.

Until 1939 the only annual income at the disposal of the Trustees for the purchase of works of art was the income of the Clarke Fund (a few hundred pounds per annum), which had been made available shortly after the First World War by the Trustees of the National Gallery who in 1939 withdrew it and allocated the income of the Knapping Fund instead. This income, which amounted at that time to about £1,170 a year, was for the purchase of paintings or sculptures by artists still living or who had died not more than 25 years before the date of purchase. Then in 1946 the Gallery was given for the first time an annual purchase grant from Parliament of £2,000 a year, which was repeated annually until 1953 when it was increased to £6,250.

These increased resources made it possible for the Director and Trus-

1. H Gaudier-Breszka, 'Red Stone Dancer', stone, c.1913

tees to play a more active role in the formation of the collection, though the money available was still pitifully inadequate in relation to the Gallery's needs: the needs of both the British and modern foreign collections. In point of fact attention seems to have been mainly concentrated at first on strengthening the collection of British painting and bringing it up to date, and 217 British paintings and drawings were bought between 1 January 1938 and 31 March 1953, as against only 27 British sculptures; and this figure includes 6 bronzes cast by order of the Trustees from plasters by Alfred Stevens and J Havard Thomas already in the collection. (The collection of works by the Victorian sculptor and painter Alfred Stevens, very highly regarded by a succession of Directors, was for many years one of the special features of the Tate, and a large gallery used to be entirely devoted to his work. It was disbanded in the second half of the 1950s and all but three of his sculptures have since been transferred to the Victoria and Albert Museum.)

In 1941, Henry Moore, then an official war artist, became a Trustee of the Tate and remained on the Board, except for a brief interval, for fourteen years. Three of his drawings had been purchased out of the Knapping Fund the year before to complement the splendid 'Recumbent Figure' 1938 in Green Hornton stone presented by the CAS in 1939, and in 1945 the Gallery bought seven bronze maquettes: four projects for the Northampton 'Madonna and Child' and three for the 'Family Group'. A cast of the finished life-size 'Family Group' itself was added in 1950 and an early stone carving 'Girl' 1931 in 1952. The other modern British sculptures bought during this period included (in order of purchase) the Gallery's first pieces by Leon Underwood, John Skeaping, Barbara Hepworth, Reg Butler and Elisabeth Frink. The Hepworth, bought in 1950, was a large more or less abstract stone carving 'Bicentric Form' and the Butler one of his most important early works, the 'Woman' in forged iron of 1949. In addition, a mobile by Lynn Chadwick was presented by the CAS in 1951.

Butler, Frink and Chadwick all belonged to the post-war generation of British sculptors, and Butler and Chadwick were among the eight young sculptors whose work was exhibited together in the British Pavilion at the 1952 Venice Biennale: the others being Robert Adams, Kenneth Armitage, Geoffrey Clarke, Bernard Meadows, Eduardo Paolozzi and William Turnbull. Their work, in a wide variety of styles and techniques, was influenced by Picasso and Giacometti as well as Moore. A large wood carving by Meadows, which had been commis-

3. W Turnbull, 'Mobile Stabile',
bronze, 1949

2. R Butler, 'Woman', forged iron,
1949

4. B Hepworth, 'Pelagos', wood,
paint and string, 1946

sioned for the Festival of Britain in 1951, was presented by the Arts Council in 1954 and an early Paolozzi 'Forms on a Bow' by the CAS in 1958, while the purchases included a later Butler of a different kind ('Girl' 1953–4) in 1954 and single works by Armitage ('Square Figure Relief') and Paolozzi ('Cyclops') in 1958. Three sculptures by F E McWilliam, including a pair of portrait busts of William and Mary Scott, were also bought in 1953 and 1957.

In 1959 the purchase grant was increased from £7,500 to £40,000 and this, together with the foundation of the Friends of the Tate Gallery in May 1958, made it possible to begin planning on a much more generous scale. As far as the 20th century British sculpture collection is concerned, the first major step was the great expansion of the Gallery's holding of Henry Moore, thanks partly to the artist himself, who made the bronzes available at little more than the cost of their casting. In the years 1959–60 the Friends bought and presented no less than seven of

his sculptures, including a carving and four smallish bronzes from different periods of his career and two large works: casts of the 'King and Queen' of 1952–3 and 'Reclining Figure' of 1957, the latter a half-size study for the stone carving made for the UNESCO Headquarters in Paris. In addition the Trustees bought at the same time another large reclining figure, 'Two-Piece Reclining Figure No 2' of 1960, while two early carvings, one in wood and one in marble, were bequeathed by E C Gregory. Then in 1963 the Trustees bought another, later bronze, the 'Working Model for Knife-Edge Two-Piece' 1962.

E C Gregory, who bequeathed the two sculptures by Henry Moore in 1959, was a director of the publishers Lund Humphries and the founder of the Gregory Fellowships in painting, sculpture and poetry at Leeds University which included as sculpture Fellows, Butler, Armitage and Dalwood. Together with his bequest of six works to the Tate, his executors allowed the Trustees to buy some further pieces from his collection at specially reduced prices, including two more sculptures by Reg Butler, another Paolozzi, and the Gallery's first sculptures by Caro, Clatworthy and Dalwood. The Caro 'Woman waking up', 1955, was one of his early figurative works. Other purchases over the period 1959–63 included the first sculptures by Robert Adams, Ralph Brown, Stephen Gilbert, Kenneth and Mary Martin, Ivor Roberts-Jones, Peter Startup and William Turnbull.

Barbara Hepworth was represented from 1950 to 1960 only by the single large sculpture 'Bicentric Form' (plus from 1959 a drawing bought from the Gregory collection), but in the course of the 1960s her representation, like Moore's, was completely transformed, thanks largely to her own generosity. First the Trustees bought in 1960 a tall slender wood carving 'Figure (Nanjizal)' 1958 and a bronze, followed in 1962 by another, more compact and massive wood carving 'Corinthos' 1954–5. In 1964, soon after Sir Norman Reid became Director, she presented four sculptures and two drawings from different phases of her career, and at the same time Mr and Mrs Marcus Brumwell gave one of her most important early abstract carvings, 'Three Forms' 1935; in addition, two recent works were purchased. Then in 1967 she presented a further nine sculptures ranging in date from 1929 to 1965, and in 1969 yet another in memory of Sir Herbert Read.

The gradual increases in the purchase grant (in 1964 to £60,000, in 1969 to £75,000, in 1970 to £265,000, in 1975 to £570,000, in April 1978 to £1,012,000 and so on), though spent mainly on trying to build up the collection of modern foreign art from a very low base, also gave an opportunity to begin a close, searching reappraisal of the Gallery's

5. J Epstein, 'Visitation', bronze, 1926

6. F E McWilliam, 'Eye, Nose and Cheek', stone, 1939

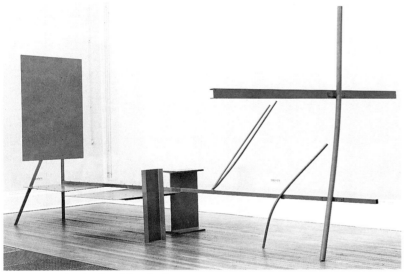

7. A Caro, 'Early One Morning', painted steel and aluminium, 1962

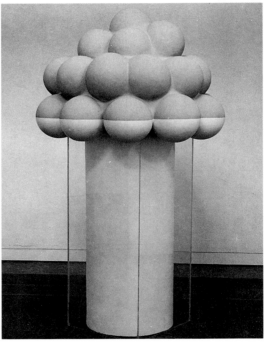

8. T Scott, 'Agrippa', fibreglass and perspex, 1964

collections of 20th century British painting and sculpture, so as to work out where the gaps and imbalances were, and try to make them good. For example, although the Tate owned a number of bronzes by Epstein, including his full-length 'Visitation' of 1926 and no fewer than ten portrait heads or busts, there was no example of his carvings which represent quite a different (and more difficult) aspect of his work. A cast of his great mechanistic figure 'The Rock Drill' was bought in 1960, and in 1972 and 1973 two of his finest early carvings, 'Female Figure in Flenite' and 'Doves', came onto the market and were secured for the Gallery. This particular version of the 'Doves' was included in the sale of the John Quinn collection in New York in 1927, but had afterwards completely disappeared from view until it was sent in to be sold at Christie's. Similarly the Trustees bought two early, pre-war carvings by McWilliam from his Surrealist period, both rearrangements of features of the human face, while an early carving by Dobson, 'The Man Child' 1921, with stylized forms, was purchased and presented by the Chantrey Bequest at the Tate's suggestion. These and other similar acquisitions parallel the great strengthening of the Gallery's collection of Vorticism which was going on at the same time, and underline the fact that the sort of works previously passed over were often among the artists' very finest and most exciting.

At the same time there has of course been a continuing need both to keep up with the later work of established artists as it emerged and to represent generation after generation of younger sculptors who sometimes introduce startling innovations. The work of Caro, for instance, took a completely different direction after 1960 when he stopped modelling figures for bronze casting and began to make abstract sculptures of open, spatial form in steel or aluminium which stood directly on the floor without any base and which were sometimes painted in brilliant colours. Starting in 1965 with 'Early One Morning' and 'Yellow Swing', the former a gift from the CAS and the latter a purchase, the Tate has acquired up to the time of writing a representative group of seven of his sculptures of this type, ranging in size from a table piece to the monumental 'Tundra' 1975 which is nearly 9 feet high and 19 feet long.

Caro's innovations were taken up by a group of younger sculptors, David Annesley, Michael Bolus, Philip King, Tim Scott, William Tucker and Isaac Witkin, who had been pupils of his at St Martin's

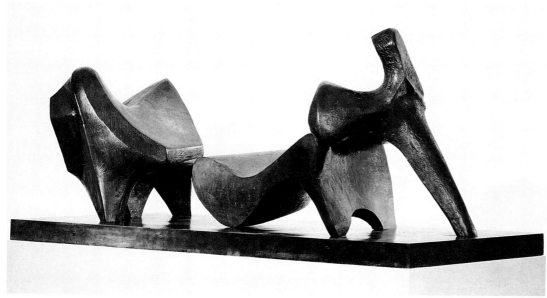

9. H Moore, 'Three Piece Reclining
Figure No 2: Bridge Prop', bronze,
1963

School of Art and who were exhibited together at the Whitechapel Art Gallery in 1965 under the title *The New Generation*, when the wide range of shapes and startling colours of their work attracted much attention. The Tate bought two sculptures from this show, King's 'And the Birds began to sing' and Bolus' 'Nenuphar', and over the next five years acquired at least one work by each of them. Then in 1970 Alistair McAlpine (now Lord McAlpine), who had been their greatest patron, presented no fewer than 48 of their sculptures from his private collection, together with 12 sculptures by William Turnbull, whose later work had considerable affinity with theirs. This gave the Tate a unique representation of their work (indeed the Gallery must own a substantial proportion of their total output in this style).

The possibility of Henry Moore giving a large group of his works to the Tate was first raised in 1964 and discussions continued over a long period between him and Sir Norman Reid, in the course of which the list was repeatedly revised and brought up to date. Henry Moore was anxious not to swamp the available space with his works and, though he attached no conditions to his gift, wanted to wait until the exhibition space at the Tate was increased by fifty per cent. In the end he was persuaded to make his gift in 1978, in time for his 80th birthday and when the extension to the modern galleries was already more or less complete though not yet open. The works consisted of 30 bronzes and 5 plasters, all but one from the post-war period, and including such famous pieces as 'Upright Internal–External Form' 1952–3, 'Falling Warrior' 1956–7, 'Three Piece Reclining Figure No 2: Bridge Prop' 1963 and 'Locking Piece' 1963–4.

Barbara Hepworth, who died in 1975, bequeathed two further sculptures to the Tate, and in 1980 the Trustees agreed to take charge of the small museum of her work which had been set up by her executors in her studio and garden at St Ives in accordance with her wishes. Together with the house and garden came the executors' gift of a selected group of 27 of her sculptures displayed in the Museum. It thereby became the Tate's first outstation. Visitors can see her working environment and also enjoy the sight of some of her larger works placed out-of-doors in her semi-tropical garden.

In 1982 the Victoria and Albert Museum transferred to the Tate seventy 20th century sculptures from their collection, all but a few by British artists and including works, mostly fairly small, by Armitage, Chadwick, Dalwood, Dobson, Gaudier-Brzeska, Gill, Moore and Paolozzi, among others. This transfer of all the V & A's 20th century sculptures, apart from certain works by Rodin, was made as a step towards rationalising the division between the two museums, whereby the Tate holds the national collection of 20th century sculpture and the V & A is responsible for sculpture up to the late 19th century. Many of these pieces came from the V & A's Circulation Department which was disbanded a few years ago.

Unfortunately shortage of space at Millbank has so far made it impossible to show more than a small proportion of the collection at any one time, and visitors are probably unaware of its extraordinary richness. The exhibition at Liverpool, though no more than a selection of some of the finest works tailored to the available space, probably provides the best opportunity to date to see what the Gallery owns. However, plans already exist as part of the second phase of development of the hospital site at Millbank for the construction of a Modern Sculpture Museum and Sculpture Court as one of the further buildings at the back of the Clore Gallery. Preliminary designs have been prepared by the same architects, James Stirling, Michael Wilford and Associates, and it is hoped to raise the necessary money before long from the Government or from private sources.

There are still a few gaps in the collection and some artists are not yet quite as fully represented as they deserve to be, so no doubt further additions will continue to be made from time to time, though on a small scale and very selectively. (The most serious gaps, it seems to me, are a large wood carving by Henry Moore and a late carving by Epstein, of exactly the type of the 'Jacob and the Angel' at present on loan to Tate Gallery Liverpool from the Granada Foundation). Nevertheless the collection is already extremely strong and does full justice to what has been one of the most successful aspects of 20th century British art: the emergence, from Epstein and Gaudier-Brzeska onwards, of generation after generation of very gifted sculptors. This is a process which is still continuing.

THE FORMATION OF THE TATE'S COLLECTION OF MODERN BRITISH SCULPTURE
Part 2

Lewis Biggs

The opening of Tate Gallery Liverpool has brought Merseysiders the opportunity of more direct access to the national collection of modern British sculpture. For the years 1988–1991, most of the important items of the collection may be seen at Albert Dock.

The present display makes it possible for the first time to take an overview of the collection. There are reasons why the Tate has never before made a display of its holdings of British sculpture on such a scale. One is the fact that British sculpture has been treated as a part of the Modern Collection of Western art and so not separated from other twentieth century sculpture and painting. More speculatively, it may be that sculpture as a medium has been collected and displayed less assiduously than painting. Sculptures demand rather more space than paintings for adequate display (as well as storage), and the Tate on Millbank has been badly short of space for at least the last thirty years. This may suggest also why the Tate's rate of acquisition of sculptures lags far behind that of paintings (see appendix I). Or is it also possible – given that the saleroom prices of sculptures rarely rival those of paintings – that sculpture is simply 'valued' less than painting?[1]

The previous chapter brings the story of the formation of the collection almost up to the present: it remains only to describe the acquisition of sculptures of the newer movements of the past two decades. However, purchases of very recent and current art have sometimes attracted a good deal of controversy – Carl Andre's 'Equivalent VIII', ('the Bricks') being a prime example. Inevitably, financial as well as aesthetic considerations are at stake, and it is not always possible to distinguish these, especially when the gallery must be discreet with regard to prices paid. One reason for this reticence is that it is often possible for a public gallery to arrange substantial discounts which would affect the market adversely for the artist if made known.

This controversy takes place not only among the public but among artists who may hope to benefit directly from the patronage of a major collecting institution. In fact, the Trustees of the Tate, as representatives of the Government, have always argued that their primary duty is to the public at large, and that although the collection and its display may benefit artists by providing examples for study and enjoyment, the direct support of artists' income is no part of their responsibility. Furthermore, opportunities for the Tate to act as a patron (that is to say, buying a work in a transaction which directly involves a living artist) are far more limited than is generally realised. Indeed, the way in which a collecting gallery like the Tate sets about acquiring objects is very little understood outside the museum world, even by art historians. Before continuing the narrative begun in the last chapter, therefore, this one starts with some comments on the circumstances and policies which have both defined the Tate's ability to act as a patron (within its wider acquisitions activity), and have helped to give the collection its present shape.

The mechanisms by which acquisitions are made are complex and varied. Purchases made using the Grant-in-Aid voted by Parliament annually for that purpose must be approved by the Trustees (see appendix II). Suggestions for purchases are put forward by the Director (often on the advice of the Keeper and curators of the relevant collection), except for items of lesser value which may be made at the Director's discretion and approved subsequently[2]. This discretionary power was vested in the Director by the Trustees to enable him to bid at auction. Funds donated or bequeathed to the Trustees, not infrequently

held in trust for a specific kind of purchase, are administered in a similar way.[3] The Knapping Fund, for instance, was set up to purchase works by British artists deceased not more than 25 years before the date of purchase. Up until 1970 these trust funds cumulatively formed a significant part of the sums available for purchase, but spiralling costs have diminished their importance in the last twenty years, so that they now play a negligible role.

In the face of these rising costs (and despite the steep curve in the increase in the Grant-in-Aid during the 1960s and 1970s) (see appendix III) the sums available to the Trustees for purchase have always lagged well behind the aspirations of the Gallery or the purchasing power of a number of other major art museums. In 1981, for instance, as the Tate Director's Report for that year remarks, the Trustees of the Getty Museum were obliged to spend $90m on purchasing art, some of it directly in competition with the Tate, whose current Grant-in-Aid was rather less than £1.9m (c.$3.3m at 1981 exchange rate).

In these circumstances, donations of art works to the Gallery have taken on the greatest possible significance. Between 1965 and 1986 almost twice as many British sculptures entered the collection by donation or transfer as by purchase (see appendix I). The proportion for all twentieth century sculpture is not dissimilar: 429 gifts as compared with 263 purchases. These simple statistics, moreover, do not reveal that it has often been the gifts that have been the most valuable additions to the collections – precisely those items which could not have been afforded through purchase monies, and so would not otherwise be represented. Examples are the immensely valuable donations of works by Barbara Hepworth (1967–8), and later by the trustees of her estate (1980), by Alistair McAlpine (1970), and by Henry Moore (1978).

The 1956 Finance Act, Section 34, allowed donations to be set against estate tax. Although this should have contributed to the attraction of memorial gifts and bequests, surprisingly the first example of this legislation being useful to the Tate was a decade later in 1966–7. Donations of considerable importance have also been channelled through the Contemporary Art Society (CAS), (founded 1910), through the Friends of the Tate Gallery (FoTG), (founded 1958), and through the Patrons of New Art (PNA), (founded 1979). Finally, an unrepeatable event which has helped to shape the collection in the last twenty years was the transfer to the Tate of all the modern sculptures belonging to the Victoria and Albert Museum. The transfer took place in 1983 as a part of the rationalisation of the two collections, and consequent on the abolition of the V & A's Circulation Department. This Department, while it had concentrated on smaller scale works suitable for touring, had been a far-sighted and imaginative patron of contemporary artists, as can be seen by its legacy to the Tate (see below).

In reality, it was only after the formation of the Friends of the Tate Gallery and the first Grant-in-Aid of significant size in 1959, that it was possible for the Director and Trustees to think in terms of an active rather than a passive acquisitions policy. It is not surprising therefore that the greatest changes in the Tate's modern collection took place during the fifteen years of the Directorship of Sir Norman Reid, (1964–1979). The resulting emphases within the collection were successfully furthered rather than altered by his successor Sir Alan Bowness (1979–1988).

In August 1979, the year of Reid's retirement, Lawrence Gowing wrote an article in *Encounter* in which he suggested that 'the Tate has a unity of purpose and a consistent intelligence not noticeable in any other museum anywhere'. He attributed this to Sir Norman's influence and recommended that the Director should be given power to make acquisitions 'unhampered' by the Trustees.[4] This comment by a sometime Trustee probably reflects a desire to simplify the complex, administratively costly, and often protracted acquisitions process, whereby a potential acquisition is normally brought physically to the gallery to be viewed by the Trustees before a decision is made.

The Director and his staff operate the acquisitions policy in the name of the Trustees through all of the agencies mentioned above. However it is only in the matter of direct purchases that they may be said to have a complete initiative.

The policy has tended to be expressed in two ways. It has been described in terms of 'in-depth' building upon an individual artist's work or upon an artistic movement. Alternatively, it has been described in terms of 'filling gaps' in order to make the collection a fuller survey. The 'in-depth' argument has tended to be used where the collection is patchy or inadequate, the 'gap-filling' where it is already approaching 'comprehensive'. A third option, which has possibly been regarded as not requiring supporting arguments, is that works of outstanding 'quality' should be acquired as opportunity affords regardless of existing representations within the collections. All three of these approaches must evidently be understood to be the reflection of a particular perspective.

For instance, in the Director's report for 1966–7 he expressed a desire for a didactic display of painting and sculpture which would show 'a more logical order, so that the visitor can follow the development and inter-relationships of the various movements...'. In this perspective the 'most comprehensive part of the modern collection is the section of British paintings of the period 1900–50, which is in many respects as complete as it will ever need to be.' On the other hand 'the Tate is pursuing a policy of representing a small number of the greatest postwar foreign artists in depth, by groups of works which form focal points in the modern collection'.

That neither a 'gap' nor 'comprehensiveness' may be easily defined is shown by the following year's report that 'the great majority of the modern works acquired during the year were ... by British artists and included a number of works which filled definite gaps in the earlier part of the twentieth century collection'. The paintings by Bomberg, Gertler, Nicholson, Piper and Spencer to which he referred were certainly highly desirable acquisitions, but were they really necessary within the terms of a teaching collection, to which the idea of 'gap-filling' relates? Fifteen years later (1984) his successor remarked of the modern British collection that 'Although the coverage of the period 1900–70 is now nearing completion in many areas, we are constantly on the watch for works which would fill the remaining gaps and enable us to achieve the ideal balance'. Clearly, apart from the 'responsibility to keep abreast of the latest developments', the changing perspectives of art history and of fashion more generally ensure that the 'ideal balance' is a forever receding goal.

However, neither the lack of a precisely defined and published policy[5], nor the complexities of the process of acquisition, have prevented the collection of modern British sculpture appearing remarkably consistent. It is a tribute to the tenacity of the staff and Trustees of the gallery that it reflects so closely the values they held during the period crucial to the collection's formation over the last twenty years.

These values might be described as 'internationalist', 'progressive', and 'aesthetic'. 'International' in that the 'in-depth' holdings of work by artists such as Hepworth, Moore and Caro may be perceived as a counterpart to the gallery's holdings by Giacometti, Gonzales and Gabo. They are seen as major figures in this context, rather than as representatives of specifically British tendencies. The special responsibility to collect British work noted above is always qualified by the awareness that the sculptures must stand alongside the best works from other countries (as well as competing with these works for purchase funds). Priority has been given to the 'progressive' art forms of this century. The policy is consistent with a reading of art history which supposes that the best Western art has been innovative. And it prizes the 'aesthetic' value of art above its value as historical evidence, in contrast to the policies of institutions such as the National Portrait Gallery, Imperial War Museum, National Maritime Museum etc, in which

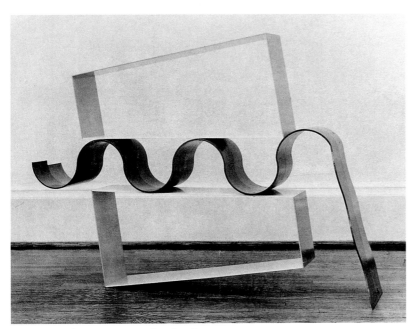

1. D Annesley, 'Swing Low', painted
steel, 1964

works of art are seen primarily as documents.

If we now return to the narrative of the formation of the collection we may see how it illustrates both the values of the staff and the mechanisms of the acquisitions process described above. The last 'movement' of British sculpture described in the previous chapter is that associated with the *New Generation* exhibition at the Whitechapel Art Gallery in 1965, which attracted international interest. Even while the Tate was making a start on collecting works by the artists represented, and others working in comparable ways, several other new or recent movements, of which Pop Art is now the most familiar and recognisable, were also requiring representation. There were also the scattered and spontaneous manifestations known variously as Events, Happenings, Fluxus and so on, and by the end of the decade there were British equivalents to the American and European critically defined movements of Minimalism, Conceptualism, Land Art, Process Art and Arte Povera. These forms of art posed particular problems to a collecting gallery, since many of the 'artworks' had a short life-span and were often intended to be antithetic to the forms of art which could be stored or owned. The Tate reacted cautiously. John Latham's 'Film Star' 1960, an assemblage using books, was bought in 1966, and may now appear to have been a first British example of post-New Generation art, but was perhaps then considered as belonging to an older tradition. It was three years before any other three-dimensional examples of this new art were bought: Michael Craig-Martin's 'Four Identical Boxes with Lids Reversed' 1969, and Barry Flanagan's 'Aaing j gni aa', 1965.

In 1970 two circumstances radically altered the situation. Alistair McAlpine presented the Tate with 60 sculptures by artists broadly associated with the New Generation sculpture. The gift meant that as far as the New Generation was concerned the Tate could concentrate on gap-filling. Secondly, in response to consistent lobbying by the Trustees, the Minister for the Arts, Jenny Lee, increased the Grant-in-Aid fivefold, allowing the possibility of a serious programme of purchases including the most recent movements. In that year and the next, Grant-in-Aid and Trust funds were used in purchasing 'Splash', a Pop sculpture by Clive Barker, experimental works by Michael Craig-Martin, Roelof Louw and Keith Milow, as well as sculptures in a more established abstract manner by Peter Hide and Nigel Hall. Then, in 1972–4 no less than 30 items of British sculpture were purchased. Besides sculptures in the more traditional conventions by Jacob Epstein and Kenneth Martin, and two works by John Davies, there was a large number of works which can be seen as British equivalents to the various forms of international art mentioned above. They included works by Keith Arnatt, Victor Burgin, Michael Craig-Martin, Barry Flanagan, Hamish Fulton, Gilbert and George, John Hilliard, Richard Long, Bruce McLean and David Tremlett.

The designation of much of this new art as 'sculpture' has always been arbitrary, and especially so since this decade has seen a resurgence of interest in the conventions of traditional sculpture. In the context of the evolution of British sculpture during the 1970s, though, there is a justification for including it in the discussion: many of the artists concerned had been associated with the Vocational Sculpture Course at St Martin's College of Art during the mid and late 1960s. Some, such as Gilbert and George, specifically claimed to be sculptors. More generally, like their counterparts in other countries, many of the artists concerned wished to distance themselves from both the abstraction and the illusionism inextricably associated with painting.

It is not surprising that the entry of these uncategorisable works (along with a good number of similar works by non-British artists, of course) into the collection was recognised by the staff of the Tate as likely to be controversial. The Biennial Report of 1972–4 which publicised these acquisitions included a 'Note on Conceptual Art' whch took care to stress the continuity of this new art with more traditional forms. Fearing that the Trustees might not approve the acquisition of a number of these works if presented singly, the Director and his staff adopted a strategy. They invited a small subcommittee of Trustees known to be sympathetic to the new art to review a complete 'package' of proposed purchases, which was then duly ratified when presented to the Board 'en bloc'.[6]

The highly fruitful Biennium of 1972–4 was followed by a relative paucity of acquisitions from 1976 to 1980. In the main these were additions to the representation of artists who had already found a place in the collection. At the start of the 1980s (also the start of Alan Bowness' term of office as Director) another grouping of British sculptors began to gain international attention. The rate of acquisition of contemporary British sculptures rose once more, with works by Stephen Cox, Tony Cragg and Bill Woodrow entering the collection in the first Biennium, and by Cox, Cragg, Antony Gormley, Anish Kapoor and Julian Opie in the second. Subsequent years have seen the addition of more sculptures by the artists associated with this grouping: one work by Edward Allington, four more by Tony Cragg, and single works by Richard Deacon, Shirazeh Houshiary, David Mach, Richard Wentworth, Alison Wilding and Bill Woodrow. There have also been recent purchases from artists working in a plurality of styles independent of this new grouping, such as Stuart Brisley, John Gibbons, Peter Hide, Ghisha Koenig, and Glynn Williams.

The transfer of a group of sixty-two, mostly small scale, British sculptures from the disbanded Circulating Department of the Victoria and Albert Museum in 1983 was an important event for the collection. From the earlier part of the century, it brought to the Tate three works by Frank Dobson, seven by Henri Gaudier-Brzeska, thirteen by Eric Gill, one by Sir William Goscombe John, Barbara Hepworth, F E McWilliam, Leon Underwood, Derwent Wood and two by John Skeaping. It also included three works by Henry Moore. Along with examples of works by Armitage, Butler, Chadwick, Clarke, Clatworthy, Dalwood, Hoskin and Turnbull, it transformed the Tate's holdings of this generation of the 1950s. It helped to flesh out the collection's skeletal representation of three dimensional systematic, constructive and kinetic art, with pieces by Anthony Hill, Malcolm Hughes and Gillian Wise-Ciobotaru. The transfer was made en bloc: there was no question of any works being declined.

When donations over this same twenty year period are compared with the purchases, the pattern is far less clear. This is to be expected in the case of bequests or donations by corporations or private individuals, where the Gallery can only take or refuse opportunities as they are

2. J Latham, 'Film Star', relief,
various media, 1960

3. M Craig-Martin, 'Four Identical
Boxes with Lids Reversed', painted
wood, 1969

6. R Wentworth, 'Shower', wood,
metal, various media, 1984

5. B Woodrow, 'Twin-tub with
Guitar', washing machine, 1981

4. J Davies, 'Young Man', painted
polyester fibreglass and various
materials, 1969–70

7. G Clarke, 'Head', forged iron on
stone base, 1952

presented. Discounting the major gifts by artists already noted, more than twenty items have been received in this way since 1965, including works by Keith Arnatt, Mark Boyle, William Butler, Anthony Caro, John Davies, John Hilliard, Richard Long, Denis Mitchell, Sir William Reid Dick and Leon Underwood. Particulary notable have been Mrs Gabrielle Keiller's presentation of Sir Roland Penrose's 'The Last Voyage of Captain Cook', and two gifts from the Trustees of the Chantrey Bequest, of bronzes by George Fullard and Michael Sandle.

However, no more coherent pattern emerges in the gifts deriving from 'organised' patronage, despite the theoretic possibility of orchestration by the Gallery in some instances. The Contemporary Art Society has been an early and consistent benefactor of the Tate collections. The CAS appoints a purchase committee each year by general vote of its subscribers – individuals and member galleries. The appointees buy art works entirely at their own discretion up to a finite sum, and every three years the member galleries are invited to state their preferred choice of gifts. These preferences are then weighted in favour of those galleries which subscribe the most, and the Tate, which provides office space and overheads to the Society, attracts special treatment. It is not possible for the staff of the Gallery to 'ventriloquise' purchases, therefore, in contrast to the case with the Friends of the Tate Gallery (see below).

Sculptures have formed a very small proportion of the gifts of the CAS to the Tate over the years, as compared with paintings. This may reflect a preference among CAS purchasers, or among the staff and Trustees of the Tate. From 1965 to 1983, four sculptures have been presented: the kinetic work 'Square Dance' 1969 by Peter Logan (given 1970); domestic-scale sculptures by Ian Hamilton Finlay, 'Sea Poppy' 1968, and Eileen Lawrence, 'Prayer Stick' 1977 (given 1979); and a work by Roger Ackling, 'Five Sunsets in One Hour' 1978 (given 1983). In the past five years, though, the CAS has been rather more adventurous, with gifts of larger scale sculptures by Antony Gormley, Keith Milow and David Mach. The Sainsbury Charitable Trust donated Barry Flanagan's 'Hare and Helmet II' 1981, in the year it was made, through the CAS. The fact that the works by Ackling, Lawrence, Logan and Mach are the only pieces by these artists in the collection, and the Scottish accent to the list, may suggest that the patronage of the CAS operates in an area of art complementary to that in which purchases are made from the Tate's own funds.

The Friends of the Tate Gallery exists to support purchases by the Trustees, and naturally the Friends' aid is called upon in cases where it is felt that the choice will be favoured by the membership. Low priority has been accorded to purchases of sculpture. The Friends have contributed only four items of British sculpture during the twenty three years under review. (This compares with a total figure of 200 works purchased or donated through the FoTG 1958–82.) The one major item is 'Genghis Khan' 1963 by Phillip King, (presented 1970). The other three are a relief by Mary Martin, made in 1966 (presented 1970); Eileen Agar's 'Angel of Anarchy' 1936–41, and Bernard Meadows' 'Lovers' 1980, (both presented 1983). Two small bronzes by William Turnbull were bought by the Sainsbury Charitable Trust and presented to the Tate also through the FoTG.

The Patrons of New Art, a group within the Friends of the Tate, was founded in 1982. Limited to 200 individual members, its special concern is the patronage of contemporary developments in art which are sometimes of less interest to the majority of the Friends. To date, the PNA have raised funds for the purchase of three major items of British sculpture: Julian Opie's 'Making It': Richard Deacon's 'For Those Who Have Ears, No. 2'; and Alison Wilding's 'Airing Light'. The Patrons may respond to suggestions from the staff of the Tate, or make purchases on the initiative of their own committee members. The Trustees are under no obligation to accept for the collection works acquired by the PNA.

Donations and bequest from individual benefactors continue to contribute to the collection. Sometimes these have been the result of a special relationship between the donor and the gallery, and there has been the possiblity of influence in both directions. For instance, Henry Moore had the opportunity to take a particular interest in the running of the gallery during his term as a Trustee, and this no doubt contributed to his decision to give a substantial number of his works to the collection. On the other hand, his stipulation that the display of these works should not disadvantage the space given to works by other sculptors was an acknowledged spur to the Gallery to plan the new extension completed in 1978. There are now plans to build a dedicated Sculpture Museum as a part of the Tate complex on Millbank. It remains to be seen whether this new initiative, and the considerable expansion in space available for showing British sculpture represented by the opening of the gallery at Albert Dock, will encourage further donations in the same way.

The importance of the CAS, FoTG, and particularly the PNA has been emphasised in a dramatic manner by the diminution of the effectiveness of the Grant-in-Aid during the 1980s. In accordance with the intention of the then Minister for the Arts (Lord Gowrie) to shift resources in all the national museums from acquisitions to conservation and building, the funds available to the Tate in 1985–6 fell to a level representing less than one quarter of the real buying power of those that had been available in 1980–1. The Government has confirmed that the figure of £1.815m will remain static until 1991, regardless of the continuing inflation of the price of art. The Tate Trustees, as noted above, have never sought to act as patrons in a direct manner. Now that it has become effectively impossible to use public funds to buy important works by the major artists of any century, it is possible that a larger proportion of the Grant-in-Aid may be spent in future on works by living artists, including British sculptors.

NOTES

I am grateful to Michael Compton for reading this essay in manuscript. I have incorporated a number of his suggestions in the text. Michael Compton retired from the Tate as Keeper of Museum Services in 1987 after twenty five years on the staff.

1 A proper evaluation of the question as to whether sculpture is fairly represented as compared with painting would need to take into account levels of quality, the historical importance of one medium against another at a given moment in time, etc. However, it seems very likely that the relatively small numbers of sculptures, as compared with paintings, in the Tate collections can be attributed directly to the difficulties of display and storage of the former. Works on paper, on the other hand, are numerically highly represented, no doubt because of their relative cheapness and ease of storage.

2 The figure has been increased fivefold in 1988, but must still be regarded as minor in relation to the price of important works at auction.

3 For a discussion of the Chantrey Bequest, see the previous chapter.

4 The staff of the Tate are, in all but technicality, civil servants, and consequently regarded in the British scheme of things as being incapable, in a constitutional sense, of accepting responsiblity, which must be taken by Trustees appointed by the Ministers of the Crown.

5 There can be no abiding policy since each meeting of the Trustees is plenary, and may therefore overthrow any decision taken at a previous meeting.

6 Michael Compton points out that 'this was probably the first, and virtually unrepeated, attempt to buy from a shopping list in order to represent a movement integrally (with failures, of course). Such efforts have been made by the Centre Pompidou regularly but are otherwise not so common world-wide as might be expected. Private collectors often behave in a more curatorial manner than museums in this respect'. Letter to the author 2 March 1989

8. R Penrose, 'The Last Voyage of Captain Cook', various materials, 1936

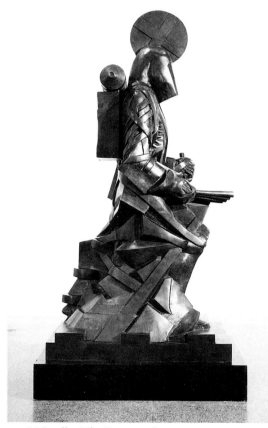

9. M Sandle, 'The Drummer', bronze, 1985

10. R Ackling, 'Five Sunsets in one hour', various media, 1978

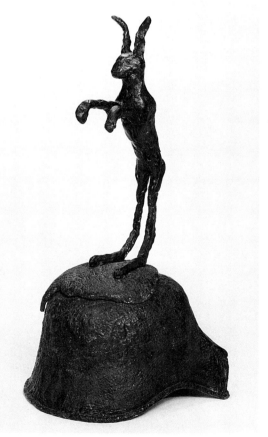

11. B Flanagan, 'Hare and Helmet II', bronze, 1981

APPENDIX I

Analysis of Acquisitions of Sculpture 1965–1986

	MODERN BRITISH SCULPTURE			MODERN FOREIGN SCULPTURE			MODERN COLLECTION Total[5]	HISTORIC BRITISH COLLECTION Total[5]
	Trust Funds & Grant-in-Aid	Gifts & Bequests	Total	Trust Funds & Grant-in-aid	Gifts & Bequests	Total		
1965–70	25	22	47	24	38	62	313	138
1970–74	54	68[1]	122	31	7	38	495	98
1974–78	23	53[2]	76	12	6	18	238	98
1978–82	26	80	106	17	5	22	374	104
1982–86	30	74[3]	104	23	77[4]	100	528	163
TOTAL	158	297	455	107	133	240	1948	601

1 includes Alistair McAlpine's gift of 60 sculptures
2 includes the gift of 49 sculptures by Naum Gabo
3 includes 62 sculptures transferred from V & A
4 includes a gift of 57 sculptures by Lipchitz and 8 transfers from V & A
5 the Modern Collection comprises paintings, works on paper and sculptures, the Historic British Collection paintings and works on paper only.

NOTE This chart is intended as an approximate indicator only. The first period is of five years, with subsequent periods of four years each. Within these years, the arrival and departure of a separate Department of Modern Prints and Drawings at the Tate has meant that sometimes works on paper are treated as a part of the total of the Modern Collection, sometimes not. Difficulties in applying the category of 'sculpture' have resulted in an approach inclusive of wall-hung reliefs and much 'Conceptual' art, inflating the figures above their relation to three-dimensional free-standing work. On the other hand, the Tate has acted as a patron to sculptors by buying their drawings, and these are not mentioned here. Finally, there is the difficulty of assigning 'national' schools to artists. Epstein, Gaudier and Gabo, for instance are treated as British artists because of their importance to the practice of sculpture in this country, while Schwitters, who spent much of his life in Britain, is not.

APPENDIX III

Grant-in-aid for Acquisitions to the Collections of the Tate Gallery have been voted annually at the level of the previous year. Increases were made in the following years:

1946	£2,000
1953	£6,250
1958	£7,500
1959	£40,000
1964	£60,000
1969	£75,000
1970	£265,000
1975	£570,000
1978	£1,012,000
1979	£1,570,000
1980	£1,888,000
1984	£2,041,000
1985	£1,815,000 (will remain unchanged to 1991)

APPENDIX II

DIRECTORS OF THE TATE GALLERY since 1965

Sir Norman Reid 1964–79
Sir Alan Bowness 1979–88
Nicholas Serota 1988–

TRUSTEES
★ = *Chairman*

1966–7
Sir Colin Anderson
Andrew Forge
Barbara Hepworth
Geoffrey Jellicoe
Anthony Lousada★
Stewart Mason
Victor Pasmore
Sir Roland Penrose
Sir Herbert Read
The Lord Robbins
Sir Robert Sainsbury
Adrian Stokes

1967–8
Andrew Forge
Dame Barbara Hepworth
Geoffrey Jellicoe
William Keswick
Phillip King
Antony Lousada★
Stewart Mason
John Piper
Sir Herbert Read
The Lord Robbins
Sir Robert Sainsbury
David Sylvester

1968–9
Andrew Forge
Dame Barbara Hepworth
Geoffrey Jellicoe
Phillip King
Anthony Lousada★
Stewart Mason
John Piper
Edward Power
Sir Robert Sainsbury
David Sylvester

1969–70
Andrew Forge
Dame Barbara Hepworth
Howard Hodgkin
Geoffrey Jellicoe
Phillip King
Niall McDermot
Stewart Mason
John Piper
Edward Power
Sir Robert Sainsbury★

1970–1
Andrew Forge
Dame Barbara Hepworth
Howard Hodgkin
Geoffrey Jellicoe
Niall McDermot
Stewart Mason
John Piper
Edward Power
Sir Robert Sainsbury★

1971–2
Sebastian de Ferranti
The Lord Harlech
Dame Barbara Hepworth
Howard Hodgkin
Niall McDermot
Stewart Mason
John Piper
Edward Power
Sir Robert Sainsbury★

1972–3
The Lord Bullock★
Sebastian de Ferranti
Andrew Forge
Lord Harlech
Howard Hodgkin
Niall McDermot
John Piper
Edward Power
Colin St John Wilson

1973–4
The Lord Bullock★
Sebastian de Ferranti
Andrew Forge
Lord Harlech
Howard Hodgkin
Niall McDermot
John Piper
Edward Power
Colin St John Wilson

1974–5
The Lord Bullock★
Sebastian de Ferranti
Andrew Forge
Lord Harlech
Howard Hodgkin
Niall McDermot
John Piper
Edward Power
Colin St John Wilson

1975–6
Sir Richard Attenborough
The Lord Bullock★
Sebastian de Ferranti
Martin Froy
Francis Graham-Harrison
Lord Harlech
Howard Hodgkin
Paul Huxley
Niall McDermot
Colin St John Wilson

1976–7
Sir Richard Attenborough
The Lord Bullock★
Sebastian de Ferranti
Martin Froy
Francis Graham-Harrison
Lord Harlech
Howard Hodgkin
Paul Huxley
Colin St John Wilson

1977–8
Sir Richard Attenborough
The Lord Bullock★
Sebastian de Ferranti
Martin Froy
Francis Graham-Harrison
Lord Harlech
Howard Hodgkin
Lord Hutchinson
Paul Huxley
Colin St John Wilson

1978–9
Sir Richard Attenborough
Lord Bullock★
Rita Donagh
Martin Froy
Francis Graham-Harrison
Lord Hutchinson
Paul Huxley
Peter Moores
Peter Palumbo
Colin St John Wilson

1979–80
Sir Richard Attenborough
Lord Bullock★
Rita Donagh
Francis Graham-Harrison
Lord Hutchinson
Paul Huxley
Peter Moores
Peter Palumbo
Colin St John Wilson
Basil Yamey

1980–81
Sir Richard Attenborough
Rita Donagh
Francis Graham-Harrison
Patrick Heron
Lord Hutchinson★
Paul Huxley
Peter Moores
Peter Palumbo
Richard Rogers
John Sainsbury

1981–2
Sir Richard Attenborough
Rita Donagh
Francis Graham-Harrison
Patrick Heron
Lord Hutchinson★
Peter Moores
Peter Palumbo
Richard Rogers
John Sainsbury

1982–3
The Countess of Airlie
Anthony Caro
Patrick Heron
Caryl Hubbard
Lord Hutchinson★
Peter Moores
Peter Palumbo
Rex Richards
Richard Rogers

1983–4
The Countess of Airlie
Anthony Caro
Patrick Heron
Caryl Hubbard
Lord Hutchinson★
Peter Moores
Peter Palumbo
Rex Richards
Richard Rogers

1984–5
The Countess of Airlie
Anthony Caro
John Golding
Patrick Heron
Caryl Hubbard
Peter Moores
Peter Palumbo
Rex Richards
Richard Rogers★

1985–6
The Countess of Airlie
Gilbert de Botton
Anthony Caro
John Golding
Patrick Heron
Caryl Hubbard
David Puttnam
Rex Richards
Richard Rogers★
Mark Weinberg

1986–7
The Countess of Airlie
Gilbert de Botton
Sir Anthony Caro
John Golding
Patrick Heron
Caryl Hubbard
David Puttnam
Sir Rex Richards
Richard Rogers★
Sir Mark Weinburg

1987–9
The Countess of Airlie
Gilbert de Botton
Sir Anthony Caro
John Golding
William Govett
Caryl Hubbard
David Puttnam
Sir Rex Richards
Richard Rogers★
Sir Mark Weinberg

INDEX

(Locations are given only when works of the same title mentioned in the texts are to be found in more than one location)